Piero della Francesca Marilyn Aronberg Lavin

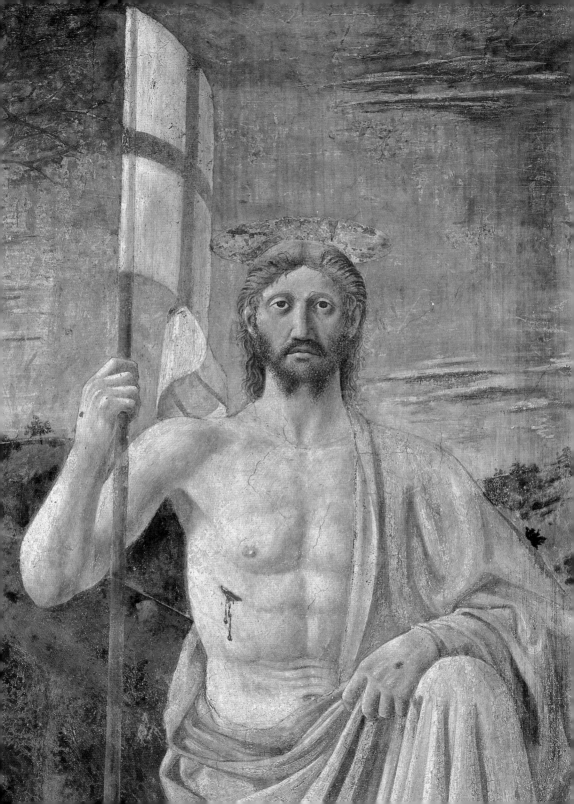

Piero della Francesca

Opposite
*Resurrection
of Christ*
(detail of 152),
1463–5.
Fresco;
225 × 200 cm,
88 $\frac{3}{8}$ × 78 $\frac{3}{4}$ in.
Pinacoteca
Comunale,
Sansepolcro

Few artists of the fifteenth century are admired today as much as Piero della Francesca (c.1413–92). Modern viewers respond in particular to the balance of his compositions, the geometric perfection of his forms and the emotional coolness of his style, which seem to speak directly across the centuries. This reaction comes not only from artists, scholars and art history students but also from ordinary tourists who have travelled to the hinterlands of central Italy where the majority of Piero's works remain.

It was not always like this. Piero was by no means universally famous in his own day. He came from Sansepolcro, a small town on the border between Umbria and Tuscany, and always considered it his home. He visited Florence for a brief period in the late 1430s but left no particular traces there. He worked for the rulers of several provincial fiefs – the Malatesta in Rimini, the d'Este in Ferrara and the Montefeltro in Urbino – returning to Sansepolcro between commissions. In mid-life he received a papal commission but stayed in Rome less than two years and never went back. By the time he died near the end of the century, he was an honoured citizen in his native town and interred in the precinct of the most prestigious church, where his well-to-do family had a burial plot of their own. Within a hundred years of his death, however, his work as an artist was all but forgotten. His paintings were considered old fashioned and his major altarpieces were in disuse. How then did he gain such prominence in the twentieth century?

The secret lies in Piero's other life, namely as a mathematician – in fact one of the greatest of his age. He wrote three mathematical treatises, one of which formed the basis of all theoretical studies of perspective that followed, including those of the artists Leonardo da Vinci (1452–1519) and Albrecht Dürer (1471–1528). Even Giorgio Vasari (1511–74), the famed author of *The Lives of*

the Most Eminent Italian Architects, Painters and Sculptors,
published in 1550, and an artist himself, born and raised in Arezzo
where Piero's most important fresco cycle was done, speaks first
about Piero as a mathematician of consummate talent. He praises
him for understanding the geometry of the third-century BC
mathematician Euclid better than anyone of his day. Vasari already
bemoans Piero's lack of fame, which he blames on Luca Pacioli,
another mathematician who he claims stole Piero's work and
published it under his own name. Only at the end of the biography
does he finally say that Piero was 'also an excellent painter'.

Piero used his expertise in mathematics in his paintings, for
example in calculating the size of bodies and objects represented
at different distances in space, and in determining proportional
relationships. In the 1920s art writers began to say that this con-
trol gave his works a distinctly 'modern' look and they compared
his paintings to those by Paul Cézanne (1839–1906; see 213)
and Georges Seurat (1859–91; see 214), and the Cubists Pablo
Picasso (1881–1973) and Georges Braque (1882–1963). The
Italian scholar-critic Roberto Longhi, author of the influential
monograph *Piero della Francesca* (published in 1927), was one
of the first promoters of Piero's modernity. Longhi described
Piero's geometric architecture and idealized, statuesque figures
as alternating with negative spaces that have as much volumetric
integrity as the positive forms. He interpreted these formal qual-
ities, coupled with Piero's unmodulated colour and luminous
atmosphere, as ends in themselves, and made it possible to see
Piero's art as pure form without the intrusion of sentiment, subject
matter or historical context.

Longhi's book was revised and republished in 1945 and was
followed in 1950 by *The Ineloquent in Art* by Bernard Berenson,
the American expatriate connoisseur who lived in Florence. In
his short but pithy book, Berenson was already complaining about
the invasion of tourists who came to his part of the world to seek
out Piero's paintings. The next year the distinguished English art
historian Kenneth Clark published his monograph *Piero della*

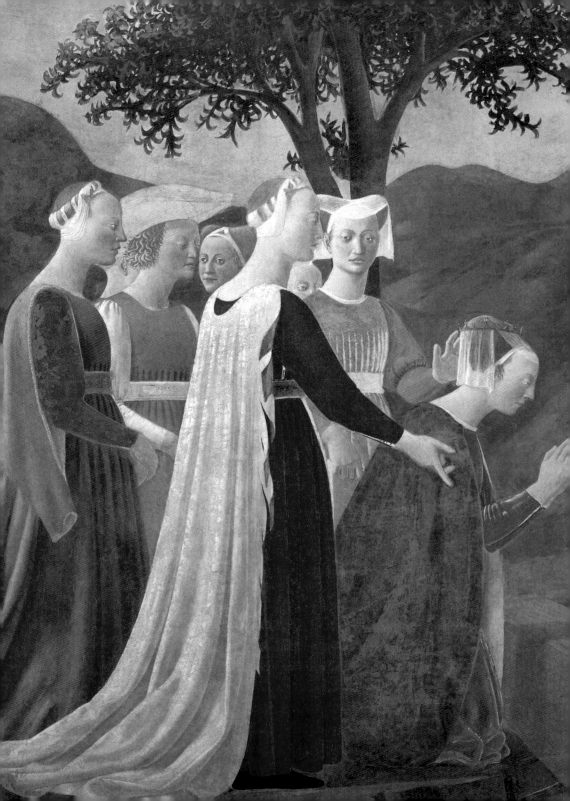

Francesca, the first to make Piero's images available to a wide audience in colour reproductions, and from which his fame spread rapidly. Clark retained a deep respect for Piero's formal values, but he also began to take his subject matter seriously.

In this context it should be remembered that no matter how artistically appealing Piero's paintings may be to current viewers, in the fifteenth century no art was created for purely aesthetic enjoyment. All painting was commissioned, and no art object was made without a predetermined function. This was the case with Piero's works; they are all (except for portraits) religious in nature. But what the fifteenth-century viewer saw were the same extraordinary things visible today: the serenely stirring style, with proportionally perfect figures set in pellucid, brightly lit pictorial space (1). This style has the strength and conviction of a Byzantine mosaic but is more natural. It has the simplicity and directness of paintings by the great fourteenth-century innovator Giotto (*c.*1267–1337; see 159), but is anatomically more correct. It has the psychological profundity of Masaccio (1402–28; see 13, 14 and 26), but is more enigmatic. And it has the clarity of space of the pious Dominican, Fra Angelico (1400–55; see 22), but is less precious. The fifteenth-century viewer would have embraced it for its spiritual values, seeing the Church's religious miracles repre-sented in a way that, for the first time, seemed rationally verified.

1
*Sheba
Venerates
the Wood*
(detail of 88)

Piero's admirers must travel to see the originals. Unlike other Renaissance masters, he is not represented in many of the world's major museums. His *oeuvre* is not large, and most of it is *in situ* in Italy: the fresco cycle of the True Cross in Arezzo; four Evangelists on a ceiling in Rome; four major pieces in Sansepolcro: the *Misericordia Altarpiece*; the *Resurrection* fresco and two frescoed single figures. The *Madonna del Parto* is in Monterchi; the *St Anthony Altarpiece* in Perugia; the *Flagellation* and the *Senigallia Madonna* in Urbino. Originally in Urbino, the Montefeltro double portrait is now in Florence, and the *Montefeltro Altarpiece* in Milan. A large altarpiece dedicated to St Augustine and made for Sansepolcro was broken up. The centre panel was lost, and the

four wings are now separated in four different museums: the Poldi Pezzoli in Milan, the Museu Nacional de Arte Antiga in Lisbon, the Frick Collection in New York (one of the only major pieces by Piero in the US) and the National Gallery in London. The latter also bought the *Baptism of Christ* in the mid-nineteenth century and the *Nativity* in the early twentieth. Venice and Berlin have one panel each, both tiny devotional images of St Jerome. Thus seeing his works takes quite a bit of travelling, and since several of the cities involved are off the beaten path, the term 'Piero pilgrimage' has been invented to describe the journey.

Even when one has seen all of Piero's paintings, however, it is still not easy to determine the place of each in the development of his career. Once he had established his signature style, he changed it only in very subtle ways. And because his paintings are visually so homogeneous, they are difficult to date. Written sources do not provide much help. The few original documents that deal directly with commissions are mostly contracts; these give starting dates for paintings that Piero often took years to complete so that the information is almost meaningless in terms of dating finished works. For example, the contract for the *Misericordia Altarpiece* is dated 1445 although the last payment was not made until 1461. Similarly, the contract for the *Sant'Agostino Altarpiece* was signed in 1454, with the last payment being made in 1470. Some contracts relate to works that have not survived (*eg* a processional standard depicting the Annunciation, 1466; and an outdoor fresco of 1478). Piero himself dated only two of his paintings: *St Jerome* (1450) and the Malatesta fresco (1451), but for such major works as the *Flagellation*, the Arezzo frescos or the *Montefeltro Altarpiece* there is no documentation whatsoever. In Piero's case the art historical game of 'date the painting' is thus wide open, with much prolonged disagreement among scholars. Some paintings, such as the *Flagellation* or the *Resurrection*, have as much as twenty-five years of variance (1440s to early 1470s).

Even more tantalizing is the almost total lack of records regarding Piero's personal life: there is no record of his birth, and he does

not seem to have kept account books. When in Sansepolcro, he always lived with his family; his father and then his brother acted as his agents in business matters. He never married or had any known long-term relationships, and had no direct heirs. Even less is known about his personality. Vasari, who usually finds some anecdote to describe the social interactions of his subjects, is silent on this point in his biography of Piero. Three painted figures have been tentatively identified as self-portraits on the basis of the woodcut that appears in Vasari's account of the artist's life (2): one of the devotees in the *Misericordia Altarpiece* (23); one of

2
Anonymous,
*Portrait of
Piero della
Francesca.*
Woodcut from
the second
edition of
Vasari's *Lives*,
1568

Solomon's courtiers in the Arezzo frescos (88); and a soldier in the *Resurrection of Christ* (152). All three show an individual of great seriousness, but add little to our knowledge of Piero himself. For insight into the man, perhaps the best evidence comes from the character of his technical writings and the paintings.

At the beginning of the twentieth century the few known facts about Piero's life were gathered together by Evelyn Marini-Franceschi, an Englishwoman who married one of his latter-day relatives and had access to family archives. In 1971 the Italian

scholar Eugenio Battisti, with the assistance of an archivist, produced a huge publication (revised in 1992) that reproduced masses of contemporary documents fleshing out the circumstances in which the artist lived. Little was added until the 1980s, when Frank Dabell, a young art dealer, and James R Banker, a historian, published a number of previously unknown documents they found in the State Archive in Florence, which houses records from Sansepolcro. These revealed important information about Piero's early career.

Understandably, interpretations of Piero's career – as an artist, an intellectual and a man – have been as varied as their authors. From the 1940s onwards, American and European scholars made a series of breakthroughs in dating, contextualizing and interpreting his work, culminating in the plethora of publications, studies and analyses devoted to Piero's art and culture that marked the quincentenary of his death in 1992. For the same occasion many of Piero's paintings were cleaned or restored. The work of consolidation, analysis and restoration carried out on the Arezzo fresco cycle was the most elaborate, taking more than a decade to complete. The present study benefits from all these efforts. In the following chapters I have brought together many aspects of Piero scholarship. I have looked at Piero's intellectual pursuits, for example his study of the classical past, including mathematical works such as Euclid's treatises on geometry. At the same time, I have attempted to show how Piero's interest in all the art around him – antique, medieval and contemporary – contributed to his own paintings. I have situated Piero's work within the political structures and religious beliefs and practices of his own time, looking at his patrons and the purposes of their commissions. And, while hoping not to take away the sense of mystery that draws so many viewers to stand before his work in silent contemplation, I have analysed Piero's personal visual language to explain the ways in which he laboured to appeal to the eye, to the faith and to the intellect of the beholder.

Pietro da Borgo The Painter and his City

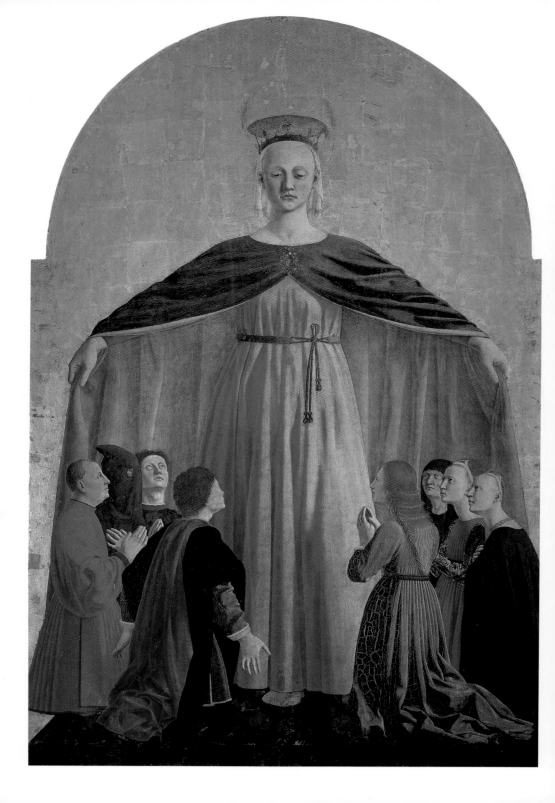

3
*Madonna della
Misericordia,*
central panel
of the
*Misericordia
Altarpiece* (23),
134×91 cm,
$52^{3}_{4} \times 35^{7}_{8}$ in

In Piero's time, the long thin peninsula of land that was to become
the unified country of Italy some five hundred years later was
divided into several territories dominated by two opposing political
forces. One was the Holy Roman Empire, the sprawling secular
power established by Charlemagne in the ninth century and
dominating most of the northern part of what is now Italy from
its capital in Prague. The other was the papacy with its temporal
as well as its spiritual centre in Rome. Known as the Papal States,
the Church's territories covered a wide band of land extending
north-eastwards from Lazio through Tuscany and Umbria to Emilia-
Romagna and the Marches. Supporters of the pope formed the
faction known as the Guelphs. Supporters of the emperor were
called the Ghibellines. Both sides divided their properties into
fiefdoms (towns and areas of land), assigning local control to petty
lords and aristocrats who had their private courts but who paid
rents and tribute to their superiors. The appointed lords, in turn,
collected rents and royalties from their subjects. Within the towns
or communes were bodies of citizens who administered the day-to-
day government and saw to the needs of the populace, always
reporting directly to their lords. By the time Piero was born, these
local governments had gained a certain amount of independence,
with a middle class that enjoyed a measure of wealth and comfort.
By the same token, the lords, marquises and dukes who oversaw
the various states (Milan, Venice, Florence, Siena, Urbino, Rimini)
had not only become very rich but were also constantly seeking
to expand their rights. To this end, they often joined forces against
their overlords and each other, switching allegiances and vying for
greater power. The lords themselves not only studied the art of war
but also trained at courtly schools to be extraordinarily cultured and
well read. Many of them made their living as *condottieri,* military
leaders who sold their services at the head of mercenary armies

to the papacy, the emperor or other states. In these pages we will meet a number of these skilful fighting men who have become well known as rulers, soldiers and, surprisingly enough, as bibliophiles and great patrons of the arts.

Piero della Francesca was born in the town of Borgo San Sepolcro, pictured in a number of his paintings (see, for example, the background of 54), which is located some 113 km (70 miles) southeast of Florence in an area which, during the first part of Piero's life, was part of the Papal States. Like many Italian towns numbering about 5,000 people, Borgo (its nickname in Piero's time) had quite a homogeneous population. People from more than two or three kilometres away were considered foreigners, and the only non-Catholics were a small number of Jews who followed one of the few professions they were allowed by the papacy, namely money-lending and playing music. The local government of these towns was run by successful merchants and professionals elected to councils for brief terms. Under this system it was often the case that the various factions and families (*eg* in Borgo the Pichi, Bercordati, Graziani and Bacci) were in sharp competition for power. Social welfare, such as feeding the poor, caring for the sick or burying dead paupers (4), was supervised by organizations attached to parish churches and specific occupations (confraternities and guilds).

In 1367 the pope handed Borgo over to Galeotto Malatesta (d.1385) and it became part of Galeotto's personal fiefdom. It must have come as something of a relief that the takeover was benign. The Malatesta were lords of Rimini and other territories on the eastern coast of Italy, and Galeotto was a sophisticated ruler. Besides rebuilding Borgo's fortifications, he reorganized the government in a way that brought civic stability, judicial tranquillity and public prosperity. He supported and approved a number of professional unions, among which was the Arte dei Calzolai or Guild of Shoe-makers, of which Piero's father was a member. In fact, the term *calzolaio* covered a number of occupations connected with the making of shoes. Leather had to be tanned, and one of the most important ingredients in the tanning process was made from a

plant called woad in English, or *guado* in Italian, which grows in
abundance in the region. Woad was also used in the production
of fine cloth, since after an elaborate process of fermenting, drying
and grinding, it produces a very effective blue dye. This colour is
the secret of the dye's success; it almost equals the blue produced
by the expensive mineral lapis lazuli but is much less costly. As a
result *guado* was highly prized throughout the Middle Ages and
Renaissance, and its production was lucrative. Because of Borgo's
traffic in woad, as well as leather and cloth, and its pivotal location

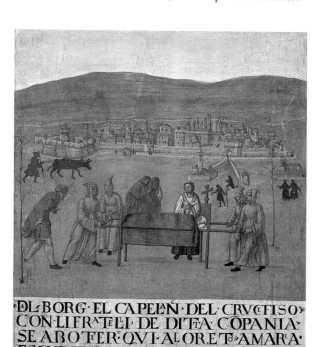

4
**Giovanni
di Leoni,**
*The
Confraternity
of the Crucifix
Ministering to
a Dying Man,*
after 1523.
Oil on panel;
68 × 57·5 cm,
26 ¾ × 22 ⅝ in.
Pinacoteca
Comunale,
Sansepolcro

at the crossroads between Tuscany, Umbria and the Marches,
and on the south–north route to Venice, it became a flourishing
market centre. Although Vasari in his *Lives* describes Piero's father
as a 'shoemaker', the family were in fact dealers not only in woad,
which they cultivated on their own land, but also in animal hides
and leather. Family members often served in local government,
and rather than the lowly shoemaker Vasari seems to imply, Piero's
father was part of the bourgeoisie and a prosperous merchant.

These circumstances probably account for the fact that the family
had a surname – at that time a sign of social status. In the fourteenth
century their name is recorded as 'de Franceschi'; 'della Francesca'
came into common use only in the fifteenth century. Piero's mother
was apparently from a different class. Born in the tiny village of
Monterchi, a few kilometres southwest of Borgo, she was called
Romana di Renzo di Carlo (d.1458), a more common style that
includes her father and grandfather, but no surname. Benedetto and
Romana were probably married sometime around 1410, and Piero
was probably born around 1413, the first of several children to
arrive within a few years. He had a sister named Angelica and three
brothers: Marco and Antonio, both of whom followed their father's
business, and Francesco, who joined the reformed Benedictine order
known as Camaldolite and lived in the large monastery at the centre
of the town. Tax records show that in 1428–9 the family's extended
household in the parish of San Niccolò included seven adult males.

Reconstructing Piero's early life up until the early 1430s is a matter
of speculation. In his time the only form of education consisted of
private instruction to male middle-class children by independent
teachers who came to pupils' homes or, more usually, taught some
twenty or thirty pupils in their own quarters. Boys like Piero usually
started learning letters and numbers at quite a young age. By the
time they were six or seven the family would have chosen what
type of schooling a boy would pursue, a decision that usually
affected the rest of his life. Two distinct choices were available:
one was to enter a grammar school, which offered a curriculum
considered appropriate for future teachers, lawyers and churchmen.
Here the pupil would learn to read and write simplified Latin texts,
gradually moving on to the poetry of Virgil and the letters of Cicero.
The other path was to enter an 'abacus' school, so called for the use
of the counting device, in preparation for a life in business. Here,
reading and writing instruction was in the vernacular, centring
on exemplary religious and moral texts – books on the virtues
and vices, biblical texts, stories of the lives of the saints (such as
the *Golden Legend*) – and chivalric romances read for pleasure.
Lessons in mathematics covering arithmetic, algorithm, algebra and

geometry were geared to the kind of problem-solving needed for business. It is fairly certain that Piero did not learn Latin in school, although he may have taught himself to read the ancient language later in life. Being the eldest son of a successful merchant, he would have been expected to enter the family business and therefore was undoubtedly placed in an abacus school. It is likely that, even at an early age, he already showed an extraordinary aptitude for numbers.

It is even possible that the abacus school helped develop Piero's interest in art, or at least in the graphic representation of mathematical structure. Perhaps his teachers recognized his ability in drawing diagrams, to say nothing of his skill in abstract thinking, and encouraged him in this direction. The decision that Piero would be an artist, exceptional for a child of his background, seems to have come later than normal. Ordinarily, a boy destined for an artistic career was apprenticed to a master by the age of ten or twelve. By contrast, Piero probably stayed for several years in the abacus school, since there is no record of Piero as an artist until 1432, when he would already have been at least twenty-three years old. By then, his younger brothers Marco and Antonio were together taking his place in the family business.

The record establishing that Piero had taken up art by 1432 was unknown until the mid-1980s, when new documents were found in the Florentine State Archive. These are records of payments to him and Antonio d'Anghiari, an older painter of limited talents, for work on an altarpiece for the Franciscan friars of Sansepolcro. Piero apparently did some menial job on the frame for what ultimately became an impressive double-sided polyptych (a picture – usually an altarpiece – made up of several connected panels). Antonio failed to complete the commission, and in 1438 Sassetta (c.1400–52), a highly regarded master from Siena, was called in to start again. The *St Francis Altarpiece* (5) was finally completed in 1444. Piero appears together with Antonio d'Anghiari once more in 1436 working on a processional standard (a painting on canvas carried through the streets on religious feast days). But it is clear that this relationship was something of a dead end, and soon

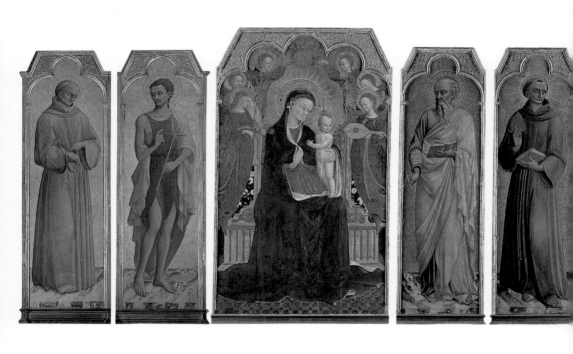

afterwards the younger man left Borgo to look for work and new experiences elsewhere.

It has been suggested that Piero paid an early visit to Urbino at this time, and then went to Perugia where he would have encountered Domenico Veneziano (*c.*1410–61), a painter with whom he surely felt a strong kinship on account of their mutual interest in colour, light and space. From Umbria both artists certainly went to Florence, where Domenico had a commission to paint a cycle of frescos in the apse of the hospital church of Sant'Egidio (the frescos were destroyed in the seventeenth century when the church was

5
Sassetta,
St Francis
Altarpiece
(photographic
reconstruction),
1438–44.
Tempera on
panel; height
of central panel
207 cm, 81¼ in.
Musée du
Louvre, Paris
(central panel
and right wing);
Harvard
University
Center for
Italian
Renaissance
Studies, Villa
I Tatti, Florence
(left wing)

6
Page of
an account
book, dated
12 September
1439.
State Archives,
Florence.
The entry
referring to
Piero is at the
top of the page

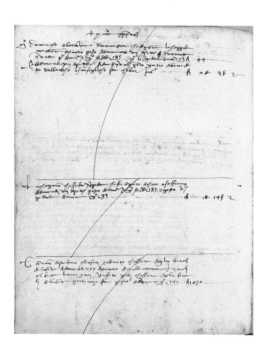

redecorated). A hospital account book (6) bears a note saying that on 12 September 1439 Piero was with Domenico and brought him a payment of 2 little florins and 15 soldi (*2 fiorini e 15 soldi*). The document gives no indication as to whether Piero joined Domenico as an assistant, as has been traditionally assumed, or worked with him as a colleague. By 1439 Piero was at least twenty-six (the age of majority in Tuscany was twenty-five), and certainly old enough to be working on his own.

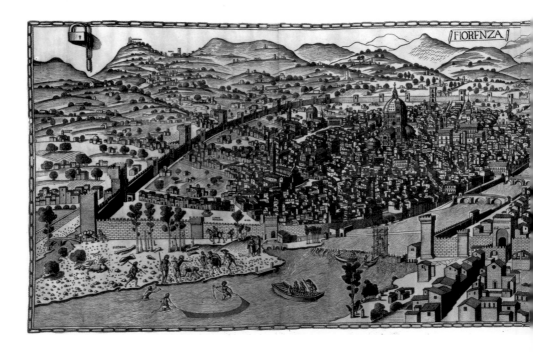

The hospital account book thus documents Piero's presence in Florence, a city that played a central role in the new age of the Renaissance (7). He was surrounded by the cultural dynamism of a society of scholars, men whose learning included the study not only of the teachings of the Church but also of newly discovered Greek and Latin texts on politics and morality, many of which were brought back by Near Eastern travellers. Striving to emulate the vigour and authority of ancient Rome, these intellectuals, known as humanists, held important government positions, and influenced law making as well as the curricula taught in schools. They also encouraged the development of civic pride in the form of public works of art and architecture, including the city's great cathedral or *duomo*. This building's enormous dome, designed and constructed by Filippo Brunelleschi (1377–1446), had been completed in 1436, making it the largest covered structure in the world at that time (8).

In 1434 the wealthy Medici family, with Cosimo at the head, had taken unofficial control of the republic of Florence. The local administration was run by the Guelph party (supporters of the pope

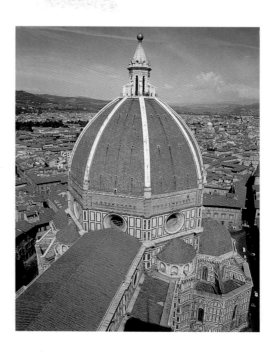

7
Attributed
to Francesco
Rosselli,
*View of
Florence,*
c.1472.
Woodcut;
58·8 × 131·5 cm,
23 1/8 × 51 1/4 in

8
Filippo
Brunelleschi,
Dome of
Florence
Cathedral,
1418–36

against the emperor), and in 1439 was playing host to Eugenius IV, the current pontiff. A power struggle between the pope and the college of cardinals, led by the Colonna family, had been raging in Rome for more than a decade, and when they threatened physical violence, the pope and his entire court took refuge in Florence. There Eugenius was welcomed with enthusiasm by his former secretary to the papal chancery, Lionardo Bruni, now the respected chancellor of the republican city.

Bruni was one of many noted humanists whose work in politics and learning epitomized the cultural context in which Piero found himself. Among Bruni's great intellectual contributions was his differentiation of the Renaissance from the Middle Ages. He saw his age as reviving the culture of classical antiquity, and quite consciously defined it as a 'rebirth' – the literal meaning of the word renaissance. Emulating the advice and actions of the first-century BC republican Roman orator Cicero, Bruni brought to his office the classical ideals of high morality combined with literary achieve-ment. He not only translated many ancient Greek writers, including

Plato, Aristotle and Plutarch, into Ciceronian Latin, but also helped to raise the status of vernacular literature by writing biographies in Tuscan Italian of the great fourteenth-century writers Dante Alighieri, Francesco Petrarca (Petrarch) and Giovanni Boccaccio. Bruni's tomb (9), designed by Bernardo Rossellino (1409–64) in *c*.1446–8, exemplifies the Renaissance fusion of classical motifs with Christian imagery. Corinthian pilasters flank a full-length funerary portrait sculpture surrounded by many references to Roman art, while a Virgin and Child look down from the tomb's pediment.

Another humanist vividly present in Florence at this time was Lorenzo Valla. Valla produced the first Latin grammar since ancient Rome. His recognition of the historical shifts in the meaning of words, and of language as a reflection of changing custom, became

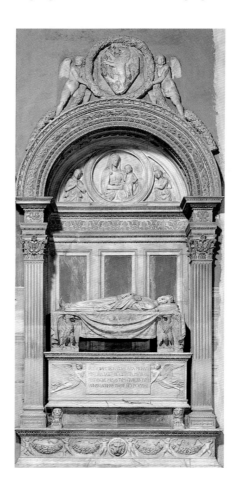

9
Bernardo Rossellino,
Tomb of Lionardo Bruni, *c*.1446–8.
Marble;
h. 7·2 m,
23 ft 6 in.
Santa Croce, Florence

a fundamental concept of humanism. On the basis of language, in fact, Valla was able to reveal as a medieval forgery a document supposedly written by the emperor Constantine in the fourth century, granting vast regions of Italy to the Church. This so-called 'Donation of Constantine' was the chief justification of ownership of most of the lands of the Papal States. We may wonder at the reaction of the resident pope (Eugenius IV), who himself was fighting to retain his political hegemony, when one of the humanists in his own employ, Flavio Biondo, tacitly agreed with Valla in his *History of Rome* (first three books written in the 1440s). While a young man in Piero's position could not have gained entry to humanist circles, the intellectual excitement they generated would have fuelled an interest in classical learning.

In spite of the high respect in which they were held in most quarters, many humanists suffered criticism from contemporary conservative thinkers. With their emphasis on 'pagan' classical literature, they were often accused of trying to undermine Christian morals and faith. In actuality, the humanists promulgated a solid grounding in the classics as a worthy preparation for the Christian life, and many of them were ordained priests. In the fourteenth century Petrarch, often called the father of Italian humanism, had himself been ordained. Among the fifteenth-century humanists, Ambrogio Traversari, an influential scholar and theologian, was a monk and abbot in the Camaldolite order. Leon Battista Alberti (1404–72), moralist, art and architectural theorist, and occasional sculptor, was a priest and member of the Curia (papal court). The main concerns of these men may have been intellectual – language, literature, politics and history – but they never gave up their active roles in the religious life of the community. Piero appears to have responded to this particular combination in the new learning, following in his own painting the ideal forms of classical art while also consciously emulating the simplicity of earlier devotional images.

Piero's visit to Florence came at a crucial time. For more than half a century the Ottoman Turks, followers of the religion of Islam, had

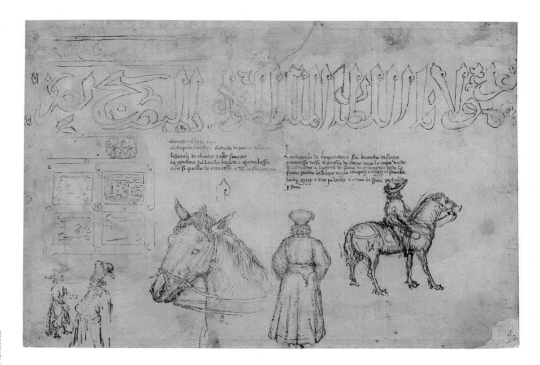

been moving westward, encroaching on the territories of the
Byzantine Empire, ruled in its later phases by the Palaeologan
dynasty. With every battle, the Turks came closer to attacking
Constantinople (modern Istanbul), capital city of Byzantium. Now
the emperor John VIII Palaeologus had come to Florence with the
leaders of the Eastern Orthodox Church to meet with the Catholic
hierarchy of Rome in a Council of Union (1438–9). This was the
second quasi-emergency meeting between a Palaeologan emperor
and a pope (the first took place in Lyon, France, in 1274, and is
discussed in Chapter 4). In both cases the dialogue involved possible
ways of consolidating not only their military forces, but also of
resolving their religious differences in matters pertaining to the
Trinity and Communion (problems still being discussed today). In
both cases the papacy tried to use the request for military aid as
a leverage to gain Roman dogmatic (and thereby political) power
over the East. Neither council was particularly successful: the two
Churches remained separate, no military help was forthcoming and
Constantinople fell to the Turks in 1453.

10
Pisanello,
*Emperor
John VIII
Palaeologus
on Horseback
and Three
Byzantine
Figures,*
1438–9.
Pen and
brown ink;
20 × 28·9 cm,
7⁷₈ × 11³₈ in.
Musée du
Louvre, Paris

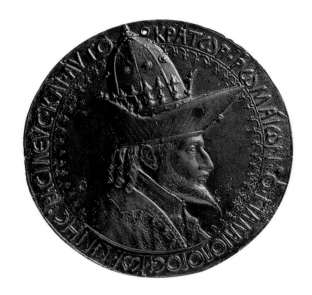

11
Pisanello,
Bronze medal
depicting
Emperor
John VIII
Palaeologus,
1438–9.
diam. 10·4 cm,
4¹₈ in.
Musée du
Louvre, Paris

The fifteenth-century Council was originally scheduled for Ferrara
but coincided with one of the city's frequent outbreaks of plague. As
a result, the meeting was moved to Florence, and the considerable
expense of housing the participants was partly taken over by the
Medici. During Piero's stay, the streets of the city were filled with
dignitaries from both sides – Italian princes, diplomats and papal
emissaries, and Byzantine potentates of Church and State. The
garments of the foreign visitors, made of silks and velvets shot
with gold and cut in outlandish styles, were thought by the locals
to reflect the garb of Greek early Christians, and were therefore
of considerable historic interest. They made an indelible impression
on Piero, who depicted Byzantine finery in many of his later com-
positions, for example in the long robes and curious hats worn by
the men in the *Exaltation of the Cross* (see 110), one of the scenes
in the fresco cycle of the True Cross in San Francesco, Arezzo.
The Tuscan draughtsman and medallist Pisanello (Antonio Pisano;
c.1395–1455) recorded the Byzantine costumes, which he drew on
the spot and in great detail (10). Pisanello also produced a profile

portrait of the emperor John Palaeologus in the form of a medal cast in bronze (11), an image that became the classic model for the exotic ruler and was copied and varied throughout the rest of the fifteenth century. Pisanello's medal is inscribed in both Greek and Latin, exemplifying the polyglot ambience of Florence at this time.

During this same period of the late 1430s a new theory of depicting pictorial space was sweeping through the Italian artistic community. This was 'linear perspective', a mathematical technique for representing three-dimensional objects and spaces on a two-dimensional surface, in which the size of objects at various distances from the eye can be gauged precisely. By the end of the thirteenth century and into the fourteenth, Cimabue (*c*.1240–*c*.1302) and then Giotto and his followers had made the edges of buildings and furniture slant to suggest their recession into space. They had also decreased

12
Donatello,
*St George
and the
Dragon*,
c.1415–17.
Marble;
39 × 120 cm,
15⅜ × 47¼ in.
Museo
Nazionale
del Bargello,
Florence

13
Masaccio,
*The Tribute
Money*,
c.1427.
Fresco.
Brancacci
Chapel, Santa
Maria del
Carmine,
Florence

the size of objects to show them in the background. These artists were interested in creating the illusion of a spatial realm beyond the picture plane, but their technique was intuitive and approximate. The new invention used mathematics to make the procedure consistent and rational. The architect Brunelleschi had demonstrated the technique with a diagrammatic view of the Florentine Baptistery as seen from the steps of the Cathedral (unfortunately lost). The first to apply it in art were Donatello (1386–1466) in the relief plaque under his statue of *St George* (12) and Masaccio, who employed it in frescoed landscape narrative scenes (13) in the Brancacci Chapel in the Church of Santa Maria del Carmine, Florence. Masaccio's fresco of the *Trinity* (*c*.1425–7) in Santa Maria Novella in Florence shows his use of linear perspective to create the effect of interior space (14). These works were on view

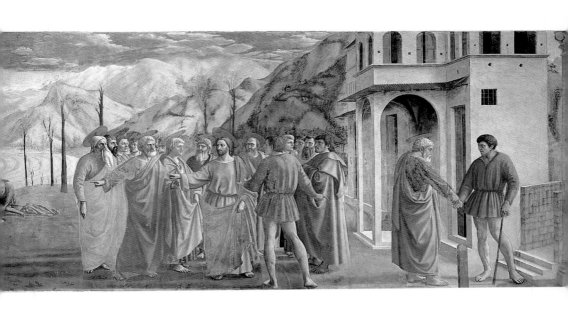

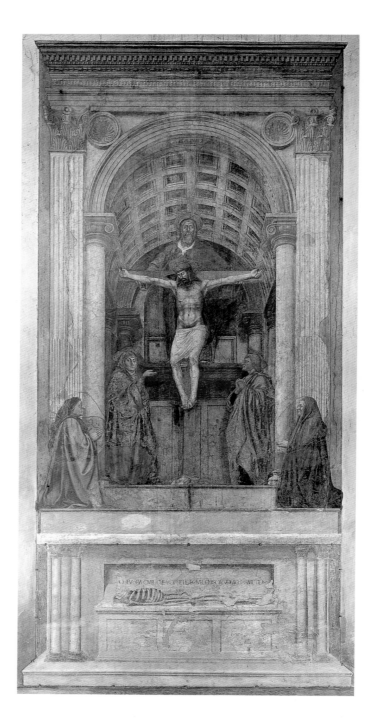

14
Masaccio,
The Trinity,
c.1425–7.
Fresco;
6·7 × 3·2 m,
21 ft 11 in
× 10 ft 5 in.
Santa Maria
Novella,
Florence

15
Paolo Uccello,
*Sir John
Hawkwood*,
1436.
Fresco
transferred
to canvas;
8·2 × 5·2 m,
26 ft 11 in
× 16 ft 11 in.
Florence
Cathedral

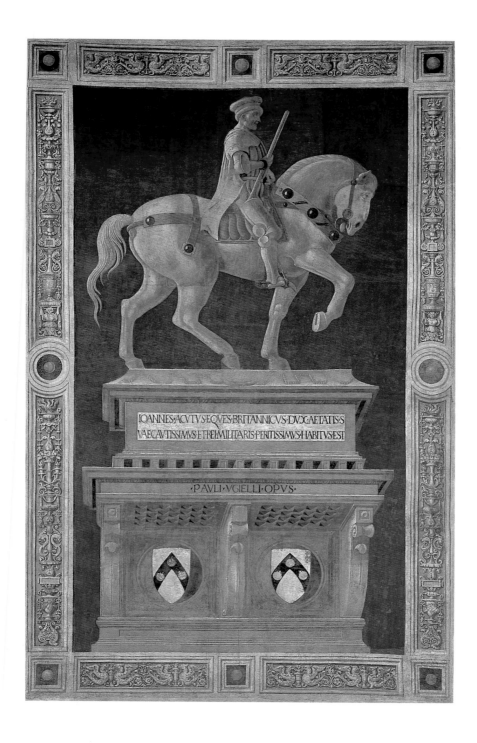

IOANNES·ACVTVS·EQVES·BRITANNICVS·DVX·AETATIS·S
VAE·CAVTISSIMVS·ET·REI·MILITARIS·PERITISSIMVS·HABITVS·EST

·PAVLI·VGIELLI·OPVS·

during Piero's stay in Florence, and he was to become increasingly concerned with the uses of perspective in both landscape and architectural settings. In 1435, Alberti circulated manuscripts of the Latin version of his *Treatise on Painting*, in which he combined the intellectual and artistic elements of the technique into a coherent theory. The treatise was translated into Italian and published the following year, and soon became a manual for all the young painters in town, including Piero.

In spite of the rational basis of the new technique, however, it could also be used in exaggerated form to achieve new levels of emotional expression. Piero would have looked with interest at such examples as Paolo Uccello's (1396/7–1475) painted equestrian monument to the English *condottiere* Sir John Hawkwood on the interior north nave wall of Florence Cathedral (15). Hawkwood was a fourteenth-century mercenary general who had fought in England and France before coming to Italy, where he was known as Giovanni Acuto. In 1346 at Cascina he won for Florence a major territorial battle against neighbouring Prato and nearly a century later was honoured for his victory with the painted monument. By manipulating the orthogonals (lines perpendicular to the picture plane) of the statuary base, Uccello designed an oblique view, creating an effect of looming power for the figure of the military hero. Fra Filippo Lippi (*c*.1405–64) constructed his *Tarquinia Madonna* of 1437 (16) with an acute angle of vision. The space in the painting recedes very suddenly, and the steep foreshortening of Mary's throne tips the holy couple precariously towards a quite disturbing intimacy with the worshipper. Domenico Veneziano had a different approach. Although he doubtless studied the unified vistas in Masaccio's Brancacci Chapel frescos (see 13), he used perspective to complicate rather than to simplify pictorial space. In his masterpiece, the *St Lucy Altarpiece* (*c*.1445–7), the tight design for the tiled floor contrasts sharply with the looping structure of the architectural background (17). With this contrast Domenico created an ambiguity that serves to monumentalize the architecture without overwhelming the figures.

16
Fra Filippo Lippi,
Madonna and Child
(the *Tarquinia Madonna*),
1437.
Tempera on panel;
114 × 65 cm,
45 × 25 ¹⁄₂ in.
Galleria Nazionale d'Arte Antica, Rome

Like Domenico, Piero was concerned with more than the creation of surface illusion and tonal effects. Both artists were also engaged with the problem of representing the human body. In one of the small-scale scenes on the pedestal, or *predella*, at the foot of the *St Lucy Altarpiece*, Domenico produced the first frontal male nude of the Renaissance, depicting the *Young St John in the Desert* (18). This little figure is elegant and balanced in his movements, and deeply expressive in mood as he drops his worldly clothes and dons his penitential garb. One of Piero's earliest works also features

17
Domenico Veneziano,
Madonna and Child with Saints
(the *St Lucy Altarpiece*),
c.1445–7.
Tempera on panel;
209 × 216 cm,
82 × 84 in.
Galleria degli Uffizi, Florence

18
Domenico Veneziano,
Young St John in the Desert,
predella panel from the *St Lucy Altarpiece,*
c.1445–7.
Tempera on panel;
28·4 × 32·4 cm,
11 × 12³₄ in.
National Gallery of Art, Washington, DC

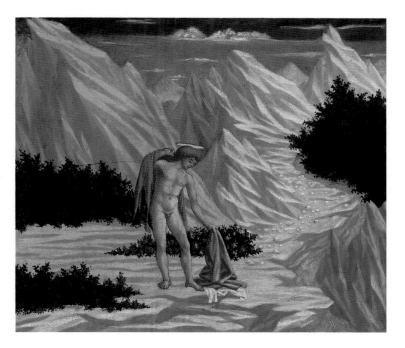

a semi-nude figure seen from the front (see 24), and although formally less graceful and nuanced than the contemporary figure by Domenico, it is just as daring, being much larger in scale and presented as a devotional image.

Another concern Piero shared with the artists he met in Florence was plasticity, or the problem of making two-dimensional forms look round and firm. Fourteenth-century painters had been content to outline their figures and separate them from their background. The challenge to show physical bulk was uppermost in the mind of such

artists as Andrea del Castagno (*c*.1421–57), who also worked in the church of Sant'Egidio. Like his colleagues, Castagno learned how to create this effect by studying the classicizing sculptures of Donatello and Luca della Robbia (*c*.1400–82), for example the latter's *Singers* from Florence Cathedral (19). He also drew anatomical guidance directly from examples of antique sculpture, which were increasingly available in sculptural fragments found and excavated in and around the city. The three artists, Domenico Veneziano, Andrea del Castagno and Piero, approached the

Piero della Francesca

19
Luca della Robbia,
Singers,
1431–8.
Marble relief from a *cantoria* (singing-gallery);
c.103 × 93·5 cm,
$40^1{}_2 \times 36^3{}_4$ in.
Museo dell'Opera del Duomo, Florence

20–1
Andrea del Castagno,
Last Supper,
1447–8.
Fresco;
c.4·7 × 9·8 m,
15 ft 5 in × 32 ft.
Refectory, Sant'Apollonia, Florence
Above
Detail

problem of representing volume quite differently: Domenico defined his figures with outlines but modelled them in colour (see 17); Castagno put his figures into gruff relief by darkening and shading the edges, as in his later frescos at Sant'Apollonia (20–1); and Piero was to develop a technique of highlighted, smoothed-out borders to make his bodies stand out (see 24). Nevertheless, they were all in search of ways to create plasticity and the illusion of bulk and weight.

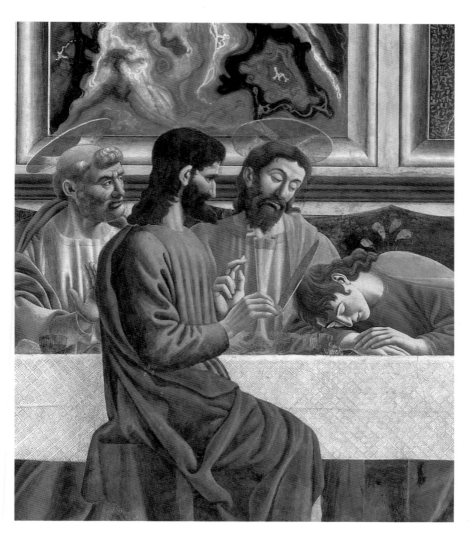

There was still another area of art about which Piero learnt much while in Florence, namely the combining of the new naturalism with the expression of traditional religious content. Here he seems to have turned to the work of the Dominican friar known as Fra Angelico. With their shining gold backgrounds and quiet piety, Angelico's early paintings are ethereal and other-worldly. From the 1430s, however, while retaining intense devotional qualities, his major works demonstrate a direct observation of nature in their glowing atmospheric effects, combined with a knowledge of linear perspective evident in his cogently designed spatial environments.

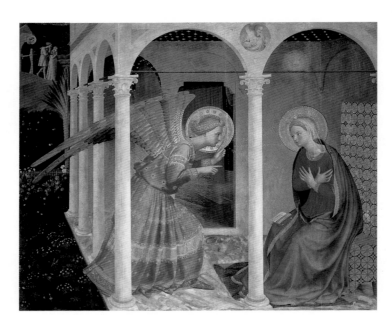

22
Fra Angelico, *Annunciation*, c.1432. Tempera on panel; 175 × 180 cm, 68⁷₈ × 70⁷₈ in. Museo Diocesano, Cortona

A fine example is the *Annunciation* now in Cortona (22), painted in around 1432. Angelico's respect for traditional spirituality, combined with his confidence in the new naturalism, provided Piero with a model he never forgot. Surprisingly, in spite of the stimulation he found in Florence, Piero did not settle in this cosmopolitan city, and there is no evidence of his presence there during the rest of his career. By 1442 he was back in Borgo San Sepolcro, where his name appears on a list of possible candidates for a position on the town council (*consigliere popolare*). The post

was not one of great power – he would have a vote on community projects for six months or a year – but the nomination marked him as a respected citizen. Three years later, in 1445, he received a commission to paint the *Misericordia Altarpiece* (23) and signed his first known contract as an independent artist.

As the visual homogeneity of Piero's paintings presents difficulties for scholars attempting to date works, it is something of an irony that his independent career begins with the one work that shows a certain development from an early to a mature style. The *Misericordia Altarpiece* took more than fifteen years to complete, being carried out in two main stages with a long gap in the middle; these phases can be dated very roughly as *c*.1445 to *c*.1448, and 1450 to *c*.1462. By the time of the final payment in 1462, Piero had also produced many of his other best-known paintings. The patrons were the members of the Compagnia di Santa Maria della Misericordia (said to have been founded in 1269). Like many other such organizations in Tuscany, this one was dedicated to the Virgin Mary in her role as giver of mercy, pity and charity, all the meanings of the word *misericordia*. By the mid-fifteenth century it was made up of twenty or so middle-class merchants who met under the guidance of elected priors to organize acts of charity. Their services included medical care and burial for members, dowries for destitute girls, hospitality for poor pilgrims, and spiritual and moral assistance to criminals and often accompaniment to their place of execution. Such activities were an expression of the growing sense of social responsibility of the new bourgeois class. At the same time, this group retained certain medieval aspects: it was a flagellant brotherhood whose members publicly whipped themselves to express atonement for private sins. They walked in processions on feast days, under strict rules for behaviour, wearing masked and hooded cloaks. Women were excluded from membership, although they were apparently allowed to worship in the group's chapel.

The brotherhood met in a small oratory on the northeast edge of Borgo, to which a hospital building had been added during the Black Death of 1348 (the particularly virulent cycle of bubonic plague that

decimated the population of Europe). The oratory was furnished with an altar where a priest from a nearby parish periodically came to say Mass. There are no records of anything but processional banners adorning the altar until about 1430, around which date the members commissioned their first altarpiece. Like many other establishments in Borgo at the time, they called on an artist from another community to do the work, in this case Ottaviano Nelli (c.1370–1444/50), a painter from Gubbio. Nelli prepared a large polyptych of a type known as a 'buttressed altarpiece', made up of a number of painted panels surrounded by a heavy carpentry frame that is anchored to the floor on four legs, or buttresses, straddling the short ends of the altar table. Nelli's construction had apparently been in place for fifteen years when the members of the confraternity, for reasons unknown, decided to replace it and hired Piero to do the job. According to the contract, Piero's assignment was to produce another polyptych in a period of three years, following precisely the form, shape and dimensions of Nelli's earlier work. (Piero's altarpiece was dismantled in the seventeenth century and the frame was lost.)

Given the importance of the commission, it is interesting to ask how the confraternity came to choose Piero. The historian James Banker recently established that Piero's family were members of the confraternity for more than a century: archival documents show that his great-grandmother Francesca and his grandfather Pietro left the organization money in their wills, and his father, Benedetto, held the post of treasurer for a time and also bequeathed the society money. All three of Piero's brothers were members, Don Francesco, the Camaldolite, even acting as chaplain for a year in 1443. Although there seem to be no records to prove it, Piero too was surely also a member, and thus well known to his patrons. They in turn apparently knew and admired his work, for they contracted to pay him 150 gold florins, a sum rather higher than was usual at the time (possibly owing to a special subvention from the Pichi family). Although Piero should have completed the altarpiece by 1448, after an initial campaign in which it appears less than half of the piece was completed, he did not again carry

23
Misericordia Altarpiece, 1445–62. Tempera on panel (reconstructed); 273 × 323 cm, $107\frac{1}{2} \times 127\frac{1}{4}$ in. Pinacoteca Comunale, Sansepolcro

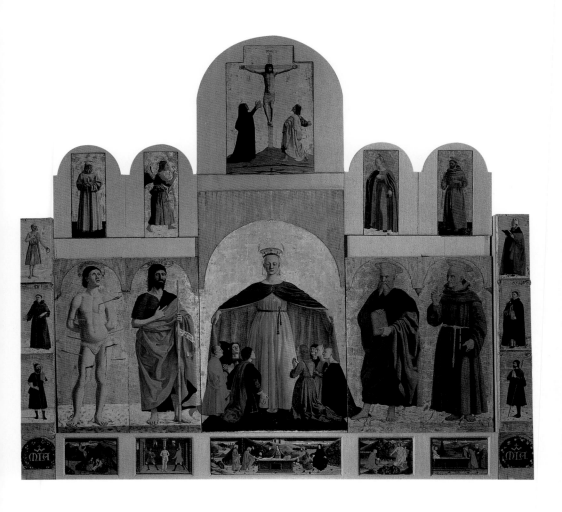

out sustained work until perhaps as late as the mid-1450s, and the process dragged on into the next decade. Soon after he signed the contract (1445), he seems to have left Borgo for a number of years, until the confraternity forcibly brought him back to complete their altarpiece. Why he conducted himself in this manner is still not known.

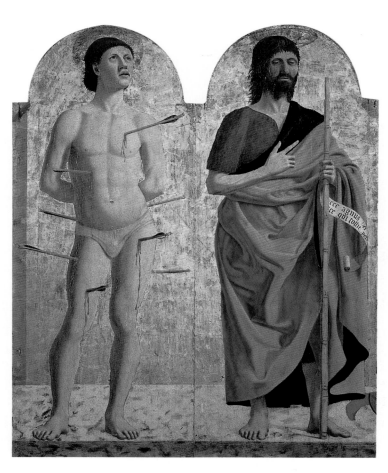

24
St Sebastian and St John the Baptist, left wing of the *Misericordia Altarpiece* (23), 109 × 45 cm, 42$^1$₂ × 17$^3$₄ in

In terms of design, however, he fulfilled the contract: he followed tradition by isolating individual saints in separate panels, giving them a background of gold leaf, and placing the subject of the dedication (the Madonna della Misericordia) in the central panel. The two saints, John the Baptist and John the Evangelist, hierarchical equals, flank the Virgin. St Sebastian at the left end, protector

against the plague, refers to the organization's function of providing health care, and on the right, St Bernardino, a great preacher who had died just the year before the commission, refers to the newly founded Observant Franciscan order and the religious renewal that was sweeping the province. At the same time, in many ways Piero quite obviously went beyond tradition; for example, whereas the surface of a polyptych would normally have been divided into compartments by small colonettes at the sides of each panel, Piero subverted these divisions on the main register by suggesting a unified spatial field behind the framing elements. He did so by placing the figures on a continuous stone step, differentiated from the gold background and stretching across the entire width of the altarpiece. He persisted with this unifying design in spite of the fact that the figures on the right were painted several years after those on the left.

The two saints to the left of the Madonna (24) show what might be called Piero's early style. St Sebastian is posed in a somewhat stiff *contrapposto* (*ie* with the weight on one leg and the other bent at the knee as a counter-support – a pose taken from classical sculpture). He tilts his head upwards and holds his arms behind his back (as though bound at the wrists to receive his martyrdom). His features are thick and his body is defined by hard-edged highlights and shadows. But even though rougher in execution than his later work, Piero already demonstrates his artistic ability, convincingly depicting a figure in the nude, a feat more difficult than one covered in drapes. The figure of John the Baptist is in the same early style, lacking in smooth transitions between the torso and extremities, and in fluidity of stance. Yet, once more Piero is provocatively innovative. He renders John's halo in sharp perspective and gives him the expression of a fanatic, eyelids lowered as if listening only to his inner voice. The *Crucifixion* on the pinnacle of the altarpiece (25) was apparently the final panel done during the early campaign. The same coarseness shapes the figures, the same harsh shadow grips Christ's nude torso. It is often said that Piero looked to Masaccio's *Crucifixion* (26) as a model for the emotional charge that drives the action. If so, Piero made the model his own by

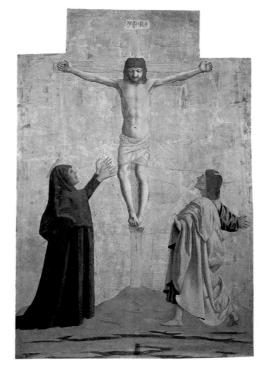

intensifying the mood. The black-draped Madonna cries out in sorrow as she shakes her over-sized hands. The youthful, grief-stricken John the Evangelist establishes the image's spatial depth by stepping forwards and throwing his arms out wide. With these two figures Piero expresses stronger emotion than he was ever again to display so directly.

Piero's *Crucifixion* panel is the climax of a Passion narrative (*ie* depicting events from Jesus' last days, death and resurrection) which begins below on the predella. After scenes of the *Agony in the Garden* and the *Flagellation*, the story jumps up to the pinnacle of the altarpiece before returning once more to the bottom for the final scenes (the *Entombment*, '*Noli me tangere*' – the meeting of Mary Magdalene and the risen Christ – and the *Three Maries at the Tomb*). Even though the predella scenes were carried out later (*c*.1458–60) and by a different artist (Giuliano Amadei, another Camaldolite monk), the down-up-down pattern of reading the narrative binds the altarpiece into a new kind of unity.

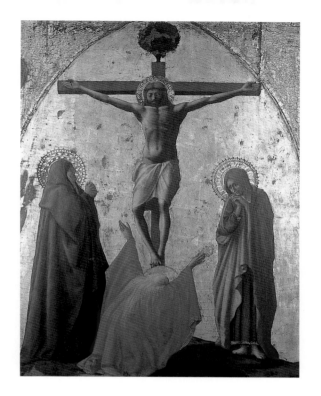

25
Crucifixion
from the
Misericordia
Altarpiece (23),
81 × 52·5 cm,
31⁷⁸ × 20⁵⁸ in

26
Masaccio,
Crucifixion
from the *Pisa*
Altarpiece,
1426.
Tempera
on panel;
82 × 64·5 cm,
30¹⁴ × 25¹⁴ in.
Museo
Nazionale di
Capodimonte,
Naples

The second phase of Piero's work on the altarpiece can be dated to after 1450; in this year St Bernardino of Siena was canonized (six years after his death), and since he, like his companion St John the Evangelist (27), has a halo, Piero's figure of him must have been painted after this date. By the time Piero returned from his travels, he had evolved a less rigid, more spatially flexible style. The poses of these saints have an easy grace, more naturalistic and relaxed, more stable in their contact with the ground. Space and light have entered into the surfaces of cloth and flesh; emotions have calmed and deepened. This is the style that permeates the main panel of the altarpiece where the Virgin Mary is depicted in strict frontality, holding out her cloak with open arms (see 3).

Her figure is remarkable, combining as it does humanity and hierarchical power. The viewer's first impression is of a huge being, towering over the people below. Her head is an almost perfect ovoid, high and dome-like, crowned by both a diadem and a halo. It is balanced on a pedestal-like neck that flares seamlessly into the

arch of the shoulders. The body is wide and thick with no indication of form beneath the garment. This configuration, placed in the geometric centre of the golden field, is symbolic. It is the result of centuries of debate among the Fathers of the Church, who in their discussions of Mary's role in the scheme of salvation, from the tenth century on gradually identified her with the concept of *Ecclesia*,

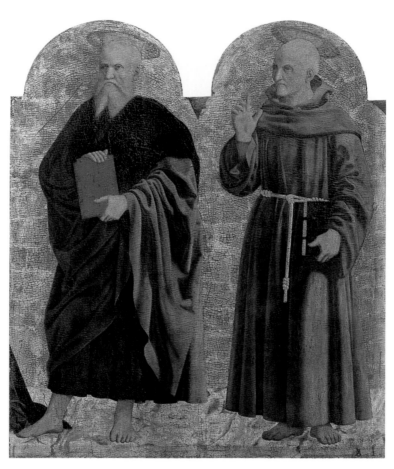

27
St John the Evangelist and St Bernardino of Siena, right wing of the *Misericordia Altarpiece* (23), 109×45 cm, 42$^7_8$ × 17$^3_4$ in

that is, the Church as a corporate institution. By Piero's time, Mariolatry was long established (more than a third of all fourteenth- and fifteenth-century churches in Italy are dedicated to the Virgin in one or another of her manifestations). As a woman she is the mother of Jesus, but at the same time, when shown on a colossal scale, larger than the figures or buildings around her, she is the complex

symbol of Maria Ecclesia, sign of the congregation of believers and the protector of all those who believe. At her breast is the gem-encrusted morse of an official of the Church. At her waist is a belt, symbolic of her virginity, repeating the shape of her own pose but also reflecting the form of the cross in remembrance of her son.

The particular aspect of Mary's character that Piero is expressing is Maria Ecclesia as the giver of charity. This configuration was already well known throughout Italy. Less than a decade earlier, a spectacular example had been painted in fresco by Parri Spinelli (1387–1453) in the church of Santa Maria delle Grazie in the outskirts of Arezzo. In Parri's version (28), the confraternity members are divided into two groups, men on the Virgin's right (the viewer's left), and women in lower status on her left. Their ranks include a broad spectrum of contemporary society petitioning together, ranging from lowly citizens to merchants, lawyers, monks and even to a pope in a triple-crowned papal tiara.

Piero's interpretation follows this conventional formula but with important changes. Along with regal splendour, the image conveys a sense of innate simplicity. Although her forehead is stylishly shaved, Mary's features are those of a country girl. Her eyes are lowered in modesty, and her air is one of compliance: though she takes the form of their divine helper, she remains the servant of the people. This physical presence is augmented by the way Piero handles the painted space. The cloak hanging from Mary's sheltering arms falls in tubular folds, each of which defines a three-dimensional area full of light and shade. The effect is one of a real semicircular space which seems to surround and engulf the group kneeling in adoration. The traditional gold ground retains its allusion to the celestial realm. Such metallic backdrops were meant to provide an unreal universe of splendour, glowing with spiritual inspiration. Piero, however, did not apply the gold-leaf in the usual thick, dense mass, but used it to create a screen-like pattern that breathes with pliancy. The number of devotees under Mary's cloak is reduced to only eight, again arranged in rigid symmetry, male and female poses matching each other like a statuary group set

28
**Parri
Spinelli**,
*Madonna della
Misericordia,*
c.1428.
Fresco.
Santa Maria
delle Grazie,
Arezzo

upon a base. They form a unified gathering and are generic in facial type, although the male figure with upturned face is thought to have Piero's features (see 2). Rather than general and all-inclusive, as in Spinelli's fresco, these devotees belong to one social class, identified as bourgeois by their finery; they seem to portray local confraternity members and their families, including a man in flagellant garb. All are infused with physical presence, and all fervent in their devotion. Combining the real with the ideal, an approach that would remain a leitmotif throughout his career, Piero achieved a new visualization of this traditional theme.

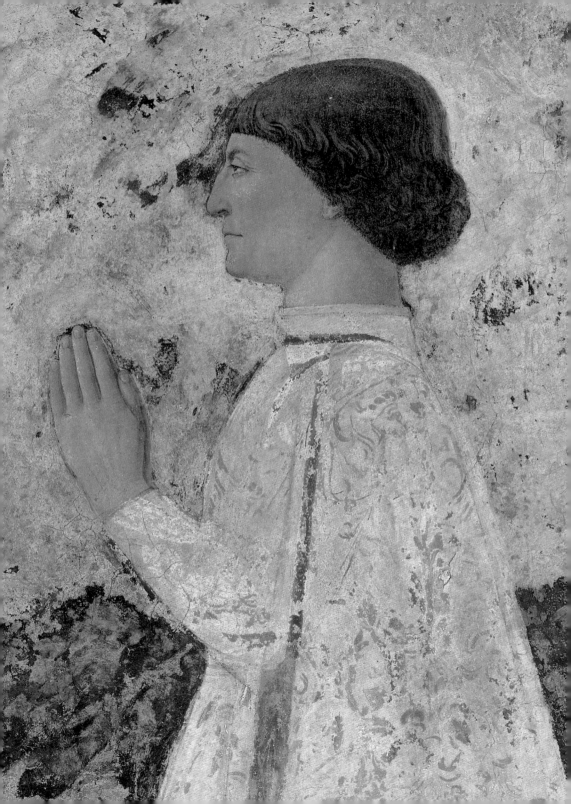

The places Piero visited between the first and second phases of
the *Misericordia* commission are known only from Vasari's text,
which states that he spent most of the time on the eastern side
of the Apennine Mountains, in the Marches and Emilia-Romagna
(northern central Italy), and perhaps also in Venice. He is supposed
to have gone to the shrine at Loreto, once more in the company
of Domenico Veneziano, to paint in the sacristy of the cathedral
there. They left the work unfinished, however, to flee the plague;
according to Vasari it was completed later by Luca Signorelli
(1441–1523), who was Piero's student. The truth of this statement
cannot be ascertained since the chapel was demolished before the
end of the fifteenth century. Ancona on the east coast is another
stop Vasari mentions, where Piero painted a 'Marriage of the Virgin'
(in fresco, also destroyed), and then Pesaro, ruled by Alessandro
Sforza since 1445. From there, if Vasari is correct, he received his
first aristocratic invitation, to Ferrara and the court of the d'Este
family. In the private rooms of either Lionello d'Este (d.1450)
and/or his brother Borso (d.1471), he painted frescoed battle
scenes, perhaps modelled on, or in competition with, Pisanello's
battle mural (1447–8) in the Gonzaga palace in nearby Mantua.
Although later destroyed, it has been suggested that Piero's scenes
are reflected in two sixteenth-century panel paintings now in
Baltimore (30) and London. With these murals, Piero had apparently
set the scene for his own later equestrian battle pieces in Arezzo
(see Chapter 4). This link would be one of numerous instances in
which Piero revisited themes, considering the same visual problems
at different times in his career.

A case in point is two depictions of St Jerome. The earlier image,
dated 1450 and now in Berlin, is a small panel depicting *St Jerome
in Penitence* (31). The landscape background, totally repainted in
the sixteenth century, was returned to its original form in the late

1960s (Jerome's lion was beyond restoration), revealing a benign forest, watered by a winding stream that snakes its way through trees with quaking reflections on its surface. In this form, the landscape prefigures ideas Piero used in his later painting of the *Baptism of Christ* (see 54). The inscription, painted on a tiny piece of parchment attached to the trunk of the tree, reads: PETRI DE BVRGO OPVS·MCCCCL ('the work of Peter of Borgo, 1450'). It is

the first known dated work by Piero and the Latin phrase and orthographic form of the letters might be thought of as reflecting Piero's nascent awareness of classical antiquity. The inclusion of the name of his town ('Burgo') suggests that he was working away from home and needed to be identified. The patron of such a devotional image could have been a man named Jerome, or a member of the

Gerolomite religious order, many of whom commissioned pictures of the penitent saint around this time. Other examples of the subject are generally set in harsh desert surroundings such as Jerome himself describes in his letters. What is new in Piero's version is the peaceful, fertile quality of the landscape.

A second depiction of this subject, *Girolamo Amadi before St Jerome* (32), is not dated but is also signed, now in full-blown Roman script: PETRI.DE BV/RGO.SCI.SEP/VLCRI.OPVS ('the work of Peter of Borgo San Sepolcro'), this time as though the words have been carved directly on a tree trunk. The setting is still more domesticated: a level rise dips towards a valley, on the other side of which can be seen a town with towers and steeples, and finally the hills beyond. There is disagreement about the identity of the town: some scholars say it represents Venice (the painting is in the Galleria dell'Accademia in that city), some say Borgo. The point, however, is the contrast between town and countryside. The saint, as in the small Berlin panel without a halo, is outside the city. Still dressed in the clothes of a desert hermit, he is seated on a stone bench near his rustic crucifix. As he rifles through the pages of the open book on his lap, he directs his powerful gaze at a devotee, who has apparently walked into the countryside to find his namesake and patron. Under a spreading oak tree the man kneels in homage in unprecedented close proximity to the saint. Their encounter is not easy: Jerome leans forward urgently and expresses admonition with his eyes. As though quoting his own commentary on the book of Isaiah, he seems to mete out moral advice through confirmation of the prophet's threat 'For ye shall be as an oak whose leaf fadeth, and as a garden that hath no water.' The mortal attends impassively, posed in the stiff profile of the traditional 'donor portrait', with palms pressed together in front of his chest. He is identified as a well-to-do person by his expensive red knee-length overgown (*cioppa*), and as Girolamo Amadi (otherwise unknown) by the inscription below the figure (added somewhat later). In quite a daring manner, Piero has emphasized the contrast in the two figures' states of mind by representing them on the same scale. This arrangement was another to which Piero would later return. In fact,

30
Ferrarese School, *Battle Scene*, c.1540. Oil on panel; 85×77·4 cm, $33^1_2 × 30^1_2$ in. Walters Art Gallery, Baltimore

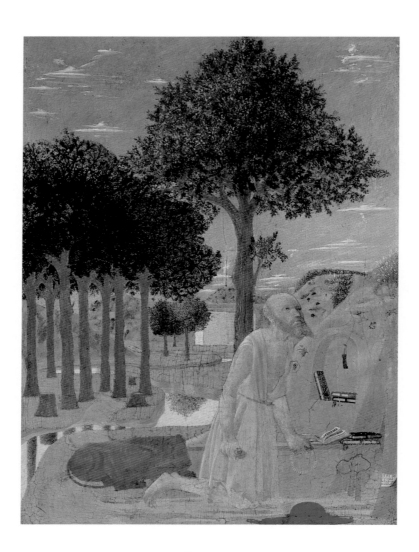

31
*St Jerome in
Penitence,*
1450.
Tempera
on panel;
51·5 × 38 cm,
20¼ × 15 in.
Gemäldegalerie,
Berlin

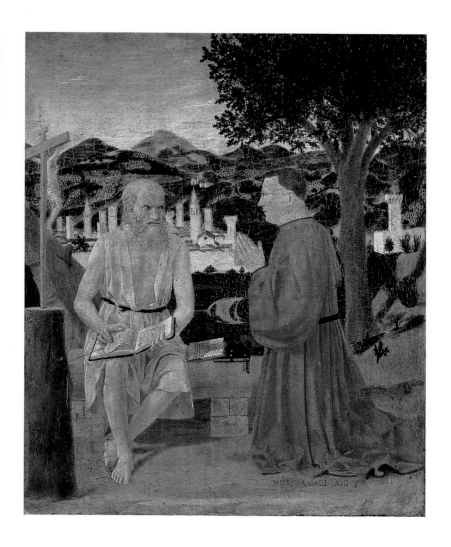

32
*Girolamo
Amadi before
St Jerome*,
c.1450.
Tempera
on panel;
49 × 42 cm,
$19^1_4 × 16^1_2$ in.
Galleria
dell'Accademia,
Venice

the small Amadi painting could be thought of as a preliminary study (*bozzetto*) for a fresco portrait Piero was to do the following year in Rimini for Sigismondo Malatesta (see 39), in which equality of scale, an atmosphere of devotion and a sense of place – all important here – would be brought together in a life-size format.

The subject of this later work, Sigismondo Pandolfo Malatesta, Lord of Rimini, had become a leader at an early age. Like all young men in the courts of Italy, he received a superior education in the classics, literature, philosophy, music and warfare. His father having died when he was in his early teens, Sigismondo had become the head of the family and spent most of his early manhood on the battlefield successfully consolidating and defending his territorial holdings. Knighted at the age of fifteen, he took on the career of a professional *condottiere*, leading armies in the service of other warring states. Yet, like many of the courtly warriors, his tastes were refined, and around his thirtieth year, in about 1448, he began a project for the church of San Francesco in Rimini that not only showed his interest in the newly revived ancient style of architecture, but also his preoccupation with expressing symbolically in words and images what he deemed to be his personal position in the universe. For this purpose he surrounded himself with humanists and poets who contrived Latin and Greek inscriptions and devices for him and he elicited the services of skilful artists and artisans to put his ideas and aims into visual form. Because of its references to classical mythology in both form and subject matter, the building later became known as the Tempio Malatestiano.

This commission from the Lord of Rimini brought Piero into direct contact with this world of recondite learning, and it is interesting to speculate how his assignment might have come about. Wanting a fresco painted on the newly refurbished wall of the church, Sigismondo wrote to a member of the Medici family in Florence to ask for guidance. Fra Filippo Lippi was suggested but could not come because of prior commitments. It is probable that Sigismondo then turned to a member of his own entourage, Jacopo degli Anastagi, a close adviser of more than a decade. Anastagi was an

eminent doctor of ecclesiastical and civil law, and a widely read humanist. He was born and brought up in Borgo Sansepolcro, and could easily have acted as the link between Piero and Sigismondo for the following reason: in 1446 his relative Giovanna degli Anastagi had married Piero's brother Marco. Once again, it seems Piero received a commission as a result of social contacts. He would therefore not have been treated as a mere hired artisan at the court, as was usual for a painter, but surely could have conversed directly with his patron, discussing the objectives of the project and responding with a description of his artistic solutions.

Territorial pride was clearly one of the elements important to Sigismondo. Rimini, on the Adriatic coast south of Venice between Ravenna and Pesaro, was recognized as a town of great antiquity, founded by the Romans as a major seaport (Ariminum). From Rome it is approached on land by the Via Flaminia, which ends at the southern entrance to the city at an elegant commemorative arch, built in 27 BC to honour the emperor Augustus. This classical monument is still visible, along with an amphitheatre, which could hold 12,000 people, and a bridge of Istrian stone with five arches finished by Tiberius in 21 AD. Rimini's modern rebirth came in the late thirteenth century when Pope Gregory X granted the administration of the city and its territories to the house of the Malatesta. Such a papal grant was known as a vicariate. With the new regime as its feudal overlords, the town became the centre of a fiefdom with lands directly to the east of Tuscany (today the province of the Marches) and to the northeast (today the province of Emilia-Romagna). By the mid-fourteenth century a strong tradition in painting had developed. Not many of the great Riminese fresco cycles remain, however, owing to damage by earthquakes and later repainting, and most of the painters are known only through civic records, Francesco da Rimini and Pietro da Rimini among them. Surviving fresco fragments, panel paintings and illuminated manuscripts reveal a distinctive local style characterized by its narrative strength and realism (33), of which Piero would have been keenly aware.

Family heritage was another theme close to Sigismondo Malatesta's heart. He belonged to the fourth generation of Malatesta rulers who were named Lords (*Signori*), but who had no higher title than that. This meant that periodically they had to petition the pope just to retain their rights. One of Sigismondo's deepest aspirations was to have his position raised to the level of true aristocracy, in his case a marquisate, from which his heirs would inherit their titles, and establishing his personal worthiness was one of the motivating

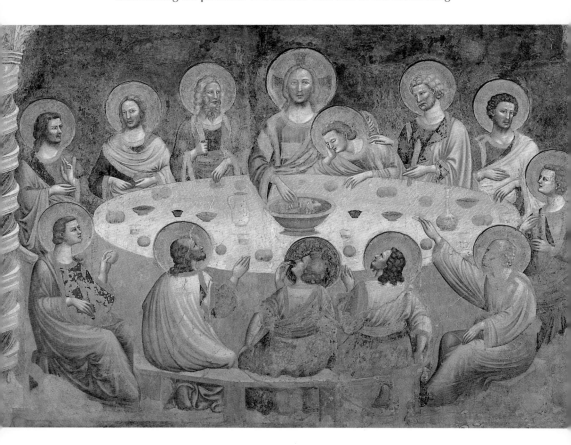

factors in his artistic programme. He was having problems in this domain, however: although celebrated for his ruthless fighting skills and intellectual interests, he was known for not following the letter of the law as laid down by the pope. By the nineteenth century this aspect of his personality had grown to legendary proportions and he was presented as one of the most notorious characters of his day. The great Swiss art historian Jacob Burckhardt wrote in 1860:

'Unscrupulousness, impiety, military skill and high culture have been seldom so combined in one individual as in Sigismondo Malatesta.' It was easy to make this characterization for several reasons. Firstly, he had gained a reputation as a womanizer: it was rumoured that he had murdered his second wife Polissena in order to live openly with his mistress Isotta degli Atti (Polissena's death of the plague in 1448 is in fact clearly documented). The second reason was his decision to switch sides in the midst of an important battle at Piombino in 1447 between Alfonso V of Aragon, ruler of Naples, and the forces of the city of Florence. Malatesta's defection left the former without a general and brought victory to the Florentines (such actions were not unusual in Renaissance Italy and more often than not were a matter of money, as was the case here). The third, and most significant, reason was that he was 'canonized to hell' on Christmas Day 1460 and later burned in effigy three times in Rome by Pope Pius II, as documented in the memoirs of Pius himself. The pope hated Sigismondo because he refused to pay a tribute of dubious legality, and because he fought virulently against the pontiff's army over territory around Ancona.

These three elements were singled out for romantic exaggeration by nineteenth-century historians and used to contrast Sigismondo as the model of an evil tyrant with Federico da Montefeltro, Duke of Urbino (of whom more later), as the ideal virtuous ruler. These two men, who grew up together, whose relatives intermarried, who fought together, and against each other over their adjacent lands on the eastern cost of central Italy, were both accomplished soldiers, discriminating intellectuals and, in their private lives, no better than might be expected. After victories on the battlefields, both discovered the thrill of learning and the power of the intellect. The courts of both were full of humanists, poets and musicians; and both men amassed splendid libraries. Their despotism reigned in an ambience of high culture. When Victorian writers such as John Addington Symonds in his *Sketches and Studies in Italy and Greece* (1898) came to laying down the outlines of Renaissance histori- ography, they found these contemporaries convenient exemplars to compare and contrast. Piero's fresco portrait of Sigismondo

33
Giuliano
da Rimini,
Last Supper,
c.1317.
Fresco.
Refectory,
Pomposa
Abbey

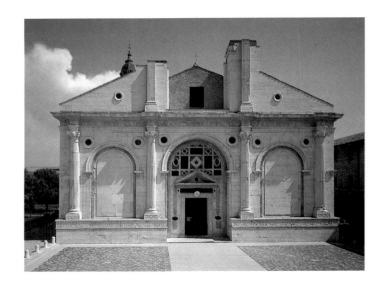

Malatesta, inside a closed chapel in a church ornamented with
an esoteric sculptural programme, is normally taken to express
the ruler's egotism, arcane interests and despotic character. This
interpretation, however, is largely based on events that post-date
the fresco, and not on the visual data.

When Piero arrived in Rimini about 1450, Sigismondo and Isotta
were living together openly; the nature of their passion was
common knowledge and seems to have offended no one. They
would finally marry in 1456. Isotta matched Sigismondo in intellect
and often ruled in his place when he was away at war. A few months
after his victory at Piombino (on the coast of southern Tuscany),
he had initiated the project to revamp the family burial ground in
the fourteenth-century gothic church of San Francesco in Rimini.
In origin, his plan was fairly modest: to provide burial chapels
for himself and his consort. Later, in an effort to compete with his
culturally advanced contemporaries in Florence, he engaged Alberti,
by now famous as an architect as well as a theorist, to create a more
pretentious plan involving the whole building. Alberti designed
the famous polychrome classicizing marble façade seen today (34),
the pillared colonnade that encases the building and a huge dome,
planned but never built, over the apse end. These elements are

35
**Matteo
de' Pasti**,
Foundation
medal of
the Tempio
Malatestiano
(reverse),
after 1450.
Bronze;
diam. 4 cm,
1 ⅝ in.
British
Museum,
London

pictured on the so-called foundation medal (35), which bears a date
of 1450 although this is now generally agreed to be commemorative
(in fact, Alberti was not called to the project before 1454). It is also
clear that he never came to Rimini, but made all the arrangements
through letters. Thus, although later in his career Piero undoubtedly
profited directly from Alberti's architectural style, so rich in antique
motifs, at this early stage in the Malatesta rebuilding he worked
alongside the architect-sculptors who directed the project from
the beginning. Matteo de' Pasti (1420–67/8) and Agostino di
Duccio (c.1418–81) were in charge of refurbishing the interior and
executing the abstruse sculptural programme, finished several years
after Piero had completed his fresco.

The rebuilding began with the first two chapels on the right
(southwest) side of the nave (36, 37). The first (A) was dedicated
to Malatesta's patron saint, St Sigismund of Burgundy, and was
designed to house his own tomb; the second (C), dedicated to the
Angels, contains the tomb of Isotta. These chapels are separated
by a rectangular chamber (B), known as the Chapel of the Relics,
closed off from the nave by a wall pierced by a door with three
heavy locks. It was here that Piero painted his major devotional
fresco. Archaeological evidence suggests that in the transformation

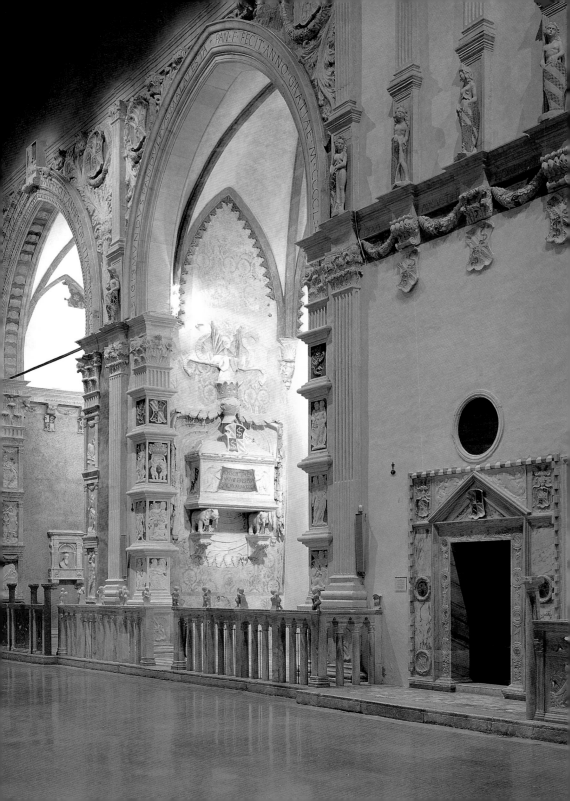

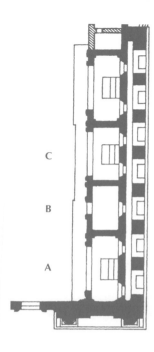

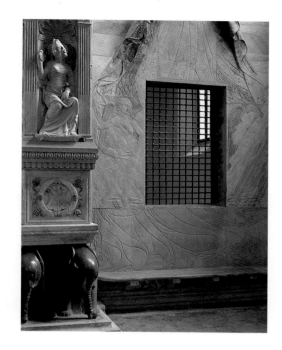

36–8
Tempio
Malatestiano,
Rimini
Left
View of the
nave, showing
the Chapel of
the Angels and
the door to
the Chapel
of the Relics
Above left
Plan showing
the chapels in
the southwest
nave.
(A) Chapel of
St Sigismund
(B) Chapel
of the Relics
(C) Chapel
of the Angels
Above right
Wall with grille
dividing the
Chapel of the
Relics from
the Chapel of
St Sigismund

of the room the ceiling was lowered and the window on the exterior
wall was shortened. What is strange is that the wall between this
chamber and the Chapel of St Sigismund was first constructed
and then partially pulled down and rebuilt with a large rectangular
opening barred with a heavy iron grille (38). The most likely expla-
nation is that, part way through construction, the idea of visual
communication between the spaces was introduced and solved
in this manner (the significance of this change will become clear).
The first stone of the project was blessed on 31 October 1447, and
the three chambers were complete early in the spring of 1449.

The fresco (39) is on the northeast wall that divides the Relic Chapel
from the nave, above the doorway, about 2·3 m (7$\frac{1}{2}$ ft) from the
ground. As he was to do again in his Arezzo fresco cycle, Piero
composed the scene as though the beholder were not standing on
the floor looking up above his head, but floating in an ideal space,
his feet level with the bottom of the painted field. What he sees
is an interior in which the floor but not the ceiling is visible. It is
closed at the back by a wall painted to imitate dark marble veneer
(the surface is now badly damaged), and adorned with classicizing

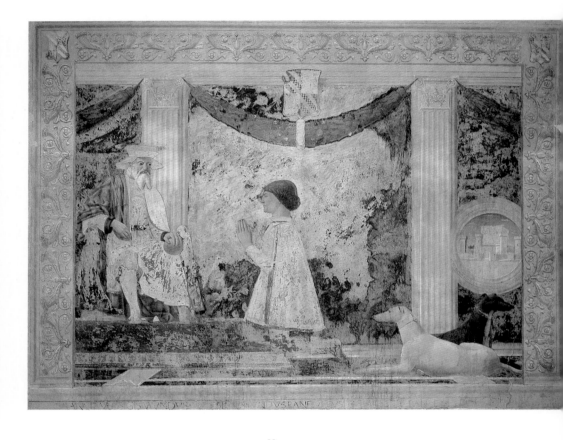

39
*Sigismondo
Pandolfo
Malatesta before
St Sigismund,*
1451.
Fresco;
257 × 345 cm,
$101\frac{1}{8} \times 135\frac{7}{8}$ in.
Chapel of the
Relics, Tempio
Malatestiano,
Rimini

pseudo-Ionic pilasters, swags of flowers and leaves, and a Malatesta shield hung at the exact centre of the upper frieze. The figure of Sigismondo kneels in profile in the centre of the composition. His portrait, as sharply defined as a Roman coin, is well preserved and full of glowing skin tones (see 29). In a stiff praying posture, he pays ritualized obeisance to an elderly haloed saint enthroned on the left. On the right, he is attended by two alert hunting dogs, one looking into the pictorial space, one looking out. Embedded in the architecture immediately behind the dogs is a circular frame that holds a representation of the family fortress Sigismondo had rebuilt to withstand the comparatively new military technology of artillery

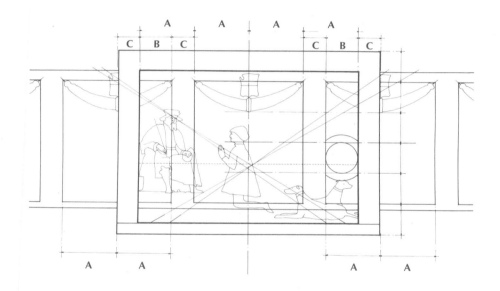

40
Diagram of
Piero's fresco
in the Chapel
of the Relics,
Tempio
Malatestiano
(after M A Lavin,
J Guthrie and
P M Schmitt)

(see 46). On the curving moulded frame is a painted inscription that gives the castle's name, its location and the date (1446) it was ready for habitation: CASTELLVM SISMVNDVM ARIMINESE MCCCCXLVI. The overall composition is bounded on three sides by a border painted to imitate carved stone decorated with cornucopias and roses, a Malatesta symbol. This border with its perspectivized edges creates the illusion of a broad opening in the wall enclosing a corridor that extends behind the real wall laterally in both directions. A painted marble base forms the lower margin, and is inscribed with the titles of the figures, the artist's name and the date of 1451.

A strong sense of rhythmic consistency in the overall design suggests that there is an abstract principle at work. Indeed, analysis shows that Piero generated all the relationships from two basic modules or units of measurement (40). One unit is the width of the side panels of the painted marble background (B); the other is the width of the painted border (C). Measurements B plus C create a third unit, (A), which equals half the width of the central marble panel at the back of the painted room. The height of the fresco, including the base and upper border, equals precisely 6 x B. The horizontal rhythm of the composition can be described as CBC AA CBC, or ACA ACA, or C AAAA C. Piero thus created the painting's effect of stability and monumentality in a thoroughly rational manner.

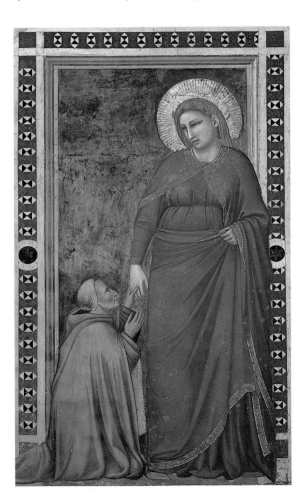

41
Attributed to Giotto,
Bishop Teobaldo Pontano before St Mary Magdalene, *c.*1320. Fresco. Lower Church, San Francesco, Assisi

42
Filarete, Pope Eugenius IV (far right) crowning Sigismund of Hungary Holy Roman Emperor. Scene from the bronze doors of St Peter's, Vatican, 1449

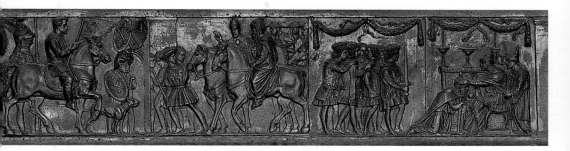

The underlying theme of the fresco is that of a votive thank-offering of a traditional sort: the figure of a donor kneeling in strict profile, giving thanks to his patron saint and praying for intercession on behalf of his soul. An example of this type from the previous century is seen in a fresco attributed to Giotto in the lower church of San Francesco in Assisi (41). A majestic standing figure of the Magdalene, patroness of the chapel, turns towards the diminutive devotee kneeling at her side whom she allows to take her hand as he prays. In spite of this intimacy, certainly new in Giotto's time, the saint's monumental size indicates that she belongs to a superior realm. Piero's image is unusual in the fact that his figures are on the same scale. The haloed figure enthroned at the left, holding a sceptre and an orb, is clearly a saint. The kneeling figure, wearing a knee-length coat of brocaded velvet, red stockings and short boots, is clearly a mortal. Yet it is he, and not the superior being, who is the focus of the composition.

Also different from the traditional donor portrait is the scene's format. Instead of the narrow vertical (as in Giotto's fresco), this composition is a horizontal rectangle. This change introduces another tradition into the mix, namely scenes of historical events or secular ceremonies. Such an occasion can be seen in the highly detailed relief on the bronze doors of St Peter's in Rome, made in 1433 by the sculptor Filarete (Antonio Averlino, c.1400–69). This shows a kneeling propitiate and his retinue before an enthroned pope (42), and represents an actual event that took place at St Peter's in May of that year, when the reigning king of Hungary was crowned Holy Roman Emperor by Pope Eugenius IV. This prototype is relevant to Piero's Rimini fresco not only because of

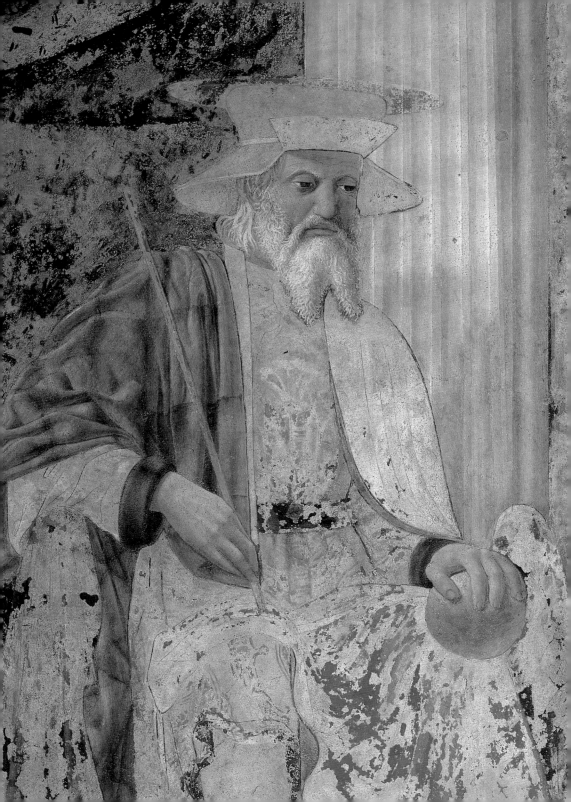

its composition but also because the event it records had particular resonance for Sigismondo Malatesta.

The facial features of Piero's St Sigismund (43) bear a striking resemblance to the new emperor, whose name was also Sigismund. The likeness of the emperor, whose reputation as a wise and benevolent ruler accompanied him as he travelled through Italy, was widely known from various contemporary images, such as

43
St Sigismund
(detail of 39)

44
Hungarian
School,
Emperor
Sigismund
of Hungary,
c.1433.
Tempera
on vellum;
64 × 49 cm,
25$\frac{1}{4}$ × 19$\frac{1}{4}$ in.
Kunst-
historisches
Museum,
Vienna

a portrait painted on vellum formerly attributed to Pisanello (44). Piero's decision to give the face of this elderly man to the saint was unusual, however. Although St Sigismund was also a king (according to hagiographic tradition the first Christian king of the Gauls), he was supposed to have died relatively young. Since he was a soldier he was usually shown as a youthful armoured knight. By contrast, Piero's saint is an unarmed venerable gentleman with an impressive

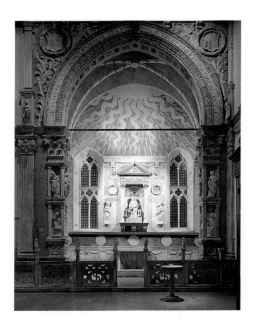

45
Chapel of
St Sigismund,
Tempio
Malatestiano,
Rimini

46
Castellum
Sismundum
(detail of 39)

47
Matteo
de' Pasti,
Bronze medal
showing the
Castellum
Sismundum,
c.1450.
diam. 8-4 cm,
3 ¼ in.
British
Museum,
London

forked white beard, wearing a hat like that of the emperor in
Pisanello's portrait, but without the fur. What motivated Piero to
make this transformation, however, is not hard to guess. Returning
north from the coronation with great pomp, Emperor Sigismund
paid an official visit to Rimini where the fifteen-year-old Malatesta
was already the family representative. On 3 September 1433 the
emperor knighted Sigismondo Pandolfo Malatesta and raised him
to the rank of *cavaliere*. As imperial recognition launched the young
Lord of Rimini on what was to be a flamboyant career, a reference
to this event in the fresco was most appropriate. The setting of
the painting – a festively decorated marble-lined room extending
laterally in both directions – has the appearance of a formal
audience hall where such a ceremony could have taken place.

In spite of these allusions to Sigismondo's earlier life, however,
Piero's fresco does not 'represent' a historical event. There are no
details of a knighting ceremony, no spurs, no sword, no symbolic
gestures. Moreover, the painted architecture is so harmonized with
the architecture of the new St Sigismund Chapel next door (45) that
it is unquestionably meant to be part of the same ecclesiastical
environment. Whether the author of the design was Matteo de'

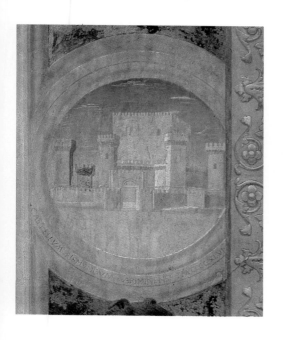

Pasti or Piero himself, this deliberate consonance is beyond doubt.
The purpose of the screened opening now becomes clear: with the
fresco placed high on the wall and the donor facing left, towards
the opening, a connection was established not only with the patron
saint but also with the performance of Mass in the adjacent chapel.
Recalling the practice of the popes and emperors of Byzantium,
the siting of Sigismondo's portrait in a 'throne room of heaven' was
meant to guarantee his perpetual participation in the act of devotion.

One of the most mysterious furnishings in this pictorial room is the
roundel or *oculus* with an architectural landscape on the viewer's
right (46). Seemingly attached to the adjacent pilaster, part of the
circular frame disappears behind the border. Sigismondo's fortress
is shown on a small scale in sharp foreshortening from directly
in front of the main entrance, as it appears from Rimini's central
piazza. The meticulous naturalism of its painted details is enhanced
by the consistent flow of light and shadow, and above all by the
morning-blue sky in the background. The image is one of Piero's
first fully realized compositions structured with mathematical
perspective. But the question remains: what is the area in which
it appears intended to represent?

There are a number of possibilities. The circular form recalls a
medal or a seal, both of which have inscriptions on their borders.
Indeed, Sigismondo commissioned Matteo de' Pasti to make a
bronze medal with his portrait on the obverse (front) and the same
architectural image and inscription on the reverse (back; 47). In
a commemorative ceremony on 10 October 1449 many of these
medals were buried under the left pilaster at the entrance to
the St Sigismund Chapel. But the painted version is too big and
too colourful to represent a bronze medal. On the contrary, the
naturalistic colour suggests a real vista, seen through a window.
Yet in terms of architecture, this suggested opening is much too
low to serve as a window; it also lacks what should be its twin

on the opposite side of the room. A third possibility is that Piero depicted an architectural model – the size is right, and there was a long tradition in church decoration of showing such small-scale buildings as votive offerings in the arms of the donor, as in the sixth-century mosaics in the presbytery of the church of San Vitale in nearby Ravenna (48). But although it seems to allude to a votive offering, here it is a framed picture with a landscape background.

48
Christ with
St Vitalis,
Bishop
Ecclesius (far
right, holding
a model of
the church)
and angels,
c.530.
Mosaic.
San Vitale,
Ravenna

In abstract terms, at least, the circle has a rational place within the geometry of the composition. The diameter of the inner circle of the roundel, it has been discovered, corresponds exactly to the unit of measurement B, and the placement of the circle is precisely in the third square from the bottom of the side panel. This rational placing explains why, even without an assurance of its precise level of reality, the circular form strikes viewers as an integral part of the design. Although ambiguous, the image retains its integrity as both an optical reality and a graphic symbol. Like the portrait of the saint, it is a hybrid that combines multiple allusions with strict naturalism, resulting in something mysteriously new.

The inscription at the bottom of the fresco roundel contains another enigmatic element: the spelling of the fortress's name, while taken from Sigismondo's own, differs from it in a significant way. It is not that one is Italian and the other Latin; the contraction of SIGIS to SIS calls attention to the fact that all syllables in both spellings have independent meanings. And here the world of humanistic learning, part and parcel of Sigismondo's court, enters the scene in the form of punning and verbal conceits. Sigismondo's name, for example, comes from the German *Sigmund*, and its two syllables have independent meanings: *Sigis* (modern German *Sieg*), which means victory, and *Munt*, which means hand or protection. When linked together they mean 'Victorious Protector'. We know that Sigismondo was aware of this meaning because he had himself described in this manner in several inscriptions carved in different places in the church, both in Latin (*Victor*) and in Greek (*Nikephoros*). The two parts of the Latin word *Sismundum* have different roots. The first syllable *sis* (or *si vis*) is an interjection

indicating that what is to follow is metaphorical, and hence means 'as it were' or 'if you will'. The word *mundus* means world or cosmos. Put together and used as the name of a castle, it states in bold terms that the building is, 'as it were, the whole world' – a microcosm of the cosmos. This idea may seem rather pretentious but when one finds that in the Renaissance many petty rulers thought of themselves and their estates in this manner, it is less surprising. Sigismondo's court poet, Basinio Basini of Parma, compared him to the emperor Augustus in his adulatory poem *Astronomicon* (1456), and placed him in the same circle in the cosmic firmament as other great rulers of the past. The notion is actually carried forward by the circular form of the image, the circle being the most perfect geometric shape – the form, according to classical and medieval tradition, of the ideal city and of the cosmos. This formula is found in the fifth-century writings of Horapollo, known as the *Hieroglyphica*. This text had come to light a few decades before Piero's painting and had been widely circulated among humanist scholars. Representing a palace in the centre of a circle, says the author, reveals the owner as a cosmic ruler. Thus, the strange representation of the Castellum Sismundum within a painted oculus, with its expository inscription, marks Sigismondo as such a ruler and by extension Rimini, his home, as an ideal political unit.

The last of the fresco's characters are the two splendid greyhounds lying at their master's feet. The dogs have prompted much discussion, some of it associating them with the Egyptian god Anubis because of their 'couchant' poses that resemble sculptures from the tombs of the Pharaohs. The association is unlikely, however, since there is no evidence of any real knowledge of Egyptian imagery in the mid-fifteenth century. The real problem is to explain the dogs' function in an ecclesiastical context and what they may have to do with Sigismondo's self-image. In fact, along with his patron saint and personal dwelling, the dogs must be thought of as further attributes of their master. Because of their innate attachment to their owners, since ancient times dogs generally had been recognized as symbols of fidelity, often

appearing on tomb monuments. Christians later made them symbols of Faith, one of the cardinal virtues (it is the Latin word for faith, *fides*, that underlies the conventional canine name 'Fido'). In a fourteenth-century manuscript Jean, Duc de Berry, had himself painted at prayer before the Madonna with two small dogs in his company (49). Sigismondo had himself shown with his greyhounds for the same reason, the dogs in both cases standing for their master's religious faith.

These dogs also relate to their master through further word-plays on his name, this time his second name and that of his father. *Pandolfo* is again a word made up of two syllables with independent meanings. *Pan* is the Greek adjective meaning all, every, universal or cosmic, as well as being the name of the ancient rustic god Pan; *dolfo,* or *dulfus* in Latin, means dolphin. Above the door leading into the Relic Chapel, and in many other reliefs in the same building

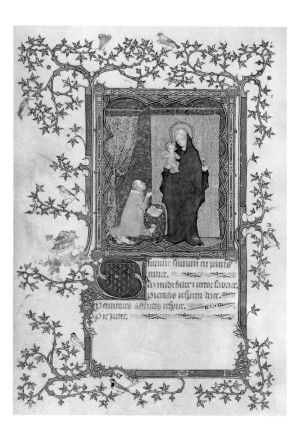

49
Jacquemart de Hesdin, *Jean, Duc de Berry, before the Virgin and Child,* folio 97v, the 'Petites Heures', c.1384–90. 21·5 × 14·5 cm, 8¹⁄₂ × 5³⁄₄ in (page). Bibliothèque Nationale, Paris

50
**Agostino
di Duccio,**
*Putti Riding
Dolpins,*
1449–56.
Marble relief.
Tempio
Malatestiano,
Rimini

51
Tempio
Malatestiano,
Rimini,
transcription
of Greek
inscription
on exterior
(after M A
Lavin and
S Walsh)

there are little 'Pans' or putti (cherubs) riding dolphins (50). But
more specifically humanist word-play must also be present in the
further relationship of *dulfus* to the Germanic name *Adulf.* This
translates figuratively as 'noble hero', but literally means 'noble
wolf'. Curiously, Piero's well-groomed greyhounds are associated
with wolves via a tradition from Roman times that the Gauls bred
dogs and wolves together to produce a breed they called *lycisci,*
hounds with outstanding leadership abilities. In the context of the
history of St Sigismund who was himself a Gaul, it is possible that
these vigilant creatures represent Piero's visualization of the mythic
breed, the *lycisci,* as personifications of the nobility and leadership
with which their master was endowed.

All the elements in the composition thus proclaim some aspect of
Sigismondo's persona: his political authority, his territorial power,
and above all, his religious devotion. It is surprising, in the light of
his later tyrannical reputation, that documentary evidence shows
him to have been a respected ruler. He is said to have worked in
co-operation with the civic officials of Rimini's Large and Small
Councils, to have honoured social contracts and laws, and to have
been popular with his people. He was riding high after his victory in

1447, and had great hopes of being raised to the rank of marquis.
The self-confident mood of this commission, which ultimately
led to the rebuilding of the entire church, was commemorated on
the side walls of the church's exterior in twin statements written
in Greek and carved in superb classical lettering (51). The texts
speak of Sigismondo as the 'bringer of victory' (*nikephoros*) in the
war he won through prayer. They go on to say that the building is
a thank-offering which, as of now, has a new dedication, no longer
to the simple friar from Assisi, St Francis, but instead to the two
forces for which Sigismondo had fought: THEOI ATHANATOI KAI TEI
POLEI, 'for God Immortal and the City'. This dual dedication has a
precedent in the classical phenomenon known as 'temple sharing',
where the temple of a god or goddess was also sacred to a divine
personification of a city (*polis*). In this case the *polis* stands for
the city-state of Rimini, not a goddess but the group of citizens who
participated in its government. The importance of these inscriptions
is that they formally and explicitly declare Sigismondo's commit-
ment to a twofold faith, divided equally between devotion and
dominion, between God and the State.

In the event, Sigismondo's career was not to continue in the path
of success. A major disappointment came when his petition to Pope
Martin V to be elevated to marquis was denied. As time went on he
became less decisive in his military career. He ended up fighting a
losing battle in southern Greece (the Morea) in the employ of the

Τ ☾ Λ
ΣΙΓΙΣΜΟΥΝΔΟΣ ΓΑΝΔΟΥΛΦΟΣ ΜΑΛΑΤΕΣΤΑΣ
ΓΑΝΔΟΥΛΦΟΥ ΓΛΕΙΣΤΩΝ ΤΕ ΚΑΙ ΜΕΓΙΣΤΩΝ
ΚΙΝΔΥΝΩΝ ΚΑΤΑ ΤΟΝ ΙΤΑΛΙΚΟΝ ΓΟΛΕΜΟΝ ΓΕΡΙ
ΣΩΘΕΙΣ ΝΙΚΗΦΟΡΟΣ ΥΓΕΡ ΤΩΝ ΟΥΤΩΣ ΟΙ ΓΡΑ
ΧΘΕΝΤΩΝ ΑΝΔΡΕΙΩΣ ΚΑΙ ΕΥΤΥΧΩΣ ΘΕΩΙ
ΑΘΑΝΑΤΩΙ ΚΑΙ ΤΗΙ ΓΟΛΕΙ ΤΟΝ ΝΕΩΝ ΩΣ ΕΝ
ΤΟΙΑΥΤΗΙ ΓΕΡΙΣΤΑΣΕΙ ΤΥΧΩΝ ΕΥΞΑΜΕΝΟΣ
ΜΕΓΑΛΟΓΡΕΓΩΣ ΑΝΑΛΩΣΑΣ ΗΓΕΙΡΕΝ ΚΑΙ ΜΝΗΜΑ
ΚΑΤΕΛΙΓΕΝ ΟΝΟΜΑΣΤΟΝ ΤΕ ΚΑΙ ΟΣΙΟΝ

last emperor of the Palaeologan dynasty against the Turks as they pressed westward after taking Constantinople. It was to be Piero's image alone that gave him lasting regal dignity: a chaplet of white Malatesta roses surrounds the swag above his head, visually suggesting a crown. Exploiting the traditional forms of both the donor portrait and the ceremonial scene but doing violence to neither, Piero fused them in a way that goes far beyond the earlier scope of either tradition, thereby elevating Sigismondo to a lofty position in the world of art that has outlasted any title he might have borne in life.

The fresco has interesting technical aspects. During World War II, before Rimini was bombed, it was removed from the wall and mounted on canvas for safe keeping. During this process a badly damaged *sinopia*, or full-scale underdrawing, was discovered on a lower level of plaster – a method of preparing a wall commonly used during the later Middle Ages. Disappointingly the under-drawing reveals nothing about the structure of the composition: there are only rough hatchings surrounding the area where Sigismondo would be placed; and the foot and a few other parts of the saint are sketched in. The escutcheon at the top of the composition, by contrast, is precisely delineated by two perpendicular, ruled lines, the vertical marking the exact centre of the upper margin. On the fresco itself, however, there is evidence of 'pouncing', indicating the more modern method of transfer. In this process, the artist prepared a cartoon (a detailed full-scale drawing) for a particular section of the fresco, the main lines of which were pricked with holes. Charcoal dust was then blown through the holes, leaving black dots on the plaster to guide the artist. During the process the cartoon itself was usually destroyed and, in fact, none of Piero's survive. The pouncing, however, can be seen quite clearly throughout the fresco, particularly on the faces and hands and along the edges of the buildings in the little architectural portrait. Piero thus combined the two methods: one an old-fashioned form of workshop practice, the other a relatively new approach to achieving precision which, as we shall see, he would use for the rest of his life.

52
Sigismondo Pandolfo Malatesta, 1450–1. Tempera on panel; 44·5 × 34·5 cm, $17\frac{1}{2} \times 13\frac{5}{8}$ in. Musée du Louvre, Paris

The fresco portrait of Sigismondo was apparently prepared for in full scale by another portrait in tempera on panel (52). This work presents a different facet of Sigismondo's character, less magisterial and more determined and taut. Heavy lids lower over staring eyes and the tight-lipped mouth is sealed. The skull, covered with a cap of dark red hair, is severely silhouetted before an almost too solid black background. Against the darkness, his cut-velvet jacket scintillates with woven threads of gold; with its surface brilliance it acts as a pedestal to the unmoving stiffness of the head. Piero seems to have been doing two things at once: studying Sigismondo's physiognomy at close range and examining the effects of the light upon the variegated surfaces. He has recorded this light, shining mainly from the viewer's left, as it hits the breathing flesh of the face. He then finds a warmly glowing counter-light that illuminates the back edge of the neck and etches the jaw and underside of the chin, creating a sense of three-dimensionality. It cools the colours of the skin and adds strength to the intractable mouth, nose and meditative eye. The result of the exercise (even more than in the fresco) is to present an image of the sitter as a metaphor of power.

The Malatesta fresco must have met with great success, judging by the way Piero's career took off in the decade that followed. While he continued work on the *Misericordia Altarpiece,* he was commissioned by another religious body of Sansepolcro, the Augustinian monks, to do an altarpiece for their church (see Chapter 5). He is also documented as working in Rome at the Vatican (after August 1458 to November 1459). In this period, he also undertook the True Cross fresco cycle in Arezzo (?1452–66), a massive task for which he formed a small workshop of assistants (see Chapter 4). Other paintings, including some of his most famous works, lack documentation but probably also come from this decade. These include the *Baptism of Christ* (for Sansepolcro, now in London) and the *Flagellation* for Urbino, which are the subject of the next chapter.

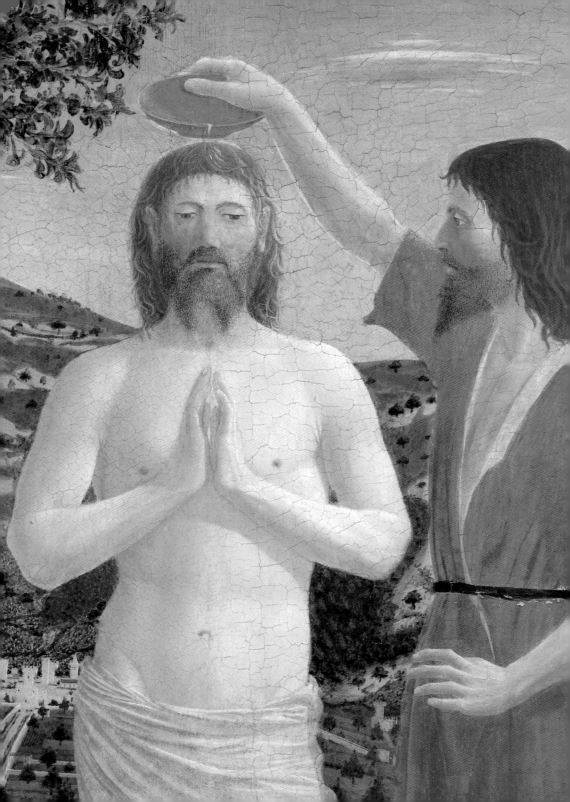

In the structure of the Malatesta fresco, Piero had already shown his predilection for organizing pictorial space in a rigorously mathematical fashion. In that case, the basis was a geometric grid which gives stability and rhythm to the composition. This chapter looks at two works, the *Baptism of Christ* (54) and the *Flagellation of Christ* (see 62), in which he used surface geometry in a more complex manner. At first glance these two paintings seem to come from very different realms: the former is large in scale and meant for public view, with a prodigious landscape and almost no geometric shapes actually represented; the latter is less than half the size, meant for private devotion, and full of straight lines and angles arranged in one of the most intricate architectural settings of fifteenth-century art. In spite of their differences in appearance, however, both are laid out according to precise mathematical calculations.

53
*Baptism
of Christ*
(detail of 54)

In the *Baptism of Christ*, which Piero painted in Sansepolcro, probably around 1455, the deep landscape in which the figures are set is itself central to the painting's meaning. Up to this point in the history of art, landscape had played a secondary role in painting, constituting an element of the background and rarely having any rational structure (Masaccio's frescos in the Brancacci Chapel being the first exception; see 13). In the *Baptism*, a work with complex levels of meaning, Piero gives landscape a new importance.

Originally the *Baptism* was the centre panel of an altarpiece with a huge gothic-style frame including a superstructure, wings and predella painted somewhat later by Matteo di Giovanni (*c*.1430–95; 55). The altarpiece was probably destined for the church of Santa Maria della Pieve, the only church in Sansepolcro where baptism was performed until 1518. It was moved at least once, before finally being taken to the Camaldolite abbey church in the early seventeenth century. Extracted from its original setting, the *Baptism*

is now displayed in the National Gallery, London, in a neo-Renaissance gilt frame, as though it were an independent work of art. The static figures and luminous sky create a perfect balance and mood of peacefulness – perhaps enhanced by the work's false isolation. At the same time there is something uncanny about the painting. The apparent calm is subverted by brooding glances and frozen poses. The scattering of forms through the space makes for a sense of suspended animation in which, though realistically rendered, the figures seem unapproachably statuesque.

Most of the components of a traditional Baptism scene are present: Christ and John the Baptist, attendant angels, the dove of the Holy Ghost, a catechumen (or new believer) and elder citizens of Jerusalem in the distance. A nineteenth-century description states that a figure of God the Father appeared on a separate circular panel (now lost) inserted in the frame above the central group. In spite of this apparent normality, the composition is unique. The River Jordan crosses the valley and meanders forward in a startling way, meeting the picture plane head on. The result of this perpendicular intersection is that the river takes on the effect of a perspective construction. Although its banks are in no way geometric, they slant towards each other, like orthogonal lines receding into space, even creating the illusion of a vanishing point somewhere near the knees of Christ. The overall setting is a valley surrounded by a ring of hills, with a towered city on the left behind Christ. The straight road that runs to the city gate identifies the town as Sansepolcro and the valley as the volcanic crater in which it nestles. It is in these hills that the waters of the River Tiber come forth and spill down into the valley. In his arrangement, Piero has created a coherent, unified outdoor space – one of the first of the Renaissance, based on the principles (but not the elements) of perspective. The space nearest the picture plane is a kind of spatial no-man's-land, populated only by the riverbed and a few medicinal herbs growing on the banks. This empty area serves as both a transition from the real world of the viewer and as a barrier that defines the sacred space.

54
Baptism of Christ, c.1455. Tempera on panel; 167 × 116 cm, 65³⁄₄ × 45⁵⁄₈ in. National Gallery, London

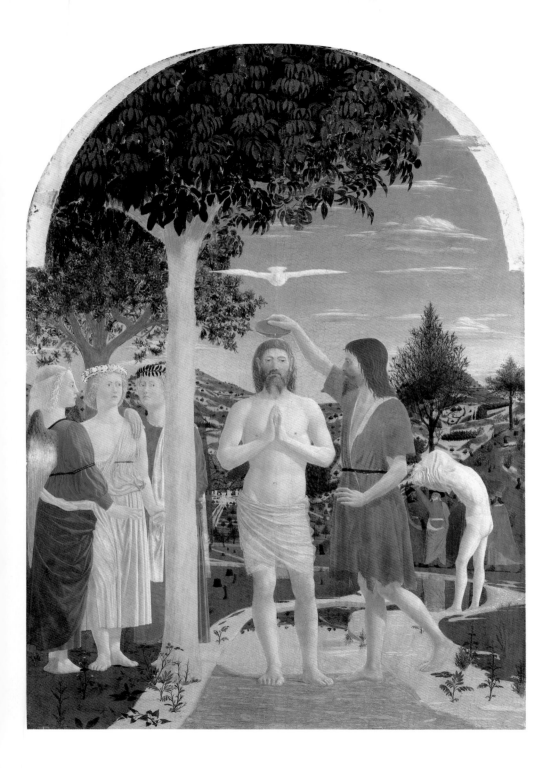

As well as incorporating Christ and John the Baptist, this first baptismal group includes, surprisingly enough, the tree that grows just at the side of the river, its smooth, silvery trunk rising to a rich growth of green leaves and nut-pods that all but fill the panel's semicircular top. From these characteristics the tree can be identified as a Mediterranean walnut (*noce*) which in this context is highly significant. Building on his description of the setting as the environs of Sansepolcro, by giving the tree such a prominent role Piero now makes a profound addition to the symbolic history of the locale. In ancient times, long before the town was founded, this Tuscan crater

55
Baptism of Christ altarpiece (photographic reconstruction). Wings and predella by Matteo di Giovanni, *c.*1460. Pinacoteca Comunale, Sansepolcro

bed was known as the Val di Nocea or the Valley of the Walnuts where such trees grew wild and thick beside the Tiber. It was there in the tenth century that the town of Borgo San Sepolcro was founded. Most cities in Italy throughout the Middle Ages favoured themselves with foundation myths, achieving historical dignity by association with biblical events (Volterra claimed identity with Mount Ararat and the landing place of Noah) or with their antique predecessors (Caprarola was said to have been founded by Hercules after he created the Lago di Vico, the town's water source, with his

spear). Borgo asserted a sacred status greater than most of its neighbours by claiming to have been 'born Christian' from the start. According to local legend, two pilgrims named Arcano and Egidio were on their way back from the Holy Land where they had acquired a large piece of stone, said to be a relic from the tomb of Christ. Arriving at the Val di Nocea they stopped to rest, and as they slept God appeared and told them to end their journey and make a home for the relic there. After several proofs of God's real presence, they obeyed the command and cleared enough of the forest to build a tiny shrine dedicated to San Leonardo. This chapel soon became a larger place of worship, and then a monastery of the Camaldolite order. Around this abbey, known as the Badia, grew the village, or 'Borgo', of San Sepolcro (Italian for Holy Sepulchre).

Because of the pilgrims' relics, because the monastery church (later the cathedral) was considered a copy of the Holy Sepulchre, and because the town carried its very name, the citizens not only conceived of their home as a New Jerusalem, but proclaimed it to be in itself a 'holy site'. In bringing the Baptism of Christ to the city's outskirts, Piero acknowledges these religious associations and presents to its inhabitants a symbolic image of Sansepolcro as an ideal Christian homeland.

The walnut tree carried even further symbolism. A sign of fertility since ancient times, for Christians the walnut had come to represent Christ's crucifixion, the hard outer shell of the nut standing for the wood of the cross and the soft kernel inside, the flesh of the Saviour. The inclusion of the tree as part of the baptismal scene, therefore, adds to the image of John's 'baptism of water' the allusion to Christ's later baptism, that of blood. In this manner Piero both sanctified the River Tiber by identifying it with the biblical Jordan, and with the symbolic tree identified Christ's Baptism as the beginning of his Passion.

At the feet of Christ the glassy reflective surface of the river comes to a stop, leaving the riverbed in the no-man's-land in front of him looking as though it were dry. Close observation, however, reveals thin lines of body-colour on the ankles of both Christ and John,

showing that they are actually standing in clear shallow water.
John Pecham, the thirteenth-century theorist of optics, observed
that light rays falling on translucent bodies at right angles to the
surface penetrate that surface more than rays impinging more
obliquely. In the mid-fifteenth century this was a commonplace of
scientific knowledge, and Piero was surely aware of it. In fact, his
dry-looking riverbed shows light rays penetrating all the way to the
bottom of the river (in this case without the resultant displacement
of refraction). That Piero painted this phenomenon as occurring
precisely at the point where Christ stands allows him, without being
untrue to nature, to create the illusion that the water has come to
a halt. He did so in order to recall an ancient tradition that at the
moment of the Baptism the water of the Jordan recognized Christ's
divinity by reversing its flow. Known for centuries as the 'Miracle of
the Jordan' (and related by the medieval Church Fathers to a series
of prefigurations of the Baptism in the Old Testament, including the
Stopping of the Red Sea) it was most frequently represented by an

allegorical figure seated in the water with his back turned (56). Piero represents the phenomenon not symbolically but 'scientifically', in a manner that would become a guiding principle in his art, in order to make the miracle look as real as possible.

In Piero's time the liturgical Feast of the Baptism of Christ was celebrated on 6 January, then still believed to be the day of the winter solstice. It was in fact one of three events celebrated on this date, which today is known as the Epiphany. *Epiphania* literally means manifestation and the three manifestations of Christ's divinity are: to the Magi, the gentile kings who visited the holy infant; to the apostles at the Miracle of Cana, when Christ turned water to wine; and to the Jews at his Baptism, when the voice of God declared 'This is my beloved son.' These three manifestations of Christ on earth are announced during the liturgy of 6 January in the *Magnificat* antiphon sung during the Mass: 'We keep this day holy in honour of three miracles: this day a star led the wise men to the manger; this day water was turned into wine at the marriage feast; this day Christ chose to be baptized by John in the Jordan, for our salvation, alleluia.' During the Middle Ages, liturgical manuscripts frequently illustrated the triple manifestation by representing the three miracles separately framed but together on a page, one above, or next to, the other (57). We will now see that Piero follows this tradition, alluding to all three miracles in his image, but modernizing it into a single, fully integrated composition.

The ritual of Baptism continues behind St John, where a semi-nude figure bends over the water with his head shrouded in his shirt. This new convert takes a pose that is deliberately ambiguous. The Church Fathers gave two interpretations to the act of baptism by immersion. One referred to undressing as symbolic of the stripping-off of vice. The other considered the white robes as a bridal garment, put on when the new person was 'married to Christ'. Piero's static, beautifully formed figure embraces both ideas, a single representative of mankind who leaves his sins behind at the edge of the river and perpetually prepares to be born into divine life through baptism.

57
Epiphany,
folio 60v,
Missal of
Odalricus,
first half of
the twelfth
century.
30 × 21·5 cm,
11 ³⁄₄ × 8 ¹⁄₂ in
(page).
Hessische
Landesbibliothek,
Fulda

58
Three angels,
detail from the
*Baptism of
Christ* (54)

Behind the catechumen four older men can be seen, a further
allusion to the Feast of the Epiphany. As though they are making a
stop for consultation on a journey, one points to the sky, two others
heed his words and a fourth strides in quickly from the right. They
wear elaborate headgear (turbans and flaring stovepipe-shaped
hats) and garments of vivid colours in the style of the contemporary
Byzantine dress that Piero had seen during the Florentine Council
(see Chapter 1). The oriental clothes are his way of identifying the
men not only as the populace who came to hear John preach at the
Jordan but also as the Magi, the eastern astrologers who followed
the star to Christ's manger. Their mission was said to be foretold in
a line from Psalm 72 of the Old Testament that was read during the
liturgy of the Catholic Mass for 6 January: 'The kings of Tharsis and
the Isles shall offer gifts. The kings of Arabia and Saba shall bring
tribute to the Lord God.' Because four kings are mentioned in the
psalm, and to emphasize the liturgical import of his painting, Piero
depicts four Magi rather than the more usual three.

The attractive youths dressed as angels (58) do not pray or hold
Christ's garments, as in most Baptism scenes, but stand apart as

though hidden behind the tree, entering the action psychologically by expressing concern and understanding of its important implications. They have rainbow-coloured wings, variegated clothes and springy blond hair bound with jewelled and floral wreaths. The one seen from the back raises his hand waist high with palm turned down and fingers extended in amazement. The other two clasp left hands, one leaning on the other and looking out at the viewer.

Throughout the history of Western culture, one meaning of the handclasp has been marriage. The same is true of the wreaths the angels wear. But here the handshake is transferred from right to left hands, and it may be that, since angels are sexless spirits and marriage is a theological impossibility, a change in the gesture was required. Nevertheless, Piero's rendering of this group appears to allude to marriage and thereby to the third miracle of 6 January, namely the Wedding at Cana. In this way Piero completes the reference to the tripart liturgy, and by giving the reference nuptial overtones, he refers to the spiritual analogue of marriage, namely Christ's symbolic wedding to the Church.

Theologically, Christ is defined as the Heavenly Bridegroom and humanity, or the Church as a corporate body, as his beloved bride (though by its very nature, this marriage is spiritual and not physical). Within this complex concept, angels were known as the Friends of the Bridegroom, assisting and participating in the divine union. This metaphor leads back to Christ's Baptism, for it is at that moment, as humanity is regenerated by the baptismal water and divine illumination descends, that the Marriage of Christ and the Church is said to take place. In Piero's version, the naturalism of the spatial construction, and the single moment of time it implies, express the theological unity of the feast in an entirely new way.

The geometric framework that underlies the composition has been analysed in depth by B A R Carter, a specialist in perspective, who suggests still further possible levels of symbolism. His work is summarized here to demonstrate again the close interrelation between Piero's art and his science.

The panel consists of two geometric shapes, a rectangle topped
by a semicircle. Their combination makes a proportion of height
(167 cm; 65 $\frac{3}{4}$ in) to width (116 cm; 45 $\frac{5}{8}$ in) of approximately 3:2.
The figure of Christ, placed at the geometric centre of the panel's
lateral dimension, is exactly one half the panel's overall height.
The modern measurement of the width (116·2 cm) converts to
almost exactly two Florentine *braccia* (an arm's length; one *braccio*
= 58·36 cm). Unlike most Renaissance panel paintings, which were
usually made of three planks of wood joined vertically, this one is
made of only two, and each plank is one *braccio* wide (a fact that
has caused a major crack down the middle, somewhat damaging
the body of Christ). This one-*braccio* measurement seems to have
been the starting point from which Piero worked out all the rest of
his calculations.

Carter began his analysis by dropping an equilateral triangle from
the top of the rectangle, with which the outstretched wings of the
dove of the Holy Spirit align perfectly, to the tip of Christ's right
foot (59). He found that the centre of the triangle he had created
falls precisely on Christ's fingertips. These salient features are
important for stabilizing the composition on the picture plane. 'We
may assume,' Carter writes, 'that Piero plotted this inverted triangle,
with its trinitarian associations, to symbolize the descent of the Holy
Spirit at the moment of Baptism.'

Piero was familiar with Euclidean geometry and Carter further
suggests that at the heart of the *Baptism*'s geometric framework
is Proposition 16 from Book 4 of Euclid's *Elements* (61), which
gives the formula for constructing a fifteen-sided figure, equilateral
and equiangular. Following Euclid, a circle and then an equilateral
pentagon are inscribed on the triangle (60). Piero may have
intended the pentagon to refer to Christ's five wounds, a symbolism
appropriate to the meaning of the Baptism as the beginning of
the Passion.

The pentagon is then used to construct a fifteen-sided figure. If
such a figure is superimposed on the *Baptism*, each of the fifteen
sides (*ie* each chord of a segment of the circle) measures 27·897 cm

(10 $^{49}/_{50}$ in), just a little short of a half a *braccio*. This measurement is precisely one third the height of Christ and one sixth the height of the panel. Finally, if the full circle of 360 degrees is divided into fifteen equal parts (following the fifteen-sided figure described above), each part will have an angle of 24 degrees at the centre of the circle and this, in Carter's view, provides the clue to what led Piero to choose this device. Euclid's Proposition 16 was thought to have links with astronomy, as most ancient astronomers saw 24 degrees as the accepted measurement of the angle of the declination of the sun towards the earth, *ie* the tilt which causes the seasons.

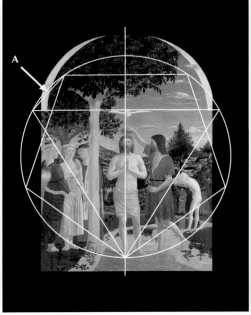

(We now know that the earth revolves around the sun, and not vice versa.)

By employing the chord of 24 degrees, and effectively putting Christ in the centre of the sun's path across the celestial sphere, Piero is identifying him with the sun in mathematical terms. The ancient world celebrated 6 January, the day of the Feast of the Epiphany, as the 'birthday' of the sun. While creating what seems to be a naturalistic setting, Piero found a mathematical way to symbolize

Christ as Divine Light. The theological value of this abstract construction goes a long way towards explaining the unexpected sense of portent at the heart of this sunny, rural landscape.

The deep penetration into space in the *Baptism* anticipates Piero's preoccupation in designing what is perhaps his most famous painting, the *Flagellation of Christ* (62). Both subjects grow out of traditional iconographic and liturgical practice, yet both exude a sense of mystery, as though awaiting uncanny events. In the case of the *Flagellation*, Piero's preoccupations with the pictorial efficacy of linear perspective, which became the subject of one of his treatises two decades later, come into play on both a practical and an expressive level. It is as though, having worked through the

59
Baptism of Christ with geometric overlay of an equilateral triangle (after B A R Carter)

60
Baptism of Christ with geometric overlay of a pentagon and circle (after B A R Carter). (A) shows a chord created by the 15-sided polygon

61
Diagram showing the construction of a 15-sided equilateral equiangular polygon, from Euclid's *Elements*, Book 4, Proposition 16

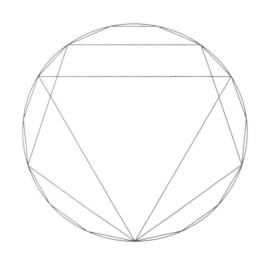

creation of deep space on the basis of intuitive observation, he moved on to the realm of measurable illusion.

The *Flagellation* was unknown until the year 1744, when it was mentioned in an inventory of the sacristy of the cathedral of Urbino. While the attribution was assured by the signature OPVS PETRI DEBURGO SCI SEPVLCRI ('the work of Peter of Borgo San Sepolcro'), absolutely nothing about its history was forthcoming. The painting is now in the Galleria Nazionale delle Marche in the Palazzo Ducale of Urbino, protected by a glass case following its theft and ransom in 1979 (the money was paid, the work returned and the thieves

were never apprehended). It is assumed, but by no means certain, that the painting was done for the city of Urbino and that Piero went there to do it.

There are several ways he might have made that journey, all of them difficult. The inland route from Sansepolcro passes northeastward up the treacherous Rocca Trabária, a thousand metres of stratified rock and trees that mark the border between Umbria and the Marches. The other road, along the Adriatic coast, turns inland south of Pesaro, winding through ever rising, rugged hills. Once at the top, the narrow byway twists around upland peaks to the lozenge-shaped town of Urbino perched on two steep hills. From the city, the views over the surrounding hilly, almost lunar landscape are precipitous. Here the Montefeltro clan ruled for more than two centuries before Pope Eugenius IV in 1443 raised the craggy territory one notch to the level of a dukedom, with the young Oddantonio as its legitimate ruler. The following year, however, Oddantonio was assassinated and Federico, his 'natural' (*ie* illegitimate) brother, who just by chance was waiting at the gates with a troop of horseman, entered the city and was hailed as the new ruler. The territory's status was lowered once again and Federico was named count, but otherwise the transition was unopposed. In the event Federico's career was brilliant, both as a civic ruler and as a powerful general who presided over a flourishing court. Although in the late 1460s and 1470s Federico was one of Piero's major patrons (see Chapter 7), there is no reason to believe he was involved in the commission of the *Flagellation*. His characteristic hawk-nose profile (see 170) is nowhere to be seen. On the contrary, it was most probably a distinguished member of the Urbinate court who was the patron and therefore responsible for introducing Piero to this cultivated milieu.

The effect of monumentality in the *Flagellation* makes it seem much larger than it really is. Rather too large for a predella (the ones made for the *Misericordia Altarpiece* are half its size), it is certainly too small for a public altarpiece. The panel has clearly not been cut down, since there is blank wood surrounding the entire

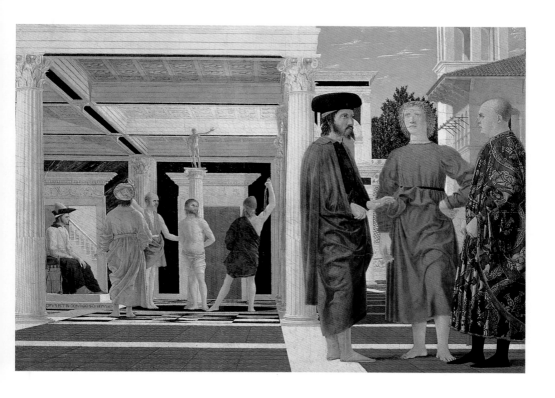

62
Flagellation
of Christ,
1458–60.
Tempera
on panel;
58·4 × 81·5 cm,
23 × 32 in.
Galleria
Nazionale
delle Marche,
Urbino

painted surface where the now lost frame (prepared beforehand by a carpenter, as was usual) would have been attached. Moreover, there are remnants all round of the 'beard' – the little edge of paint that filled the gap between the panel and the frame. The picture's small scale confirms that it was made for a private environment. It goes by the name of 'Flagellation' even though Jesus, his torturers and the judge, Pilate, are represented far behind the picture plane on a miniature scale.

In the most prominent position, thrust towards the viewer, are three quite distinctive male figures. This spatial disparity implies an extraordinary shift away from the traditional meaning of Flagellation scenes which generally depicted Jesus as the central foreground figure, flanked by the torturers. As a result of Piero's highly innovative composition, and perhaps because of the dearth of documentary evidence, the painting's possible subject has received a great deal of attention. There have been some thirty-five interpretations of the iconography, which fall roughly into three categories:

(1) Biblical. These take the work to be a variation on the New Testament Flagellation scene. Figures are identified as diverse biblical characters, such as the Old Testament King David portrayed as a soldier; King Herod, who had attempted to kill the infant Jesus; Judas, the disciple who betrayed Jesus; the Sanhedrin, or Jewish council of Jerusalem, who wished to destroy him; Joseph of Arimathea, in whose tomb his body was laid; or other religious figures, such as St Jerome and rabbis, or Jews in general.

(2) Local history. This group of interpretations propose a parallel between the Flagellation scene in the background and contemporary historical events. The foreground figures are identified as the counts and dukes of Urbino, their sons, relatives (and assassins), or aristocrats, merchants and scholars from other communities (Arezzo, Mantua, Milan).

(3) International current events. These interpretations link Christ's torment in the background with the 'Turkish threat' to Italy after the fall of Constantinople in 1453. The foreground figures are seen as

diplomatic players in this struggle: Palaeologus family members (Byzantine), Corvinus family members (Holy Roman Empire), Turkish ambassadors, members of the western Church hierarchy and allegorical figures of all of the above.

For a small work of art from an out-of-the-way town, the panel has carried a heavy burden of contention. Ironically, it is not only the question of meaning that makes the *Flagellation* so intriguing, but (even more important) its perspective contruction. Within the tiny format Piero created a spatial environment so complex that it was not fully understood until the 1950s, yet so accurately conceived that it can be measured and reconstructed in both plan and elevation.

The setting includes several parts: a large open piazza paved with brick-red tiles and unbroken white stone strips; an open portico decorated with richly coloured marbles; in the background left, a two-storey marble building encrusted with porphyry and black stone; and a pink domestic edifice with a tiled roof and an open-work tower on the right. The back of the piazza is closed by a wall of inlaid marble, above which is visible a tree in full leaf.

The Flagellation scene proper is set under the portico. All the traditional components of this subject are present: Pontius Pilate, the Roman governor of Judea, to whom Piero gives a high-crowned hat (of which more later) and the red shoes of a classical ruler. He is enthroned in his praetorium, or judgement hall, accompanied by an anonymous turbaned adviser, who is seen from the back (63). Christ is tied to a column between two flagellators brandishing flails and whips. The arrangement is similar to the *Flagellation* by Pietro Lorenzetti (active *c.*1306–45) in the Lower Church of San Francesco in Assisi, painted around 1325 (64), where the columned praetorium is off-centre and Pilate is seated with a turbaned counsellor at his side. This asymmetrical composition was repeated in a reduced form on the predella of an altarpiece by Niccolò di Segna (active 1331–65) painted *c.*1346–8 on the high altar of the main church in Borgo San Sepolcro (65), which Piero surely knew. What is out of the ordinary in Piero's scene is that Christ's body is

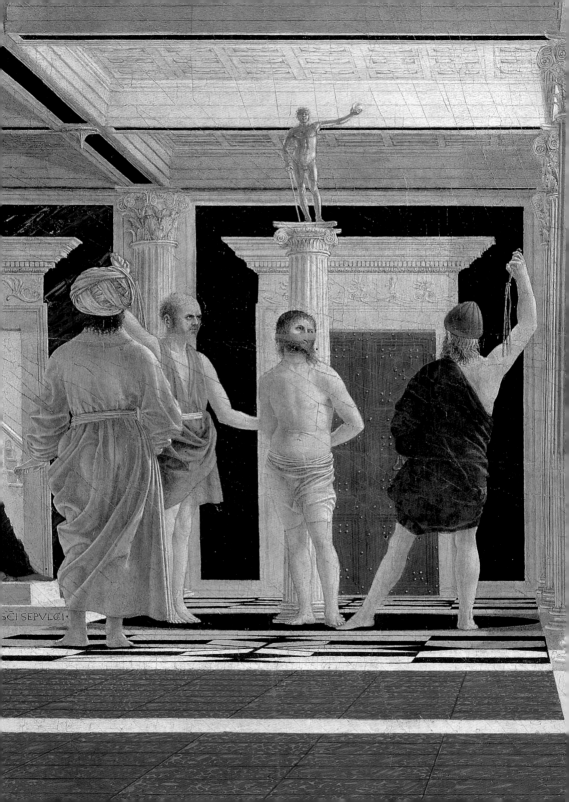

gloriously unharmed and the column is topped by a golden statue of a nude male figure with one hand on a staff and the other holding a crystal globe.

Very often in scenes of this subject, additional characters, such as 'the chief priests, and elders, and all the council' who participated in the proceedings (Matthew 26:59), are included, and the three figures out in the piazza may recall such men. But the figures are more prominent than usual and oddly distant from the scene they might be witnessing. Turning their backs on Christ's torture, they are engaged in what seems to be a specific conversation. The

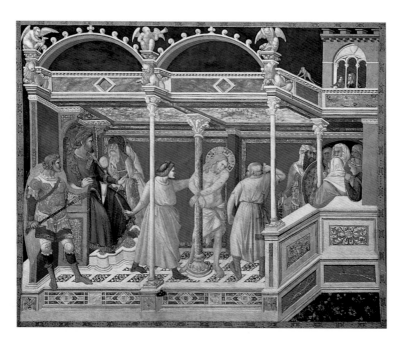

63
Flagellation
(detail of 62)

64
**Pietro
Lorenzetti**,
*Flagellation
of Christ*,
c.1320–5.
Fresco.
Lower Church,
San Francesco,
Assisi

bearded man speaks with open mouth, extending his left hand palm-down as if to ensure calm. His companion listens attentively, thumbs hooked into the belt of his rich robes. The young man between them stands silently, looking directly at the spectator with strange golden eyes. His blond locks curl around his head like flames and his feet are bare. Each figure is juxtaposed with a different side of the piazza. The bearded man appears before the marble buildings; the bald man is backed by the civic mansion; and the youth in the middle stands before the wall and what is surely a laurel tree in

the distance. This effect is entirely dependent on Piero's deep perspective projection.

Piero gives the clue to understanding this effect in the pavement of the foreground of the piazza. Large squares are made up of red tiles set eight by eight and surrounded by white strips. This configuration forms a unit that remains constant throughout the pavement. There are two units in front of the praetorium, the first which is cut off slightly at the picture plane. The praetorium itself is three units deep. Following these indications, in 1953 Rudolf Wittkower working with B A R Carter succeeded in reconstructing a plan and elevation of the first five units of the painted space (66). The plan

shows the position of all the figures, marked by footprints. The foreground figures stand towards the back of the first unit of tiles, but all are in front of the architecture on the left. The plan also reveals the design of the patterned pavement in the praetorium, which is difficult to make out in its foreshortened state. It turns out to be squares inlaid with red porphyry on a white marble background. Christ at the column is at the centre of a serpentine green circle with pink spandrel-shaped corners.

The next step is to determine the full depth of the painted space (67), and light is the element to observe. Light falls on the

65
Niccolò
di Segna,
Flagellation
of Christ,
predella panel
from the
Resurrection
Altarpiece
(156),
c.1346–8.
Tempera
on panel.
Sansepolcro
Cathedral

66
Plan and
elevation of
the Flagellation
of Christ,
showing a
reconstruction
of the floor
patterns (after
R Wittkower
and B A R
Carter)

67
Plan of the
Flagellation of
Christ, showing
the depth of
the piazza
(after M A
Lavin and
T Czarnowski)

foreground from the left at a very steep angle. The praetorium then casts a large shadow on the pavement behind the figures in which six units can be counted. Since the open portico accounts for three units, the enclosed palace structure behind it covers another three. After that, the piazza is once again filled with sunlight, implying another area of open space, bounded by the second marble building. (In fifteenth-century descriptions of Jerusalem, Pilate's dwelling is described as a compound of buildings.) The countable white paving strips number sixteen before their spacing becomes so tight that they merge. This point

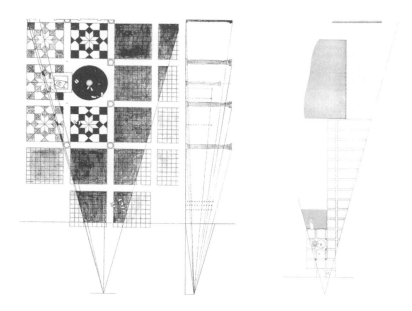

corresponds to the corner of the second marble building, which also casts a shadow on the pavement. The shadow is now at such a distance that the darkened tiles are seen as one mass. The effect is to indicate that the wall at the back of the piazza is very far away. Indeed, the projection can be estimated at about 91 m (250 ft) or, more correctly for Piero's time, about 156 Florentine *braccia*. As one *braccio* equals 58·36 cm (23 in), or almost precisely the height of this panel, that dimension must again have been the starting point for Piero's calculations.

The rationality of the setting makes the final element to which Piero calls attention all the more surprising. Having established the direction of the light out in the piazza as flowing from the left, he paints the light in the scene of the Flagellation as coming from the opposite direction. This reversal can be observed in the consistent highlights on the right side of all the vertical forms in the praetorium: the upraised arm of the flagellator with his back turned, the right side of the golden statue, the front face of Pilate's dais, even the studs on the door at the back. Beyond the reversed highlights, the coffered ceiling above Christ is illuminated in a spectacular way, many times more brilliant than the rest of the ceiling. Although the light above Christ – 'The Light of the World' – is associated with him, it does not emanate from him. The golden rays that surround his head have brilliance but do not shed light. The lighting effect therefore must come from another source.

Again Piero uses a logic so consistent that it is possible to pinpoint the exact location of the source. He has painted the roof beams as casting shadows on the coffered ceiling. The clearest shadows are those on the right side of the coffers of the first bay, the one in the left back corner of the same bay, and the one over Pilate's head. The angles of these shadows are measurable, and with these measurements the planes that define the shadows' surfaces can be plotted. The point at which the planes intersect locates the source of the light (68). The axonometric diagram (a graphic method of representing objects in three dimensions, in this case from above; 69) shows this point in space: just beyond the second column, at a height between Christ's head and the feet of the golden statue. The mystical nature of this light is emphasized by the irrational position of its source. Piero's totally rational construction serves to make the unnatural phenomenon look as real as possible. With this effect, he marks the praetorium as a sacred space, and the biblical event taking place within it as a miraculous apparition.

Now it becomes relevant to ask what Piero's purpose was in taking great pains to create this construction. My answer to this question to some extent fits into the second category of interpretations: it is

68
Diagram of the praetorium in the *Flagellation of Christ*, showing intersecting planes of shadow that locate the position of the secondary light source (after M A Lavin and T Czarnowski)

local and personal, befitting the painting's small size. The difference from other interpretations is that, rather than anecdotal, I find the content of the painting to be uniquely intellectual and psychological, and therefore typical of Piero's inimitable ability to give visual expression to the deepest preoccupations of his learned clients.

The Christological apparition in the middle ground appears in response to the conversation in the foreground, with the formal reciprocity of the two groups binding them together. In both triads the central figures – the blond boy in the foreground and Christ under the portico – are considerably paler than their companions; both stand with their weight on the right leg, left arm bent at the

elbow; both have distinguishing features over their heads, the statue on the column above Christ, the verdant tree above the boy. The three-quarter view pose and hand gesture of the bearded man are echoed by the combined poses of the left-hand flagellator and the turbaned figure. These formal analogies are surely the key to this remarkable image. They suggest that the blond boy in the foreground can be identified with the beautiful Christ Triumphant in the back, who bears his torture and is glorified before both pagans and Jews. St Paul defined this aspect of Christ's nature when he correlated tribulation and glory: 'We ... rejoice in hope of the glory

69
Axonometric
view of the
praetorium in
the *Flagellation
of Christ*,
showing the
position of the
secondary
light source
(after M A
Lavin and
T Czarnowski)

of God. And not only so, but we glory in tribulations also: knowing
that tribulation worketh patience' (Romans 5:2–3). The inclusion
of the golden statue atop the column of the Flagellation further
defines the concept of Christian glory. The precious material of the
figure recalls the classical Sun god (*Sol Invictus*); the staff he holds
palm-down recalls the gesture of Hercules, the hero of classical
mythology, who held his club in this manner as he rested after
his labours; and the elevated silvery sphere in his outstretched
arm is an imperial sign of universal sovereignty. In other words,
Piero gives the statue attributes describing the pagan qualities that
Christ himself embodied and superseded. The 'statue on a column'
formula, moreover, signified triumph in the Christian world as well
as in classical antiquity. The Flagellation scene is thus not a narrative
but an image of the triumph of Christian glory, a consolatory model
for human sufferings.

Consolation was one of the great, newly revived, concerns of
Renaissance humanists. From antiquity onwards the rhetoric of
mourning had had its own literary form known as the Consolatory

Letter or Oration (*epistola* or *oratio consolatoria*). As developed by Cicero, the goal of consolation was to allay or diminish a friend's distress over the illness or death of a loved one, which were believed to result from luck or 'fortuna'. The Church Fathers, on the contrary, thought such distress was punishment for Adam's fall, while conceding that worldly tribulation could also be a vehicle for divine correction, with adversity bringing the afflicted person back to the paths of piety. The rekindling of classical sentiment began with Petrarch, who was the first to use the 'majesty of words' to staunch the tears of the bereaved, and soon after, the humanist and statesman Coluccio Salutati advocated friendship and duty to chase away depression. By the mid-fifteenth century the 'Art of Mourning' had undergone a full-scale revival, with the publication of many Consolatory Letters. Giannozzo Manetti's *Bitter Dialogue* (*'Antonini, dilectissimi filii sui, morte consolatorius'*, 1438) gives an intimate view of the psychological, philosophical and spiritual sensibilities in the search for consolation, finding grieving natural and humane. Francesco Filelfo, a well-known humanist who spent time at the courts of both Rimini and Urbino, wrote eighty pages on the subject in his *Consolatory Oration for Jacopo Antonio Marcello on the Death of his Son Valerio* (1461), a rich compendium of philosophical and Christian remedies. He concludes that the human soul is the image and likeness of the divine mind, and that grief for a son is the vehicle for secular immortality.

Piero defines his consolatory theme by comparing the two groups. The beautiful boy in the foreground (70) is, like Christ, fair skinned; he is barefoot; and, without engaging in the action taking place around him, he gazes abstractedly into the distance. His backdrop creates the effect that he too, like Christ, is crowned with glory: the leaves of the distant laurel tree – the plant that from ancient times has symbolized victory or glory – sprout wreath-like around his head. If he, like Christ, is a 'beloved son', then he too has been subjected to worldly tribulation.

Piero has replaced the 'majesty of words' with the dignity of visual forms in painting a 'picture of consolation'. I propose that it was

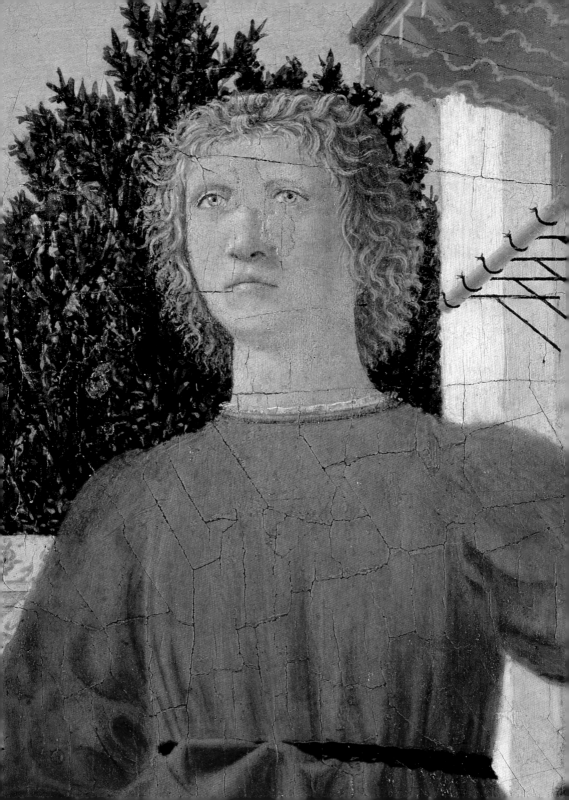

commissioned in response to circumstances that occurred around 1458 to 1460, when the sons of two lifelong friends fell prey to devastating illness, and the fathers came together in their common grief. One of these men was a high-ranking member of the court of Urbino, Federico da Montefeltro's nephew Ottaviano Ubaldini della Carda, his chief counsellor and treasurer of the state. Ottaviano was famous in his time as a man of culture, an intellectual with a taste for literature and art – among many other things, he owned a painting by the Netherlandish master Jan van Eyck (c.1395–1441). He also had an extensive knowledge of astrology, a field that during the Renaissance included astronomy, geography, mathematics and optics. Since the study of perspective was part of optics, it too was a branch of astrology. Ottaviano, therefore, would not only have appreciated Piero's work in perspective but could have known enough to request its use in this commission. In 1458 Ottaviano's only child, the teenage Bernardino Ubaldini, died of the plague. There are many records of Ottaviano's mourning, including touching Latin tributes by the court poet Porcellio Pandonio, noting the untimeliness of Bernardino's death and describing him as an 'ivory-coloured youth'. Among the possessions of Ottaviano Ubaldini, today housed in the Vatican Library, is another testimony of his bereavement: a copy of the 1461 *Consolatory Oration* by Francesco Filelfo, elaborately dedicated to him in remembrance of this tragedy.

Ottaviano's features are known from portraits made in the early 1470s: a stone roundel inscribed with his name (71), and another image in which he is shown as a man in his fifties, in the guise of the mathematician Ptolemy accepting an armillary sphere (a model of his measurements of the world) from a personification of Astrology (72). Representing one of the great astrologers of history, he is dressed in flowing robes, and shown with the long black beard traditionally associated with scholars and sages. Piero's bearded figure is a younger man (Ottaviano was thirty-five in 1458), dressed in clothes of an exotic cut. His raspberry-coloured cloak with over-long sleeves and mushroom-shaped hat of black wavy goat hair are based on the Byzantine costumes Piero saw in Florence during the

71
Anonymous,
*Ottaviano
Ubaldini*,
1474.
Marble
roundel;
diam. 50 cm,
19 ³⁄₄ in.
Façade, San
Francesco,
Mercatello

72
**Attributed
to Joos van
Ghent**,
*Ottaviano
as Ptolemy
Accepting
an Armillary
Sphere
from the
Personification
of Astrology*,
c.1475.
Oil on panel.
Formerly
Berlin–Dahlem
(destroyed)

73
Filarete,
The arrival
of Emperor
John VIII
Palaeologus
in Italy.
Scene from
the bronze
doors of
St Peter's,
Vatican,
1449

Council of 1439 (and are similar to costumes reproduced on the bronze doors of St Peter's by Filarete; 73). Although Piero's figure has stiff, wiry hair, his features resemble Ottaviano's with the same sad and serious gaze. The figure's backdrop identifies him with the apparition of the Flagellation since his body seems to overlap the classicizing architecture of Pilate's palace. He is thus privy to the inner sanctum, having access through his 'science' to superior insights. He speaks to his companion, lifting his hand in a reassuring way, offering him, and himself, words of consolation.

The man in profile who listens intently is dressed in an elegant full-length *cioppa*, made of Italian blue-velvet brocade with a thistle pattern in gold thread. It is fur-lined with large semicircular sleeves

and open cuffs. The thin line of crimson material seen over his right shoulder has been identified as a liripipe, or a stylishly rolled-up hood. His feet are covered with soft black leather boots. He is bareheaded with close-cropped grey hair shaved high at the back and at the sideburns. This figure is clearly a man of consequence. His profile (74) can be compared with a bronze bust (75), often attributed to Donatello and dated *c.*1450, identified as Ludovico II Gonzaga, Marquis of Mantua. In Piero's version, when Ludovico would have been about forty-seven, the general configuration is virtually identical. Although unluckily in the painting the tip of the nose has been destroyed, he has the same stern, set mouth, and slightly receding chin, flaccid at the neck. The figure's back-drop again helps to identify him. A multi-storeyed domestic palace

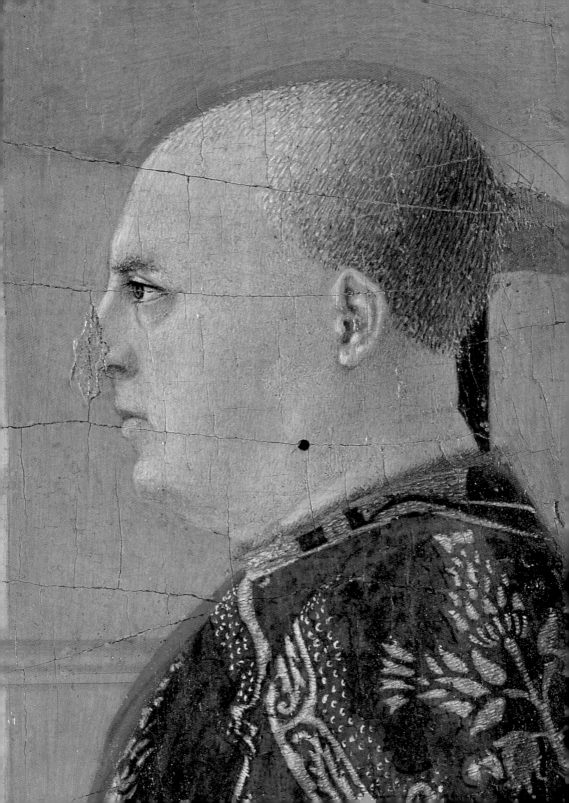

bespeaks a man of wealth and prominence, consistent with someone of Ludovico's aristocratic station.

Ottaviano Ubaldini and Ludovico Gonzaga knew each other most of their lives. As children they studied together at the court school just outside Mantua. Later they learned the military arts together in Milan. From many letters it is known that in adult life they were in constant correspondence. When Ludovico Gonzaga's granddaughter

74
Foreground
figure from the
Flagellation
(62)

75
Attributed
to Donatello,
Ludovico II
Gonzaga,
Marquis of
Mantua,
c.1450.
Bronze.
Staatliche
Museen, Berlin

prepared to marry Federico da Montefeltro's son in the mid-1480s, Ottaviano Ubaldini was called upon to cast the horoscope for the date of consummation of their nuptials (see Chapter 8).

Gonzaga, too, lost a son through illness. Although the youth, named Vangelista, was not his biological son but his nephew, Ludovico adopted him after his brother's death and the tragedy that befell

him was deeply felt. Vangelista is named by a Mantuan chronicler as Ludovico's favourite child and singled out for his courage and beauty. He is called *belo, grando, biancho* ('handsome, tall and fair' – *ie* blond and light-skinned). Between the ages of sixteen and twenty, Vangelista was overcome by an illness so grave (possibly something akin to meningitis) that it crippled his entire body and finally killed him. These events took place between 1456 and 1460, or at almost exactly the same time as the death of Ottaviano's son.

In the painting, the two men face each other in mutual consolation. Ottaviano, in his superior 'scientific' wisdom, leads the discussion as they share understanding of the double tragedy that has befallen them. The contents of the conversation take shape between them in the image of a youth whose palpability brings him into sharp contact with reality, while at the same time his ideal beauty, golden eyes, timeless garment, bare feet and the laurel leaves surrounding his head, remove him to a symbolic realm. Piero has again made a mystical experience look as real as possible. This handsome figure personifies the 'beloved son', who, like Christ, will rise to glory, helped by the love and remembrance of those who pray for him and for themselves. The enigmatic separation of the two groups of figures thus serves a quite specific purpose. Piero lavished his considerable mathematical skills on the little panel to create a compelling pictorial space for a work of private devotion and remembrance, whose theme is consolation.

Fresco as Epic The Cycle of the True Cross in Arezzo

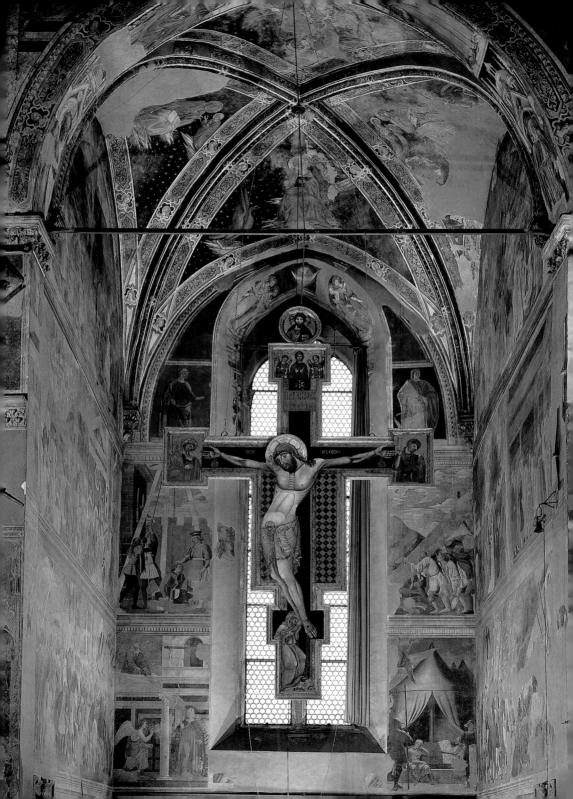

Piero della Francesca is often praised for his skilled use of the 'classic' fresco technique. The standards set for what is called *buon fresco* ('good fresco') follow the description laid out by Cennino Cennini (*c.*1370–1420) in his handbook on painting, *The Book on Art* ('*Il libro dell'arte*'). Correct fresco is done, says Cennino (himself a painter), with pigments dissolved in water applied to fine plaster while it is still wet. His tone is tinged with a certain pride because the challenge is to work quickly and make no mistakes. For centuries Piero, along with Michelangelo and other great artists, was believed to have painted only in *buon fresco*. This opinion began to change, however, with advances in restoration techniques. In the 1960s cleaning campaign of Piero's *Legend of the True Cross* cycle in San Francesco, Arezzo (76), it had already been shown that, in spite of the rules, Piero – like many other artists, including Michelangelo – used tempera (pigment with egg binding) on top of the fresco after the plaster had dried to bring out certain surface details. In the later, fifteen-year restoration campaign, completed in early 2000, even more revelations were forthcoming. It is now known that Piero, this most classic of artists, experimented not only with tempera but also with tempera mixed with oil (*tempera grassa*) and with the application of true oil glazes (pigment mixed with oil) on the wall. This chapter will focus on Piero's grand cycle in the church of San Francesco, keeping in mind that, in addition to his other achievements, he was also a technical innovator.

The importance of the Arezzo cycle has been recognized over the past century and a half, with many invaluable contributions, made by as many authors, greatly increasing our understanding of the complex narrative. One common starting point has been the assumption that the secular patrons, members of a wealthy Aretine family named Bacci, were the chief promoters of the subject matter. As a result, much historical research has focused on the sparse

76
San Francesco, Arezzo. View of the apse (the Cappella Maggiore) showing Piero's *Legend of the True Cross* fresco cycle, *c.*1452–66 (before restoration)

information concerning them. While this line of enquiry has increased our knowledge of the Bacci, in reality it would have been the Franciscan friars – the administrators and main users of the church – who determined the subject of the cycle, and it is the subject's meaning for them at the time of commissioning that we must seek to understand. It is increasingly clear that religious orders chose the images that bedecked their houses of worship, and although the monks and friars routinely sought outside financial aid to carry out their theological plans, theirs was the final say in the choice of topics. The secular patrons had to agree, at least in the first half of the fifteenth century, and were required to accept restrictions on making their presence and participation known through portraits or other visual allusions. The artist's contribution was to shape the overall programme and give it visual form. In this case, it is clear that Piero worked with the Franciscans to develop ideas that were new and relevant to the time and place. In his hands, the theme of the True Cross took on epic proportions, in which its relevance to the Franciscan order was enriched, the city of Arezzo was glorified, and the foundation and mission of the Church of Rome was reaffirmed. While remaining true to the visual heritage of the sacred legend, Piero made all this visible by rearranging the sequence of the narrative, by adding scenes of the first Christian emperor, Constantine, and by pairing two great military episodes that show the power of the cross. He could not have introduced these iconographical and structural changes without lengthy deliberations with the friars; but considering the benefits he offered, it is no surprise that his ideas were readily accepted.

Within a month of the official completion of restoration in the spring of 2000, some 50,000 people made reservations to see the fresco cycle over the summer. The 'Piero Pilgrimage' was given a new lease of life. Some of the visitors who came, and still come, to admire Piero's paintings might be surprised to learn that he was originally not the first choice to carry out this commission, and that another artist had been engaged and had already started the cycle before his arrival. But to put the commission into its full perspective, some background information is required.

The church of San Francesco in Arezzo was founded in the late thirteenth century, after the Aretine Franciscans were given land and permission to build their friary inside the city walls. The construction dragged on for almost eighty years until finally the three chapels of the apse end were completed in 1377 and decoration could begin. Sometime after that, probably in around 1410, the Bacci family came to an agreement with the friars to sponsor a suitable new decoration in the apse, a rectangular space known as the Cappella Maggiore. In return the Bacci would have the use of the area in front of the apse as their family burial ground and would be allowed to mount their coat of arms on the pilasters that flank the entrance to the apse, which they did. These transactions, all well documented, were normal procedures during the Renaissance. In 1417 the head of the family, Baccio di Magio Bacci, died and was duly buried in the church. However, the decorations did not get underway until the later 1440s, and only after the Franciscans had complained about the delay. Baccio's son Francesco and two of his nephews then raised some of the money for the project by selling a vineyard, and soon hired Bicci di Lorenzo (1373–1452), an elderly, well-respected but rather banal painter from Florence, to do the job. The programme for the decorations would have been drawn up at this time. Work began on the commission, but in 1447 Bicci became ill, and his workshop had to continue without him. When he died in 1452, the four *Evangelists* on the vault, two of the four *Fathers of the Church* on the underside of the arch, and a *Last Judgement* on the triumphal arch over the entrance to the chapel had been completed. Some scholars say Piero was called in in 1452, others claim not till c.1457, while still others say that he did most of the work after 1459, when he returned from Rome. Nothing concrete is known about when or how the commission fell to him. That the frescos were finished by 1466 can be deduced from a document concerning another work that cites the cycle in the past tense.

In any case, when Piero arrived the Franciscan preaching friars of Arezzo were in pretty much the same situation as their predecessors at the order's mother church in Assisi when the first church of San

77
Upper Church,
San Francesco,
Assisi

Francesco was being decorated two hundred years earlier, in the
1270s and 1280s (77). That huge building had been largely financed
and supported by the papacy, and over the centuries the order's ties
to Rome had remained direct and strong. In the later thirteenth
century Pope Gregory X had had hopes of unifying the Orthodox
Church of Byzantium with the Church of Rome and in 1274 had
called a council in the French city of Lyon, giving major roles in the
proceedings to prominent Franciscans. The presiding chair went to
the best-known living Franciscan friar, Bonaventura di Bagnoregio,
whom he made cardinal for the occasion. Three Franciscan friars
were sent to Constantinople to escort the Byzantine emperor
Michael Palaeologus to the Council. After the emperor's arrival,
it became clear that his agenda was less concerned with Church

doctrine than with petitioning the Western nations for help in fending off the Turkish Muslims who were threatening to invade his territories. Neither the emperor's petition nor papal plans for unification had notable success. Although Pope Gregory was dedicated to fighting the Turks, his own recent crusade (1271–2) had been a disaster. Neither he nor anyone else in the Vatican was ready to take to the battlefield again. The Franciscans, on the other hand, were eager to follow the papal mandate. Their new approach of preaching in the streets, licensed by papal permission, constituted a powerful new weapon, and they pledged to harangue the populace with sermons on the need for a crusade. This pledge, along with the papal agenda itself, is reflected in the painting in the apse of San Francesco in Assisi, where Cimabue's frescos give visual form to the order's vow to combat the foes of Christianity and the Church's promise to retake the Holy Land from the Muslim Turks.

In the fourteenth century the Franciscan interest in the safety of the Holy Land became more specific. Under a custodial grant from King Robert of Anjou, representatives of the order became responsible for the physical protection of certain holy sites in Nazareth, Bethlehem and Jerusalem, where the Franciscan presence is still much in evidence today. Meanwhile, through the rest of the fourteenth century and in the early fifteenth, the two related issues remained major preoccupations: unification with the Orthodox Church and the 'Turkish Question'. The popes Eugenius IV, Nicholas V and Calixtus III all renewed the petitions to the Franciscans to 'preach the crusade', soliciting the assistance of specific friars such as St Bernardino of Siena who were particularly effective in persuading public opinion.

In 1438–9 another East–West council was called, and another Byzantine emperor (John VIII Palaeologus) came to petition for Western aid (see Chapter 1), and again the call to arms ultimately went unheeded. In 1453 Constantinople fell to the Turks, and soon after the Italian mainland itself was being threatened. A brief respite came in 1456, when the Observant Franciscan preacher-soldier Fra Giovanni da Capestrano joined the militantly anti-Turkish

János Hunyadi, regent of Hungary, in the defeat of the Ottoman Sultan Muhammad II at the Fortress of Belgrade. There on the River Danube, Fra Giovanni claimed victory in the name of the cross. Both men died very soon afterwards and the campaigns ended. But the initiative returned soon to the papacy, and Pius II convened yet another council (in Mantua, 1459) to persuade the princes of Europe to join him in creating a naval force for a counter-invasion. (These efforts, too, failed, and Pius died at Ancona, the eastern port of departure; the matter remained unresolved for another century.)

The atmosphere at the time of Piero's Franciscan commission was thus charged with concern for the defence of Christianity and with the Franciscans' own sense of responsibility in carrying out a role entrusted to them by the papacy. In choosing the quite complicated story of the True Cross, the Aretine Franciscans were not only confirming this mission but also renewing their own artistic tradition, set down earlier in Franciscan churches in Florence (Santa Croce, 1388–93; 78) and Volterra (San Francesco, 1410; 79), where the subject matter already carried a large measure of crusade

propaganda. The representations at Arezzo are based on two entries in the thirteenth-century *Golden Legend* by Jacobus de Voragine, whose narratives relate to the Church's feast days: the Invention (or Finding) of the Cross (the entry for 3 May), and the Exaltation of the Cross (the entry for 14 September; a feast established in the fourth century to which was added the historical narrative of the early seventh-century reconquest of Jerusalem). By the fifteenth century the *Golden Legend* was widely circulated in many languages and even employed in Italian schools to teach reading. For these reasons, the narrative used in the Arezzo cycle would have been familiar to all concerned.

More fundamentally, a miracle involving the cross formed part of Arezzo's spiritual history. Franciscan dedication to the cross derived from St Francis's lifelong devotion to its theological significance as the sign of Christ's sacrificial gift. Not only did he meditate on the cross constantly throughout his religious life, but he also received the bloody wounds of the nails on his own body (called the *stigmata*). One of his many visions involving the cross occurred at Arezzo in about the year 1211. Francis had been travelling through the Tuscan countryside with a companion named Silvestro – so the story goes – when he arrived outside the city walls. There he was saddened to see devils exulting over the town because of the strife they were causing. (This incident no doubt had to do with the historical facts, since the leading families of Arezzo – the Tarlati, Pietramala and the della Faggiola – were unusually militant with each other in this period.) Francis told Silvestro to give a command that would exorcize the demons. As he intoned the order, the devils fled 'screaming and crying', leaving Arezzo in peace; the event was portrayed in the fresco cycle on the life of St Francis, often attributed to Giotto, in the Upper Church of San Francesco, Assisi (80). Immediately thereafter, Francis had a vision of a golden cross, the arms of which 'circled the whole world'. In remembrance of these events, he founded a convent for friars of his brotherhood in the outskirts of Arezzo. It was this very community that later moved into the city and built the church in which Piero's frescos appear.

Anyone familiar with this story would recognize that Francis's vision of a cross in the sky mirrors the vision that Constantine had on the eve of his victorious battle against the emperor Maxentius. And in fact this parallel was corroborated, indirectly and directly, by the biographers of both men. The fourth-century historian Eusebius first compares Constantine's victory to that of Moses over the Egyptians at the Red Sea, and calls him a 'New Moses' who saved his people

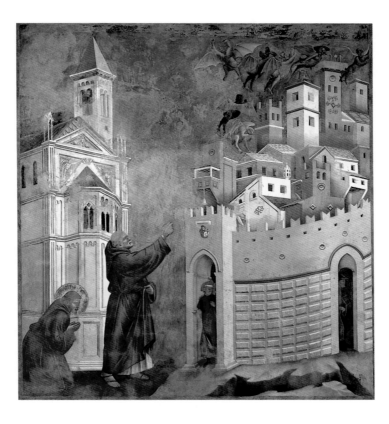

80
Attributed
to Giotto,
*St Francis
Exorcizing
the Devils
from Arezzo,*
c.1290–1300.
Fresco.
Upper Church,
San Francesco,
Assisi

from the pagan pharaoh and led them to the Promised Land of Christianity. St Bonaventura, Francis's biographer, often used the epithet of the 'New Moses' for 'the little poor man', as St Francis was affectionately known, because he led the worshipper to salvation through the promise of the Franciscan order. Bonaventura then goes on to identify St Francis directly with Constantine, saying that Constantine's real victory was the same as that of St Francis: 'God revealed the sign of the cross to two members of Christ's mystical

body: to Emperor Constantine I and to St Francis. As he chose to imprint the sign of victory on Constantine, so he chose to imprint the sign of penance on St Francis' (Sermon 4 on St Francis of Assisi).

Although episodes involving Constantine are fully described in the *Golden Legend*, they rarely appear in earlier Franciscan True Cross cycles. In fact, Piero's is one of the few to include them in more than three hundred years, and the first to do so on a monumental scale. The presence of two Constantinian scenes in Piero's cycle could be explained, therefore, on the basis of the spiritual connection between Francis and Constantine. Besides the fact that it makes the Franciscans' close relationship with Rome clear and explicit, there are certain local factors that contribute as well. Constantine held a prominent place in Aretine history. Founded by the Etruscans and sustained by Rome as a military garrison named Arretium, Arezzo recorded its history in chronicles, every one of which starts with the fact that the city was one of the first communities to convert to Christianity during Constantine's reign. (With the Edict of Milan in 313, Emperor Constantine gave Christians the right to practise their religion openly.) It was, moreover, a matter of civic pride that Arezzo's first bishop, San Donato, was elected directly by Pope Sylvester I, who was in turn elected under Constantine and, according to one tradition, baptized Constantine and made him a Christian. While the city took pride in its classical past, it thus found spiritual satisfaction in its early conversion to the new faith.

These were some of the historical factors Piero confronted when he undertook the planning of the cycle. In order to take them into account, one of his first steps was to make radical changes in the chronological order of the scenes. The narrative sequence (81) does not, as might be expected, read from the left wall to the right and from the top down, but rather starts on the top tier of the right wall and reads 'backwards' from right to left. It shifts direction on the middle tier and then proceeds to jump from wall to wall in what at first seems to be a quite anomalous fashion, ending on the left wall at the top. The cycle's meaning, like that of Piero's *Flagellation*,

has long been under debate. For example, the military scenes have been associated, quite plausibly, with the mid-fifteenth-century Turkish threat and the actual battles fought to counter it, such as the Battle of Belgrade of 1456. Then there are figures that have been identified as real people: because of its resemblance to Pisanello's medal (see 11), the equestrian figure of Constantine has often been identified as the emperor John Palaeologus, and one scholar even claimed that the figure of King Solomon was a likeness of Cardinal Bessarion, a Byzantine prelate who converted to Roman Catholicism and was appointed Protector of the Franciscan order in 1458.

81
Diagram
showing the
disposition
of scenes in
Piero's *Legend
of the True
Cross* fresco
cycle.
(A) *Adam's
Soliloquy
on Death*
(B) *Seth at the
Gates of Paradise*
(C) *Seth Plants
the Sacred Wood*
(D) *Sheba
Venerates
the Wood*
(E) *Meeting of
Solomon and
Sheba*
(F) *Burial of
the Wood*
(G) *Annunciation*
(H) *Vision of
Constantine*
(I) *Victory of
Constantine*
(J) *Raising
of Judas*
(K) *Finding
of the Cross*
(L) *Proofing
of the Cross*
(M) *Battle of
Heraclius*
(N) *Judgement
and Execution
of Khosrow*
(O) *Exaltation
of the Cross*

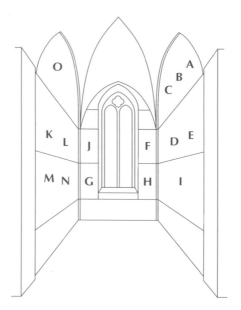

Historians have used the frescos to illustrate their research, until for some the cycle assumed a topical structure, almost like a news report – an approach without historical precedent in the fifteenth century. Without disregarding the historical context, one of the aims of the discussion that follows is to view the project in light of the great tradition of ecclesiastical mural decoration, used since Early Christian times to broadcast the teachings of the Church in visual form. The interpretation presented here, namely the importance of the Franciscan–Roman–Aretine connection, refocuses attention on the fresco cycle itself as the primary document of its own message.

The story of the True Cross is a complex compilation of legend and history that traces the wood of Christ's cross from its origins in the time of Genesis through to 628 AD, when the relic was stolen by a Persian king and then retrieved by the Byzantine emperor. Jacobus de Voragine's version includes all the variations he could find for each incident, listed with their sources in true scholarly fashion. For the most part, Piero followed the text quite closely, often even encapsulating the multiple accounts that Voragine compiled. He also added new themes and reshaped the old to conform to the Franciscan agenda.

He divided the walls of the Cappella Maggiore, which measure approximately 13·7 m (45 ft) in height, into three superimposed tiers separated by the painted cornices of heavy architectural mouldings. The top tiers on both sides are pointed lunettes to fit into the arches of the vaulting; the other tiers are rectangular. On several tiers there is more than one episode arranged against a single background in what is called 'continuous narrative', that is, not separated by vertical frames. Piero made no perspective adjustments to allow for the height of individual tiers. No matter how high or low, each composition is seen as if at eyelevel, with the spectator expected to imagine themselves standing in space with their feet at the level of the painted ground. Using backgrounds of rolling hills or sky, Piero opened up the walls but then locked the figures on to shallow frontal planes, balancing cool blues that recede with warm reds that thrust forward. With a solemnity that can be compared with classical high-relief friezes (82), he thus formed a densely populated design that gives the cycle the sense of measured classicism.

The narrative begins on the right wall on the top tier, reading from the viewer's right to left (83). It is likely, but not necessarily the case, that Piero started painting here. He sets the tone of the cycle by beginning with a scene of his own invention, unique in the history of art. Distantly related to apocryphal stories of Adam and Eve that expand on the Book of Genesis, it shows the ancient patriarch seated on the ground, gesticulating with his right hand

(84). In his decrepit state, he is supported by his equally old and
flaccid-breasted wife Eve who herself leans on a stick. Speaking to
three of his offspring, Adam now reveals to them for the first time
the consequence of their parents' 'Original Sin', namely death.
As the concept is new to them, they listen in thoughtful silence.
The dying Adam continues his soliloquy explaining that life ending
in death makes salvation necessary. Since the cross, the subject of
the cycle, is the instrument of salvation, Piero's innovation gives
the story a logical starting point, something that was missing from
all earlier painted versions.

The sons of Adam represent three stages of early mankind: one is
nude, one dressed in animal skins, and the older man – probably
Seth, the oldest surviving son – is swathed in a woven drape. The
nude boy appropriately takes the pose of the *pothos*, a type of
mourning figure used in classical sculpture. Piero has suggested
his pulsing musculature with a single fluid line incised in the
plaster, much in the manner of Roman Aretine red-ware pottery.
Indeed, an ancient kiln containing many intact vases was unearthed
in Arezzo during Piero's lifetime and could have provided him
with inspiration.

83–4
Story of Adam.
Fresco.
Apse, San
Francesco,
Arezzo
Right
Detail

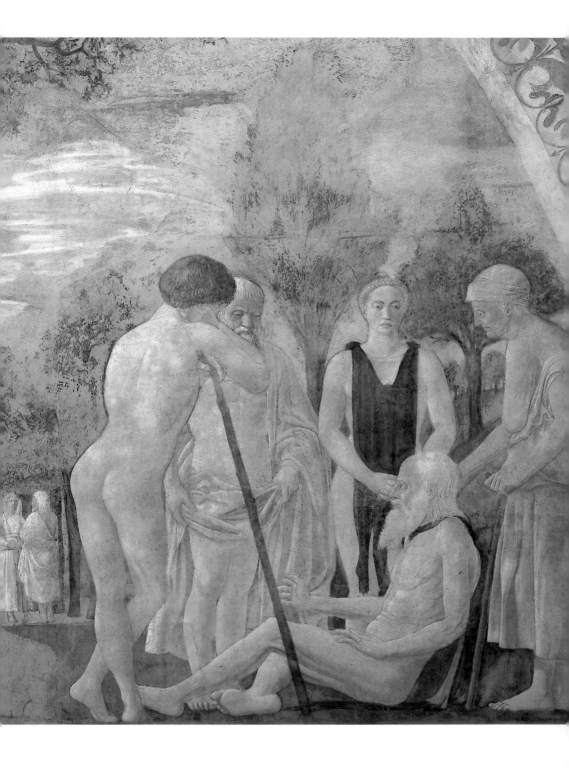

Moving from right to left and following the technique he used in his *Baptism* (see 54), Piero places the next scene in the background. He has made a spatial breach and change of scale to represent a different location and a different time. When Seth hears of his father's impending death, he travels to the Gates of Paradise to implore the archangel Michael to save Adam with the 'oil of mercy' (forgiveness). Even at this small scale, the angel's stern glance can be seen to express his refusal. Instead Michael offers Seth a branch of sacred wood and tells him to plant it over the dead Adam, prophesying mysteriously that from this branch the source of salvation will spring.

By the time Seth returns Adam's funeral is in progress. Again moving to the left, in an area that has sustained a great deal of damage, Seth kneels over his father to plant the branch of sacred wood. A number of Adam's thirty sons and thirty daughters crowd around in various poses of disbelief and sorrow. In spite of the action of the scene, it is the vast tree that rises and fills the upper part of the lunette that is (or was, before its devastating loss of paint) the focus of attention. What remains of it today looks black and bare, but originally it was covered with coloured leaves and shoots painted in tempera, now lost. According to legend, when Adam and Eve sinned under the Tree of the Knowledge of Good and Evil, it blackened and withered away to nothing. But when the archangel Michael promised man's future salvation, it revived. In its original splendour, Piero's tree represented a forecast of triumph over Adam's melancholy death. He made it a symbol of one of the most paradoxical concepts in Christian thought: that of the *felix culpa* – the 'fortunate fall' or 'happy sin'. Without the 'happy sin' of Adam and Eve, the coming of the Saviour would never have taken place.

At the left end of the lunette, Piero began to experiment with a technique that at this moment some of his contemporary artists also found intriguing. He began to exploit the spatial implications of walls at right angles to each other, that is, he started using corners as expressive agents; a good example of this approach can be found

in the first tier of Fra Filippo Lippi's Prato frescos, where the Baptist's head is handed around the corner (85). At the far left end of Piero's lunette two youthful figures face each other (87). The one with dark hair and wearing animal skins points to the action of the funeral. His shadowed, turning profile still bears the marks of pouncing (holes in the cartoon through which charcoal dust is forced) along the eye and cheek. His equally well-preserved companion, an androgynous blond girl with half-bare chest and face glowing with rosy light, by contrast, is the only figure in the lunette who looks away from the centre. In fact, this young person stares fixedly out across the corner of the chapel. When we follow her gaze, we find that she is looking at a prophet who holds a scroll, standing around the corner on the top tier of the altar wall. And the prophet, probably Jeremiah, returns her glance (86). According to church doctrine, Christian destiny was foretold by the Old

85
Fra Filippo Lippi,
Beheading of St John the Baptist,
1452–66.
Fresco.
Pieve di Santo Stefano, Prato

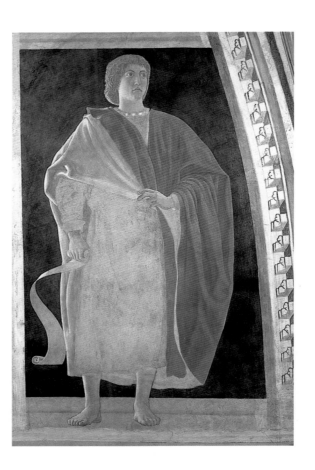

86
*Prophet
Jeremiah* (?).
Fresco.
Apse, San
Francesco,
Arezzo

87
Two children
of Adam, detail
from the *Story
of Adam* (83)

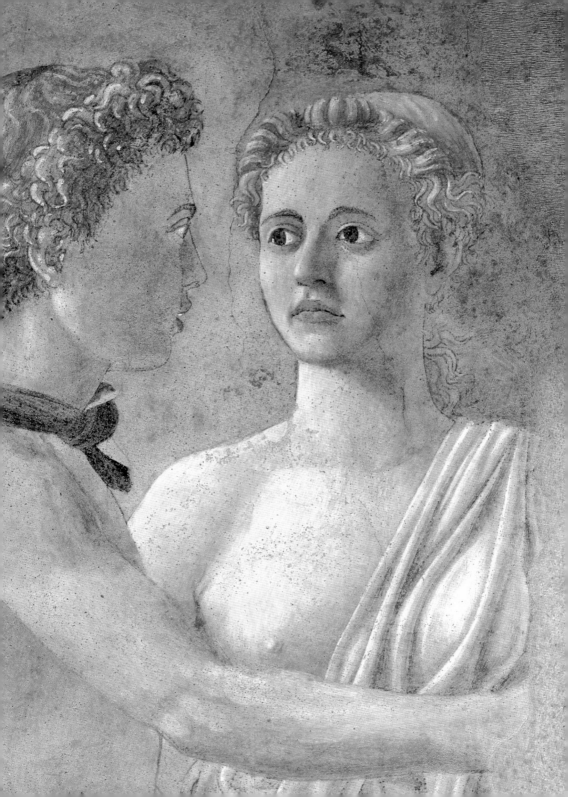

Testament prophets, and in the painted exchange this youthful figure is already hearing the prophet's voice: 'Behold, the days come, saith the Lord, that I will raise unto David a righteous branch, and a king shall reign and prosper' (Jeremiah 23:5–6). The look on the face of Adam's child shows that she understands the portentous message.

The written version of the legend moves forwards in time to the period of King Solomon, who, when he saw the beauty of the tree that grew over Adam's grave, wanted it cut for use in the building of his great palace. His desire could not be fulfilled, however, because the planks magically kept changing size. Thoroughly frustrated, Solomon had the wood thrown across a stream to serve as a bridge. Soon the Queen of Sheba came on her famous visit to 'try the wisdom of Solomon with hard questions' (1 Kings 10), and when she saw the bridge she recognized it as holy wood, its future having been foretold to her in a vision. With this secret knowledge, she warned ominously that 'one greater [than Solomon] will hang from this wood', and bring Israel down. The frightened king had the wood sunk in a deep pool, where later the water performed healing miracles. In earlier fresco cycles of the cross, as in one by Agnolo Gaddi (active 1369–96) in Santa Croce, Florence, this sequence is shown in three scenes, all of which imply that Solomon is a fool.

Piero omits this part of the story and represents only Sheba's recognition of the wood and her meeting with Solomon. He now reverses the direction of the narrative and has it progress from left to right. While the first scene of this sequence initially resembles older versions, it soon becomes apparent that he has changed the connotations dramatically (88). After journeying through distant hills and a broad valley, Sheba and her entourage have come to a stop. Recognizing the holy wood in a squared-off log, the queen kneels in veneration. Her tall, handsomely dressed ladies-in-waiting share her wonder, gracefully gesturing towards the beam; her grooms and servants are quietly attentive. Piero's image focuses on the implications of a woman from southern

Arabia, powerful, rich and known for her occult powers, doing obeisance to the wood of the cross; his depiction of her longing for conversion and belief is moving and persuasive. In this atmosphere of religious ritual we encounter the almost geometric perfection of Piero's forms. The heads are ovoids, the necks are cylinders, and the wood itself is not a rough-hewn log but a consciously crafted rectangular shape. One senses Piero's burgeoning interest in mathematics, and following the theories of the classical philosopher Plato (particularly those in the *Timaeus*), his forms are reduced to universal 'regular bodies', thus bringing them to a level of abstraction so admired in his work today.

The narrative moves right across a painted colonnade that divides the episodes without isolating them, and the novelty of Piero's interpretation continues. The scene of the *Meeting of Solomon and Sheba* is unique in cycles of the True Cross, and its introduction here must have been deliberate. There are two possible meanings for such a meeting scene, both stemming from tradition. The first is based on Christ's own words: 'For she [the Queen of the South] came from the uttermost parts of the earth to hear the wisdom of Solomon' (Matthew 12:42). This passage was elaborated by St Ambrose, who explained that the great King Solomon, having been appointed by God, was a prototype for Christ; Sheba symbolized the Church; and their meeting stood for the marriage of Christ and the Church. As the monarchs greet each other, Piero again uses the handclasp to convey this meaning (89). The magnificence and stateliness of the occasion are also expressed visually. The monumental Corinthian portico, developed from the one in the *Flagellation* (see 62), is now flush with the picture plane, and the rooms are aggrandized to 'Solomonic' proportions: the heavy marble ceilings and impossibly long stone lintels could not actually have been built. To ensure narrative continuity, Piero reused cartoons from the left part of the tier, reversing them so that the same cast of characters is repeated with only minor variations. The recent cleaning has revealed Sheba's gown to have been a regal red damask patterned with gold.

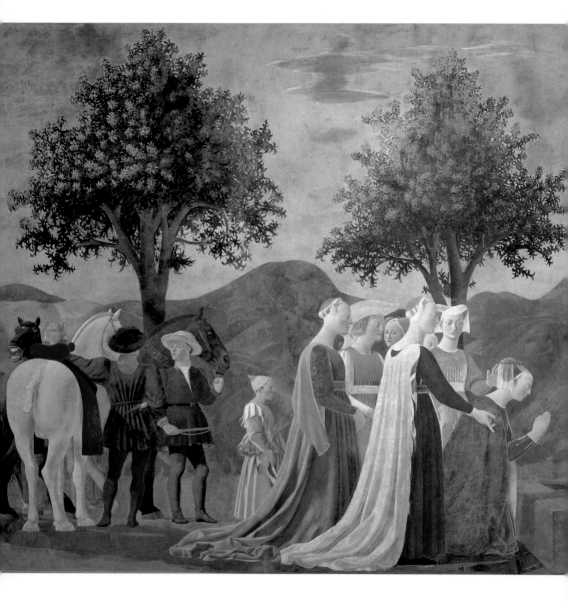

88
Sheba
Venerates
the Wood (left);
Meeting of
Solomon and
Sheba (right).
Fresco.
Apse, San
Francesco,
Arezzo

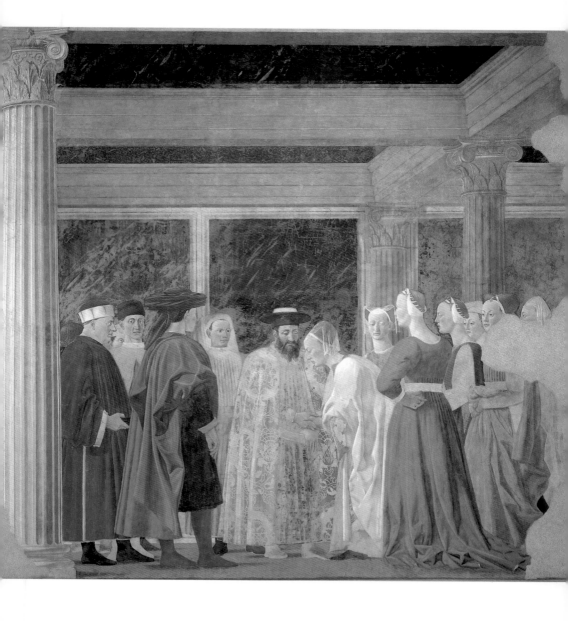

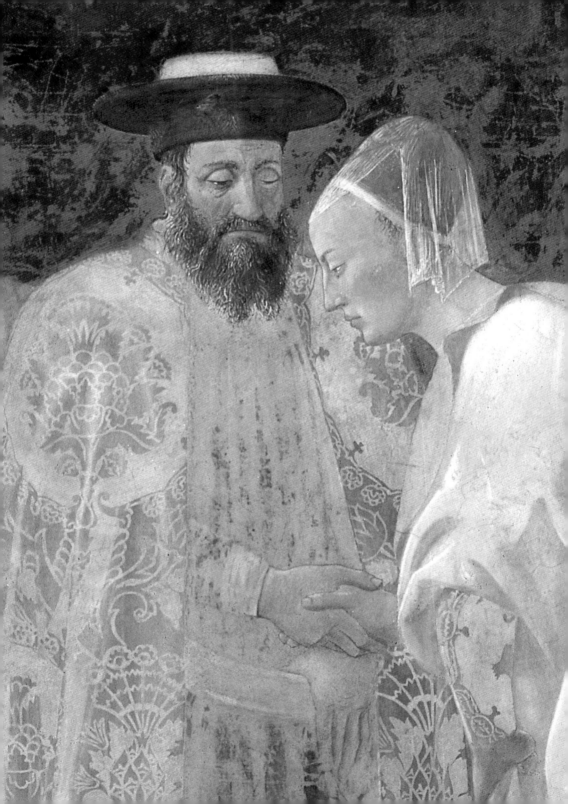

The second traditional meaning for such a scene, however, is perhaps even more important. Sheba, the 'Queen of the South', was identified during the Middle Ages with the Magi, the Gentile (*ie* non-Christian, non-Jewish) kings who recognized the infant Jesus's divinity and knelt to worship him. Here, Sheba bends forward and lowers herself before Solomon, recognizing his superior wisdom and acknowledging his appointment by God (1 Kings 10:8–9). In the context of a Franciscan cycle, she takes on the role of the contemporary eastern Gentiles, the Muslims (called 'pagans' at that time) who, if the pope and the Franciscans had their way, would recognize the wood of the cross and bow in submission to the superiority of Christianity. Sheba's maidens again watch in heavy silence, awed by the encounter. The great dignity of Piero's portrayal conveys the seriousness of this theological propaganda.

From the right wall the chronology moves back to the altar wall (right side, middle tier), as physically distant as possible from the noble Solomonic scene. There Piero follows the fortunes of the discarded plank of wood (and the duping of Solomon), and treats them in a new, almost comic, manner. Three thick-set labourers struggle together to up-end a knotty plank of wood into a pool (90). The work is hard and each one strains in his own way: the first has removed his red coat and hat and thrown them on the ground. He has slipped one arm out of his jacket and loosened his leg coverings which are falling down. As his shirt parts, his genitals are shamelessly exposed. The second, who wears a cap and short smock and bares his chest, uses a strut to hoist his load, biting his lip with the effort. A wreath of leaves and berries circles the head of the third man as he pushes forward and down with his bare hands. The wreath is an allusion to bacchanalian revelries and suggests pagan drunkenness. Indeed this man's buttocks back up to the corner, on the other side of which the dark horse in the Sheba scene whinnies in derision (the two characters interact across a divide, as in the tier above). The men are in the process of burying the uncooperative wood in a pool (from where it will later rise up and be used to fashion the cross, an episode Piero omitted). It slants diagonally from upper right to lower left,

directing the eye to the *Annunciation* (91), the next episode in the chronology.

The Annunciation is the moment in the story of Christ's life when the archangel Gabriel announced to Mary that she had been chosen to bear the son of God. The subject is very frequently represented in Italian art of the early Renaissance, always involving an angel who speaks to Mary and often showing parts of Mary's house, including her bedroom. But although the Old and New Testament sections of the story are implicitly connected by the life of Christ, no other cycle of the cross includes an Annunciation. I suggest that, in Piero's case, a Marian subject formed part of the commission from the beginning for the following reason. In 1290 Pope Nicholas IV, the first Franciscan pope, recognized his brothers in Arezzo by conceding an indulgence (*ie* a pardon releasing sinners in purgatory from the punishments set down by the Church for their misdeeds) of forty days to worshippers who came to the church of San Francesco on the Feast of the Annunciation (25 March), a concession that was renewed in 1298. The choice of the Annunciation as a subject surely relates to this locally important tradition. If this is so, Piero has again fulfilled his assignment in a characteristic manner, drawing out the inner relevance of a scene required by his patrons to the subject of the cycle as a whole.

Although Mary's house (the *Santa Casa*, the relic of which is enshrined in the pilgrimage church in Loreto) was a simple wooden structure, Piero represents it as a monumental building in the same elegant classical style as Solomon's palace, with marble portico and walls encrusted with veneers of precious stone. With this elevation of status, Piero characterizes Mary not as a frightened adolescent but once again as Maria Ecclesia, a symbol powerful enough to stand for the forty days' indulgence that she represents (92). He divides the scene into four sections, each of which contributes to a larger meaning. At the upper left, God the Father initiates the process by sending forth the divine spark from his hands; originally there were golden rays, now lost, to carry this emission. His gesture corresponds with the arrival of the archangel Gabriel who raises his

hand in blessing as he alights in the forecourt of the house. The blessing right hand and the palm frond he carries in his left align with the central beam of an intricately carved doorway, a clear reference to the prophecy of Ezekiel (44:1–3; perhaps the unnamed prophet in the top tier above), who said that the Messiah would arrive through the 'closed Eastern door' – an epithet that refers to Mary's eternal virginity. Unlike the lily the angel often brings (a symbol of Mary's purity), the palm frond he carries here announces Mary's glorious death: it represents the key to paradise, lost when Eve first sinned but regained when Mary died. It was often said that when Gabriel uttered his greeting 'Ave' it unlocked the sin of 'Eva', being the same letters but in reverse. Thus, even as he represents the beginning of Mary's mission, Piero defines her destiny as Maria Ecclesia, who in her immortality represents the promise of survival to all those who believe.

Mary's monumental stature is much too large for the portico, reaching almost to the top of the nearby snow-white column. In this way, her new pregnancy is juxtaposed with the 'swelling' of the column (for which the architectural term is *entasis*), reinforcing the notion that she is a pillar of the Church. Piero also refers to other teachings of the Church Fathers, such as those that say that the moment of her conception was also the moment of her theological 'marriage' to Christ. On this account he has prepared a view into her bedroom, where he shows the bower-like ceiling, an elaborate diaper-patterned wall and a fragment of her platform bed. This is the bridal chamber for the bride and bridegroom of the Old Testament Song of Songs, with whom the Virgin and her Son had long been identified.

The final section of the composition shows an arched window with a half-open shutter on the second floor of Mary's house. A wooden tapestry-bar crosses the window and has a loop used for tying material at one side. Not only is the barred window yet another reference to the virgin birth (Jeremiah 10:21), but the shadow of the bar seems to pass directly through the tying-loop, mimicking the miraculous entrance of the Holy Spirit into Mary's womb. With

91
Annunciation.
Fresco.
Apse, San
Francesco,
Arezzo

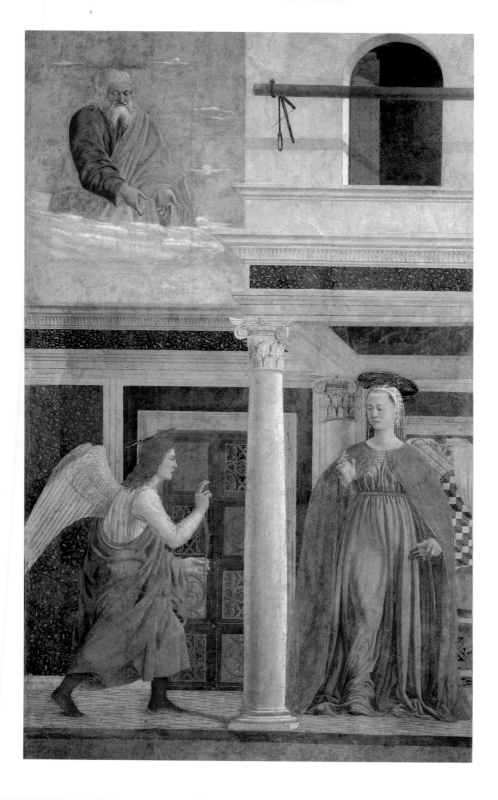

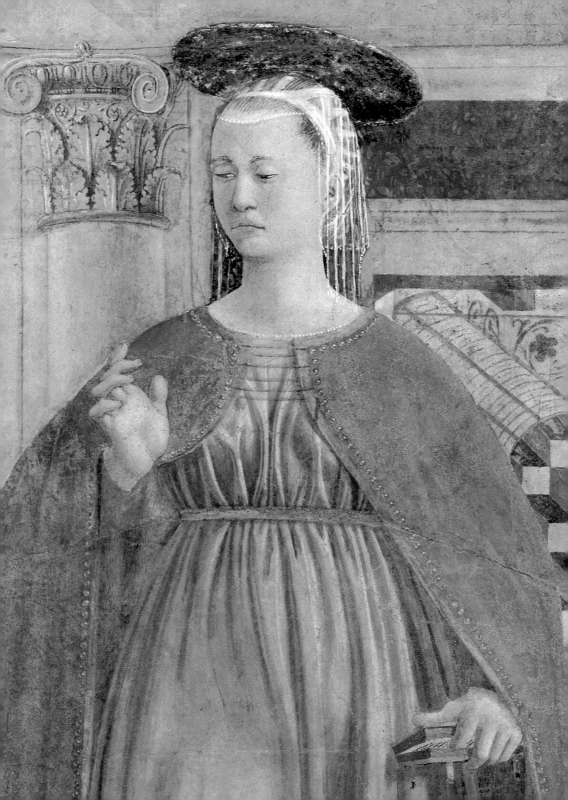

these multiple references to the beginning of Christ's life on earth, Piero interprets the Annunciation as the link between the two halves of the story of the True Cross.

Following the compositional rightward thrust of the *Annunciation,* the next scene in the chronology is the *Vision of Constantine* (93). Three different versions of this miracle are offered in the *Golden Legend*: in one an angel appears the night before battle and urges Constantine to look heavenward, where he sees a flaming cross that bears the legend *In hoc signo vinces* ('in this sign you will conquer') in gold. In another he sees the flaming cross in a dream with an angel standing nearby telling him that he will win under this sign. And in the third, Christ appears and tells him to have a standard made bearing a cross to help in battle. Piero includes elements from all the descriptions, without directly illustrating any. He shows a military camp under a star-filled sky with the light of dawn just beginning to show (this was revealed in the 1990s restoration). Constantine lies in bed in a tent, asleep and dreaming. There is an angel, a mystical light and a cross. There is no inscription, and the cross Piero represents, although originally painted in gold, is tiny. In fact, it is almost hidden behind the angel's hand as he plunges upside-down into the scene. Emphasizing not the object but its power, Piero thereby defines the light illuminating the episode as the element that drives the miracle. One of the first scenes of the Renaissance to be set under a darkened sky, this luminous image would remain unmatched in painting until the seventeenth century.

Once again, Piero gave this traditional subject new meaning. Two armoured soldiers guard the sleeping Constantine. The one on the left holding a spear turns his back as if to keep the figures inside the tent from leaving; the other, raising his mace, faces out as if to prevent others from getting in. Standing on either side of the tent, their bodies hide the fastenings and make the flaps seem miraculously suspended. The view of the sleeping Constantine is thus presented as a revelation. In his prone position at right angles to the tent pole he resembles nothing so much as the figure of Adam, who from medieval times was often shown at the foot of

the cross in representations of the Crucifixion (94). He alludes to
the original sinner who was replaced by Christ, the 'New Adam'.
The emperor's body-servant who sits on the edge of his bed takes
the traditional pose of a mourner, resting his head on his hand. His
pose makes the message clear: we are witnessing a death – that of
the age of paganism on the eve of Christian victory, not just over
worldly enemies but over death itself.

The scene that follows around the corner on the right wall shows
the Victory of Constantine (95) in the battle with his competitor,

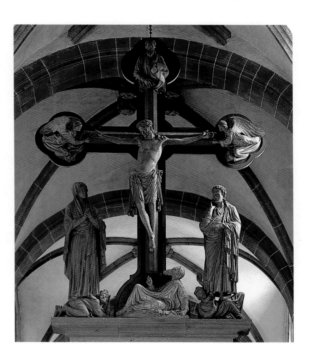

93
*Vision of
Constantine.*
Fresco.
Apse, San
Francesco,
Arezzo

94
Triumphal
cross,
c.1235.
Painted wood.
Wechselburg
Schlosskirche

Maxentius, for the office of emperor. There is no artificial framing
at the corner, and portions of soldiers and horses seem to emerge
from somewhere behind the altar wall. A captain on a rearing horse
and a bare-headed trumpeter signal the charge. The impression of
great numbers of soldiers is created by the many lances that project
beyond the top edge of the fresco. Battle dress includes classical
armour – moulded leather cuirasses, skirts and leg-guards – along
with other more contemporary types in laminated steel, bearing
butterfly knee-hinges in the latest Milanese fashion. All the

95
*Victory of
Constantine.*
Fresco.
Apse, San
Francesco,
Arezzo

96
**Johann Anton
Ramboux**,
Copy after
Piero's
*Victory of
Constantine*,
c.1820.
Watercolour;
33·5 × 61·3 cm,
13$^1_4$ × 24$^1_8$ in.
Graphische
Sammlung,
Kunstmuseum
Düsseldorf

cavalrymen ride with stirrups, a convenience fourth-century Romans did not have. As the army moves towards the right, the crowded, expectant atmosphere calms to that of an organized march, coming to a halt at the edge of a river. Under the banner of an imperial eagle, Constantine holds up his talisman and causes his foes to flee across the river to the right. Piero dramatizes the moment in an extraordinary way. He does not put the conquering Constantine in the foreground, but rather places him in the second range. The dark horse of an amoured knight overlays Constantine's white steed, forcing it into high relief. The shaft of the knight's great long spear cuts across the emperor's head, emphasizing the virile profile and creating sharp angles in tension with his razor-sharp visor.

Constantine's headgear and profile have confounded art historians for almost a century because of their resemblance to those of Emperor John VIII Palaeologus, as recorded twenty years earlier on Pisanello's bronze medal (see 11; Piero shows a pink hat with a green visor, whereas the emperor's real hat was described as snow-white with a huge ruby at the top). Although Palaeologus had returned to Constantinople after the Florentine Council of 1439 with a document of union, he had failed to gain ratification from his own Church patriarchs. He then lost the power to administer his country and spent the rest of his life in a state of depressed torpor. It seems unlikely that two decades later this despondent person could have been the model for a great hero. More probably both the medal and Piero's depiction depend on a type frequently used to represent imperial dignity or ideal masculinity. An earlier example can be seen in the profile head of a military guard on the left of a fresco by Spinello Aretino (c.1350–1410) in the sacristy of San Miniato in Florence (97), where the angular hat and sharply pointed dark beard create the same sense of tension. In Constantine's case, the hat assumes a higher measure of dignity from the crown which encircles it and already designates him as emperor. For the first time in history, the victory of Constantine is represented not as a battle but as a miracle.

97
Spinello
Aretino,
*St Benedict
Receiving
Totila*,
c.1387–8.
Fresco.
Sacristy,
San Miniato,
Florence

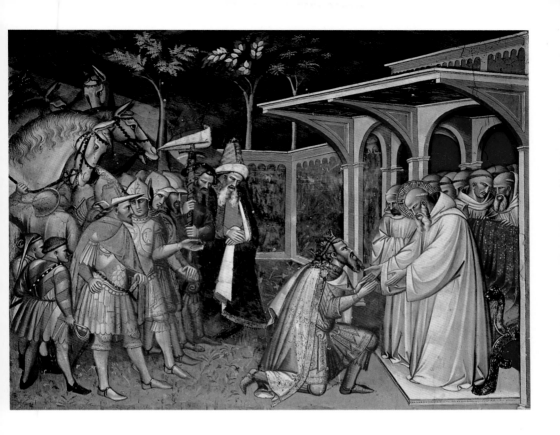

Much of the right side of this tier is unreadable owing to losses from damp and inept cleaning in the nineteenth century. Watercolour copies made by a German student named Johann Anton Ramboux (1790–1866), who was unaware of the author of the frescos, record the compositions as they appeared in the early nineteenth century (96). In this scene, they show that the enemy general, who rides on the right bank under a flag emblazoned with a venomous basilisk (a mythical creature that could kill with its eyes), wears the same peaked hat as Constantine, but with the red and green colours reversed. One of his cavalrymen is still stumbling up the river bank, accompanied by a naked horseman riding bareback on a mangy horse, a barbarian type perhaps meant to be a Hun. The enemy army also carries a flag emblazoned with the head of a Moor (here a black African Muslim, representing the legions of unbelievers) to which a soldier looks up in vain for help.

One version of the story in the *Golden Legend* locates Constantine's battle for leadership of the Roman Empire at the Milvian Bridge (still extant over the River Tiber in the northwest corner of Rome); another says he was at the River Danube fighting barbarians. In the first version, he wins over Maxentius, a fellow Roman, in a bloodless battle based on trickery (Maxentius falls into his own trap in the form of a faulty pontoon bridge). In the other, he defeats the barbarian hordes by 'rushing upon the enemy and putting them to flight, killing a great many'. The warrior in the water seems to allude to the river trick; the barbarian horseman to the battle on the Danube. But Piero represents neither of the legendary events, nor, as has been claimed, modern history. There is no voice from the sky, no bridge of boats, no Roman monuments, no rugged shores of Serbia, no fortress of Belgrade. On the contrary, the scene takes place in a tranquil Tuscan landscape, with sturdy peasant houses on the banks of the river, and ducks floating peacefully on its placid surface.

The cleaning of the 1990s revealed new miniature details of this peaceable world: shimmering reflections in the water, water lines along the banks (similar to the ones in the *Baptism*; see 54), and painted in the distance with a few quick flicks of the brush, two tiny donkeys carrying their loads with a boy running towards them. Thus with an almost patriotic air, Piero transports the crucial victory close to home, to the River Tiber, not at Rome but at its source in the Alta Valle Tiberina near Arezzo. In this impressive image, the allusion to Constantine as the 'New Moses' would have had a special resonance for the Aretine congregation of this Franciscan church.

Soon after Constantine's victory, his mother, St Helena, went to the Holy Land to search for Christ's cross. Her first discovery was that only one man, ironically named Judas, knew its whereabouts. Because Judas refused to tell his secret he was thrown into a dry well. After seven days of torture, he recanted and was pulled from his subterranean prison. This is the scene that is represented back on the middle tier of the altar wall to the left of the window (98). This composition complements the *Burial of the Wood* on the right side of the window (see 90). Instead of a lowering action, this is one of

raising: a body is hoisted up with the aid of a single fixed pulley. Although represented in a scientifically correct manner, the appearance of this lowly construction tool signals again the comic mode. In this case, however, Piero even alludes to the source of the comedy – surprisingly enough, the vernacular writings of Boccaccio!

The hilarious story of 'Andreuccio da Perugia' in Boccaccio's famed story cycle the *Decameron* (1348–53) begins after the 'hero' falls into a dunghill and is looking for a place to wash. Two tomb robbers guide him to a well where there were usually a rope, a pulley and a great bucket. Finding the bucket gone, the thieves tie Andreuccio with the rope and let him down to the water. Guards of the watch come for a drink and pull on the rope expecting the bucket. Instead, much to their consternation, they find Andreuccio (99). The image of foppish dandies pulling on a rope attached to a young man in Piero's version seems intentionally to recall this low-brow comic situation. The painting style of the scenes on both sides of the window is much rougher than in the rest of the cycle and is therefore often attributed to Piero's assistant Giovanni da Piemonte (*c.*1436–after 1487). The point of this change of hand was probably to suggest the comic element through the manner of painting, which is close to but cruder than Piero's.

The two altar wall scenes are similar on another level because in both cases, beside the comic, a more serious note is struck. The motif of wood-on-shoulder in the *Burial of the Wood* scene recalls the theme of Christ carrying the cross. In the case of the *Raising of Judas* scene, Judas's release has been likened to Christ's Resurrection, but in reality the reference is more complex. The official-looking man on the right grasps Judas by the locks to haul him up. This manner of extrication refers to the means by which the prophet Habakkuk was carried by an angel to 'a place he did not wish to go', as shown in a fifth-century carving on the doors of Santa Sabina, Rome (100). (He did not understand he was called upon to feed and thereby save Daniel in the lions' den.) Like Habakkuk (another prototype of Christ), Judas at this moment does not yet understand that he is being taken by force for a higher good.

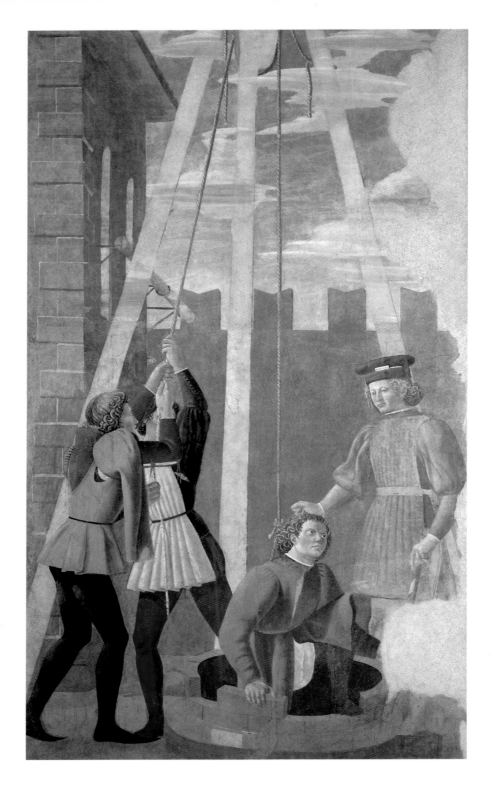

98
*Raising
of Judas.*
Fresco.
Apse, San
Francesco,
Arezzo

99
*The Story of
Andreuccio,*
woodcut from
Boccaccio's
Decameron,
Book 2, 1492.
Fondazione
Giorgio Cini,
Venice

100
Habakkuk
carried by
an angel,
*c.*432.
Wooden panel
from the doors
of Santa Sabina,
Rome

Unlike his evil namesake, who ended his life in suicide, the new Judas, in complying, will be greatly honoured as St Helena's confidant and later as a Church official.

They appear together in the next two episodes which are placed on the middle tier of the left wall. Like those involving Sheba, these scenes are arranged in continuous narrative, one taking place before a landscape and the other with an architectural setting (102). They represent the liturgical feast formerly celebrated on 3 May: the Invention or Finding of the Cross, and the Proofing of the Cross to distinguish it from those of the two thieves. While following traditional representations of the two episodes quite closely, Piero made a number of innovations. On the left, Helena and her entourage (including an elegantly dressed dwarf and the figure of Judas, who issues directions) gesture towards the workmen who have already discovered one cross and are about to bring up a second from a pit where a worker is half submerged. The mood of the scene is one of intense concentration as all the figures, standing in a rough semicircle, focus on the action, their shared emotion cutting across differences of social status and ethnic origin.

101
Helena's entourage, detail from the *Proofing of the Cross* (102)

The top of the newly found cross overlies a remarkable cityscape that rises behind a saddle in the hills; in the cleaning of the 1980s and 1990s the hills were discovered to have been painted with oil. The town is clearly recognizable as Arezzo with its girdle of crenellated walls, church towers and tiled roofs. Notwithstanding its realism, the view can also be seen as a series of beige, red and black cubes and triangles that draw the back and foreground together and graphically express the transfer of the cross's sacred efficacy from the holy site in Jerusalem to an actual place in Tuscany. These pictorial values are among those that make Piero so attractive to the modem viewer, but they surely also inspired awe in the fifteenth-century citizen and identified the town with a higher perfection, an ideal city where divine miracles could take place.

On the right side of this tier, Helena, her women (101), a bearded man and nude youth venerate a cross held by a workman. Three men, presumably passers-by, observe on the right. They wear the

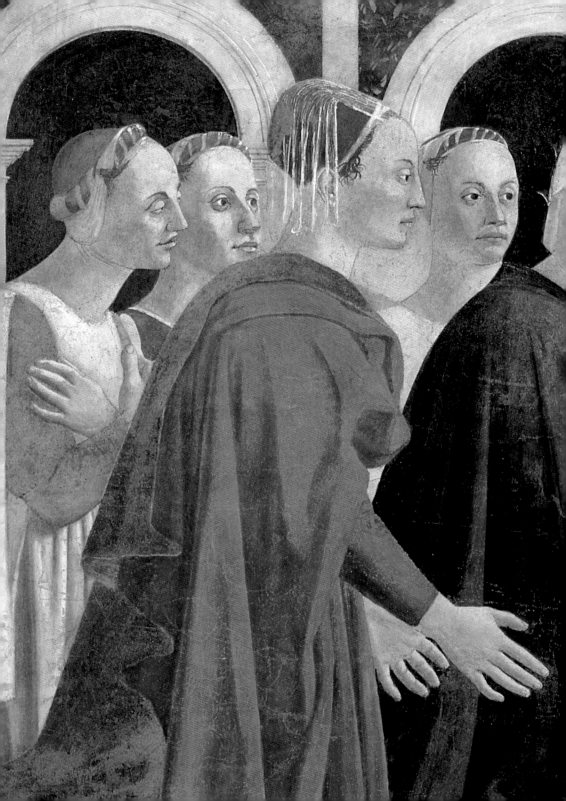

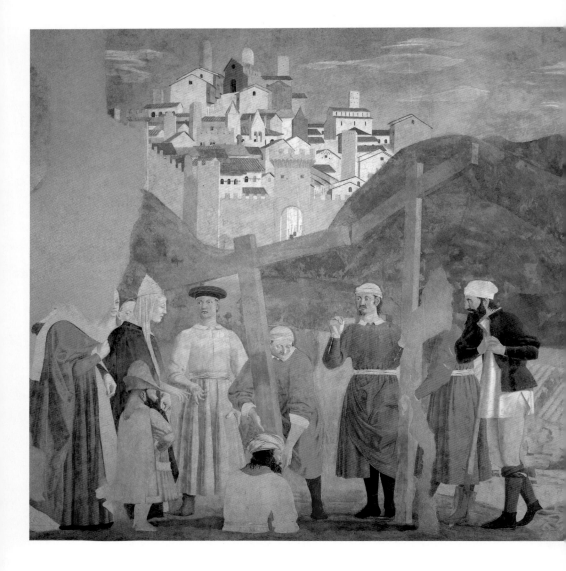

102
*Finding of
the Cross* (left);
*Proofing of the
Cross* (right).
Fresco.
Apse, San
Francesco,
Arezzo

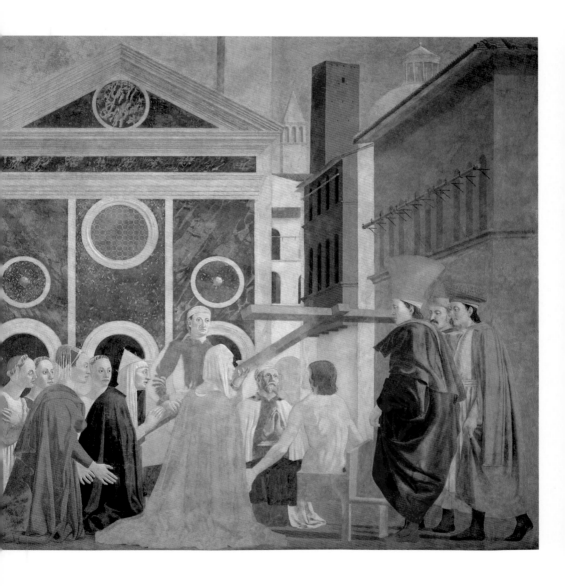

type of costumes Piero often used, and the distinctive exotic hats worn over white turbans: one high, flaring and shaped like a stovepipe, another stiff and conical with contrasting brow-band, and the third mushroom-shaped and made out of fur. As in the *Baptism* and the *Flagellation* (see 54 and 62), Piero draws on the repertory of contemporary Byzantium to underline the scene's Near-Eastern locale.

Piero shows the moment immediately after Christ's cross is identified. Helena had all three crosses placed on the body of a young man being taken on a litter to his burial, and when the 'true' cross touched his flesh, he arose and gave thanks. It is the sight of this miracle that brings the women to their knees. The story in the *Golden Legend* says that at this moment the devil was vanquished and he ran off screaming in a loud voice. Once more, the worshippers in this church would have been encouraged to identify the finding of the cross (often called the 'devil's trap') with the civic cleansing of Arezzo by St Francis, when the devils fled the city 'screaming and crying out'.

There is still a further level of meaning in this episode, one that relates Helena to the Virgin Mary in the neighbouring *Annunciation* scene around the corner on the first tier of the altar wall. St Ambrose, a figure of whom is painted on the underside of the entrance arch, wrote that as 'Mary (who trapped the devil with her virginity) was visited to liberate Eve ... [so] Helena was visited that emperors might be redeemed'. Ambrose, the earliest of the Fathers of the Church, and the first author to report on the life of St Helena, then quotes her as saying: 'As the holy one bore the Lord, I shall search for his cross ... she showed God to be seen among men; I shall raise from the ruins the standard as a remedy for our sins.'

In the *Golden Legend*'s description of Helena's exploits, it is said that she found the crosses near a temple to Venus, which she had destroyed and then replaced with a new basilica. Piero makes reference to these details with an urban setting the likes of which had not been seen before in paint. The three-part church façade,

decorated with roundels, coloured marble veneer and pedimental roof, combines Early Christian elements with new features from the Renaissance. Moreover, the narrow, receding Jerusalem street, of which he gives a partial view, is lined with contemporary Italian palaces. What is perhaps equally striking and historically provocative is the ghostly white dome with lantern, a part of which is visible above the houses. The form is neither that of the Pantheon (the most famous dome in the ancient world, but which has no lantern), nor the cathedral of Florence (the only modern dome complete in Piero's time, but which is not semicircular in outline; see 8). It could possibly refer anachronistically to the church of the Holy Sepulchre in Jerusalem, one of Helena's foundations. That structure had a semicircular shaped dome and a lantern, and was known in the west from charms and models brought back by pilgrims from the Holy Land. The fact remains that there was nothing of this sort yet built in fifteenth-century Italy, and fifty years or so later the architect Donato Bramante (1444–1514) would use the design in his project for the new basilica of St Peter's in Rome.

For three hundred years after its finding by St Helena the cross remained in Jerusalem undisturbed. Then, in the summer of 628 AD, in an attempt to steal its powers, it was carried off by Khosrow II, king of the Sassanian Persians. The Byzantine emperor Heraclius came from Constantinople to rescue the relic, and a battle ensued. This historical event is one of the few such cases fully described in the liturgy of the Western Church. The account is read on the Feast of the Exaltation of the Cross (14 September), the day on which Heraclius restored the cross to Jerusalem. By pairing this battle with Constantine's on the opposite wall, Piero portrays both as justified 'holy wars', of the kind that was currently needed.

While giving the battles parallel significance, he contrasted their form, changing the traditional iconography of the later combat in several ways. He made the *Battle of Heraclius* into a mass conflict as it had never been before (103). More usual were depictions of two knights clashing on a bridge such as Agnolo Gaddi's version

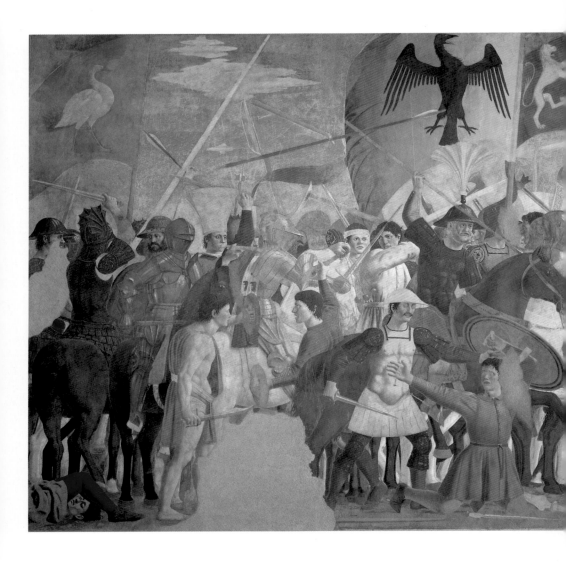

103
*Battle of
Heraclius;
Judgement
and Execution
of Khosrow*
(far right).
Fresco.
Apse, San
Francesco,
Arezzo

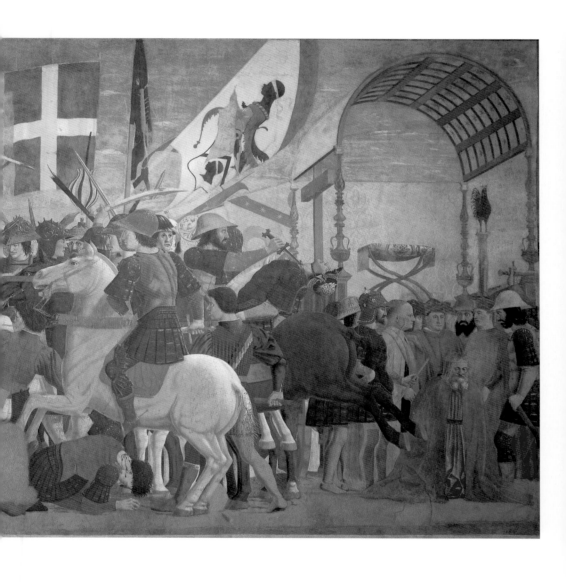

in Santa Croce, Florence (104; the legend speaks of single combat between the leaders' sons). Piero packs most of the tier with a noisy mêlée that mixes officers, cavalry, infantry, mercenaries and slaves, all fighting for their lives. Their battle-protection is again a temporal mix, including moulded leather body-armour in the ancient Roman style, contemporary harnesses of laminated steel, helmets in both Italian and German shapes, and civilian clothes of a variety of types. The weapons include everything used in hand-to-hand fighting throughout the Middle Ages, such as spears, lances, swords, daggers

and hatchets, often flying through the air. Many of the fallen show their wounds and bleed profusely. Piero again uses his shorthand of heads, torsos and extremities painted with great detail, but without completing the bodies. One of the most dramatic fragments is seen in the lower left-hand corner, where a prone body cut in half at the edge of the field lifts its knees to frame a decapitated head with half-closed eyes. This technique of abbreviation lends itself magnificently to excerpting. An arbitrarily cut-out group of figures, such as those on the left of the scene (105), makes a strong impact,

deriving power from the sheer physical force and frightening anonymity of the clash of armoured knights. For today's viewer such images beguile one into thinking they are self-sufficient Modernist abstract designs. In actual fact, the composition as a whole, in which the chaos of battle is the ultimate effect, must have rung true to contemporaries who knew the consequences of local warfare all too well. The famous Battle of Anghiari between the Milanese and the Florentines had taken place in 1440 just outside Piero's native town: he could therefore have witnessed the massing of soldiers first-hand. Moreover, in 1453 during the conflict between Florence and Naples, he received a crossbow from the Commune in order to take part in a military exercise. Judging by his detailed rendering of arms and armour, he clearly knew their construction very well.

In spite of the sense of confusion in the tightly woven mass, Piero gives ample indications to distinguish the victors from the vanquished. He does so by means of the flags and trailing banners that wave above their heads. The ones on the left, lifted in full display, are those of the Holy Roman Empire: the 'Capitoline goose' (legendary saviour of the Roman army), the imperial eagle, the golden rampant lion on red ground (with tiny fleur-de-lis added in the sky immediately above, perhaps a reference to the kings of Anjou who enjoyed the title 'King of Sicily and Jerusalem') and the traditional crusaders' cross (white on red). The flags to the right, all in states of collapse, bear signs of the anti-Christian 'infidel': the treacherous scorpion, drooping on a broken pole; the Saracen moors' heads, ripped and in decline, with sky showing through the tears; and the Turkish crescent moons and stars, already falling to the ground.

Immediately under the imperial eagle a horseman in a white-plumed helmet raises his lance with the confidence of a general; he is possibly Heraclius himself. His chestnut horse in juxtaposition with the white horse just behind makes a striking parallel to Constantine and his companion on the opposite wall (see 95). And yet their actions are in total contrast. Constantine vanquished

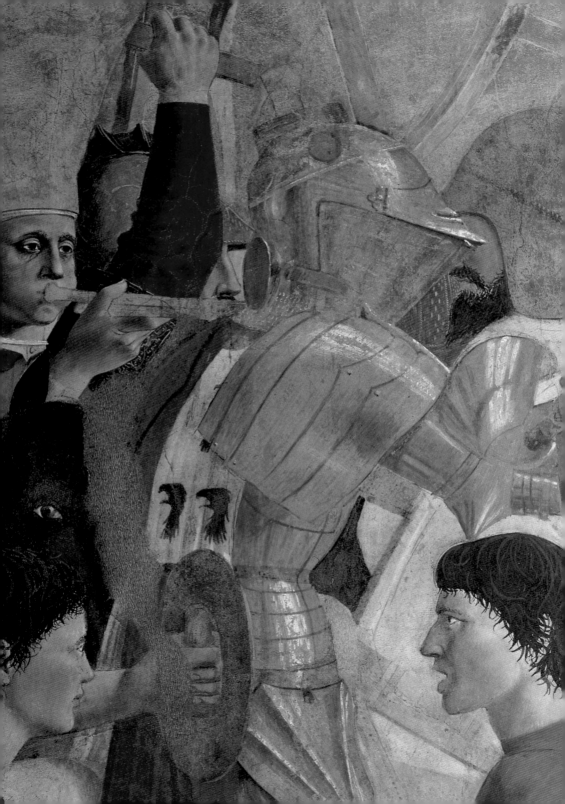

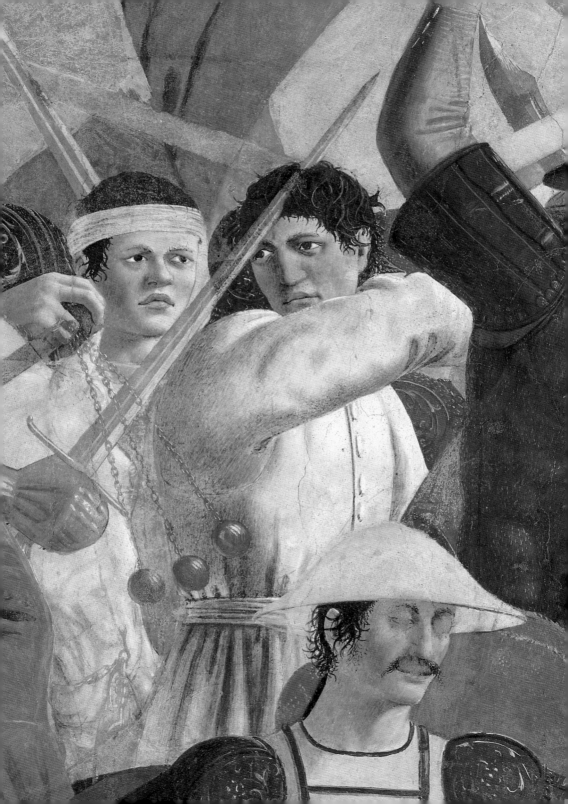

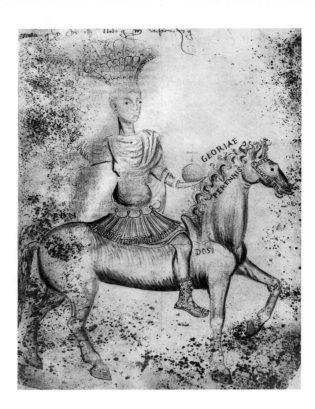

106
**Attributed
to Cyriacus
of Ancona**,
*Byzantine
Rider*, MS 35,
folio 144v,
c.1440.
Pen and ink.
University
Library,
Budapest

107
Battle scene,
c.110 AD.
Marble relief
incorporated
in the Arch of
Constantine,
Rome

Maxentius, his rival Roman, without spilling one drop of blood.
Heraclius fights not brother Roman but hated infidel, and brings
him down with the sword. Piero's figure has a venerable lineage:
his pose and costume, most particularly the plumed helmet, have
been compared to a drawing attributed to the Italian antiquarian
and humanist Cyriacus of Ancona (106), on whose costume
studies Piero often relied. Cyriacus travelled extensively in the
Eastern empire where he must have made this drawing after
an equestrian statue that was still extant in fifteenth-century
Constantinople, and which may have represented Heraclius
himself. The larger motif of rider, fallen enemy under the horse
and foot soldier seen from the rear (108) was discovered long
ago on a Roman relief (107), appropriately enough on the Arch
of Constantine which Piero would have seen in Rome. Thus,
although the costumes and armour at times allude to contem-
porary life, these classical quotations locate the battle in the early
centuries of Christendom.

Historically, King Khosrow was reputed to be a necromancer of great power. His objective was to use the magic he believed the cross to have to gain control over the universe. Towards this goal, he built a tower of silver where he sat enthroned. Other cycles of the cross (see 104) had shown this act of blasphemy with Sassanian subjects worshiping Khosrow as a god. Piero has eliminated this part of the narrative and encapsulated the king's crime, judgement and punishment in one image at the right end of the tier (109). He has suggested the tower by constructing an airy pergola, consisting of a semicircular canopy (smooth on the outside and studded with stars underneath) supported on spindly columns made up of grotesque-like vase and vegetal forms. Before a damask cloth of honour stands a faldstool, Khosrow's now empty throne. It was there, between the stolen cross (left, which seems almost disgorged from the mouth of the soldier with the dagger in his neck) representing the Son, and a cock placed on a column (right) standing for the dove of the Holy Ghost, that the earthly king pretended to be God, the first member of the Trinity. Indeed Piero has identified the features of Khosrow, as he awaits decapitation

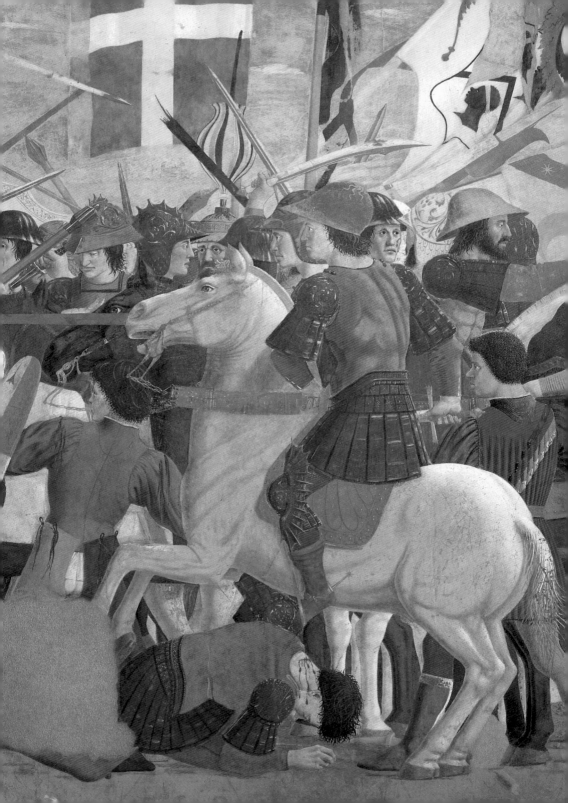

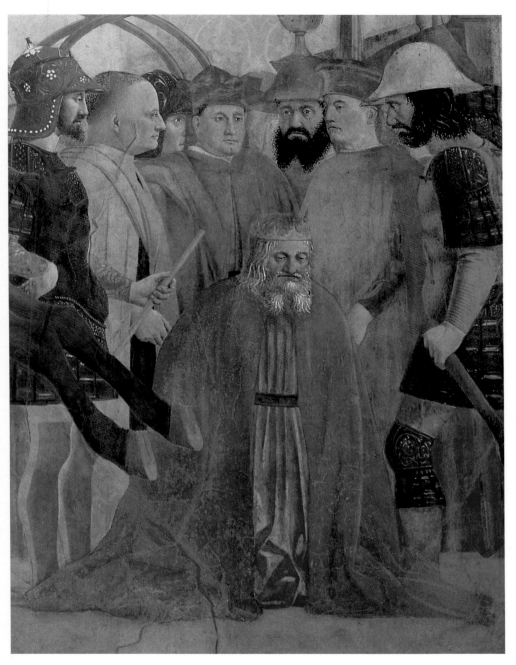

108
*Battle of
Heraclius*
(detail of 103)

109
*Judgement
and Execution
of Khosrow,*
detail from
the *Battle of
Heraclius* (103)

on his knees before the pergola, with those of the lofty face of God the Father in the *Annunciation* (see 91) just around the corner on the altar wall. In this way, Piero has given visual substance to the infidel's outrageous blasphemy.

As he awaits the downward stroke of the executioner, the condemned man is judged not only by his seventh-century military captors (the handsome warrior at the left wears a pearl-studded helmet encircled by a crown that identifies him as Heraclius' princely son) but also by the ages to come. Representing witnesses at the execution, three men in fifteenth-century costumes – one with greying head in profile, one in a flaring red turban and one wearing the stiff red bonnet and *cioppa* of a high-born citizen – are surely members of the Bacci family, the Aretine patrons of the cycle. Since there are no known portraits for comparison, the specific identity of these men has long been a matter of speculation. They could be the long dead paterfamilias, Baccio and the documented sponsors (Francesco and his nephews). One might be a certain Luigi Bacci, the man Vasari claims was the donor but who is otherwise unknown. Vasari's wife was herself a member of the Bacci family, so he could have had special information no longer extant. Only one member of the family was directly associated with the papacy – Giovanni Bacci, Francesco's son. Although in 1448, long before Piero began his work, he fell out of favour with the Roman hierarchy, he was until that year *chierico della camera* (clerk of the chamber) and might have been charged with reinforcing the papal 'preaching mission' to the local Franciscans.

The last scene in the cycle appears in the lunette high up on the left wall (110). It is often given the title of *Exaltation of the Cross*. Although it is a unified image with a number of men walking inwards on the left and a kneeling group facing them on the right, a landscape and a view of a walled city in the background, there are several events again encapsulated in one composition. The legend describes Heraclius after the battle planning to restore the relic of the cross to its sanctuary in Jerusalem. Dressed in imperial regalia and mounted at the front of his army, he tried to enter the city. He

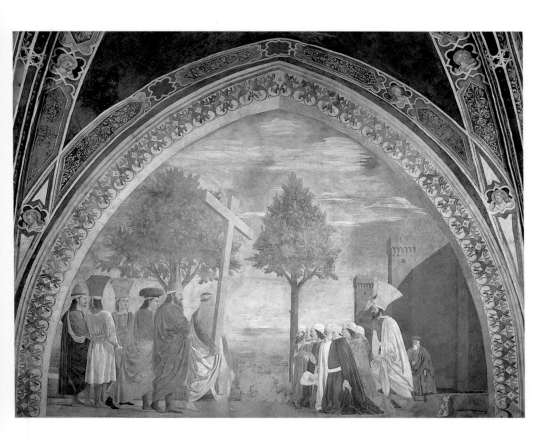

110
*Exaltation
of the Cross.*
Fresco.
Apse, San
Francesco,
Arezzo

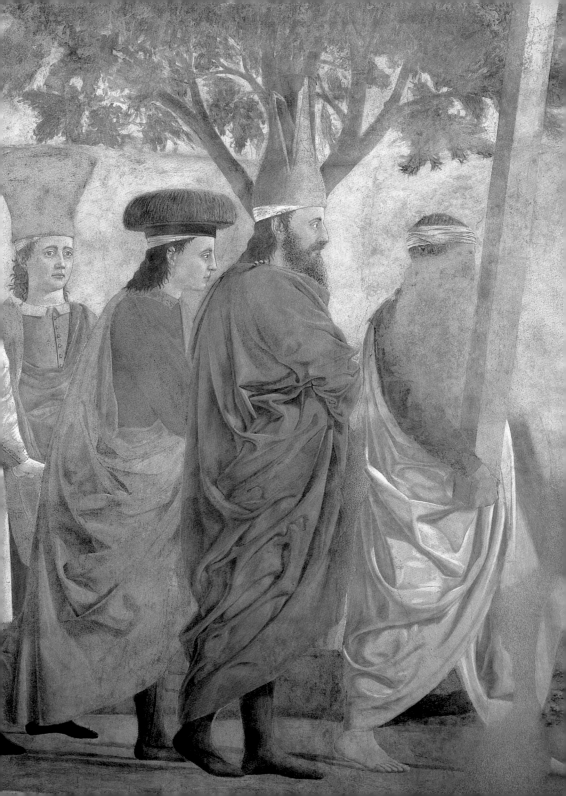

was stopped, however, by an angel who had walled up the gate and who reprimanded him for his pride and arrogance. After this reproof, Heraclius took off his ceremonial robes and his shoes and donned a poor man's raiment. He went easily the rest of the way to place the cross on the same spot on Calvary from which it had been stolen by the Persians (these events are described in Lesson VI in the Breviary for 14 September). Piero's interpretation contrasts with other depictions of this passage, such as Agnolo Gaddi's fresco in Santa Croce, Florence (112), in which Jerusalem's gate is the major focus. Instead he sets his scene far outside the town, with no gate visible. The procession entering from the left (111) includes five men wearing the same Near-Eastern robes as in the *Proofing of the*

111
Exaltation of the Cross (detail of 110)

112
Agnolo Gaddi, *Exaltation of the Cross*, 1388–93. Fresco. Apse, Santa Croce, Florence

Cross (see 102), and Heraclius, whose upper body is unfortunately lost. It is evident, however, that he is carrying the full weight of the cross, wearing simple robes, and humbled by walking barefoot. In this way Piero not only emphasized Heraclius' penitential act but also ensured that contemporary worshippers in this church recognized it as a clear premonition of the barefoot poverty that constitutes one of the chief virtues of the Franciscan order.

The action of the scene is simply Heraclius' encounter with a group of kneeling Jerusalemites, who, with heads tilted at different angles, concentrate on venerating the cross. One doffs his hat as a sign of

respect; another, older gentleman is still rushing up the road to join the group. The distance they have travelled from the city is suggested by the great fortress walls that rise behind them, casting shadows on the ground.

The point of the changes Piero introduced is to refer to the ancient Roman custom known as *adventus*, a formal ceremony of greeting granted to regal visitors. Following the ancient tradition, the greater the distance outside the city gates, the greater the respect shown for the visitor. But here, the honoured guest is not the emperor but the cross he carries; and like the tree in the first lunette of the cycle, the wood is elevated to fill the upper space. By matching this scene with the first of the cycle, the message of redemption is emphasized. In the words of the liturgy: 'We should … give thanks unto Thee, O holy Lord, who didst establish the salvation of mankind on the tree of the cross; that whence death came, thence also life might arise again, and that he who overcame by the tree also might be overcome' (Preface, Feast of the Exaltation).

Now, stepping back and looking at the chapel as a whole, it is possible to see the narrative sequence following what seems to be a quite irrational path (113). This was a major sticking point in understanding the cycle until the 1960s, when the iconographic scholars Michel Alpatov and Charles de Tolnay, followed by the structuralists Maurizio Calvesi and Jonathan Goldberg in the 1970s and 1980s, saw that the scrambling of the narrative led to a series of pairs facing each other across the chancel, matching in both formal organization and theme. The pairing of tiers is indeed striking: the lunettes show the beginning and end of the story under the wood of the cross; the middle tiers show the mystical intuition of queens who recognize the wood, each set once in landscape, once in architecture; the lowest tiers show battle scenes in which Roman emperors are victorious under the sign of the cross. The upper tier of the altar wall shows significant events in the form of genre scenes, the first in Italian art on a monumental scale; and the lower scenes are both annunciations in which angels appear to Mary and Constantine.

It should be pointed out emphatically, however, that in the thousand-year history of Italian mural painting, the rearrangement of strict chronology was not the exception but the rule. While there are some fresco cycles that read simply from the left to the right and from top down, the majority show other dispositions. Moreover, there were a number of established ways to change the order of the episodes that must have been known to both patrons and artists. These patterns can be identified as follows: the Double Parallel (narrative chronology moving from the apse to the entrance on both walls), the Apse Pattern (moving around the apse left to right from the top down or bottom up), the Wraparound (moving around

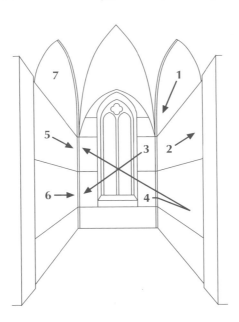

113
Diagram showing the narrative sequence of the *Legend of the True Cross*

the nave starting at the apse on either side), the Boustrophedon (moving in a zigzag), the Cat's Cradle (moving in an X-shaped pattern), the Straight Line Vertical (moving straight up or down both walls), and the Up–Down Down–Up (moving down one side and up the other). These patterns always presumed the observers' prior knowledge of the narratives, and their recognition of the rearrangement as conveying ulterior meaning. It would have been universally understood that the purpose of rearrangements in a large-scale fresco scheme was to express important concepts of

morality, theology and religious politics embedded in the apparently simple stories.

In Piero's case, the pairing of scenes was only one result of the change in sequence. The fact that the cycle starts at the upper right follows the protocol developed in the Early Christian period and found in almost every medieval church in Italy. Used here, it reinforces the story's orthodoxy. The reading order on the upper two tiers of the right wall – right-to-left and then left-to-right – follows the 'Boustrophedon' pattern (114). With it, Piero emphasized the movement through time and space represented in those scenes.

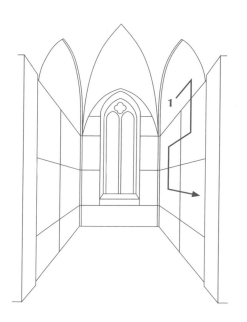

The four episodes on the altar wall are arranged in a 'Cat's Cradle' (115), calling attention to the essential connections between scenes of disparate origin, in this case Roman history and medieval legend. The *overall* movement of Piero's narrative is first on the right wall moving downward, and then passing to the opposite wall moving upward to end at the top. This path traces the 'Up–Down Down–Up' pattern (116), traditionally used, as here, to place scenes of spiritual exaltation in the upper region, closest to the celestial realm. (The order is varied here for the purpose of pairing.) Piero was thus following medieval tradition in his rearrangement of the

story's chronology, but he added his own dimension by using so many patterns in such a complex bond.

Both the theme and the loose narrational mode of the actual story are reminiscent of those of a medieval romance. Troubadour songs such as the *Chanson de Roland* and other chivalric poems were still very much alive in the fifteenth century and read by every school child for pleasure and excitement; and they too are concerned with stalwart knights, pious ladies, the quest for a holy relic and above all, the liberation of Jerusalem. They all sing of the Christian mission in the conflict with the infidel East (pagans/Moors/Muslims

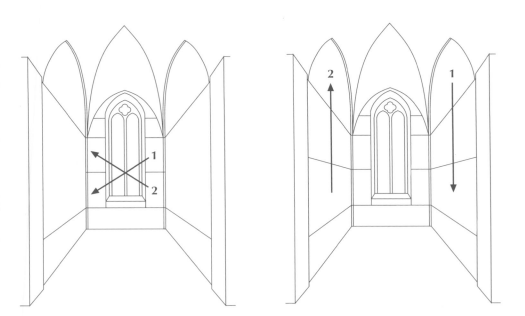

in contemporary terms) who continued to sweep around the Mediterranean basin. Structurally, they are also full of temporal leaps, sharp turns and contrasting episodes juxtaposed. Piero's narrative sequence recognizes this heritage in the story.

If an adherence to the visual heritage of the sacred legend had an appeal for the general public of the time, a series of classicizing design elements, including the pairing of themes, spoke to the intellectuals of the new humanist society of the Renaissance. It was at this very moment in literary history that poets and writers such

as Donato Acciaiuoli and Ugolino Vernio were composing in
elegant Ciceronian Latin. Relying heavily on the rules laid down by
Horace in his *Ars Poetica* (*c.*19 BC), they and others were striving
to revive the form of the classical epic. This goal in literature
was not to be achieved until the next century, in the works of
Luigi Pulci, Ariosto and Tasso, and in the seventeenth century by
Francesco Bracciolini, whose epic is actually based on the story
of Heraclius and the cross. Long before, however, Piero had found
the visual equivalents to Horace's list of requirements for the 'epic
mode'. His compositions are grave and dignified; the figures are
posed with decorum; emotional expression is reserved and unified;
the scenes are filled with variety but not cluttered; the spatial
constructions are rationally controlled and have proportional
harmony. There are, as we have seen, even some elements that
blend the serious with the humorous. These characteristics were
all very modern in the fifteenth century because, unlike the erratic
serial fables of the troubadours, they follow the rules of classical
rhetoric. Piero's compositions of balance and symmetry thereby
elevate the Franciscan mission to 'preach the crusade' into a heroic
account of Christianity's foundation. What seems most appealing
in the cycle – its dignity and grandeur – seemed equally compelling
in fifteenth-century terms. For Piero used his abstract, ideal,
classical style to provide for the patrons, the city and the world of
the Renaissance, its first, fully fledged Christian epic.

During the period Piero was associated with the Arezzo frescos, he
was called to Rome. This commission, which lasted less than a year
and a half, from the autumn of 1458 to the early winter of 1459,
might have been the result of the Franciscan–Vatican connection or
could have been based on the advice of his compatriot, the architect
Francesco da Borgo (Francesco da Benedetto Bigi; *c.*1425–68),
already at work in the Holy City. Piero was assigned the mural
redecoration of certain rooms in the private apartment of Pius II,
newly elected on 19 August 1458. Sadly nothing remains of his
paintings since another new pope, Julius II, had the rooms once
more redecorated, this time by Raphael (1483–1520). Nevertheless,
Piero's work must have been well received for, as recorded in a

document of 12 April 1459, he was paid the impressive sum of 150 florins, and 80 more on 23 May. On the other hand, the fruits of a second Roman commission (undocumented) are preserved at least in part. In Santa Maria Maggiore, one of the major pilgrimage churches of Rome, the chapel of San Michele just off the baptistery was under the patronage of the French Cardinal d'Estouteville, an important member of the Curia (papal court) and an art patron. When it was converted into a side entrance to the great basilica early in the twentieth century, the chapel lost most of its fifteenth-century mural decoration. But Piero's hand can still be seen in ceiling frescos where he painted the traditional subject of the four evangelists with their symbols. The best preserved among these is St Luke with his bull (117). Holding a stylus in his right hand and a small ink cup in his left, Luke is shown as remarkably young and blond. Although he was a painter according to tradition, Luke

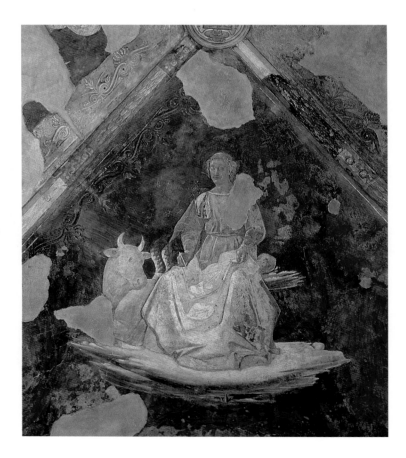

117
St Luke,
c.1459.
Fresco.
D'Estouteville
Chapel,
Santa Maria
Maggiore,
Rome

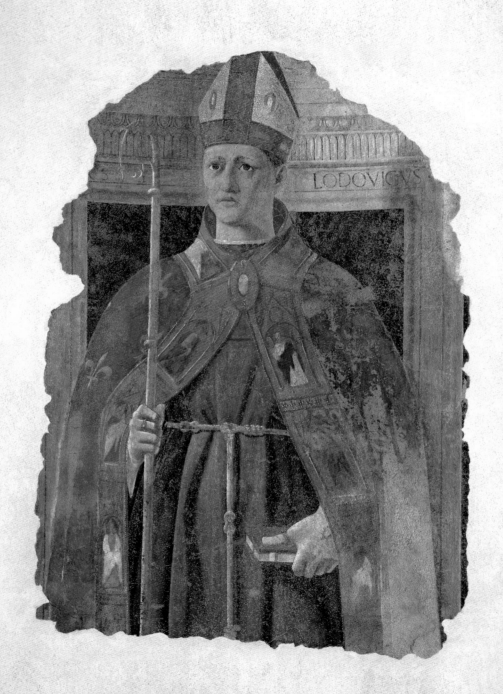

is shown here with heavy features more suggestive of a farmer, in keeping with his bovine companion (which is not well preserved). Most remarkable, however, is the technique Piero used to paint on the vault. Instead of watercolours on wet plaster, he prepared the ground with fine plaster and marble dust bound with glue, as though the ceiling were a panel rather than an architectural surface. This approach allowed him to execute minute details, as seen in Luke's mantel, which is folded back over his shoulder and edged with a border of fine gold. The ribs of the vault are decorated with swags of leaves bound by classicizing scrolled acanthus volutes, and the background of the field was originally covered in azurite blue, again a medium rarely used on walls. While in Rome, Piero clearly continued the technical experiments he was trying out in Arezzo. In the end, however, his Roman sojourn was cut short. Vasari reports that upon hearing the news of his mother's death on 6 November 1459 he left for Borgo, never to return to the papal city.

Back in his native town, Piero was involved in a commission to paint a votive fresco of St Louis of Toulouse (118). The figure, which is over life-size and presented in three-quarter view, bears a now-mutilated laudatory inscription and the date 1460. Most scholars agree that Piero designed the fresco, though there is a difference of opinion as to whether he actually painted it. The commission reflects the political situation in Borgo, much changed over Piero's lifetime. He had seen the city's loss of independence after the papacy sold the territory to Florence in 1441; from this time the administrative chief was no longer an elected local but an official sent from the Tuscan capital. In 1460 this post was filled by Ludovico Acciaiuoli, a member of the distinguished Florentine family of statesmen and humanists. In spite of their differences, the citizens of Borgo were happy with his administration because he restored civil authority to them, symbolized by the office of *gonfaloniere* (honorary standard bearer). The votive fresco was meant to honour Acciaiuoli for this benefit. It was painted on the wall of the Palazzo del Capitano (the modern Palazzo Pretorio) where the governor lived; it is now housed in the local museum. The subject is Acciaiuoli's namesake and patron saint, a dedicated

118
St Louis of Toulouse, 1460. Fresco; 123 × 90 cm, 48$\frac{1}{2}$ × 35$\frac{1}{2}$ in. Pinacoteca Comunale, Sansepolcro

119
**Simone
Martini**,
*St Louis of
Toulouse
Crowning
Robert of
Anjou*,
1317.
Tempera
on panel;
250 × 188 cm,
98$\frac{1}{2}$ × 74 in
(main panel).
Galleria
Nazionale di
Capodimonte,
Naples

Franciscan friar who refused the Angevin throne of France but
was allowed to retain his religious vows only if he took the office
of bishop. He is shown in a traditional manner, following the model
set by Simone Martini (*c*.1284–*c*.1344) in the early fourteenth
century (119). Piero's version brings out the pathos of this young
man's situation, by showing him in his Franciscan habit almost
overwhelmed by his bishop's mitre and cope.

Piero soon returned to Arezzo to continue work on the True Cross
cycle. There he seems to have encountered another member of
the Acciaiuoli family, Lorenzo, who was attached to the cathedral.
In this building there is another single-figure fresco, in this case
undoubtedly by Piero. It was possibly the connection between the
artist and the Acciaiuoli family that brought Piero this otherwise
undocumented commission, to be discussed in the next chapter.

If the female figures in the Arezzo frescos are Piero's idea of abstract perfection, they are also his fundamental statement of admiration and respect for women, the beauty of their outward physical form conveying inner moral virtue. Piero's women call to mind lines from the Book of Proverbs (31:10–30):

Who can find a virtuous woman? For her price is far above rubies … She girdeth her loins with strength, and strengtheneth her arms … She layeth her hands to the spindle, and her hands hold the distaff … She maketh herself coverings of tapestry; her clothing is silk and purple … Strength and honour are her clothing; and she shall rejoice in time to come … Favour is deceitful, and beauty is vain: but a woman that feareth the Lord, she shall be praised.

120
St Mary Magdalene c.1460.
Fresco; 190×80 cm, 74 ³⁄₄ × 31 ¹⁄₂ in.
Arezzo Cathedral

Although he spent his life as a bachelor, Piero expresses in his paintings an understanding of and a reverence for female power, a conviction that seems to have grown with the passing years. From the 1460s onwards, the majority of Piero's commissions involve dedications that focus on female figures. This chapter looks specifically at an image of Mary Magdalene and several works featuring the Madonna.

Piero's fresco of *St Mary Magdalene* (120) is in the cathedral of Arezzo, on the nave wall just to the left of the sacristy door. It is flanked on its left by the huge marble tomb of Bishop Guido Tarlati (d.1328), moved to this location from the altar area in 1783. As seen today, the tomb crowds the fresco and blocks part of the painted architectural frame (121). Apart from some other minor damage, the image, which was recently cleaned, is rather well preserved.

The circumstances in which the work was painted are unknown, but Lorenzo Acciaiuoli, a priest who had acted as religious overseer of Sansepolcro, was appointed Bishop of Arezzo in 1461. Piero's

previous association with the Acciaiuoli family (see Chapter 4) may have led to the commission. The solitary, full-length figure appears to be the first in a long line of isolated figures of the saint serving as votive portraits – depictions of real women shown as the Magdalene as a way of documenting their repentence. Another early example from about 1500–10 is the *Portrait of a Woman as the Magdalene* (122) by Piero di Cosimo (1461/2–c.1521). It would be interesting to know who requested this fresco in Arezzo. The name Maddalena does not appear in the Acciaiuoli family tree, seemingly ruling out a namesake of that family.

121
Arezzo
Cathedral.
View of nave
showing
the *St Mary
Magdalene*
in situ

122
**Piero di
Cosimo**,
*Portrait of a
Woman as the
Magdalene*,
1500–10.
Oil on panel;
72 × 53 cm,
$28\,^3/_8 × 20\,^7/_8$ in.
Galleria
Nazionale
d'Arte Antica,
Rome

The haloed saint stands in an architectural setting, above a not entirely preserved painted marble dado similar to the one Piero had used in his True Cross cycle in San Francesco. She is presented frontally, one foot forward as if pausing in a moment of serious reflection. As a physical presence, she is massive. Her head rests on a sturdy neck and the topography of her face is enriched by broad modelling that inflates her rosy cheeks and mobile mouth. Her eyes are deeply moving, an effect achieved partly through their asymmetricality. The figure is framed by a stony arch that closely echoes the shape of her head and shoulders; simulated acanthus

carvings scroll on its surface. This classicizing architecture is viewed as though slightly from below, and, although its parts are monumental, it seems dwarfed by the grandeur of the woman. She stands on red pavement with a low marble parapet some distance behind her and an open sky above. The illusion is of a high-placed balcony, a superior realm to which the saint has been removed in order to fulfil her function as divine intercessor.

Piero has dressed the Magdalene in a pleated dress of bright green with a voluminous red over-mantle lined with white. He undoubt-edly chose these three colours for their deep Christian meaning, standing as they do for the cardinal virtues. White symbolizes faith; green stands for hope; and red represents the greatest of the virtues, charity. It is ironic that Piero literally clothes the Magdalene in virtue since by his time she was considered to have been a prostitute and therefore the lowest of the low. Since the introduction of gender studies to the history of art, the Magdalene's character has evinced a great deal of interest. She is known to be a composite of three women in the New Testament: one a rich advocate of Christ; one simply a woman named Mary; and one a prostitute who repented of her sins and followed the Saviour. By Piero's time it was the identity of only the last that had survived, and the story of this repentant prostitute parallels the life of St Peter, who having denied the Lord three times was raised to the highest theological position, prince of the apostles and the first pope. Mary's removal from the lowest level of carnality to the highest spiritual realm made her a model for women of all types and classes who, though gaining strength within society during the Renaissance, were still required to prove their virtue.

The arrangement of the Magdalene's cloak forms a kind of cloth mandorla (the Italian word for almond, and often used for the frame of light surrounding sacred figures) around her, emphasizing the object she carries. As a sign of her former profession, she frequently carries a jar of oil; moreover, in the context of the Crucifixion, this jar has a deeper meaning. Arriving at Christ's tomb, she planned to use its contents to anoint his body before a final burial. She was not

able to do so since the Resurrection had taken place and there was no longer a body to anoint. In reference to this miracle, the jar that Piero has given her – a gleaming cylinder, banded with gold and topped with a moulded finial – is in the form of a liturgical pyx or box used to hold the consecrated host (a special wafer that, according to Roman Catholic belief, is transformed during the Mass into the body of Christ). With a delicacy of effect quite difficult to achieve in fresco painting, Piero has placed in the strongly foreshortened fingers of the Magdalene a transparent vessel of luminous rock crystal – a mystical stone thought to be made of pure congealed snow, and according to popular belief possessed of magical properties. Piero has here likened the transformation of ordinary snow into something supernatural to the mystery of transubstantiation – the metamorphosis of a piece of ordinary bread or wafer into the flesh of Christ that takes place during Mass.

The legend of the Magdalene relates how, after Christ's death, she passed the rest of her life in physical abnegation. She retired to the desert and lived as a hermit, meditating continually on this very mystery. When she grew old and too weak to walk, the angels carried her to a place where she could be given communion. As time passed and her clothes fell to tatters, God performed another miracle to shelter her from shame. The hair that had been a sign of beauty in her youth grew long and covered her nakedness. In Piero's impassive, pensive image, Mary Magdalene is still young and strong; but he alludes to the full cycle of her life by representing stringy hair sprouting with new life in preparation for her final days. With broad, sweeping forms, Piero has conveyed the vigour of her belief, her repentance and her assurance that the worshipper too will achieve forgiveness.

Another of Piero's ideal women shares some similarities with the Magdalene but also conveys different meanings. In the fresco popularly known as the *Madonna del Parto* (123, 124) he evokes the Virgin Mary's queenly status as he had done in the *Misericordia Altarpiece* (see 3), but in a new way. Giving her neither crown nor throne, he makes her size and setting convey her elevated status.

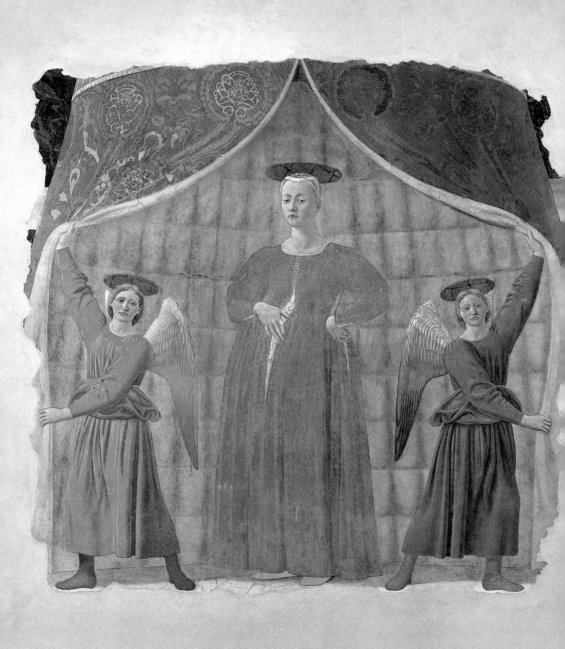

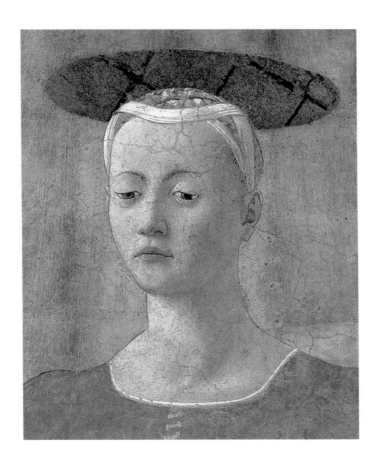

123–4
*Madonna
del Parto,*
c.1460.
Fresco;
206 × 203 cm,
81 $\frac{1}{8}$ × 79 $\frac{7}{8}$ in.
Presently in
school building,
Monterchi
Above
Detail

Piero della Francesca

125
**Rossello
di Jacopo
Franchi**,
*Madonna
del Parto,*
c.1420.
Tempera
on panel;
122 × 60 cm,
48 × 23 ⁵⁄₈ in.
Museo di
Palazzo
Davanzati,
Florence

126
Mary with
Saints
Pudenziana
and Prassede,
9th century.
Fresco.
Crypt, Santa
Prassede,
Rome

He shows Mary in mid-pregnancy standing in the centre of a richly
textured tent, the flaps of which are held open from the inside by
two angels, much smaller in size. The central figure's grand scale
identifies her as Maria Ecclesia, symbol of the Church itself. She
stands before the spectator, turning slightly to her right towards an
unseen source of light. With a gesture of infinite grace, she touches
her womb and alludes to her own fecundity. The popular name of
parto, which means 'delivery', is thus something of a misnomer
since she is pointing not to the birth of Christ but to her pregnant
state. She belongs to a class of images of Mary standing by herself
without the Christ Child that developed in Tuscany in the fourteenth
century and were surely votive altarpieces commissioned for
pregnant women. In such images, as in an early fifteenth-century
example by Rossello di Jacopo Franchi (1377–1456; 125), Mary

frequently wears a high-placed belt which emphasizes her enlarged abdomen while also symbolizing her virginity. The hand placed across the womb was part of this tradition as was the pointing gesture, which occurs as early as the ninth century in a fresco in the crypt of Santa Prassede in Rome (126).

Piero shows no belt, however, and has unlaced her antenatal gown to make a long opening down the front. Under the melancholy of her downward gaze, there is something provoking about that slash of white, almost vaginal in shape. Any fifteenth-century viewer would have associated it with yet another manifestation of Mary's role in the scheme of salvation. As it developed in the later Middle Ages, Mary began to be seen as sharing her son's future fate in the Passion. This vaginal shape was used to represent the wound

inflicted on Christ's side. Strangely enough, this gash is often represented as an isolated entity, worthy of devotion, as in an early fourteenth-century manuscript illumination where the wound is separated from Christ's body, turned vertically, set upon a stand and surrounded by an inscription, among other symbols of Christ's Passion (127). And we will see something similar in the *Montefeltro Altarpiece* (see 176) on the figure of St Francis, whose robe is torn in precisely this shape to expose the stigma in his side, an imitation of Christ's. The opening in Mary's dress is at once her burgeoning motherhood and her future sorrow at the death of her offspring.

The two angels opening the drapes of a tent, signifying revelation, also have a long history in both painting and sculpture. These angels are in identical mirror-image poses, each with one wing showing, one arm raised above the head and the other crossing the body, and one leg extended in a lunging pose. They were clearly done with the same cartoon, flipped from one side to the other. This repetition has caused some scholars to doubt Piero's authorship, forgetting that such visual rhythms could have meaning. The twins are in fact idealized abstractions of bodily movement, their gestures ritualistic. Their colours too are abstract, and Piero alternates draperies, foot coverings and wings of green and red with those of red and green,

128
Workshop
of Lorenzo
Maitani and
Andrea Pisano,
*Virgin and
Child
Enthroned
with Angels,*
c.1310–30.
Bronze and
marble; height
of main figure
200 cm,
78¹⁄₄ in.
Museo
dell'Opera
del Duomo,
Orvieto

127
Christ's
Wound and
Instruments of
the Passion,
c.1320.
Manuscript
illumination.
Bibliothèque
Royale Albert 1er,
Brussels

varying the human aspect of the figures only subtly in skin tone and expression. These qualities in fact provide the clue to the meaning of the setting.

Although now mutilated and changed in form, the tent setting joins a long tradition of depicting Mary in a circular pavilion with the flaps open. This arrangement can be seen in a sculpture of the *Virgin and Child Enthroned with Angels* (128) from the façade of Orvieto Cathedral, done in the style of Lorenzo Maitani (d.1330) who worked on its stone carvings at the end of the 1320s. (The group is now in the cathedral museum in Orvieto.) In Piero's case, the tent is covered with cut-velvet damask of a royal red. The interior, by contrast, is a regular pattern of furry brown rectangles. They make one think of God's explicit instructions to Moses for setting up the first tabernacle for the Ark of the Covenant in which the tablets of the Law were housed (Exodus 26 and 38): the construction of the tent was to include ten curtains of 'fine twined linen' of blue, purple and scarlet, adorned with cherubim of

129
Freestanding
altar with
mural
altarpiece,
*c.*1280.
Santa Balbina,
Rome

intricate workmanship, and eleven curtains of goats' hair. Counting from the bottom to the very top in the central range, there are indeed eleven rows of pelts, distorted only where their seams are magnified by the glassy surface of the figures' transparent golden haloes. The Church Fathers had created yet another Marian epithet when they designated her as the *Foederis Arca* or the 'Covering of the Ark'. (In this case the Ark means Christ, who replaces the Old Law with the 'new dispensation' – Christianity.) Piero visualizes this epithet: the iconic angels, replacing the cherubim, open the tent flaps to reveal the 'Covering of the Ark' in the guise of a self-assured pregnant woman who is modest yet powerful, sympathetic yet profoundly miraculous. Piero again shows his propensity to work within the traditions of religious art while transforming those traditions into images that are both more personal and more ideal.

Piero's authorship of the fresco was recognized in 1889 by a journalist who came upon it while walking in the Tuscan country-side. After newspaper publication of the find, the fresco was detached from the wall of a cemetery chapel and taken to Florence. Along with surface qualities, the original shape of the pavilion was lost as a result of this transportation. Documents published in 1977 show that the painting was once the focus of the high altar of a small fourteenth-century church called Santa Maria a Momentana (or Santa Maria della Selva), just outside Monterchi, about 20 km (13 miles) southwest of Borgo. Piero's fresco replaced a still earlier altarpiece of the same subject, which in fact may explain its somewhat archaic subject matter and shifts in scale. The earlier painting was apparently a mural that served as a devotional image behind the freestanding altar table, an arrangement still to be seen in the church of Santa Balbina in Rome (129). Piero followed this antiquated form and it remained the only frescoed altarpiece in his *oeuvre*. In the centuries following its completion, the fresco's physical surroundings had been drastically transformed. In 1785, the ruined nave of the church was demolished and the apse with Piero's fresco was made into a little chapel, which became the centre of a new cemetery. Before these facts were known, there were stories that connected the painting to the birth and burial

place of Piero's mother, after whom he was supposedly named. She was indeed born in Monterchi, a point that may have played a role in his accepting the commission; her first name, however, was not Francesca but Romana, and she could not have been buried in the Momentana cemetery, established 325 years after her death. She was probably interred in Sansepolcro, along with the rest of her husband's family.

Many myths connected to the painting have thus been discarded, along with any thought that it may have been the work of an assistant, rather than Piero himself. In fact, it has become one of Piero's most beloved images – a must on the 'Piero pilgrimage' – particularly since his quincentenary in 1992, for which occasion it was cleaned. At this time, the fresco was again moved, to a school building inside Monterchi, where it is displayed along with interpretative materials concerning its cleaning and restoration, and a collection of images that puts it into its historical and icono-graphic context. Such is the fresco's popularity that discussions concerning its final resting place – whether it should be returned to the cemetery, left where it is or housed in a new church – are still going on.

The *Madonna del Parto* was influenced in part by the circumstances of the commission. This was also the case around 1460 when Piero received a commission for a massive polyptych for the new convent church (built in 1455) of a community of lay women in Perugia, all of whom were rich noblewomen following the strict rule of the reformed Franciscan order. The leader, a local woman named Margherita di Onofrio, particularly venerated St Anthony (the most important Franciscan saint after St Francis), to whom both the convent itself and the altarpiece were dedicated. The high social status of the convent is indicated by the appointment as Minister General in 1467 of Ilaria Baglione, daughter of Braccio Baglione, the most important man in the town. The single document that records Piero's commission is the final instalment of his pay, 15 *fiorini*, issued to his brother Marco (who frequently acted as his agent) on 21 June 1468. The document speaks of the altarpiece

as '*già fatto*' ('already made'). Quite soon after, Marco bought a small piece of property outside Sansepolcro from one Nello Baglioni, apparently a relative of the Baglioni family of Perugia.

The polyptych (130) is one of Piero's most complex productions, showing as it does his facility for turning rather conventional commissions into new, experimental ventures. As an altarpiece, the work is outstanding for its size and odd shape. It is taller and thinner than most, rising to the exceptional height of more than 3 m (10 ft), and having a strange stepped gable superstructure that at first glance gives the ensemble the appearance of a rocket about to take off. Upon this gable is displayed a superb architectural vista in which an Annunciation scene of the utmost refinement is set. Adding to the overall height of the altarpiece is the rare but not unknown form of the predella (or base) in two stages, one above the other. The polyptych's central panel depicts the Madonna and Child. This woman is more directly queenly than the *Madonna del Parto*: wearing a gold-shot crimson dress beneath her heavy blue mantle and seated on a throne, she represents a new physical type in Piero's *oeuvre*, impressively robust and full-bodied. The infant too is extraordinarily hefty, his muscular nudity confirming beyond all doubt the human form that the son of God has assumed. While raising one hand in blessing, he holds a bunch of cherries over Mary's womb to signal her fertility. The sense of real presence is epitomized in the haloes, now treated as polished discs of solid gold that reflect the top of each figure's head.

The form of the central portion is traditional, showing the Madonna and Child set against a gold background and accompanied by four saints: Anthony and John the Baptist on the left, and Francis and Elizabeth of Hungary on the right, each pair positioned with one figure slightly behind the other to create a perspective that points to the Madonna and Child. The dais which raises Mary's throne is also shown in perspective, beginning outside the colonettes that mark her sanctuary. The throne itself is an impressive structure with marble panelling and carved volutes, and is surmounted by a half-dome adorned with coffers and rosettes. This Renaissance-style

spatial zone is in marked contrast with the carved architectural frame, gothic both in its slim proportions and the pointed arches and keystones which hang between the saints. Piero also changes what is essentially a traditional gold backdrop into a tooled surface with the rich texture of damask. In this way he has enhanced the regal aspect of this celestial region to create a contrast with the simplicity of the barefoot saints.

All the saints but John the Baptist are early (*ie* thirteenth-century) Franciscans: St Francis (canonized in 1228), St Anthony (canonized in 1232) and St Elizabeth (canonized in 1235). The presence of the last is doubly meaningful in Perugia. Elizabeth was one of two women to be sainted in the first decade of the order, and, like the majority of the sisters in this convent, she was an aristocrat, in fact a queen. Even more important, her canonization actually took place in Perugia, where she subsequently had an active local cult. The upper predella, which has the form of an architectural base, displays three small roundels set in painted architectural frames – a black circle in the centre and a female saint on each side. Both of these saints came from rich families and therefore were advocates and models for the women of this convent. Clare, the daughter of an aristocratic family of Assisi, was the first woman to join St Francis in his life of poverty, founding the parallel order of the Poor Clares. Agatha, a high-born young woman from Catania, Sicily, was an early Christian martyr. On a salver she holds her breasts which were cut off when she refused to worship pagan gods. During this torture Agatha declared that her true nobility was in being a slave to Christ.

The predella's lower level is given over to miracles of the three Franciscan saints in the main section of the altarpiece. In the simplified style common to predella paintings, the panels represent (from left to right): *St Anthony Resurrecting a Child, St Francis Receiving the Stigmata* and *St Elizabeth Saving a Child from a Well.* The three are composed reciprocally, with the perspective of the outer fields directing the eye towards the centre panel. *St Francis Receiving the Stigmata,* in spite of its diminutive size, is a vision of great strength. As the seraph carrying the figure of the crucified

130
St Anthony Altarpiece, completed by 1468.
Tempera and oil on panel; 338 × 230 cm, 133 × 90½ in.
Galleria Nazionale dell'Umbria, Perugia

Christ descends towards Francis, its burning rays of blood-red colour light up the miracle. All three scenes, fixed in their little cubes of space, are firmly located in daily life. They set the tone for the other earthly scene on the polyptych, the *Annunciation* in the stepped superstructure above.

Despite an art-historical tendency to believe that the odd shape of the superstructure was the result of a later intervention, it was in fact precisely as we see it in 1568, when Vasari described it with admiration. Moreover, during recent cleaning and restoration it was discovered that the vertically placed planks of wood on which the *Annunciation* is painted extend all the way down through the framing of the main tier, indicating that they were constructed and painted at the same time. Scholars now suggest that the pointed shape was made to fit into the complex vaulting of the apse of the recently built church.

The angel Gabriel and the Virgin Mary face each other before a monastic background of cloister, interior space and upper storey (or tower) – buildings again constructed with linear perspective. The difference from the predella scenes is that here the structure is more complex and challenging. The sunny atmosphere that brightens the sky and casts strong shadows on the brick-red

131
Annunciation,
c.1143–51.
Mosaic.
Entrance
to the apse,
Martorana,
Palermo

132
Domenico
Veneziano,
Annunciation,
predella panel
from the
St Lucy
Altarpiece (17),
c.1445–7.
Tempera
on panel;
27·3 × 54 cm,
10³⁄₄ × 21¹⁄₄ in.
Fitzwilliam
Museum,
Cambridge

pavement is dampened by sombre details. The columns that surround the cloister are clustered into groups of four and filled with funereal slabs of black marble, echoing the central roundel of the predella. Mary is again too big for her environment, the contrast in scale between the figure and the porch in which she kneels indicating that here too she is to be seen as Maria Ecclesia, symbol of the Christian Church. The room behind her, customarily her bedroom, is shrouded in black. Often in traditional images the angel and Mary interact across an empty space: on either side of the entrance to an apse, as in a twelfth-century mosaic in the church of the Martorana, Palermo (131); between the tops of wings of altarpieces; or in separate roundels set within the frame. The spatial separation of the figures in such cases represents the miraculous domain of the Holy Spirit as it descends from the hand of the Father. Piero draws on this tradition, placing Mary and the angel on either side of an empty space but adapting the conceit to his own mathematically guided style. His composition recalls the small *Annunciation* scene in a predella panel of the *St Lucy Altarpiece* by his friend Domenico Veneziano (132). There the space between the figures recedes through an arched portal ending at a symbolic vine-covered closed door. In a similar manner, Piero's figures flank the deep colonnaded corridor at the head of the

cloister. This path ends at an arched panel of variegated marble, foreshadowing the stone that sealed Christ's tomb.

The innovation continues as the dove of the Holy Spirit descends diagonally towards Mary, emitting an aureole of golden rays. Where the rays touch the spandrels of the archways, the inlaid architectural decoration turns from black to red. The red of this magical transformation is the traditional colour of the virtue Charity; it is repeated in a dramatic downward descent, not only in the colour of the enthroned Madonna's gown but also in the wings of the diagonally descending seraph in the *Stigmata* predella scene below. St Francis's taking the pain of Christ's Passion on to his own body is thus equated with Mary's charity in taking the Lord into her body. The simple girl of the *Annunciation* – pale, unadorned and obedient – comes to fulsome maturity and splendour as the Queen of Heaven, crowned at the top of the altarpiece by the stepped and pointed shape of the pediment. (It is interesting to note that in a twelfth-century illustrated manuscript, Ecclesia wears a crown of this shape; 133.) Enthroned between her devotees at the centre of the altarpiece, she inspires their saintly actions as seen in the predella. In spite of, or perhaps because of, the altarpiece's unortho-dox structure, Piero has woven all the parts into a complete whole, a sensitive hymn of praise for the 'Mother of God', chief advocate of

133
Christ and
Ecclesia,
folio 69v,
the Frowin
Bible,
1143–78.
38 × 28 cm,
15 × 11 in.
Engelberg
Abbey

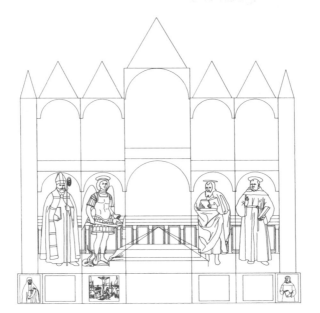

the Franciscan order; and this in turn he has passed on to the women of this community who had left their worldly lives to follow her example of poverty, chastity and obedience.

The fourth queenly woman who might fit well into this chapter is unfortunately a missing Madonna. She formed the centre of the *Sant'Agostino Altarpiece* (134) but disappeared when the painting was dismantled. The altarpiece was done for the high altar in the monastery church of Augustinian friars in Sansepolcro and is fully documented. The first contract with Piero was drawn up on 4 October 1454, with the stipulation that he finish within eight years. The work actually went on for fifteen, with the final payment received on 14 November 1469. When the friars moved from their original church to Santa Maria della Pieve in 1555, they probably took the altarpiece with them. In 1635 it was seen in the church of Santa Chiara still intact, but in 1680 the four saints – Augustine, Michael, John and Nicholas – were described as being in the home of a private collector. Neither the central panel nor the frame are mentioned. At some point, the polyptych was dismantled, and the wings along with small figure pieces from the frame and predella

were sold separately. The parts are now dispersed in the museums of Lisbon, London, New York and Milan. Not until 1941 did art historians recognize that the pieces all formed part of the same altarpiece and the job of reconstruction begin. With no trace of the centre panel, its subject became a matter of speculation, with suggestions ranging from a Madonna and Child through to the Assumption and the Coronation of the Virgin. Only recently have documents describing the work dating from 1635 and 1825 been published, verifying once and for all that it was indeed a Madonna and Child.

In an all-male convent, four male attendant saints were appropriate. The two on the outsides are Augustinians: to the viewer's left, St Augustine himself, the order's patron. At the opposite end, St Nicholas of Tolentino, recognized by the star that always lit his way, does honour to Brother Francesco di Nicola da Borgo, prior of the convent. The two inside saints, the archangel Michael to the left and St John the Evangelist to the right, refer to the patron whose names are supplied in the documents. He was Angelo di Giovanni di Simone d'Angelo, a wealthy 'mule-owner', hence the angel (Angelo) and St John (Giovanni), who is also patron saint of Borgo (and a more logical identification than the rather obscure St Simon who has also been suggested). The four saints together give protection and homage to the enthroned Queen of Heaven and her Son. This arrangement resembled that of the *St Anthony Altarpiece* and explains the cut-off forms in the right foreground of the St Michael panel and the left foreground of the St John panel as the perspectivized corners of the dais on which the throne was placed.

The setting, which originally unified all the panels, is a development of the one seen behind Mary Magdalene (see 120): an amalgam floor, backed by a continuous low wall of stone and inlaid marble. The parapet here is more elegant and refined, however, with Corinthian pilasters and a classical frieze. From this distinguished setting and the saints' stately demeanour, it may be assumed that Mary was a lofty, noble figure of great dignity. There is hope that some day she will reappear.

Although in form Piero has again treated the saints as a traditional alignment of figures, in technique he displays a dramatic change. All the *Sant'Agostino* figures are *tours de force* of illusion, possessing qualities of textures and reflective surfaces we have not seen before. The explanation is Piero's new proficiency in the use of oil paint, the existence of which has been demonstrated in laboratory studies. This technique involves mixing small amounts of pigment with oil to form glazes which are applied in thin layers, one upon the other. It is often said that Piero learned about oil painting from the works of Flemish artists, particularly Jan van Eyck and Rogier van der

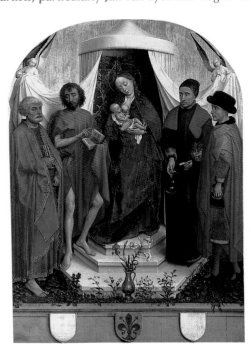

135
Rogier van der Weyden, *Virgin and Child with Saints Peter, John the Baptist, Cosmas and Damian*, c.1450. Oil on panel; 53 × 38 cm, 21 × 15 in. Städelsches Kunstinstitut, Frankfurt am Main

Weyden (*c*.1399–1464). Northern painting was greatly admired in Italy at this time by both patrons and painters, and examples were often brought back from Flanders by merchants and bankers whose business took them there. Van der Weyden, on the other hand, actually travelled to Italy and is known to have received commissions and sold paintings when he visited Italy in 1450. His *Virgin and Child with Saints Peter, John the Baptist, Cosmas and Damian* (135), commissioned by the Medici family in Florence, makes an interesting comparison with Piero's altarpieces. The most

significant aspect of his use of oil paint, however, is the manner in which he made it his own. For whereas his northern contemporaries created magnificently clothed mannequins lacking convincing skeletal structure, Piero applies the powerful decorative effects to figures of consummate structural solidity.

In this altarpiece, under the sky-blue background, each figure takes a pose characteristic of his place in the celestial hierarchy, and each is meticulously identified and differentiated by his costume. The dedication of the monastery is symbolized by the figure of St Augustine, Bishop of Hippo in the early fifth century (136), and Piero treats him as a historical effigy, stiff and venerable. His role as patron of the order that follows his doctrine of absolute predestination and the immediate efficacy of grace is reflected in his friar's habit, while his position as one of the four Fathers of the Church is seen in the bishop's ceremonial cope that engulfs him. It is in the textures of this cope that the new technique becomes evident. The illusion is primarily of gold and black cut velvet edged at the bottom with gold fringe. Broad bands of embroidery face the openings with fully developed scenes of Christ's infancy and Passion on either side, the shapes of which respond to the folds of the material; the three lower scenes on the left-hand side, for example, curve around a fold created by the movement of Augustine's right hand. Despite these fluctuating surfaces, the scenes retain their pictorial consistency. The bishop's crosier the saint holds in his white-gloved hand is topped with a golden crook, and the transparent crystal shaft catches the light along its entire length. Throughout, each material, be it stiff gold braid, wrinkled skin, grizzled beard, nubbly embroidery or glassy crystal, is treated with a different surface, belying the severity of the personality underneath.

For the figure of St Michael (137), Piero took seriously the problem of representing an archangel (eternal sexless spirit, servant and messenger of God) who is at the same time a mighty warrior (fearsome, all-powerful avenger, instrument of God's judgement). He created a challenging apparition that combines angelic delicacy with sensuous physical strength. Michael looks forth with a

menacing gaze. His curling hair supports a braided wreath below a golden halo. His great white wings show his angelic status, while his armour, gold- and jewel-encrusted but archaeologically correct, assign him to Roman military ranks. The stiff leather skirt and unearthly blue breastplate, inscribed ANGELUS POTENTIA DEI ('Emissary of God's Power') at the bottom, cover a transparent long-sleeved tunic, bound by gems at wrists and neck, all filled with light and reflection. Below bare legs, he wears low red boots closed with fussy little laces. This formidable creature stands victorious on the body of Lucifer transformed into a serpent. He holds its head as a disgusting trophy of what he accomplished with his bloody scimitar, as if to conquer Eastern heresy with its own weapon. He truly is a spirit from another world, an unsettling and unforgettable visitor to our own realm.

The care-worn aspect of the apostle St John (138) is explained by his history. As a youth, John suffered several traumatic events. Although he was the most cherished of Jesus's apostles, when the soldiers of Herod came to arrest his master, John abandoned him and fled. And yet Christ on the cross, with supreme forgiveness, entrusted the care of his mother to his still beloved John. Later, after surviving the torture of boiling oil in Rome, he went to the Aegean island of Patmos, where in a vision he was allowed to see the terrors of the end of time. Through his written description of the Apocalypse (the biblical Book of Revelation), John became one of the world's greatest teachers. Piero poured these experiences into the face of his painted apostle who, hoary with age and weighted with foreknowledge, contemplates his own writings with quiet satisfaction.

The last man in the line, Nicholas of Tolentino (139), was elevated to sainthood in 1446, only eight years before the altarpiece was commissioned. He was thus a 'modern' Augustinian, known for his preaching, his miracles and his life of renunciation. In fact he had previously been depicted as thin and emaciated (140). Because Piero's figure is, by contrast, ebullient and robust, it has often been taken for an actual portrait of the convent's prior, the likeness of a

136
St Augustine,
1454–69.
Oil and tempera
on panel;
132 × 56.5 cm,
52 × 22¼ in.
Museu Nacional
de Arte Antiga,
Lisbon

137
St Michael,
1454–69.
Oil and tempera
on panel;
133 × 59.5 cm,
52³⁄₈ × 23¹⁄₂ in.
National
Gallery, London

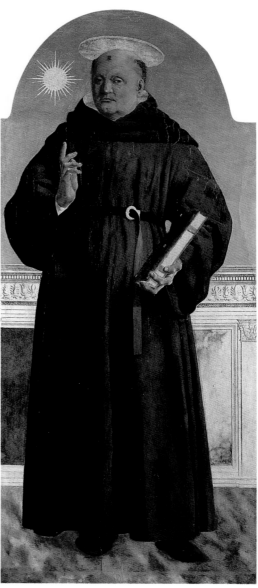

138
*St John the
Evangelist,*
1454–69.
Oil and tempera
on panel;
131·5 × 58 cm,
51¼ × 28⅞ in.
Frick Collection,
New York

139
*St Nicholas
of Tolentino,*
1454–69.
Oil and tempera
on panel;
139 × 59·5 cm,
54¾ × 23½ in.
Museo Poldi
Pezzoli, Milan

140
Riminese School, *Crucifixion with St Nicholas of Tolentino* (far right), c.1340–8. Fresco. Chapter House, San Nicola da Tolentino, Tolentino

voluble preacher. He wears the grey cassock of an Augustinian; a silver buckle on his belt holds the leather strap with a tension that makes it turn and catch the light. Yet behind this realism and the figure of a *bon viveur*, there is the serious contemplation and moral leadership signalled by his admonishing gesture.

The eminence of this guard of honour gives some idea of how Piero might have characterized the missing Madonna. She would again have been an 'ideal Piero woman', combining youth, strength, health and abstract perfection of form. These characteristics grew out of Mary's position in the Christian hierarchy, which by the fifteenth century was as Christ's partner in the scheme of salvation, ruling as the Queen of Heaven at his side: mother, bride and co-redeemer of humankind. They also stemmed from the rising position of women in society, whereby, at least among the upper classes, women were being educated and their legal rights in marriage recognized. But above all they came from Piero's ability to represent a divine spark that shines through as both humanity and divinity in ordinary beings.

Reliance on mathematics in the production of art may seem out of keeping with certain Romantic preconceptions of the artist as an inspired genius, but Renaissance painters and architects entertained no such notions. On the contrary, they were preoccupied with the problem of representing their subjects in a rationally informed manner, and it was they who first experimented with mathematical perspective, basing their work on current theories of optics. Piero knew the work of Brunelleschi and Alberti in this field. In planning his compositions, Piero employed his skills as a mathematician and geometrician in an objective way, yet the use of mathematics in his art was ultimately directed towards expressive ends.

141
Studies of cranial proportions, from *De prospectiva pingendi*, Book 3, Proposition 8, folio 61r. *c.*1470–80. Biblioteca Palatina, Parma

The three important mathematical treatises that Piero wrote are the *Trattato d'abaco* ('Abacus Treatise'; Italian manuscript in the Biblioteca Medicea–Laurenziana, Florence), essentially on algebra; the *De prospectiva pingendi* ('On Painted Perspective'; Italian manuscript in the Biblioteca Palatina, Parma; Latin translation in the Biblioteca Ambrosiana, Milan), a guide to the use of linear perspective for painters; and the *Libellus de quinque corporibus regularibus* ('The Book on the Five Regular Bodies'; Latin manuscript in the Vatican Library, Rome), on plane and solid geometry. Our understanding of these texts, and of Piero's approach to pure mathematics, has benefited from the work of such scholars as Cecil Grayson, Margaret Daly Davis, J V Field and Martin Kemp, and much of what follows here is based on their contributions.

By 1450 Piero had already produced the first treatise, ostensibly in the form of the type of textbook that had originally entered European education at the beginning of the thirteenth century. At that time the mathematician Fibonacci (Leonardo Pisano), who was born in North Africa and studied mathematics with Arab teachers, moved to Italy and introduced Arabic numerals and Hindu-Arabic

systems of computation to Europe. These were easier to use in calculations than Roman numerals. During the fourteenth century the new conventions were translated into Italian, simplified and used for teaching fairly basic mathematics to young boys who would be entering the business world. In the two-tier educational system of the time (see Chapter 1), these boys attended abacus schools (*scuole dell'abaco*), in contrast to grammar schools attended by boys who would follow professions in law, the church and other such areas requiring a knowledge of Latin.

By Piero's time, abacus schools were intended to train not only merchants, but also carpenters, stone masons, goldsmiths, engineers, artists and architects. Basic teaching tools, abacus texts dealt with multiplication tables, fractions, proportions, division, ways to barter and exchange money, and methods of calculating weights and measures (which differed from city to city). For commercial transactions they taught the so-called 'rule of three' (*regole delle tre cose*), an example of which is: if eight yards of linen cost seven lire what will three cost? The problem is then abstracted to the equation: $8:7 = 3:x$. This method provided a way to calculate not only pricing but also proportions, as in finding the capacity of a barrel or judging the amount of grain in a conical heap. Problems with particular relevance for craftsmen or artists included calculating the height of a tower or the surface area of a pavilion, the paving of a piazza with brick, or the measurement of a round vase or chalice.

In the introduction to his 'Abacus Treatise', Piero says he was asked by a patron to write about 'calculations necessary for merchants'. A family crest on the opening page shows the patron to have been a member of the Pichi family, prominent citizens of Sansepolcro who had contributed to the cost of the *Misericordia Altarpiece* (see Chapter 1). As well-to-do merchants, the Pichi may have had some practical reason for the commission. Piero's treatise, however, is no ordinary school-book. To begin with, the exercises differ from those in other such textbooks in that they contain more abstract geometrical problems which quickly increase in complexity. One

of his easiest begins: 'There is a triangle ABC, which along each side is 10 *braccia*. I want to put in it the largest circle that will fit. I ask what will be its diameter.' In what became a marked feature of his approach he offers one exercise after another, each increasingly difficult and bound to wear out his students, but at the same time making them stretch for higher and higher skills. In fact, in spite of his stated subject, he was already proceeding beyond algebra towards the study of Euclidean geometry. Euclid had been translated from Greek to Latin in the thirteenth century, so for this subject he must already have had at least some reading knowledge of Latin. It has been pointed out, indeed, that many of the problems posed in the 'Abacus Treatise' were to become the basis for his more developed solutions in the book on the regular bodies written some thirty years later.

In the intervening time, Piero was thinking about painting and geometry simultaneously. To produce such paintings as the *Baptism of Christ* (see 54) and the *Flagellation of Christ* (see 62), for example, he must have been concentrating not only on narrative, iconography and painting technique, but also on many problems of both plane and solid geometry. His second text, 'On Painted Perspective', probably written between 1470 and 1480, consists of detailed drawing instructions apparently addressed to students. Piero begins the book by dividing the art of painting into three domains: drawing, measurement and colour. He then declares that he will deal with only the second, namely measurement, or 'the profile and outline put proportionately in their place; this is called "perspective" [*prospettiva*].' There is no proof, of course, but some of the drawings in this book appear to reflect actual problems he encountered in his paintings. For example, his diagram showing 'How to project on the perspective plane the ground plan of an octagonal building' (142) looks like a study for (or reproduction of) the perspectivized decorated pavement of the praetorium in the *Flagellation*. Similarly, the projection of a house perpendicular to the picture plane (143) resembles a building on the right of the same painting, and also the houses in the *Proofing of the Cross* at Arezzo (see 102). His drawing of a column capital in

perspective (144) involves a solution similar to those he would have encountered in representing Pilate's palace in the *Flagellation* and Mary's home (see 91) and Solomon's palace (145) at Arezzo.

Some of the ideally shaped heads in the Arezzo frescos (see 88 and 102) were surely prepared with drawings similar to the ones projected in the treatise, where besides measuring the proportions of the face and cranium, profile and full-face, he reconstructs the concentric circles of the head in section (see 141), descending in

Piero della Francesca

142
Drawing of an octagon in perspective, from *De prospectiva pingendi*, Book 1, Proposition 29, folio 16r. *c.*1470–80. Biblioteca Palatina, Parma

143
Drawing of a house in perspective, from *De prospectiva pingendi*, Book 2, Proposition 9, folio 25v. *c.*1470–80. Biblioteca Ambrosiana, Milan

a line from the centre of the top of the head. A related discussion puts the head in motion: 'And because the head that you made was without any slant, I want you to make another that has two movements, that lifts in the front and leans to one side' (146). Looking back now at the kneeling women and men in the *Proofing of the Cross* (see 102) and *Exaltation of the Cross* (see 110), it is clear that the variations in the tilt of those heads, employed

hec a'secunda porta ptrahemus. 194. equidistantes f 6. que ce-
det lineam. 200. et. A. in puncto. 196. et. 164. equidistantem
f 6. que cedet lineam 254. et. 249. in puncto 204. et. 174.
equidistantem. f 6. que scindet lineam. 254. et. 249. i puncto
205. et. 181. equidistantem. f 6. que scindet lineam orbium
habentem a' 201. in puncto. 206. Post modum. ptrahemus i p
me porte. 195. et. 197. 198. et. 199. Secunde porte hee sunt
pductiones videlicet. 196. et. 204. 205. 206. Absoluta est
domus cum portis quas proposuimus. si quis aduertat lineaz
deductiones que suo ordine posite totum id opus efficiunt.

145
Detail of a
column capital
from the
*Meeting of
Solomon and
Sheba* (88)

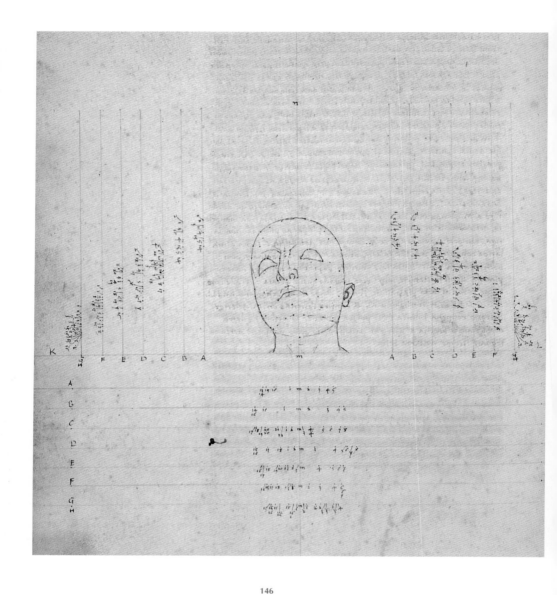

146
Perspective
projection
of a tilted
head, from
*De prospectiva
pingendi*,
Book 3,
Proposition 8,
folio 76v.
*c.*1470–80.
Biblioteca
Palatina, Parma

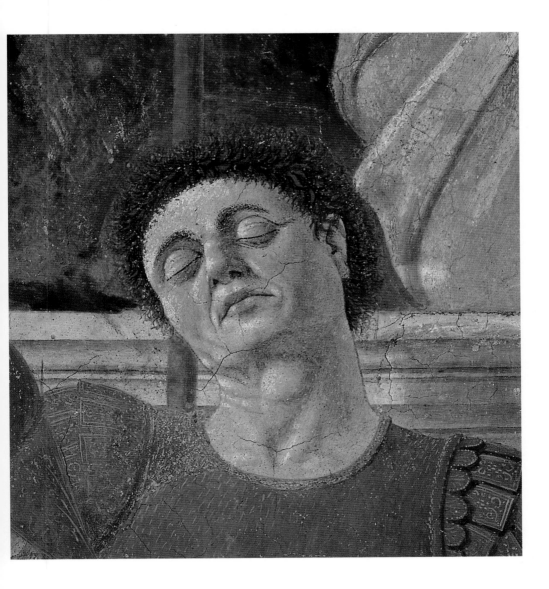

147
Detail of the
head of a
soldier from
the *Resurrection
of Christ* (152)

for expressive purposes, is the result of careful mathematical calculations. Likewise the tilt of the heads of the sleeping soldiers in the *Resurrection of Christ* (147) has been arrived at through calculations like those demonstrated in his treatise.

Another later work, the *Montefeltro Altarpiece* (*c.*1472–4; see 176), is set in an elaborate vaulted area again similar to an illustration in the treatise 'On Painted Perspective' (148). The Duke of Urbino, Federico da Montefeltro, is depicted kneeling before the Virgin in this work. In 1469 Piero had travelled to Urbino. (His probable earlier visit to paint the *Flagellation* for Federico's close relative, Ubaldini, is discussed in Chapter 1; the paintings he produced during this later stay and the close relationship he developed with Federico and his son Guidobaldo are discussed in Chapter 7.) Montefeltro, a military intellectual, was not only a great patron of the arts but also a bibliophile, and Piero's treatise on perspective may have been commissioned by him. Piero dedicated his last book, 'On the Five Regular Bodies', to Federico's son Guidobaldo. In the dedication he says that he considers this study to be á continuation of his previous book on perspective, and that he wishes the two to be kept together in the *studiolo* (library-study) in the Urbino ducal palace. Indeed, both Latin manuscripts are written on the same paper and transcribed by the same hand. It thus seems likely that the treatise 'On Painted Perspective' was commissioned by Federico da Montefeltro himself, who would have been acquainted with Piero's extraordinary skill. One can easily image Federico asking him to set down the principles of his art in mathematical terms.

The important connection between Piero's paintings and his book on perspective is not without an ironic aspect. For throughout his career, when he applied his great skills to three-dimensional vistas, he never used the mathematical aspect of the representation for its own sake. On the contrary, he consistently chose the mechanical technique of perspective projection to portray irrational effects. It was his way of demonstrating the veracity and logic of spiritual truths. In asking him to record his knowledge, his highly intellectual and visually sensitive patron may have seen through his

representations of religious 'mysteries' to the rational principles of their substructure.

Piero's final book, his treatise 'On the Five Regular Bodies', is now held in the Vatican Library, along with the rest of the Urbino collection. It was written in old age, perhaps between 1482 (the death of Federico) and Piero's own death in 1492. In the dedication to Guidobaldo, Piero mentions his advanced age. The treatise, covering plane and solid geometry, is divided into four parts dealing with (1) plane geometrical figures, (2) solid bodies inscribed in a sphere, (3) regular bodies placed one inside the other and exercises concerning spheres, and (4) irregular bodies. The five regular bodies

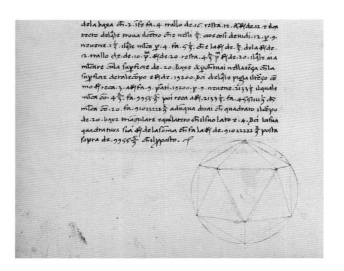

149
Diagram of an icosahedron, from the *Trattato d'abaco*, folio 113v. Early 1450s. Biblioteca Medicea–Laurenziana, Florence

150
Diagram of a pentagon inscribed within a circle, from the *Libellus de quinque corporibus regularibus*, folio 17r. c.1482–92. Biblioteca Apostolica Vaticana, Rome

of the title, the only equal faced, equiangular solids that can be comprehended in a sphere, are the cube, tetrahedron (a pyramid with four equal faces), octahedron (with eight equal triangular faces), icosahedron (with twenty equal triangular faces; 149) and dodecahedron (with twelve sides that take the form of regular pentagons). In the section on irregular bodies Piero seems independently to have alighted upon the notion of 'truncation', that is the cutting off of the angles or edges of a solid with a plane face, or the cutting off of the vertex of a cone or pyramid by a plane. Indeed, he went on to describe the properties of six resultant solids: the truncated tetrahedron, cuboctahedron, cube, octahedron,

& est. 4. Ergo si cadat cathetuſ Anguli .A. cadet ſup baſi
C D. eam partienſ p̃ equa in punc̃to .F. Et qa ꟾC. equat AD.
& quelibz eſt radix ipſiuſ 20. additiſ 2. Et p̃ penultimam
p̃mi Euclidiſ habeſ cp̃ ꟾC. pot q̃tum. 2. lineç. AF. & DF. q̃
tenent angulu rectum. Et ſic. AD. poteſt q̃tum AF. & DF.
Ideo m̃lcata ꟾC. que radix ipῖ 20 additῖ 2. cum radice ipῖ
20. additῖ 2. cum radice ipῖ 20 additῖ 2. reddit 24 addi-
ta radice ipῖ 320. Vnde demaſ multiplic̃ p̃em. CF. q̃ eſt
2. q̃ iſe m̃lcata efficit. 4. quem tolle d̃ 24 adã̃ta radice
ipſuiſ 320. relinqtur 20. addita radice ipῖ 320.̃ Ɪ t radix
ſumq̃ /q̃ efficit radicem ipῖ 320/ poſita ſup 20. eſt cat̃ı, t̃uſ
AF. que eſt perpendicularis / que queritur.

XXXVI
Si ab angulo penthagoni eqlateri cui latuſ ẽ 4 .demit-
titur p̃pendicularis ſup lineam tendentem ſub ãgulu
penthagonicu . Queritur q̃ta ſit ipſa perpendicularis.
Sit penthagonuſ ABCDE. & linea que ſub tenditur
angulo penthagonico eſt BE. Et p̃ precedentẽ habeſ cp̃
eſt radix ipῖ 20. additῖ 2 & ſit triamgulus ABE. Et ab an
gulo .A. cadit p̃pendicularis ſup BE. ꟾ punc̃to. F. & fiunt
parteſ due equaleſ. Partire igr̃ radicem ipῖ 20. additῖ 2
evit radix ipῖ 5. addito 1. que ꟾ ſe m̃tra facit 6. additſ
radice ipſῖ 20 / quam aufenſ a uilateriſ AB. q̃ eſt 16.
relinquetur 10. dempta radice ipſuſ 20. Ergo .AF. p̃pe
dicularis eſt radix euſ qᷓ ſup eſt d̃ 10. eãducta raã d̃ 20.

XXXVII
Penthagoni equilateri ABCDE. cui arculi diameter
ubi eſt deſcriptuſ ẽ 12. Q̃ta ſit eῖ ſupſicieſ.
Vclideſ in viii. xiii. dicit cp̃ latuſ ſexanguli additus
lateri decanguli efficiut lineam diuiſionem h̃entem

dodecahedron and icosahedron. That the ancient Greeks, namely Archimedes (third century BC) and Pappus of Alexandria (in the fourth century AD), had recognized these properties many centuries before was not known in Piero's day, since the original sources were not discovered until the late sixteenth century.

Piero describes this work's contribution to be the application of arithmetical principles from his early 'Abacus Treatise' to the geometrical theorems of Euclid. An illustration in the first part (150) combines the pentagon and circle in a manner that recalls the kind of calculations Piero might have made for the symbolic geometry of the *Baptism* (see 54 and 59–61). While short on text and long on examples, this last treatise, besides showing new and increasingly deep study of Euclid's *Elements*, brings to the solutions he presents greater refinement in their methodology and accuracy.

Piero wrote all three of his mathematical texts in Italian. His two later treatises were probably translated into Latin for a more formal presentation by his compatriot Matteo da Borgo, a respected member of the Urbino court. It is also more than likely that Matteo is the author of two rhetorically sophisticated Latin poems appended to the text of 'On Painted Perspective'. Their praise for Piero is a clear demonstration of the esteem in which he was held in his own time. The poems are presented here in English for the first time (translation provided by Christopher Drew Jones):

To the author

At last, here's the end of [this] work that teaches so many
Representations of figures, drawn from authoritative sources.
Now, even if you've read but half, show [your proficiency] in this skill,
That its glory may return to the author, at last.

To the reader

You who read this work, the issue of an esteemed painter's skill,
Refrain from words of malicious criticism,
And, as you marvel forthwith at the excellent product,
Tell by whose assistance [this] precious art comes:

Strength of mind, wisdom of spirit, virtue –

These a-plenty, O Piero, are your constant companions.

The name of Borgo you now extol throughout all the towns

Of Italy, and you make your own [name] famous by your art.

You are our glory: your banners we follow, fighting back

Those who pitch their camps in hostility to your own.

May life be yours above and beyond your allotted years.

O that I may enjoy so great a good, so long as you live.

In his *Life* of Piero (1550), Giorgio Vasari claims that the book 'On the Five Regular Bodies' was plagiarized by another mathematician

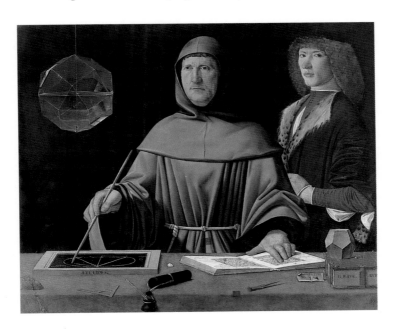

151
Jacopo de' Barbari, *Portrait of Fra Luca Pacioli*, 1495. Oil on panel; 99 x 120 cm, 39 x 47¼ in. Galleria Nazionale di Capodimonte, Naples

from Sansepolcro, Luca Pacioli, who published the text as part of his own book, *Divina proportione* ('Divine Proportion', 1509). Pacioli did indeed include parts of Piero's 'Abacus Treatise' in his 1494 publication *Summa de arithmetica*, and in 1509, the year after Guidobaldo's death, he merged the whole text of the 'Book on the Five Regular Bodies' into his *Divina proportione*. Nevertheless, Vasari's charge of plagiarism needs to be taken with a pinch of salt.

Pacioli was born in Sansepolcro but spent his career travelling throughout Italy, from Venice to Naples, from Milan to Rome,

teaching mathematics. In the late 1470s he joined the Capuchin branch of the Franciscan order. In the 1490s he was at the court of Ludovico Sforza in Milan, where he met Leonardo da Vinci, and the two became close collaborators. He also taught at the court of Urbino, where he too was patronized by the young duke Guidobaldo. A portrait of Pacioli, signed and dated 1495 by Jacopo de' Barbari (*c.*1460–*c.*1516), shows him giving a geometry lesson (151). A wooden dodecahedron lies on top of one of his books, and a superb but impossibly large transparent icosahexahedron is suspended in mid-air on his right. The young man depicted with Pacioli, who was in the past incorrectly identified as Guidobaldo, may be a self-portrait of the artist. With his left hand, Pacioli points to a page in an open book identified as Book 13 of Euclid's *Elements*, and with his right he draws the geometric diagram that illustrates the passage.

While Pacioli did make a practice of incorporating other people's works in his own, this was not so unusual for the period. His treatment of Piero was especially complimentary: he reserved great praise both for Piero's superior mathematical skills and his prowess as an artist. Pacioli was responsible for putting many of Piero's abstract propositions into relation with real problems in architecture, and it was he who gave Piero the title '*monarca della pittura*' ('monarch of painting'). Although they may have circulated quickly and widely, Piero's manuscripts were never printed independently, and their promulgation by Pacioli actually made them more easily available than they might otherwise have been. Through this medium, Piero's treatises were rightfully able to take their place as the basis for theoretical writings, particularly on the subject of perspective, for the next two centuries, including those by Leonardo da Vinci and slightly later by the German artist and theoretician Albrecht Dürer. It will be remembered that Vasari, who observed Piero's career with great admiration, gave him greater praise as a mathematician than as a painter.

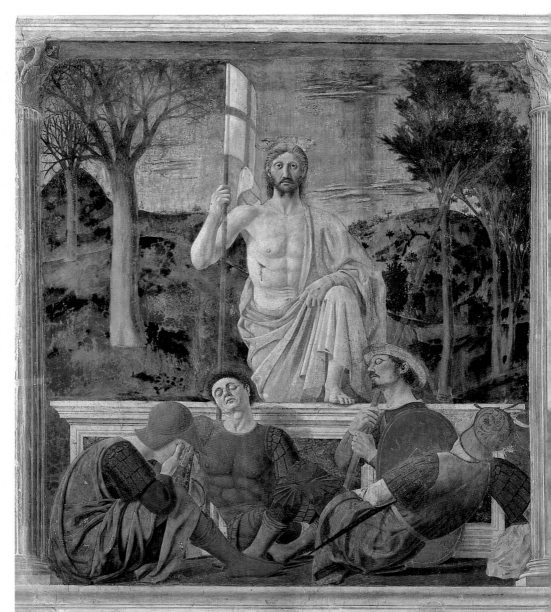

On 1 February 1459, a gothic building known as the Residenza (today the city picture gallery) was officially returned to the citizens of Sansepolcro as a place for the local councils to hold their most serious meetings. This gesture was a sign of the partial restoration of the city's civil autonomy from the grip of its Florentine owners. Relatively soon after the transfer, the space was divided into two contiguous chambers, the first for use as an entrance area and the larger one behind to serve as the formal meeting room and hall of judgement. Placed high on the wall that divides the rooms, in a position of prominence facing the main entrance to the building, is Piero's fresco of the *Resurrection of Christ* (152). Although this was a major civic commission, documentation is once more lacking. Scholars have dated the fresco as early as 1447 and as late as 1474, with the most likely time of execution being 1463–5. A document of 1474 concerning structural repairs to the building mentions the painting; it is possible that it was moved and re-installed in its present location at that time.

During the later Middle Ages and the Renaissance communal meeting halls were regularly decorated with murals that showed military victories, properties owned by the commune, or allegories of governance and civic virtue. The Sienese Palazzo Pubblico, for example, has wall paintings by Ambrogio Lorenzetti (d.1348) that are among the most famous and elaborate (153). There are almost no chambers used for civic or legal functions that have religious representations. Yet it was a religious subject that Piero was asked to paint. To understand what might have motivated the commission we must look for a moment into the history of the subject.

The moment of Christ's Resurrection is not described in any written source. Biblical accounts state that after the Crucifixion his body was placed in a rock-cut tomb made for another man. The cave-like

152
Resurrection of Christ,
1463–5.
Fresco;
225 × 200 cm,
$88^5_8 \times 78^3_4$ in.
Pinacoteca Comunale, Sansepolcro

153
**Ambrogio
Lorenzetti**,
*Allegory
of Good
Government:
The Effects
of Good
Government
in the City,*
c.1338–9.
Fresco.
Sala della
Pace, Palazzo
Pubblico,
Siena

structure was closed with a large stone and sealed with wax. Guards were set to watch the tomb to ensure that Christ's followers would not steal the body and claim that it had risen, as Christ had predicted. After three days his disciples returned; the earth quaked and an angel descended and rolled back the stone, showing that Christ's body was gone. The guards then shook with fear, having seen nothing. There were thus no witnesses to the moment of returning life.

The representation of Christ newly revived – in or near the tomb, swathed in drapery, holding a banner and surrounded by military guards – was an artistic invention of the late tenth or early eleventh

Piero della Francesca

154
Andrea Mantegna, *Resurrection of Christ*, predella panel from the *San Zeno Altarpiece* (179), 1456–9. Tempera on panel; 71×94 cm, 28×37 in. Musée des Beaux-Arts, Tours

155
Giovanni Bellini, *Resurrection of Christ*, 1475–9. Oil on panel; 148×128 cm, $58\frac{1}{4} \times 50\frac{3}{8}$ in. Gemäldegalerie, Berlin

century. Several different positions for the figure of Christ were developed, including Christ stepping from the tomb with his left leg raised, as in a predella panel by Andrea Mantegna (1430/1–1506; 154); standing before the tomb; and even floating in the air. Giovanni Bellini (c.1431/6–1516), in his *Resurrection* of 1475–9 (155), places the risen Christ far above a rock-cut tomb in which a sealed sarcophagus can be seen, with soldiers gazing up at him in consternation. Piero chose a composition that had particular resonance in Sansepolcro. In all its basic elements, his version replicates the main panel of the altarpiece in the town's main

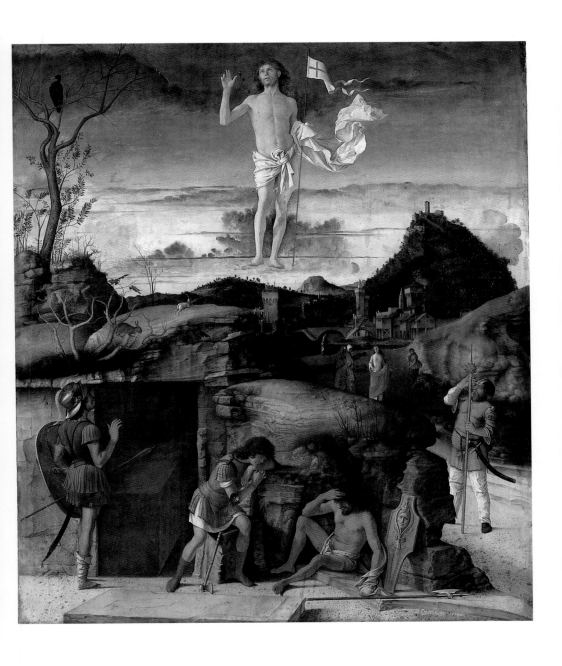

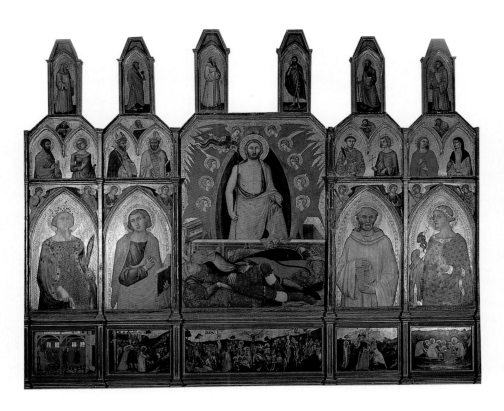

church (156), painted by Niccolò di Segna in *c*.1346–8; Piero had already referred to one of the predella panels from this work in his *Flagellation*. Because of its auspicious subject, involving the tomb of Christ, this altarpiece was clearly a major object of veneration in Sansepolcro; Piero's fresco was to become an even greater one.

His *Resurrection* is set within a painted architectural frame in the form of a Corinthian portico. When the fresco was moved some of the painted frame was destroyed, including a long inscription on the bottom step which unfortunately was not recorded. What remains of the painted architecture is seen in steep perspective from below, with the underside of the lintel at the top and of the upper frieze of the sarcophagus clearly visible. When it comes to the figure of Christ, however, Piero changes the viewpoint dramatically and shows him straight on. Christ rises from the dead to stand erect inside his sarcophagus, with one foot poised on the rim. He holds a winding sheet of springtime pink around his muscular body with his left hand and supports the *labarum*, the red-cross banner of his triumph over death, with his right. He stares directly before him, eliciting from the viewer an uneasy sense of tension between the reality of his three-dimensional form and the spiritual meaning of his presence.

This tension is particularly evident in the way Piero has constructed the face (see frontispiece). There existed a tradition for representing Christ not as a beautiful ideal being, but as a somewhat threatening, even frightening man-God, as in the monumental images of the Pantocrator seen in Byzantine churches (157). Such an image was familiar to Piero in the huge early medieval painted wooden crucifix that hung in the abbey church of Sansepolcro (158). This giant carving, made of wood that dates from the ninth century, stares down at the worshipper with bulging eyes and a riveting glance. What Piero adds to his face is a labourer's physical strength, a ruffian's flattened nose and coarse beard pointing to the juncture of the clavicle. He paints the dark eyes as sleepless and tormented, unbending in their concentration, and creates an image both repugnant and hypnotically compelling, with all the mystery of the eternal.

156
Niccolò
di Segna,
*Resurrection
Altarpiece*,
c.1346–8.
Tempera
on panel;
233 × 237 cm,
91³⁄₄ × 93¹⁄₄ in.
Sansepolcro
Cathedral

More than giving emphasis to Christ, the shift of viewpoint is an attempt to solve a theological problem inherent in the subject. In most depictions of the Resurrection, Christ's tomb, in spite of what the Bible says, takes the form of a sarcophagus with a lid tipped upright or off to one side, as seen in Niccolò di Segna's *Resurrection* (see 156). The issue of how Christ's body passed through the sealed tomb is thus not even alluded to. There is no lid in Piero's painting and since its upper rim is viewed from below, the top surface of the sarcophagus is hidden. As a result, we are encouraged to believe that the palpable figure of the Saviour has stepped forth miraculously from a tomb that remains hermetically sealed.

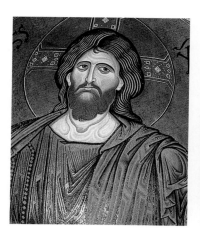

157
The Pantocrator, 1180s. Mosaic. Apse, Monreale Cathedral

158
Detail of painted wooden crucifix, 9th century. Sansepolcro Cathedral

159
Giotto, *The Resurrected Christ Appearing to Mary Magdalene*, c.1303–6. Fresco. Scrovegni Chapel, Padua

In choosing sleeping soldiers to represent the guards, Piero was following tradition. Many earlier representations, such as Giotto's composite scene in the Scrovegni Chapel in Padua (159), show several armoured men lying about in somnolent poses. Piero gave his sleeping soldiers a variety of positions that keep them oblivious to Christ's presence. He put them in a fan-like arrangement that reinforces the quality of Christ's rising. The lines of force in the triangular quintet continue from the V-shape vortex beneath his foot up and out to follow the arrangement of the trees. The colours of the soldiers' uniforms alternate between green, brown and red, making a dark contrast with Christ's pastel drapery. The man on the

left with his knees drawn up covers his face with his hands. The two in the centre sleep, cramped in the same spatial shorthand that Piero used in his Arezzo frescos. It is often said that the features of the bareheaded man with his eyes closed are those of Piero himself (again, in comparison with Vasari's woodcut; see 2). In contrast to the static poses of the first three, the soldier on the right, with bat-shaped knee-guards, tips backwards, audaciously unbalanced, as if he were magnetically attracted to a large chunk of stone on the ground behind him. It should be recalled that here, in the town hall,

we are faced with an image of the tomb of Christ, the very object that gave the town of Sansepolcro its name. And thus we are told to recognize this stone as the founding relic carried here from the Holy Land by saints Arcano and Egidio.

The difference in setting of Piero's work from Niccolò di Segna's prototype is in some ways only superficial. The older panel has a symbolic background, dark and abstract, filled with hierarchically

placed angelic beings. Piero's has a landscape, strongly Tuscan in character; yet it too is symbolic in content. In what at first appears to be a natural vista, the viewpoint is once more changed, and the perspective reversed. There are rows of trees on either side of Christ moving back in space. But rather than converging as they recede, they actually spread apart and return the eye to the central figure of Christ. Moreover, the two types of trees are in themselves symbolic. On the right there are three green trees, slim but in full leaf. To the left, there are two trees that are more mature but bare. Again Piero has used a traditional form of landscape known as 'moralized', of which an example can be seen in Bellini's *Resurrection* (see 155), in which the opposite sides of a composition are meant to offer the spectator moral choices. And the choice is quite the reverse of what one would expect. In Piero's image, graceful green trees lead down to a valley where the easy life of a villa beckons. The more mature but strictly barren trees, strategically placed on Christ's right-hand side, march up a hill towards a steep mountain, an arduous ascent. What the landscape tells us is that the path of virtue is the more difficult but the more rewarding, and it echoes the call to morality found in Christ's commanding gaze.

Piero's *Resurrection* is thus no simple Easter morning but an archetypal image, removed from natural time and space. The risen Christ is given an unusually judgemental aspect, as if in anticipation of his role at the end of time. In a church setting the allusion might not have been surprising, and half a century later documents show that an altar was indeed installed below the fresco. But in a purely civic context, its content had another meaning. In Piero's time many accepted the notion that a rationally planned city-state was an institutional remedy for Original Sin, and that civic crimes were only continuing reflections of that sin. Moreover it was thought that the right to judge, to punish and reward was a gift of God, and that the state was not a secular unit but an extension of the court of heaven where good men sought to carry out God's will. Piero's 'Christ in the Council Hall', which later in the century became the town's seal and remains so today (160), is a figure who both protects the judge and purifies the judged. High on the wall of the

entrance chamber, this image was meant as a call to virtue to judge and advocate, to the guilty and the innocent, as they entered to take up their duties.

As powerful as the fresco is, its didactic mission was ultimately lost. Whether because of a change in the room's function or diminished interest in works by Piero, the painting was whitewashed in the eighteenth century. The lime-based covering had a devastating effect on the surface, and as always, when it was removed many of the surface refinements were also lost. Besides this direct assault, the greens of the landscape have oxidized and turned an almost uniform brown. Nevertheless, the great psychological power of the image remains almost miraculously undiminished.

Around the same time that he was working on the *Resurrection*, Piero painted another votive fresco in Sansepolcro. Discovered by chance in 1954 during repairs to the monastery church of Sant'Agostino, it is an under life-size young male saint, of whom

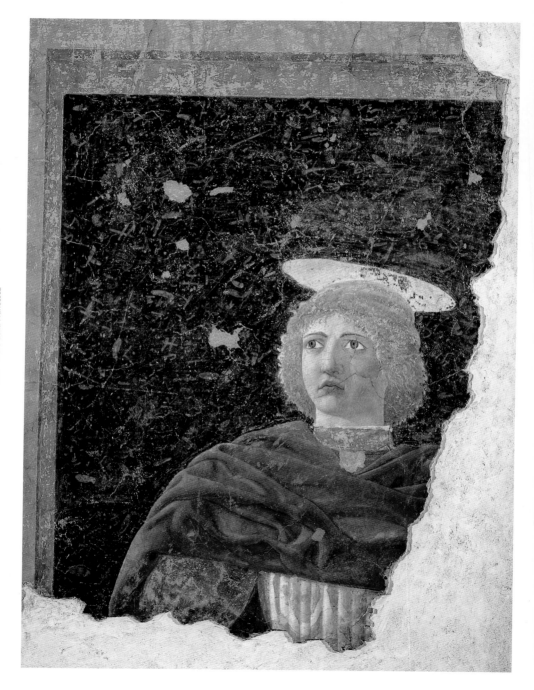

only the upper part of the body is preserved (161). Workmen came upon the fresco just under four metres (13 ft) above the floor of the right wall of the nave, at the apse end. In 1957 it was removed from the wall and transported to the town's museum. The young man is splendidly dressed, with a somewhat troubled expression in his large, well-defined eyes. Set against a background representing a slab of green-black marble with a lighter green moulded frame, the haloed saint wears a green cut-velvet tunic under a stiffly pleated tabard (similar to the costumes in the *Raising of Judas* in the Arezzo frescos; see 98) and a magnificent wine-red mantle lying in heavy folds about his shoulders. The counterpoint of greens and reds is carried over into the well-preserved colour of the cheeks

161
St Julian (?),
c.1463.
Fresco;
130×105 cm,
51$^1_8$ ×41$^3_8$ in.
Pinacoteca
Comunale,
Sansepolcro

162
Piero's house,
via Aggiunti,
Sansepolcro

and shadowed chin; the healthy glow of the face belies the soulful expression. Because of this combination of elegance and serious- ness, the figure is frequently identified as St Julian the Hospitaller, a well-to-do young man who, owing to a horrible mistake, murdered his own parents. After his appalling deed, he spent the rest of his life in expiation and good works. With a turn of the head, he looks to his right, and therefore towards the altar area of the church, with a glance of perpetual obeisance.

By the mid-1460s Piero's family owned several pieces of property in Sansepolcro, among which were two houses on the via Aggiunti which they joined together and refurbished in the new Renaissance

style (162). In one of the rooms, Piero painted the only purely classical subject of his career, a remarkable figure in fresco of the demi-god Hercules (163). After its rediscovery in the 1860s, it was almost immediately cut from the wall. In this process, besides the usual degradation of surface and colour, strips of the background at the top and the lower part of the figure's legs at the bottom were lost. No records were made of the painting's original location in the house. On the advice of the art historian Bernard Berenson, Isabella Stewart Gardner, an early twentieth-century collector, bought the piece in 1908 and transported it to her home in Boston, Massachusetts (now a museum).

Despite the damage, it remains an impressive figure. As in Piero's other fresco compositions, the hero is seen head on, his near-nude body shining with appropriate firmness and muscularity. The modelling is done within a continuous outline of light, all the more dramatic because of the darkened background. The skin of the Nemean lion, tied at his neck and groin in a manner similar to the one on Adam's son in the Arezzo cycle (see 83), indicates that he has completed the first of the twelve labours set in punishment for the destruction he wreaked in a fit of madness. The full face, youthful and surrounded by coarse black hair, expresses the difficulty in gathering concentration to complete the rest of his tasks. He seems to have stepped into a marble doorway, pausing with one arm akimbo to announce his arrival and show his power by extending his club. The terracotta-coloured wall behind him, decorated with classical palmette friezes, gives him a thoroughly classical setting. It is still not certain whether he was one of a series of heroes or an independent composition. If the latter, the figure could have made reference to the foundation myth of Piero's mother's native town, the name of which, Monterchi, was thought to derive from the Latin *Mons Herculis* (the hill of Hercules).

163
Hercules,
1460–6.
Fresco;
151×126 cm,
$59^1/_2 \times 49^5/_8$ in.
Isabella
Stewart
Gardner
Museum,
Boston

In 1469 Piero, who was now in his late fifties, was summoned to the town of Urbino, not by Count Federico da Montefeltro, ruler of the city, but by the members of a lay confraternity dedicated to the Corpus Domini (Body of the Lord) who needed his advice. This fact

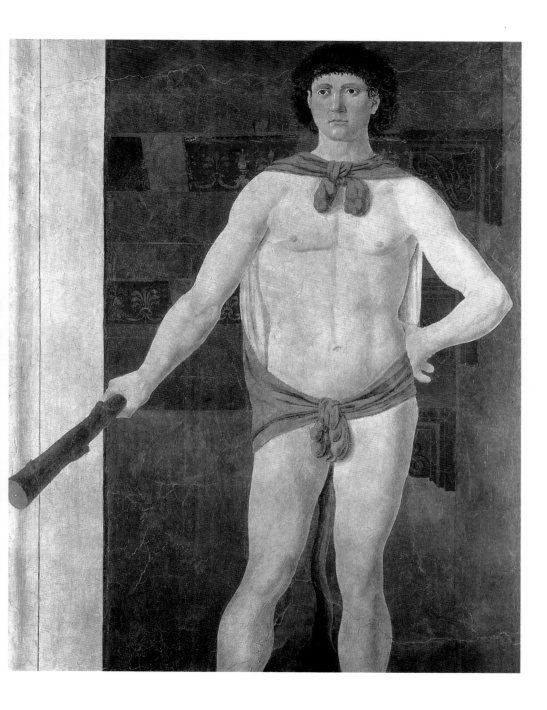

is known not because of a document of payment to Piero but as a result of one to Giovanni Santi (*c.*1435/40–94), the father of Raphael. Santi was a painter-poet of sorts, a native of Urbino and a 'familiar' at the Montefeltro court. The document concerns Santi's reimbursement for ten *bolognini* to cover expenses for 'Master Piero of Borgo who came to look at the panel to make it, at the expense of the fraternity' ('*maestro Piero dal Borgo ch'era venuto a vedere la taula per farla a conto del la fraternità*'). Piero thus went to Urbino to advise on the panel for a new altarpiece for the meeting house of the organization. The Florentine painter Paolo Uccello had been commissioned to do the altarpiece in 1465, and he worked for the confraternity until 1468 but got no further than producing a predella. Famous today in its own right, the predella is made up of a sequence of six lively scenes recounting the widely known story

of the *Miracle of the Profaned Host* (164). A Jewish family buys a consecrated host and attacks it with knives, so the story goes, attempting to re-enact the death of Christ by 'murdering' it. The miraculous wafer thereupon bleeds, the family is discovered and arrested and then burnt at the stake. The host is salvaged and later administered to a dying woman. This story is one of a number of such anti-Jewish myths that circulated throughout Europe from the thirteenth century on. This one was very widespread. Said to have taken place in Paris, it was recorded in the early fourteenth-century Italian chronicles of Giovanni Villani and later in the century also used as the basis for a religious play presented to the populace at large as part of religious festivals.

For some reason Uccello seems to have displeased the confraternity members and was dismissed, after which Piero was called in. He

164
Paolo Uccello, *Miracle of the Profaned Host*, predella of the *Corpus Domini Altarpiece*, 1465–8. Tempera on panel; 33 × 351 cm, 13 × 138$\frac{1}{8}$ in. Galleria Nazionale delle Marche, Urbino

may have been asked to make a judgement (*stima*) about the altarpiece, or he may have been asked to finish the task himself. In the event, the confraternity's final resolution was to commission the Flemish painter Joos van Ghent (active *c.*1460–80) to complete the *Communion of the Apostles* (165), which he did in 1474. The subject – a moment during the Last Supper, when Christ established the sacrament of Holy Communion – was still quite rare in Italian art, although it had been depicted earlier by Fra Angelico in a fresco in the San Marco priory in Florence (166). Federico da Montefeltro was a member of the confraternity (he appears in the altarpiece, in profile on the right, along with other members of his family), and his first personal contact with Piero could have been related to this occasion. There is a flattering reference in a court poem to a portrait of the count by Piero that might have dated from a few

years earlier. On the other hand, it is possible that they had met in the previous decade while Piero was working for Ottaviano Ubaldini (see Chapter 3). Although there is no way to verify this information, it is clear that Piero's long-standing relationship with Federico was established by the end of the 1460s, for he soon fulfilled some of his most impressive commissions for that great patron.

By the time of Piero's arrival, Federico's cultural activities were in full swing. He was reshaping the city, rebuilding walls and had started the project to reconstruct his palace which is perched on the cliff overlooking Urbino's rugged domain. In the course of the following years, this building became one of the most important monuments of early Renaissance architecture (167). After supplying a model, Luciano Laurana (1420/5–79) was officially hired as supervising architect in 1468. He was the primary planner of the

165
Joos van Ghent,
Communion
of the Apostles,
main panel of
the *Corpus Domini*
Altarpiece,
1474.
Oil on panel;
283·3 × 303·5 cm,
111$\frac{1}{2}$ × 119$\frac{1}{2}$ in.
Galleria Nazionale
delle Marche,
Urbino

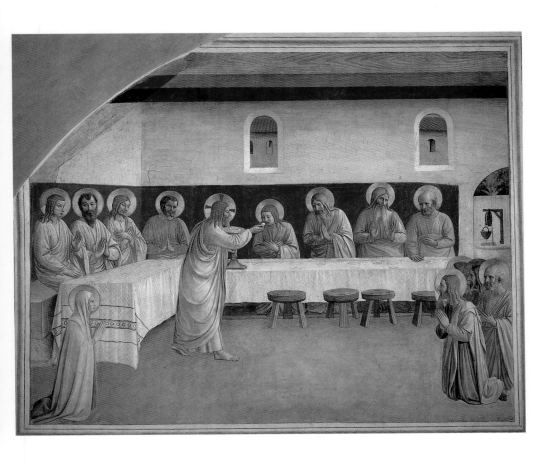

166
Fra Angelico,
Communion
of the Apostles,
c.1440–5.
Fresco.
Museo di
San Marco,
Florence

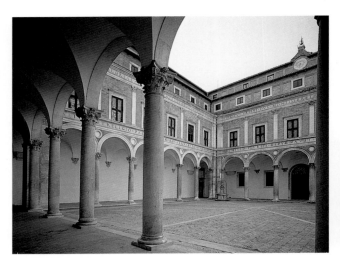

complex structure, which combines bastion-like strength with monastic solemnity and self-important classical grandeur. The pace of court life can be felt in the royal staircase and throne room, a depth of seriousness in the private study and chapel, and the magnanimous relationship between ruler and subjects in the audience room and vestibule with its spectacular view from the balcony (168). What is of interest here is the fact that many of the architectural elements – columns, pilasters, mouldings and other decorations of the courtyard and carved doorways – are so close to those depicted in Piero's earlier paintings that scholars have suggested that he was a motivating force behind the design. The composite Corinthian capitals of Pilate's praetorium in the *Flagellation* (see 62), the columns of Solomon's palace in Arezzo (see 88) and those in the *Montefeltro Altarpiece* (see 176) suggest the conceptual basis for similar elements in the Palazzo Ducale at Urbino. That Piero might have become an adviser to Federico (six or seven years his junior) on such important matters suggests a kind of relationship between artist and patron that was matched only by the relationship of the painter Mantegna with the Gonzaga rulers of Mantua. No ordinary artisan could have risen to such a level of interaction with a ruler, and the implications not only indicate again Piero's relatively high social rank but also that his intelligence and taste brought him special respect. The visual

evidence in his painted works, and the evidence of the treatises on mathematics (see Chapter 6), further confirm these suggestions.

Piero's stay at Urbino was during the most brilliant and yet the most poignant period in Federico da Montefeltro's career. After years of military activity, conflicts and victories, he had become a great lord of his fiefdom, known not only for his tactical expertise in battle but also for the cultural splendours and cultivation of his court. As a professional soldier and as an intellectual, Federico was enormously effective. In establishing the line of succession for his own family, however, he was less successful. His first wife, Gentile Brancaleoni, was childless and had died young. He had legitimated one of his illegitimate sons named Buonconte, but this young man had died of the plague as a teenager in 1458, alongside his cousin, the son of Ottaviano Ubaldini (see Chapter 3). In 1460, after careful consideration, Federico took a second wife, the socially prominent Battista Sforza (1446–72), daughter of Alessandro Sforza, Lord of Pesaro and brother of the Duke of Milan. Battista was well-educated, versed in Latin and poetry, rich, healthy and fourteen years of age. Federico doted on the young woman who was an enormous asset to the court. She was generous and modest, and capable of administering the affairs of state during her husband's frequent absences. Their union produced eight children in eleven years of marriage, but – unfortunately from the parents' point of view – all of them female. At one point, Battista secluded herself in the provincial capital of Gubbio to pray to the local patron St Ubaldo for a son. It is said that she offered her life in return for divine assistance in achieving this goal. Finally, on 25 January 1472, through the saint's intercession (as it was generally believed), Prince Guidobaldo was born. The entire province rejoiced with the couple, and Federico expressed his joy by making donations to several religious societies, including the Confraternity of the Corpus Domini. Their happiness, however, was short-lived. In the spring of the same year, Federico was hired by Florence to put down a rebellion in their subject state of Volterra. He hastily put together quite a large force and with his usual combination of strength and good judgement overpowered the fortified city,

169
Battista Sforza,
c.1472–4.
Tempera and
oil on panel;
47 × 33 cm,
18^5_8 × 13^1_8 in.
Galleria degli
Uffizi, Florence

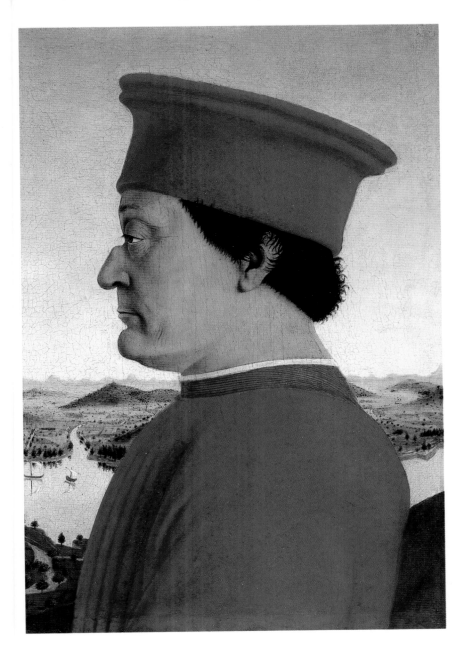

170
*Federico da
Montefeltro,*
*c.*1472–4.
Tempera and
oil on panel;
47 × 33 cm,
$18^5{}_8$ × $13^1{}_8$ in.
Galleria degli
Uffizi, Florence

put a stop to the fighting and as much as possible quelled the pillaging that had started even before his arrival. It was considered a great victory. Reports of the event say that he took no monetary reward for this action, but accepted a triumphal pageant and celebration in Florence that went on for three days. He also received from his Medician employers gifts of land, houses, furnishings and other portable property. But while he was being rewarded, his wife Battista fell gravely ill with pneumonia. Federico rushed to her side and found her alive but no longer able to speak. On 6 July 1472 she succumbed, having reached the age of twenty-six. Her funeral was an extraordinary affair, attended by papal ambassadors, dignitaries and humanists from far and wide. But by her own wish, she was buried without a monument in the church of San Francesco, in the common tomb of the sisters of Santa Chiara of Urbino, dressed in the simple garments of a Franciscan tertiary, the lay religious order to which she had always belonged and which she had generously supported.

Federico was devastated by her death. As letters and poems of consolation poured in, including a heartfelt statement from Pope Sixtus IV himself, he went into retirement. He vowed not to marry again and refused all new military commissions. As he had never done before, he turned away from public life to concentrate on intellectual pursuits. He attended to the building of his palace; he added great volumes to his already famous library; and he com-missioned visible records of his son's auspicious birth, the death of his beloved wife and his own devoted mourning. The astonishing paired double-sided portraits of Federico and Battista by Piero della Francesca are among these works (169, 170).

Although the current frame is a nineteenth-century reconstruction, Piero's portraits of Federico and Battista were made to be hinged together. The landscape backgrounds, seen in the distance and from a great height, continue from one panel to the other. This contiguity is true on both sides of the panels. These characteristics were unique in Italy at the time, and are universally recognized as stemming from new trends in northern European painting,

171
Hans Memling,
Willem Moreel and Barbara van Vlaenderbergh,
c.1470.
Oil on panel;
each panel
37 × 27 cm,
$14^5_8 × 10^5_8$ in.
Musées Royaux des Beaux-Arts de Belgique, Brussels

introduced by the painter Hans Memling (1430/40–94) from Bruges, whose paired portraits of Willem and Barbara Moreel similarly show the couple against a landscape background (171). While following the Flemish model in oil technique, in opening the background on to a landscape and in joining husband and wife together in a single composition, Piero has nonetheless adapted the genre to suit his classical ideals and the solemnity of the occasion. He showed both sitters in absolute profile, without the slightest hint of rotation. Their bodies are cut by the frame at mid-chest in a manner identical to the newly invented three-dimensional sculptured bust portrait, cut off between the shoulder and the elbow and modelled fully in the round. The obvious difference is that the painted version isolates the profile in the manner of an ancient medal or a plaque in low relief. Thus clinging to the picture plane, the undulating surfaces are silhouetted against the open sky, suspended high above the distant landscape. The countryside is more placid and earthy than the stony territory around Urbino, and it looks as if it had been tamed by the benevolent rulers who float above. Cleaned in the early 1990s, these

panels glow with an atmospheric magic that picks out the highlights on every landscape detail and takes the eye to the furthest reaches of the mist-covered hills. These effects of what is called aerial perspective show knowledge of the fact that air is full of vapour and that every droplet of moisture reflects a point of light. Piero again demonstrates his mastery of the oil technique, bringing brilliance and clarity to the relatively near forms – boats on the lake and their reflections – and dissolving fields and hills into a shimmering mass in the distance. Unquestionably, these effects reveal his deep study of northern European painting, some examples of which were in Italian collections; at least one – a bathing scene by Jan van Eyck (now lost) – could be found at the court of Urbino in the collection of Ottaviano Ubaldini.

Both Federico and Battista are dressed in courtly clóthes, he in a red surcoat and bonnet of state, she in a damask-sleeved dress and jewels of enamels and pearls. Her hair is dressed with ribbons and brooches held in place by a tie under her chin. Yet in spite of this festive regalia, there is a prevailing air of sadness as the couple gaze at each other across the empyreal space. Piero knew Battista's face, smooth and fair, perhaps from life but also as it appeared in a few paintings, a sculpture by Francesco Laurana (c.1430–1502; 172) and an eerie, slack-jawed death mask. Federico's face he had before him: the wen-specked cheek and prominent nose scored in 1450 in a jousting accident that also took his right eye. That he took great pains to control the shapes is evident from changes in the outlines now visible under the final layer of paint. No tone, no curve, no strand of hair could be moved without disturbing the balance he has attained. Piero sought not the sparkle of life, but images that would outlast time.

Again in the manner of medals or coins these extraordinary panels have emblematic images on the reverse (173, 174). Both sitters reappear in miniature as full-length figures in compositions consisting of three salient parts. The lowest level represents a moulded marble parapet with chiselled inscriptions of Latin verses. Federico's poem tells of his perpetual fame and how it is equal to

172
Francesco Laurana,
Bust of Battista Sforza,
c.1470–5.
Marble;
h.50·8 cm,
20 in.
Museo
Nazionale
del Bargello,
Florence

CLARVS INSIGNI VEHITVR TRIVMPHO ·
QVEM PAREM SVMMIS DVCIBVS PERHENNIS ·
FAMA VIRTVTVM CELEBRAT DECENTER ·
SCEPTRA TENENTEM

173
*The Triumph
of Federico da
Montefeltro*
(reverse of 170)

QVE MODVM REBVS TENVIT SECVNDIS·
CONIVGIS MAGNI DECORATA RERVM·
·LAVDE GESTARVM VOLITAT PER ORA·
CVNCTA VIRORVM·

174
*The Triumph of
Battista Sforza*
(reverse of 169)

the greatest ancient Roman military leaders. Battista's speaks of how she was eulogized for her modesty in accepting praise for her husband's deeds. The use of the past tense here is one of the reasons her portrait is considered posthumous.

The second realm is the deeply extending landscape background, again continuous between the two panels and seen from on high. The view shows the countryside of the Marches, Federico's territory, in a peaceable, idealized form with gentle hills, winding roads, a lake with an island and boats floating on its glassy surface.

The third and most important part of the image is the flat plateau that stretches across the panels, high above the landscape behind and cut off from the stone parapet in front by jagged folds. There the couple face each other, both enthroned on a type of classical folding stool restricted to the use of people of the highest rank, called a curule chair, placed on a dais mounted on a wheeled cart. Each cart is driven by a winged putto and pulled by striding animals – white stallions (symbols of power) for Federico, and unicorns (symbols of chastity) for Battista. Though the animals are in motion, they confront each other with no possibility of movement. Each of the main characters is accompanied by symbolic figures that personify ideas and attributes. Federico, in full armour and raising his baton in a gesture of command, is crowned with a wreath by a figure of Fortune/Fame, winged and standing on a little globe. Seated at the front of the cart are the cardinal virtues that characterize his reign: Justice with her scales, Prudence with a mirror, Fortitude with a broken column, and Temperance, who turns her back. Battista is shown reading – an extraordinary compliment, for lay women were rarely shown in intellectual pursuits at this time. Her companions are the theological virtues of Faith (with the cross, chalice and wafer), Charity (with the pelican), Chastity (in white) and Modesty (covered in drapery). Each of these miniature figures is exquisitely detailed, painted with radiant colours and highlights that intensify the variety of textures. The overall configurations have been compared to scenes from the *Triumphs of the Virtues*, poems by Petrarch that were often illustrated in the fifteenth century (175).

But more important is the reference to a territory described by writers from Alain de Lille in the early thirteenth century to Ariosto in the early sixteenth: the realm of Fortune, difficult to enter, accessible only to those whose honour, courage and virtue make them worthy of her gifts. It is here that Federico and Battista are allowed to dwell. For all of this praise, however, the eulogies remain curiously abstract. No names are mentioned; no armorial emblems appear. Identification on both sides of the diptych is purely visual. No more devoted memorial could have been created for a proud, sad man who was openly committed to the memory of a partner with whom he shared an equal measure of love and respect.

175
Apollonia di Giovanni,
The Triumph of Chastity,
from Petrarch's
Trionfi,
folio 78v.
1442.
Biblioteca Medicea–Laurenziana, Florence

How the diptych was displayed has always been a mystery. Suggestions include its being placed on a table where both sides could be seen by walking about. Another idea has it on permanent display in an opening in the wall between the audience room in the Palazzo Ducale and another space later made into a chapel. Since it must have been hinged, and judging by its relatively small scale, a more plausible idea is that it was opened to its different sides on different occasions, and was therefore something of a keepsake for private reflection. By the end of the sixteenth century it was in the 'Large Wardrobe' or collection gallery along with other works of art commemorating the couple.

The second painting Federico da Montefeltro commissioned from Piero was an altarpiece of substantial size (2·48 x 1·70 m; 8 ft 7 in x 5 ft 7 in), today in the Brera Gallery in Milan (176), transported there by Napoleon. When it was first rediscovered in the later nineteenth century, the painting was so dull looking that it was attributed to a little-known painter called Fra Carnevale (Bartolomeo di Giovanni Corradini; active 1445–84). At that point, no one knew of Piero's use of the oil technique. When the panel was cleaned and restored in the mid-1990s, a dazzling range of pictorial effects emerged: brilliant enamel-like colours, transparencies of crystal and gauze, gold-shot fabrics, reflective surfaces of polished metal and marble, and glittering precious stones. During the cleaning the modern frame was removed and it was discovered that the wood had been slightly shaved on the right-hand side. This disfigurement had cut off details on the edge and made the composition asymmetrical. It was also observed that the wooden planks of the panel are joined not vertically in the usual Italian way but horizontally, in the manner of northern painting, and that the bottom plank is lost. Originally, therefore, there was a larger area of floor in the foreground than there is now.

176
Montefeltro Altarpiece, c.1472–4. Oil on panel; 248 × 170 cm, 97$\frac{5}{8}$ × 66$\frac{7}{8}$ in. Pinacoteca di Brera, Milan

The subject is that of any number of other devotional images, a *sacra conversazione,* or the Madonna and Child enthroned with flanking saints and, in this case, four angels at the back. None of the figures has a halo. Mary sits on a backless throne, her hands joined in prayer over the body of the Christ Child who lies asleep across her lap. All but one of the saints are easy to recognize: starting at the left we have John the Baptist, St Bernardino of Siena, St Jerome, St Francis and St Peter Martyr. While the bearded gentleman holding a book at the right has no specific attributes, he most probably is St John the Evangelist, balancing the other John at the opposite end. The tattered nature of the penitential saints' clothes contrasts sharply with the richness of the robes worn by the angels. In the foreground, Federico, again in armour, kneels in the pose of a donor, his hands clasped in prayer before him. The group is set in the interior of a large church of which portions of the wall-panelling and the vault are visible. A marvellous inverted shell forms part of

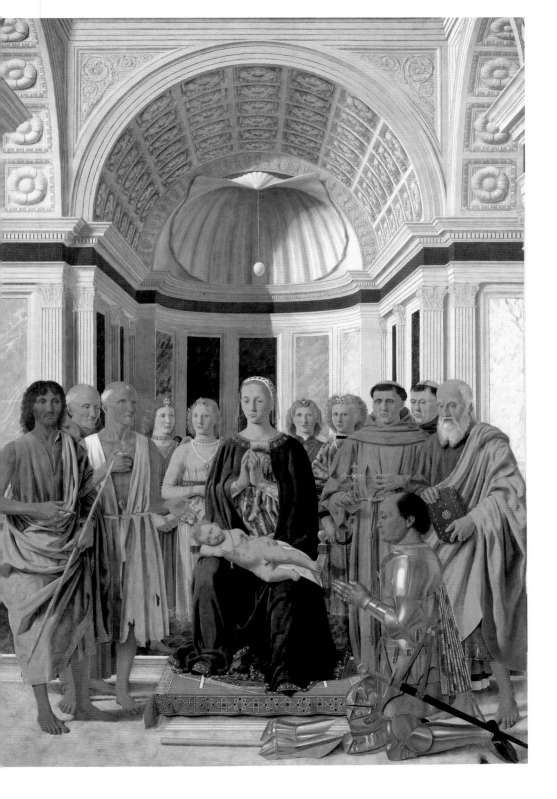

177
Jan van Eyck,
Madonna
in a Church,
*c.*1425.
Oil on panel;
32 × 14 cm,
$12^5{}_8 \times 5^1{}_2$ in.
Gemäldegalerie,
Berlin

the decoration of the back of the apse, and from its apex is suspended a solitary egg hanging from a golden chain. Because there is no figure of Battista, the painting is thought to date from after her death in July 1472. And because Federico wears no signs of the honours he received in August 1474, it was probably completed before that date. Quite possibly the painting was destined for the altar in Federico's future tomb chapel.

Although the theme is traditional, everything else about the work is extraordinary. It is Piero's first so-called *pala,* a term of unknown origin used to designate the new Renaissance form of the altarpiece. Gone is the gothic frame with pinnacles; gone are the many separate panels (see 156). Instead the *pala* is a single vertical rectangle, without predella, and with a painted field that is spatially unified. This format would become standard throughout Italy in the years to come. The most spectacular innovation is, in fact, the spacious, light-filled building. It stems from an iconographic type known as the 'Madonna in a Church', familiar in northern art: Jan van Eyck had painted more than one such image before 1440 (177). The dimensions of this version make the symbolism plain. An oversize figure of the Virgin dominates an architectural setting that is less than half her scale. She is literally Maria Ecclesia, an updated version of the hieratic late medieval figure of Mary (with or without the Christ Child) framed by a miniature *aedicula* or tabernacle. Piero's image shows essentially the same subject, but his is the first instance of such an interior setting in Italy, and the first anywhere to show the church in the newly conceived, monumental Renaissance style. A further difference is that the figures no longer involve an irrational leap of scale; he has created merely the impression that they somehow dominate the grand building. How did Piero create this effect? The answer lies again in reconstructing the geometry of the space. This example takes more concentration than usual to discern, but as always Piero provided enough clues to follow his rationale. Today the task is perhaps a little more difficult than it was originally, since the edge of the right-hand side has been lost. We will presently see why its survival would have made the reconstruction somewhat easier.

Another problem is that the no-man's-land of space that meets the picture plane (or would have met it, if we still had the missing plank of wood) is not articulated with pavement designs like that in the *Flagellation* (see 62), which would have allowed us to start a perspective reconstruction and measure the depth of the floor. There are, in fact, very few lines in the composition that recede directly into the depth (these are called orthogonals). The arches of the transept interrupt the porphyry frieze, and the receding lines of the Virgin's dais are partially masked. Yet if one looks at the level of John the Baptist's hip on the left, one finds the base of a pier at the corner of the nave and the transept. Following the edge of this pier to its top, the corner of the frieze above the pier comes into view. Before the shaving, these elements would have been matched on the right-hand side. Astonishingly, these meagre details make it possible to interpret the space. They indicate that the spectator is placed towards the front of a long nave at the end of which are Mary and her entourage, with the crossing of the transept, the forechoir and apse behind them (178).

The sanctuary area is remarkable: a long, coffered barrel vault is enhanced with gold-flecked rosettes; the walls are articulated with finely carved fluted Corinthian pilasters framing variegated marble panels that change colour according to the flow of light. As opposed to the front part of the church, this space has unbroken orthogonals that make it possible to locate the vanishing point at just about the level of Mary's eyes. The real depth of the barrel vault can be gauged in the following way. Estimating the figures to be average in height (about 170 cm or 5 ft 8 in), the height of the crossing piers can be judged at about 4·3 m (14 ft). In relation to the piers, the exceptionally large forward-facing coffers on the transept arches on either side of the crossing are calculated at about 230 cm square (or 7 $\frac{1}{2}$ ft). Assuming that all the coffers of the ceiling are the same size, this measurement can be multiplied by six (the number of rows of coffers in the barrel vault) to produce the length of the coffered barrel vault. The result is approximately 15 m (or 45 ft). The design of the architecture, with its horizontal frieze dramatically foreshortened, further enhances the impression of depth, and the overall effect of the perspective projection is to create the illusion of a miniaturized structure. By placing natural-sized figures against what appears to be dwarfed architecture, Piero makes them seem (without their actually being so) too big for the building, thereby evoking the iconography of the Maria Ecclesia. In other words Piero once again uses the rational science of geometry to create an irrational effect. It may have been on the basis of this incredible manipulation of perspective that Federico requested the theoretical study Piero later provided (see Chapter 6).

A shadow falls over the left side of the forechoir and the apse, but a beam of light illuminates not only the right side but the suspended egg as well. This uncanny ovoid shape is echoed in the larger oval of the Madonna's head that looks as though it were directly below it. However, from the reconstruction we know that the apse is actually far behind, and although it is shaped like a hen's egg, it is probably that of a larger bird such as an ostrich. While the use of eggs as church furnishings may strike the modern viewer as strange, it is part of a long tradition. Ancient graves often contain eggs as

178
Hypothetical plan of the *Montefeltro Altarpiece* (after Meiss)

signs of regeneration and immortality, and in other situations they can symbolize fertility. In a Christian context they came to stand for Mary's fecundity as well as Christ's resurrection, and it is for this reason that eggs, and particularly the precious ostrich egg, often hang in chapels and churches. What makes Piero's egg different from these examples is its simplicity. In reality they are usually encased in metal supports, combined with oil lamps and discs to keep rodents away. This type can be seen in the central panel of the *San Zeno Altarpiece* by Mantegna (179). Piero's egg has none of this extra apparatus; it appears to hang quite simply, probably from a small piece of wood inserted vertically through a hole at the top and then turned horizontally inside the egg, and tied to the supporting chain. This simple method is characteristic of Piero because the lack of decoration emphasizes its geometric shape.

**179
Andrea
Mantegna,**
*Virgin and
Child with
Saints* (the
*San Zeno
Altarpiece*),
1456–9.
Tempera
on panel;
212 × 125 cm,
83¹⁄₂ × 29¹⁄₄ in.
San Zeno,
Verona

Mary joins her hands above the Christ Child, who lies asleep across her ample lap. The compositional thrust of his somnolent pose unites with Federico's arms and sword to form the only diagonal disturbance in the otherwise vertical composition. With sunken eyes and down-turned mouth, Christ looks gravely burdened as he rests his head uncomfortably on one arm and flexes a knee for balance. The overall mood of the scene, in spite of brilliant colours and shining light, is in fact one of quiet, even melancholy solemnity. In such an atmosphere, it comes as no surprise that the motif of the sleeping Christ Child is a proleptic reference to the death of the Saviour.

Other details emphasize the allusion to Christ's sacrifice. Around the child's neck hangs a circle of beads strung with a tiny ball of crystal and a sizeable amulet of uncut coral (180). These semiprecious stones have traditionally been worn by infants as protection against illness and the 'evil eye' – the belief being that both its precarious state of health and its moral innocence make every newborn particularly vulnerable to attack by the devil. Such amulets, worn at the neck or wrist, are thus meant to help protect the child from harm both physically and spiritually. The qualities of the materials also connect them physically and spiritually to

Christ's Passion. Rock crystal, as mentioned before, symbolizes purity; and red coral from the sea, the blood of Christ's sacrifice. Indeed, in the natural branching of the coral, the tree of the Crucifixion itself was often recognized and coral was frequently used to represent the cross in larger, more elaborate settings. Worn by the Christ Child, who came to earth himself to save humanity from evil, the necklace reinforces the reference in his pose to his later death and entombment.

What is unusual, it might be said unnatural, about the inclusion of the traditional piece of coral, and what first calls attention to it, is

180
Montefeltro Altarpiece (detail of 176, showing coral amulet)

181
Diagram of the pulmonary tree

the gravity-defying position of the amulet: it does not hang vertically at the lowest point of the necklace's loop but seems miraculously suspended and turned horizontally, so that it lies directly over Christ's breastbone. Moreover, when viewed close-up, the branch of coral bears a close resemblance to the human pulmonary tree, with the trachea, main stem bronchi and secondary bronchi visible (181). (These observations were made by a medical specialist who has studied the painting and who noted that the right bronchus branches at an angle commonly seen in children, which is less horizontal than that found in adults.) Piero thus seems to have

intended the coral piece to take the shape, rotation and anatomical location of the pulmonary tree inside the body over which it hangs. He has, at the same time, represented a natural phenomenon: a piece of coral supposedly found with this auspicious shape used for a magic amulet.

In considering how Piero might have acquired this anatomical information, several points are relevant. By the 1470s, public autopsies on human cadavers were held annually, mandated for public instruction in Italy in both civil and university statutes. The bodies used were either those of executed criminals or people who died without explanation. A major goal of medical experts was to settle the question of the seat of human vitality, *ie* whether it could be found in the head (brain) or the heart (thorax). Following the classical texts of Galen and Hippocrates, Avicenna in the eleventh century had said it was the brain, while Averroes, following Aristotle, later said it was the heart. Around 1400 Mondino de' Liuzzi tried to resolve the problem by dividing the body into three areas or 'ventricles'. The upper ventricle, whose organ was the brain, he said contained the *anima* ('soul'); the middle chamber within the thoracic cavity (heart, lungs and arteries) contained the *spiritus* ('spirit'); and the inferior ventricle, the organs of the liver and viscera, contained the 'natural members'. The theory of spirits, in which the thoracic cavity was the generating site of breath and hence of the 'vital virtue' that maintains life itself, held sway throughout the Renaissance. That the theory was known in Piero's time is proved by Leonardo da Vinci who in his notebooks on human anatomy, written in the last quarter of the fifteenth century, describes and discusses the problem in exactly these terms. Finally, Piero could have observed the real thoracic structure quite readily. From a practical point of view the pulmonary tree is so large and easy to find within the chest that an inexperienced dissector could do so. It is quite red in colour, and its overall cartilaginous structure is resistant to post-mortem changes outside the body for days or weeks without refrigeration or preservatives. Thus, even if Piero's knowledge of anatomy were not otherwise extensive, he could have seen and inspected a pulmonary tree without difficulty. What he

represented here, a minutely observed segmental bronchial division, red in colour, is anatomically correct.

According to this interpretation, the meaning Piero gives to this naturalistic symbol within the painting constitutes one of his most original extensions of tradition. For at least a century the Christ Child had been depicted with all his external body parts exposed to symbolize his state of being simultaneously human and divine. So too, Piero's entirely nude divine child asserts his physical reality. By positioning the naturalistic but uncanny charm over the analogous internal organ of the sleeping infant, Piero alludes to the lungs from whence Christ breathed his last, demonstrating that Christ died a real, physical death. Like the nudity, the anatomical form of the amulet declares the infant to be both flesh and spirit.

As witnesses to the coming sacrifice, the six male saints that surround the dais represent pillars of the Church, a theological guard of honour to Ecclesia and the Christ Child. They all concentrate on the image of future salvation which they have been called upon to protect. This is the august group before which Federico da Montefeltro kneels in an unbending pose. Given the full ecclesiastical character of the setting, the most striking aspect of his appearance is his gleaming suit of armour. A hundred years earlier frescos in burial chapels, such as one in the Basilica del Santo in Padua, had shown north Italian princely warriors coming before the Madonna dressed in battle gear (182). But those fourteenth-century soldiers had had a different air about them. They all came in the company of patrons, usually military saints, to implore for help and protection in their martial deeds. Alessandro Sforza, soon to be Federico's father-in-law, had commissioned a small private altarpiece from Rogier van der Weyden and his workshop during his eight-month stay in France and the Netherlands in 1458, in which he had himself represented fully armed and kneeling before the Crucifixion (183). In the painting his helmet with a large armorial bearing is behind him on the ground. He is accompanied by his daughter Battista, soon to be Federico's bride, and her brother Costanzo, with only a low hillock separating them from the

182
Altichiero
da Zevio,
Bonifacio Lupi
and his Wife
Presented to
the Virgin and
Child,
1372–9.
Fresco.
Cappella di
San Giacomo,
Basilica del
Santo, Padua

183
Workshop of
Rogier van
der Weyden,
Crucifixion,
central panel
of the *Sforza*
Altarpiece,
1458.
Oil on panel;
54 × 46 cm,
21$^1_4$ × 18$^1_8$ in.
Musées
Royaux des
Beaux-Arts de
Belgique,
Brussels

biblical scene. Piero was probably familiar both with the fourteenth-century tradition and with the little Sforza painting (also no doubt known by Federico), and respectfully took it as the starting point for his own composition.

Yet neither Federico's gaze nor his pose imply such supplication. He is not presented by a patron, and he does not look at the Madonna. He is, in fact, emotionally quite independent. His profile head is the same as in the Uffizi portrait (see 170) – without the hat and with fewer warts, but just about equal in size. Piero has also shown the same suit of amour as on the back of that painting, but now with every detail technically correct and fully developed. There is even a reflection of an arched window that lets light into the basilica on Federico's shoulder-guard, worn like a badge upon his sleeve. The point of this military garb becomes clear in the way Piero has arranged Federico's helmet (where his praying arms and knee-guard are reflected), mitten-shaped gauntlets and commander's baton in front of the Madonna. With great formality, they are placed like votive offerings before her, Federico's pledge of protection to Mary and her Son.

This singular reinterpretation of the donor figure brings with it new levels of personal meaning. In May of 1474, Federico broke his self-imposed retirement to go to Rome, where he was welcomed by the pope but, surprisingly, received an insulting rebuff from the College of Cardinals. The object of his visit was to petition for a marriage between his daughter Giovanna and Giovanni della Rovere, one of the pope's nephews. Federico and Sixtus were on very good terms, and the idea of joining their families was agreeable to both parties. Federico went so far as to offer the vicariates of Senigallia and Mondavio to his prospective son-in-law. The project failed, however, because, in contrast to the pope's amicable feelings, most if not all of the cardinals harboured a deep distrust of Federico. They doubted his allegiance because of his anti-papal activities in 1469 when he commanded the force that attacked and defeated the army of Paul II in the Battle of Rimini. Nevertheless, when Federico arrived in Rome Sixtus ignored the cardinals' complaints and housed him at

San Pietro in Vincoli in the quarters of another nephew, Cardinal Giuliano della Rovere, the future Pope Julius II. On 28 May, when he was received by the papal court, he was seated on the benches immediately below the last cardinal. This was a signal place of honour, usually reserved for the eldest sons of kings. The cardinals were scandalized and angrily voiced their objections. In the end, they won out by voting down the marriage and Federico left Rome empty-handed.

Federico's petition came in the midst of an inflammatory political situation that for almost two years had threatened the pope's temporal power and prestige. The cities of Umbria, mainly Todi, Spoleto and Città di Castello, were in rebellion against papal ownership. While Federico was in Rome, murderous rioting broke out in Todi and rapidly spread. Sixtus dispatched the papal army under command of the warrior-cardinal Giuliano. Bloody sieges soon quelled Todi and Spoleto, but when an attack was launched against Città di Castello, the tyrant Niccolò Vitelli held his ground. What was worse, Vitelli negotiated military support from the Duke of Milan and the Medici. A costly and embarrassing stalemate continued through July and August of 1474.

In these critical circumstances, Sixtus was able to take matters into his own hands and, in spite of the fact that Federico was related to the Duke of Milan and a recent employee of the Medici in Florence, the pope summoned Federico to his aid. The count arrived back in Rome on 20 August with more than two thousand horsemen. The next day in a magnificent ceremony at St Peter's he was heaped with honours during the Pontifical Mass. First Sixtus created him Knight of St Peter; after the Gloria he was led from his place at the left of the pope to kneel at the foot of the throne. The pope presented him with a blessed sword and commanded him to fight for the Church and against the enemies of Christ's cross. The sword was buckled in place and golden spurs were strapped to his feet. Federico then drew the sword from its scabbard and brandished it three times in the air. After the reading of the Epistle, he again came forward to make his oath of fidelity. The pope then raised his rank

and invested him as Duke of Urbino, pronounced him Gonfaloniere (honorary flag-bearer) of the Holy Roman Church, and made him general of a new Vatican league. Before this ceremony took place, King Ferdinand of Naples, another of the pope's unwavering allies with whom Federico had been staying most of the summer, had decorated him with the Royal Order of the Ermine. On 18 August he had been unanimously elected to the Order of the Garter, England's highest military honour. The College of Cardinals now recanted its decision and voted in favour of the Montefeltro–della Rovere marriage. The banns were announced on 22 August, the day after the investiture. Two days later Federico arrived with his army at the papal camp outside the walls of Città di Castello. Reports of his encounter say that the news of Federico's mere physical presence broke the deadlock. Vitelli capitulated without bloodshed and was taken back to Rome. A great procession formed with Federico at its head, re-entering Rome through the Porta Flaminia on 9 September.

That so many honours were heaped upon Federico simultaneously implies much preparation and co-operation beforehand. Yet any hint of the new dignities was tactfully omitted from his altarpiece, and the emphasis was placed on his trustworthiness and fidelity. Herein lies the reason Piero took such pains to arrange the Maria Ecclesia symbolism. Overlaying conventional religious subject matter, the painting displays Federico as a new kind of Christian knight, boldly pledging to the Church, along with his personal piety, his entire physical force and military prowess. Piero portrays him as an eternal sentinel guarding the ecclesiastic organization of Christianity, creating for Federico a visual pledge of fidelity to the mission he hoped would soon be conferred on him publicly, as official Defender of the Faith.

The history of the altarpiece is obscure until the nineteenth century, when it was removed by Napoleon's emissaries from the small Observant Franciscan church of San Donato on the outskirts of Urbino. This is where Federico had originally been provisionally buried, pending the construction of a more elaborate tomb chapel

184
Attributed to Girolamo Genga, Plan for the interior of San Bernardino, after 1545. Pen, ink and wash; 28·8 × 21·1 cm, 11$^1$⁄$_8$ × 8$^1$⁄$_4$ in. Galleria degli Uffizi, Florence

in what was to be the nearby church of San Bernardino. However, at the time of Federico's death in 1482 the building was probably not yet started, and his remains stayed in San Donato until the mid-sixteenth century. A drawing attributed to Girolamo Genga (1476–1551) shows what the apse of San Bernardino was to have looked like, with the painting over the altar (184). When it was first photographed, the altarpiece was covered with grime and soot, and the connection with Piero had long been forgotten. As late as the 1950s, when the influential English art historian Kenneth Clark published his book on Piero, the work was re-attributed to the artist but still considered an example of his loss of interest in painting, an almost negligible piece. It awaited the late twentieth-century techniques of restoration to bring it back into the light and to reveal it as one of Piero's greatest technical triumphs.

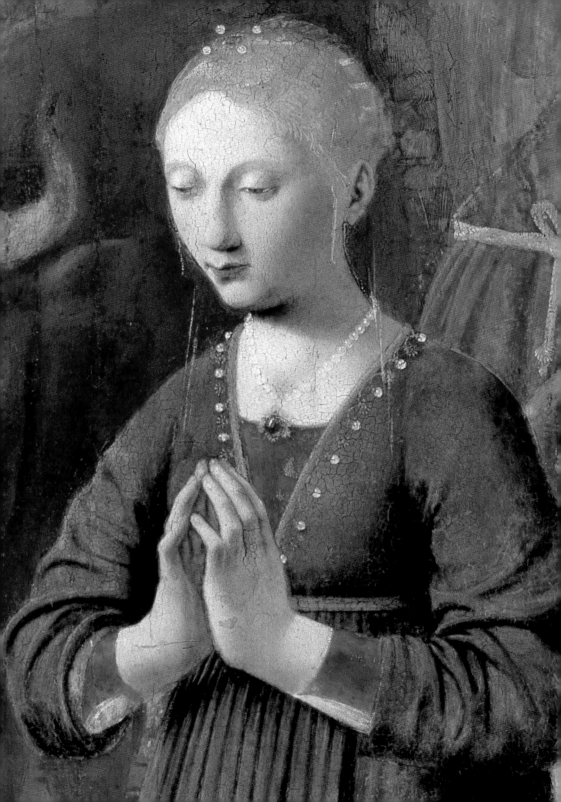

185
Virgin Mary,
detail from the
Nativity (193)

Piero spent most of the last twenty years of his life living at home
in Sansepolcro. Regarded as a distinguished citizen, he participated
actively in the government and religious life of the community.
In February 1474 he was elected director of works on the town's
fortification walls, and the next year he became a prior of the
Confraternity of San Bartolomeo, the city's most important
charitable organization (he was continuously re-elected until
1482). During the same period he was repeatedly appointed as a
city councillor for successive terms of four months. Along with his
brothers, Marco and Antonio, he purchased several properties in
and around Sansepolcro, probably as investments, and he provided
his nieces with good dowries. He painted a single figure in fresco
for the Confraternity of the Misericordia in 1478 (now lost), and in
1480 he was nominated as one of the auditors of the commune. In
April 1482 he rented a furnished room with use of a kitchen garden
in Rimini, where he can be imagined going for a time to relax and
be by the sea. In 1486 he and his brothers hired proxies in Arezzo
to help in obtaining payment for work on the San Francesco cycle,
still not received in full after more than twenty years. In July 1487
Piero drafted his will in his own hand, saying that he was of sound
mind, intellect and body ('*sano di mente, d'intelletto e di corpo*').
The document was copied officially into Latin by a notary. Although
Piero seems to have lost his sight just before he died in 1492, the
statement discredits the story that he had gone blind much earlier.

It might be conjectured that having completed his treatise on
perspective sometime in the 1470s (see Chapter 6), Piero had
pushed his interest in problems of visual abstraction to the limit.
Yet a loss of conviction in the usefulness of perspective need not
be assumed in suggesting that in what are probably his two last
paintings Piero gives evidence of seeking another kind of reality,
still more mysterious and ambiguous than in his earlier work.

The new approach is seen in a small panel of the *Madonna and Child with Two Angels* (also known as the *Senigallia Madonna*) now in the Galleria Nazionale delle Marche, Urbino (186). It is about a quarter of the size of the *Montefeltro Altarpiece* (see 176), and therefore clearly created for private devotion. The painting was found and recorded for the first time in 1822 in Santa Maria degli Angeli, an Observant Franciscan convent outside what is now the resort town of Senigallia, on the Adriatic coast between Pesaro and Ancona. In 1462 the Senigallia property had been wrested in battle from Sigismondo Malatesta by Federico da Montefeltro. Twelve years later, in October 1474, the duke gave it to Giovanni della Rovere, along with the vicariate of nearby Mondavio, to celebrate Giovanni's betrothal to his daughter Giovanna (see Chapter 7). The nephew of the pope was sixteen at the time and his fiancée was eleven or twelve. The young man was appointed *prefetto* (mayor) of Rome the following year to help consolidate his uncle's power, then moved to Urbino where for four years he was schooled in the art of war and learning at Federico's court. In 1478 Giovanni and Giovanna, both by now a little more mature, returned to the papal orbit in Rome and were finally married. They were said to be an admirable couple, known for their piety and seriousness. They stayed in Rome while the Rocca (fortress/palace) of Senigallia (187) was refurbished, moving there in about 1480 to preside over the territory. Most probably, Piero's small *Madonna* was painted around 1478–80 – not for the convent where it was found, which was in a state of disrepair at the time and not refurbished until after 1491, but for the couple's new living quarters in the Rocca. It could have been commissioned by Federico as a gift, as has been suggested; or, having been introduced to Piero by the duke, the couple themselves might have ordered it as a votive image. As was also to be the case with her brother Guidobaldo, Giovanna was concerned about offspring; indeed the couple had no children until almost ten years after their wedding. The panel is small enough for Piero to have painted it wherever he was and had it sent to them; or, they could easily have taken it with them to Senigallia if they had acquired it before they moved. The work was probably transferred

186
Madonna and Child with Two Angels (the *Senigallia Madonna*), 1478–80. Oil on panel; 61×53.5 cm, 24×21 in. Galleria Nazionale delle Marche, Urbino

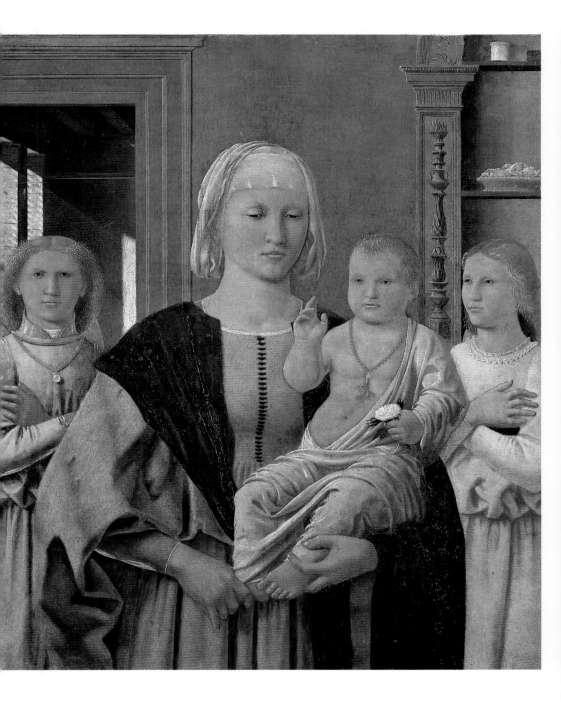

187
La Rocca,
Senigallia

to the convent at a much later date. Following its rediscovery in the nineteenth century, it was taken to the Palazzo Ducale in Urbino, and cleaned and reframed in the early 1990s.

What is new and surprising about the *Senigallia Madonna* is its off-balance, asymmetrical composition. Retaining the elegant classical style of the architecture of the *Montefeltro Altarpiece*, the setting is an interior in which the space can no longer be plotted. Since our view is cut off on all four sides, it is genuinely ambiguous. Nowhere in the composition do the vertical forms contact the horizontals of ground or ceiling: the arched wall niche on the right and the open doorway on the left are severed by the frame. As a result, the forms seem to hover, encased in a sacred space without clear limits.

The figures of the Madonna and Child are among the most intro-verted and rigid in Piero's long career. Broadly proportioned and modestly veiled with a transparent cloth edged with indescribably delicate stitching, Mary holds the infant effortlessly with one arm,

her eyes lowered as she fondles his feet. Christ seems almost the embodiment of the Man-God, posed in an erect seated position beyond his years, raising his right hand in a pontifical blessing. His tightly knit features play between youth and age, with too-small eyes that focus out beyond the spectator. The details of the image suggest an interpretation that ties together Christ's incarnation, birth and Passion, as in other works by Piero. He is draped in an unusual toga-like garment that alludes to the dress of ancient philosopher-teachers. The image reflects the way Jesus appears in Early Christian iconography: young and often preaching, as on an early fourth-century sarcophagus from Rome where he is depicted delivering the Sermon on the Mount (188). In the painting, the infant bares the side of his torso that will in later life receive the wound from the centurion's spear as he hangs on the cross. The same pulmonary tree-shaped amulet seen in the *Montefeltro Altarpiece* (see 180, 181) hangs at the bottom of the string of coral beads. Again, it rests against Christ's chest, and can be interpreted as foreshadowing his Passion. The white rose Christ grasps in his left hand offers a similar meaning: a familiar symbol of purity, it also bears the thorns of his sacrifice.

188
Sermon on the Mount, c.300–10. Fragment of a marble sarcophagus; l.114 cm, 44⅞ in. Museo Nazionale delle Terme, Rome

The two attendant angels standing behind the main figures cross their arms in a gesture of veneration. They are differentiated in rank and mood. The one in the position of honour to Mary's right (189), perhaps an archangel, is the more vigorous, contacting the worshipper directly with his gaze. His garment is decorated with gold embroidered epaulettes and a hard gold collar. His heavy braided gold necklace with a large pearl pendant reveals his high position. Piero has arranged the crisply curling ends of his hair to join his necklace in creating a circle that replaces the halo – absent, as with all the other figures – around his head. His penetrating gaze seems at once to communicate the arrival of the Saviour while also expressing foreboding of his fate to come. The angel on the viewer's right is of lower rank. He is bedecked more simply with one strand of pearls and a frilled neckline, and his glance and attention are directed outside the picture towards the left, implying more than one worshipper at the scene.

The partially visible niche behind the second angel, with its classicizing motifs, at first seems no more than a secular detail. But the carved decoration simulated on the pilaster-shaped jamb is in the form of a tall candelabrum – the burning flame on the top suggesting the Paschal candlestick that burns throughout Holy Week, bearing messages of both the tragedy of Christ's Crucifixion and the hope for salvation. Two items on the shelves of the niche offer a similar meaning: the sewing basket full of cloth refers to Mary's duties making veils in the temple, and to the apocryphal story that she also had already sewn the linen of Christ's shroud during his infancy; and the small round box on the top shelf fore-shadows the shape of a liturgical pyx, container for the wafer of the host.

189
An angel, detail from the *Senigallia Madonna* (186)

The doorway on the left first alludes to the Marian epithet of the *Porta Coeli*, or Mary as the 'door to heaven'. What is extraordinary, at least for Piero, is that it gives access to a view of a second room into which light falls at an oblique angle. The effect is a reworking of a motif adapted from Flemish art, developed earlier in the century in such works as the Turin Book of Hours by Jan van Eyck

190
Jan van Eyck,
*Birth of St John
the Baptist*,
folio 93v,
the Turin
Hours,
c.1422.
28·4 × 20·5 cm,
11 1/8 × 8 in
(page).
Museo Civico,
Turin

(190). The motif, in a fairly matter-of-fact form, appears in Florentine art of the generation before Piero, for example in Fra Filippo Lippi's *Annunciation* (191). Piero takes over the motif but gives the inner room its own poetry. He creates a specific source of light in the form of two shuttered glass windows, the light from only one of which, because of the angle of vision, is reflected on the back wall of the room. Although the Holy Family lived in Jerusalem after Jesus was born, some scholars have claimed that the back room refers to Mary's bedchamber in the Holy House of Nazareth, where the Annunciation took place. In fact, the physical remains of this building were long since said to have been miraculously transported by angels, first from Nazareth to the coast of Yugoslavia (in 1291), and thence to Loreto in 1294 (192), where Piero had worked in his youth, less than 50 km (31 miles) south of Senigallia. If this is the story alluded to here, the archangel staring at the current worshipper would refer to the Annunciation that occurred in the Holy House. Rather than creating a narrative situation, however, Piero's unmeasurable space has given form to a mystery. Light is represented in the Virgin's bedroom in three parts, entering from the two windows and reflected on the wall, in an apparent reference to the solemn essence of the Trinity, passing miraculously from heaven to earth at the moment of incarnation. The presence of the angel would seem to confirm the light as an allusion to Father, Son and Holy Ghost, simultaneously present at that moment. The room itself, moreover, is full of life, as the light gives vitality to the motes of dust and molecules of moisture that fill the void of the atmosphere. Again, Piero makes a natural phenomenon signify spiritual miracles.

Even if Piero learned these visual effects from northern European art, as the small scale of the painting and its materials (the work is done in oil on walnut wood, a northern usage) would seem to suggest, no northern painting ever looked like this one – weighty in its weightlessness, sombre in its brilliance, spacious in its interpenetrating spaces, and divinely beautiful in its touches of unidealized earthiness.

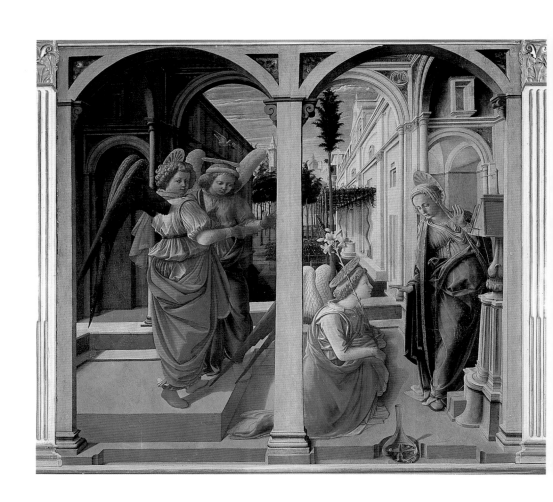

When Federico da Montefeltro died in 1482, his son Guidobaldo was ten years old. Ottaviano Ubaldini, who had been at Federico's side throughout his career, thereafter took the position of regent of the state. (See Chapter 3 for a discussion of Ottaviano's ties to Piero's *Flagellation*.) It became Ottaviano's responsibility to bring up the young prince, whom he is said to have cherished. He was revered as a good and just ruler, knowledgeable in theology, music and literature. As has been noted, he owned a painting by Jan van Eyck from which Piero could have drawn information about

191
Fra Filippo Lippi,
Annunciation,
late 1430s.
Tempera
on panel;
175 × 183 cm,
69 × 72 in.
Martelli
Chapel,
San Lorenzo,
Florence

192
Translation of
the Holy House
to Loreto,
c.1500.
Woodcut;
10·3 × 8·2 cm,
4 × 3¹₄ in

northern media and style. Astrology was another of Ottaviano's interests: he was described by Giovanni Santi as 'in astrology so informed, he seemed truly born to the field'. When Guidobaldo came of age in 1487 and assumed the dukedom, Ottaviano remained his closest adviser until his own death in 1498. On 11 February 1488 Guidobaldo married Elizabetta Gonzaga, the granddaughter of Ludovico, Marquis of Mantua. For that occasion, as was the habit in the fifteenth century, a horoscope was cast to

plot the date for consummation to ensure fecundity. With the collaboration of the court astrologer (an indispensable member of every Renaissance court), Ottaviano Ubaldini was called upon to fulfil this task. The date that emerged was 2 May, a full three months after the wedding. As may be imagined, the length of the wait caused some consternation in both courts and Ottaviano was persuaded to cast a second horoscope. The new date moved the day of consummation only by three weeks, to 19 April. In the event, the marriage remained childless, and the Montefeltro line came to an end. After Guidobaldo's death in 1508, court writers retrospectively blamed Ottaviano, dead for a decade, for the couple's infertility. They accused him, in fact, of having caused it by witchcraft. The issue at hand was the loss of the Montefeltro properties which were taken back by the pope and handed over to members of his own della Rovere family. Thus Ottaviano's positive role in the history of Urbino and his great personal abilities were overshadowed, indeed forgotten, until the present day. It was probably at the instigation of Ottaviano Ubaldini, for example, that Piero wrote his treatise on the 'five regular bodies', dedicated to the young duke Guidobaldo.

193
The Nativity,
after 1483.
Oil on panel;
124·4 × 122·6 cm,
49 × 48¼ in.
National Gallery,
London

In his last decade, after a lifetime of fulfilling the requests of others, Piero seems to have ended his painting career with a work that had special significance for himself. This is the *Nativity* (193), today in the National Gallery in London. It is painted in oil on a panel almost square in shape, and is now housed in a modern frame. It was undoubtedly started some time after 1483, and although not recorded during Piero's life, the painting is listed in the inventory of Piero's heirs, first in 1500 and again in 1515, as still belonging to the family. This fact means that Piero owned it when he died, that he most likely painted it without a commission, and possibly for his own family tomb chapel. Although the altarpiece currently looks as though it might be unfinished, the conservators of the National Gallery report that it was in fact completed. While they found evidence of very harsh cleaning and scraping down to the original priming and drawing, particularly in the shepherds' heads and bodies, they also discovered small fragments of pigment showing the original finish in many areas. St Joseph's head is abraded,

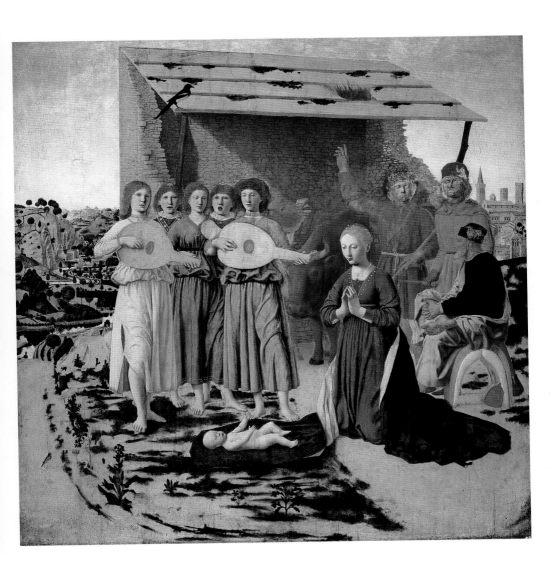

for example, but his feet and hands are perfectly intact. Various explanations for how this condition came about have been offered, none of them wholly convincing. A facetious theory was contributed by the writer William Gaddis in his 1955 novel *The Recognitions.* The author describes his hero coming upon a monk in the Spanish countryside who seems to be painting this very work. He soon discovers, to his horror, that the man is not painting at all but invidiously rasping away the pigments, proceeding with calculated ruin from figure to figure.

Despite its damaged state, the painting can be understood as a conceptual whole. In fact, the thought behind each and every element is so unified that the composition could be called Piero's final visual meditation on the reality of the mystical world. The moment is just after Christ's birth when he is lying on the ground and Mary kneels to adore him. Five angels stand above him making music. Behind them, an ass lifts its head and brays while an ox lowers its head to look at the baby. On the right behind Mary, Joseph sits on a saddle with his hands folded as two shepherds enter the scene, one pointing heavenward. The event is taking place on a small, high-placed promontory, behind which on one side is a view over a valley with a winding river hemmed in with palisades, and the other is a vista of a tranquil town with well-organized streets, towers and a large basilica. The scene of the Nativity has thus been transported from the manger outside Bethlehem on a snowy night to a beautiful day in Tuscany on the outskirts of Sansepolcro. As in his *Baptism* (see 54), Piero again shows the sanctity of his native land. However, in contrast to that painting, where the vista into space is unobstructed, here the action is confined to an apron-like stage where it remains quite close to the picture plane. The crumbling shed in the near vicinity, the one piece of architecture that might have been used to measure the space, is irregular – the only building in Piero's entire *oeuvre* that is set askew to the picture plane.

Piero took inspiration for his arrangement from several sources both old and new, and in his inimitable way combined them into something that is unique. His painting is in the tradition of a theme

194
Attributed to
the Parement
and Baptist
Masters,
The Nativity,
folio 4v,
the Turin
Hours,
c.1395.
28·4 × 20·5 cm,
11 $\frac{1}{8}$ × 8 in
(page).
Museo Civico,
Turin

known as the *Adoration.* This motif was introduced at the end of
the fourteenth century on the authority of a vision experienced by
St Bridget of Sweden, an important late medieval mystic. After she
was canonized in Rome in 1391, Bridget's account of her vision
became quite famous: she saw the Virgin, after a painless birth,
kneeling before the Christ Child who was lying naked on the
ground, shivering with cold and lifting his arms to his mother.
She heard 'the singing of the angels, which was of miraculous
sweetness and great beauty'. Already by about 1400, painters
were representing these and many other details described by
Bridget; an example is a French manuscript illumination from the
end of the fourteenth century (194). The motifs, especially the
kneeling Madonna and the child on the ground, soon became

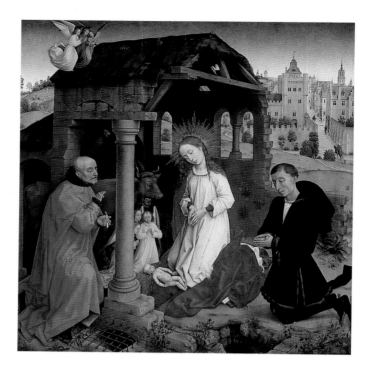

standard throughout Europe and were still current in Piero's time.
A composition to which Piero's painting has been compared because
of its irrational space is the *Bladelin Altarpiece* by Rogier van
der Weyden (195) of the early 1460s; and a nearly contemporary
fresco of the subject by Alesso Baldovinetti (1425–99), painted in
the atrium of the church of the Annunziata in Florence in 1460–2,
anticipates Piero's composition in the foreground podium arrange-
ment even more closely (196). Nearer in time to Piero's work is
the *Portinari Altarpeice* (197) by Hugo van der Goes (*c*.1440–82),
painted in the Netherlands and shipped to Florence in 1483. This
very large work is famous for the lower-class social status of its
figures, particularly the shepherds and the naked Christ Child lying
directly on the earth; also remarkable are the floral symbols of
the Eucharist prominently displayed in the foreground. Domenico
Ghirlandaio (1448/9–94) took up these very elements in his
Sassetti Altarpiece (198), dated 1485, but put the reclining child
on the end of Mary's robe. He also elevated the ambience by making
the collapsing manger into a broken classical sarcophagus, and the
supports for the ragged roof into Corinthian pillars. Piero himself
reproduces many of the requisite details: Mary shown as a beautiful
maiden with light red hair; the child on the earth, his snow-white
body dramatically silhouetted against the royal blue of his mother's
robe; the angels singing the *Gloria* in his praise. But Piero's image
is distinguished from his predecessors by his rejection of all visual
rhetoric. Without abandoning the timeless quality of his earlier style
he eschews a monumental setting. He reduces all the elements of
the story to their most mundane semblance, and gives each new
humble form an exalted meaning.

The image of a flat area in the countryside open to the sun has
resonance for any inhabitant of Tuscany. Such a formation is called
an *aiuola* (or *aia* in Tuscan dialect) and regularly used on farms as
a place to dry and thresh grain from the stalk. Grain of course is
the main constituent of bread, and bread is that daily food which
Jesus identified as his body. The *aia* thus provides Piero both with
an unobstructed view of the infant and a simple reference to the
Eucharistic description of Christ as the 'Bread of Angels'. Although

195
**Rogier van
der Weyden**,
The Nativity,
central panel
of the *Bladelin
Altarpiece*,
c.1441.
Oil on panel;
91 × 89 cm,
35¹⁄₄ × 35 in.
Gemäldegalerie,
Berlin

196
**Alesso
Baldovinetti**,
The Nativity,
1460–2.
Fresco.
SS Annunziata,
Florence

the infant shivering on the ground is a real newborn, he already shows understanding of his mother's gifts and he lifts his arms and gazes up at her with gratitude. Moreover, his nakedness reinforces Bridget's vision, proving once again that the Word of God has indeed become flesh.

Mary this time is not an Amazonian figure of Ecclesia but a lovely girl (see 185), the 'fairest among women' ('*pulcherrima inter mulieres*') from the Song of Songs. The opposite of the *Senigallia Madonna*, she is, in fact, more delicate and conventionally beautiful than any of Piero's earlier figures of the Virgin. She is richly adorned

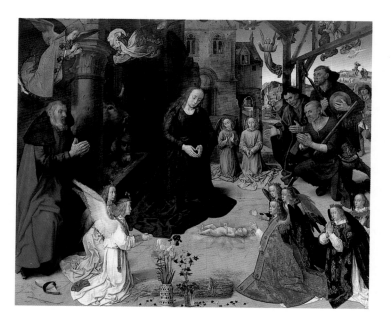

197
Hugo van der Goes,
The Nativity,
central panel
of the *Portinari Altarpiece*,
before 1483.
Oil on panel;
253 × 304 cm,
99⅝ × 119¾ in.
Galleria degli
Uffizi, Florence

198
Domenico Ghirlandaio,
Adoration of the Shepherds
(the *Sassetti Altarpiece*),
1485.
Tempera
on panel;
167 × 167 cm,
65¾ × 65¾ in.
Sassetti Chapel,
Santa Trinità,
Florence

in fine raiment and bedecked with jewels, and yet she shows her humility by kneeling directly on the earth.

The five musical angels (199) are without wings or halos. The three in front are the instrumentalists, two strumming lutes and the third bowing a viol. They could be ordinary folk making music in the countryside, and their pastel three-quarter-length gowns reflect their relaxed positions as they play. The two singers standing behind them, however, introduce another mood. They both wear crossed dalmatics encrusted with pearls and other gems over deacons' albs.

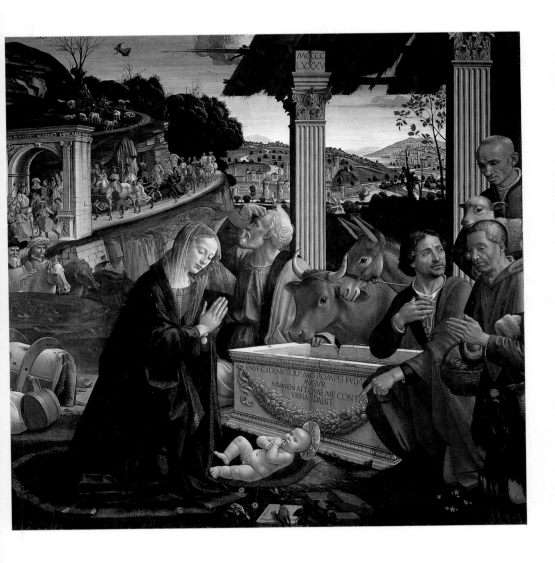

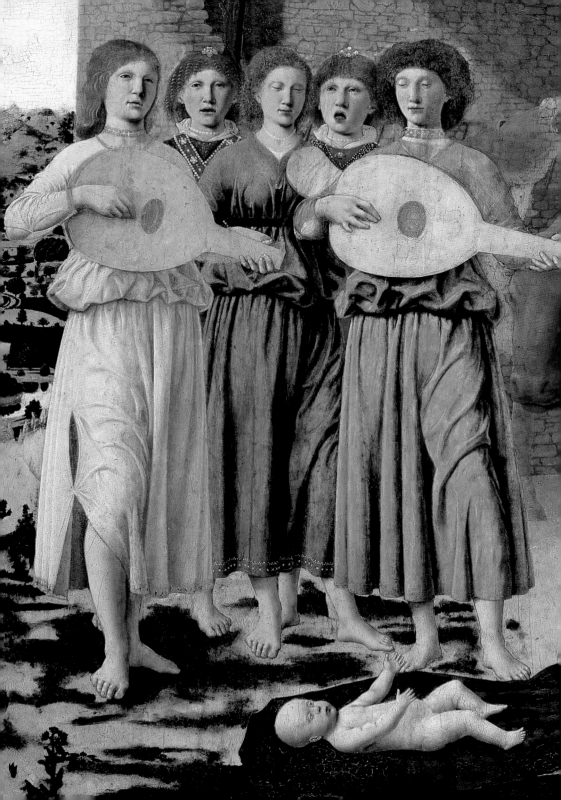

As they intone the *Gloria* with the 'miraculous sweetness' described by St Bridget, their rich robes indicate that their song is part of a liturgical ritual. Yet Piero has shown this angelic concert being performed by peasant boys who, whether arrayed in finery or simply dressed, stand barefoot in the grass.

Since the earliest Christian times, scenes of the Nativity have included representations of an ox and an ass; sarcophagi also showed the baby in the feeding-crib or manger (*tegurium*) and often a shepherd or two (200). The animals served as a fulfilment of the prophecy of Isaiah: 'The ox knoweth his owner, and the ass his master's crib' (Isaiah 1:3). Piero gives the lowly animals new meaning. The ox that 'knows his owner' lowers his head to gain a view of the child. No one before Piero had depicted this animal

199
Choir of angels, detail from the *Nativity* (193)

200
The Nativity, early 4th century AD. Fragment of a marble sarcophagus. Vatican Museums, Rome

expressing such deep understanding. On the other hand, the ass (thinly painted and now quite transparent) raises its head and brays with an open muzzle. Both in life and art, donkeys are usually thought of as stupid and contrary, as of course they often are. But here, according to Piero's careful placement, this one joins the singing of the liturgy: 'O all ye beasts and cattle, bless the Lord: praise and exalt him above all forever' (from Sunday at Lauds I in the Divine Office). Again Piero relied on tradition for this figure and its meaning; Biagio di Goro Ghezzi (active 1350–84) had shown both a donkey and a sheep singing at the Nativity (201). But Piero places the head of his animal side by side with the group of musicians, and in this way makes the ass part of the angels' liturgical choir.

In many scenes of the Nativity the building that houses the figures is shown in a state of decay – a symbol of the fall of the Old Law (Judaism) at the birth of the 'New Adam' (Christ). For the most part, such structures are represented in the style of contemporary architecture, be it in northern Europe (see 197) or in Italy (see 198). Piero follows this tradition of showing a broken building but makes the architecture into a lowly farm-shed built of crumbling field-stone, with a lean-to roof supported by unfinished staves. In this simplified form it recalls the Early Christian *tegurium*, the purpose of which was to hide the Saviour's divine status from his unbelieving enemies.

The figures of the two shepherds (who are in a particularly bad state of repair) enter the scene still holding their working staffs. They wear the clothes of simple country folk but carry themselves with great solemnity. One raises his hand and points heavenward. Piero had used this pose years earlier in his *Baptism* (see 54) where it indicated the figure's divine source of knowledge. At the same time this rustic character carries his cylindrical staff as though it were a sceptre. This combination of gestures is reminiscent of a well-known type of statue of the Roman emperor Augustus, the most famous example being the *Augustus of Prima Porta* (202). Although

this particular version was not found until the eighteenth century, the motif was well known from other sources, including a number of coins (203). The reference is appropriate here because of Augustus' connection with the story of Christ's birth as told in a medieval legend. Supposedly one day the emperor was with his soothsayer, the Tiburtine Sibyl, in his chambers on the Capitoline Hill in Rome. He asked her if the world would ever see the birth of a greater man than he. The sibyl's answer took the form of a

201
Biagio di
Goro Ghezzi,
The Nativity,
1375.
Fresco.
San Michele,
Paganico

202
Augustus of
Prima Porta,
*c.*19 BC.
Marble;
h.203 cm,
79⁷⁄₈ in.
Vatican
Museums,
Rome

203
Silver denarius
of Augustus,
reverse
showing
portrait of
the emperor,
31–29 BC.
diam. 2 cm,
³⁄₄ in.
British
Museum,
London

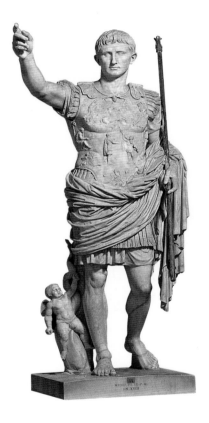

wondrous vision floating in the sky. Augustus saw a beautiful woman with a male child on her lap accompanied by a voice saying: 'This is the altar of the Son of God.' To commemorate this vision the church of Santa Maria in Aracoeli (*Ara Coeli* means 'Altar of Heaven') was founded high on the Capitoline Hill. Whereas Ghirlandaio represented this event with all its trappings on the entrance arch to the Sassetti Chapel in Santa Trinità, Florence (204), where his

204
Domenico
Ghirlandaio,
*Augustus and
the Tiburtine
Sibyl*,
1485.
Fresco.
Santa Trinità,
Florence

Adoration altarpiece is housed, Piero alluded to the same vision by raising the lowly shepherd to the status of an emperor.

Piero also gave the same paradoxical combination of high and low to the figure of St Joseph. He begins with a touch of the Nativity narrative by putting the old man on a saddle with a waterbottle leaning underneath. These are genre details from the Holy Family's journey from Nazareth when Mary rode on a donkey and Joseph led the way. Now Joseph is seen in profile, seated with one leg crossed over the other knee and his fingers laced together on his lap. He is thus not the despondent husband of many fourteenth- and fifteenth-century Nativity scenes, but rather is cast in the role of philosopher or judge, who contemplates the miraculous birth enthroned on the saddle as though it were a curule chair. Furthermore, he is in the pose of the *Spinario* ('Thorn-puller'; 205), a famous antique statue which Pope Sixtus IV had just put

on display on the Capitoline Hill, precisely where the *Ara Coeli* vision took place.

The last character Piero introduced is the large bird perched on the roof of the shed (206). From its black and white markings it is clearly a magpie (called *gazza* in Italian), a bird commonly seen in the fields of Tuscany. Piero shows this one off in profile, its long black tail fully extended and head and black beak in dignified isolation. It is important to remember that this type of bird is usually considered a bothersome pest: large and bony, it is easily domesticated, but is also a thief that hides the shining objects it steals. Most of all, it is annoying because of its relentless chatter. In classical times it was known as the very opposite of Calliope, the Muse of Music, and in Tuscany there is a proverb that relates its racket to a woman's scolding tongue: 'Women are saints in church, angels in the street … and magpies at the doorway.' In Piero's stately version there is no hint of squawking thievery. His magpie is preternaturally still and by that contradiction makes

205
Spinario
('*Thorn-puller*'),
1st century BC.
Bronze;
h.73 cm,
28¼ in.
Museo
Capitolino,
Rome

its meaning clear: the bird's unusual silence has stifled the false
words of the Old Law and thereby acknowledged the arrival of the
new, 'true' Word.

Piero thus has tied every member of this group to the same mission.
Be they human, animal or spirit, each finds its own way to recognize
the Messiah and praise his advent. In this, his last painting, Piero
seems to shed his sombre mood and, showing profound respect
for all God's creatures, to reveal his own good humour and sense
of divine joy.

206
Magpie,
detail from the
Nativity (193)

Epilogue

The didactic intensity of Piero's writings would lead one to believe that he was surrounded by students and assistants throughout his career. But this seems not to have been the case. Only one co-worker has been securely identified, namely Giovanni da Piamonte, first recognized by Roberto Longhi on the basis of an altarpiece signed and dated 1456, the *Virgin and Child with Saints Filippo Benizzi and Florido* (208). Giovanni's name has since been found scratched into the plaster of the dado below the Arezzo frescos with the date of 1486–7, when he was apparently called back to make some repairs. Another name that has been suggested as an assistant is Lorentino d'Angelo Aretino, and there must have been others, but they remain elusive. Piero's persistent and detailed use of pouncing (*ie* charcoal forced through pin holes in the cartoon) around the edges of every part of every form in his frescos made it almost impossible for his helpers to go wrong in terms of following his outlines and details, so strong was his guiding hand. However, there was no way they could achieve his graceful suavity, the lack of which is sometimes easy to see (*eg* the figures in the *Burial of the Wood* and the *Raising of Judas; see* 90 and 98*).

There are a few painters who may have studied Piero's work during their own careers. The one who seems most sympathetic to Piero in both style and content is Luca Signorelli, who according to Vasari was Piero's student. Certainly, Luca's representations of muscular bodies and three-dimensional forms bespeak a personal contact with Piero's figure construction, and in his *Flagellation of Christ* of *c.*1480 (209) he even followed one of Piero's ideas, namely the motif of the statue on the column. Bartolomeo della Gatta (1448–1502), who worked in both Urbino and Arezzo, also followed aspects of Piero's style in the rigorous faceting of the forms and background details, as in a fresco of *St Jerome in Penitence* in Arezzo Cathedral. Perhaps the closest parallels to Piero in concept

207
Salvador Dalí,
*Madonna of
Port Lligat*,
1949.
Oil on canvas;
49·5 × 38·3 cm,
$19^1{}_2 \times 15^1{}_8$ in.
Patrick and
Beatrice
Haggerty
Museum of
Art, Marquette
University,
Milwaukee

208
**Giovanni
da Piamonte**,
*Virgin and
Child with
Saints Filippo
Benizzi and
Florido*,
1456.
Tempera
on panel;
150×100 cm,
59×39⅛ in.
Santa Maria
dei Servi, Città
di Castello

209
Luca Signorelli,
*Flagellation
of Christ*,
c.1480.
Tempera
on panel;
84×60 cm,
33⅛×23⅝ in.
Pinacoteca di
Brera, Milan

and execution are the three remaining long narrow panels with
cityscapes, done for the ducal palace in Urbino, probably as
furniture mounts; one remains in Urbino (210), one is in Berlin
and the other is in Baltimore. Besides Piero himself, they have been
attributed to several artists including Fra Carnevale (Bartolomeo
di Giovanni Corradini; d.1484) and the architects Luciano Laurana
and Francesco di Giorgio Martini (1439–1501). Whoever the
actual painter might have been, the cool, symmetrical scenes of
ideal vistas bear the stamp of Piero's mentality if not his touch.
A number of Madonna paintings also emulate his manner, the
two most relevant being the *Williamstown Madonna* (211), and
the *Villamarina Madonna* in Venice, both surely painted during
Piero's lifetime by relatively close associates, perhaps with some
corrections and emendations by the master. More subtle reflections
of Piero's approach can be found outside his native territory. The
Venetians Giovanni Bellini and Cima da Conegliano (*c.*1459–*c.*1518;
212) followed Piero in their *Baptism of Christ* paintings, where the
riverbed in the foreground again looks dry, evoking the Miracle of
the Jordan.

Piero's death at the age of nearly eighty occurred on the same day now famous for Columbus's discovery of America, 12 October 1492. He was buried just outside the building of the Badia in the Cappella di San Leonardo – the original foundation site of Sansepolcro. He lies with the rest of his family, with whom he had remained in close contact all of his life. The event in Sansepolcro was noted in the local Book of the Dead; otherwise, except for the reflections of his writings in the work of other theoreticians of perspective, Piero slipped from sight for several centuries. In 1839 the German art historian D J Passavant discussed Piero's *Flagellation* in a footnote to his book on Raphael, and twenty-two years later Sir Charles Eastlake, the first director of the National Gallery, London, expressing some concerns about its condition,

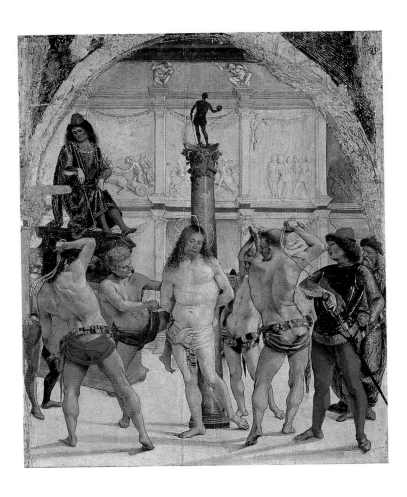

210
**Follower of
Piero della
Francesca**,
Ideal City,
last quarter of
the fifteenth
century.
Oil on panel;
67·5 × 240 cm,
$26^5_8 \times 94^1_2$ in.
Galleria
Nazionale
delle Marche,
Urbino

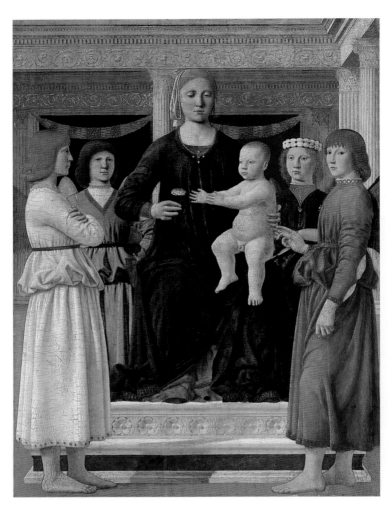

211
**Follower of
Piero della
Francesca**,
*Madonna and
Child with Four
Angels* (the
*Williamstown
Madonna*),
c.1495.
Oil transferred
to canvas laid
on panel;
117·8 × 78·4 cm,
46³⁄₈ × 30⁷⁄₈ in.
Sterling and
Francine Clark
Art Institute,
Williamstown,
Massachusetts

212
**Cima da
Conegliano**,
*Baptism of
Christ*,
1492–4.
Oil on panel;
350 × 210 cm,
137³⁄₄ × 82⁵⁄₈ in.
San Giovanni in
Bragora, Venice

bought the *Baptism* for the museum. Then in 1872 Charles Blanc,
a French art theoretician and newly elected director of the École
des Beaux-Arts in Paris, cast his eye on Piero. Blanc decided that
training in the school should return to stricter academic techniques
than had been in use during recent decades. For this purpose, he
reintroduced the teaching method of copying from casts of classical
and Renaissance sculpture, and ordered 157 painted replicas of
Italian Old Masters intended as study tools. They were to become
the basis of a 'Musée des Copies', and included reproductions
of paintings by Botticelli (1444/5–1510), Raphael and Titian
(*c*.1485–1576), a reduced version of Michelangelo's *Last Judgement*

and, surprisingly enough, large-scale copies of two tiers of Piero's
Arezzo frescos. Somewhat condensed in width, these showed the
Finding of the Cross and the *Battle of Heraclius* (see 102, 103).
A little-known French painter named Charles Loyeux (1823–98)
had been sent to Arezzo to fulfil this commission and ended up
becoming a local hero.

Meanwhile in Paris the overseers of the École found the idea of
a copy museum objectionable. Blanc was dismissed and the part

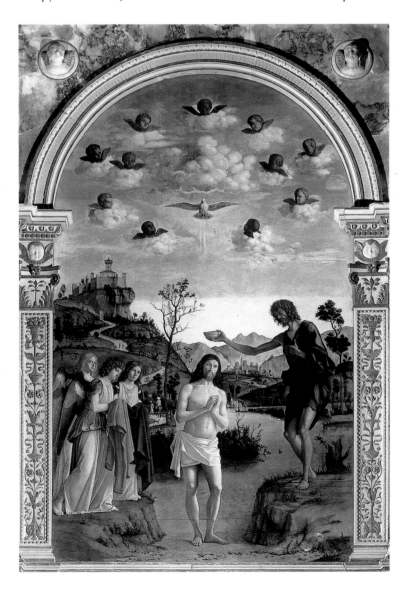

of the museum that had already been formed was dismantled. When Loyeux's facsimiles arrived in 1874 the committee was greatly displeased, and the paintings were not destroyed only because they had been so costly. In the end they were hung high on the walls of the school chapel, along with a great number of the other replicas, where they are still to be seen, with some difficulty, today. Charles Blanc and the then school librarian Eugène Müntz continued their crusade to bring art historical knowledge of Piero and the early Italian School to Paris, and had photographs and drawings brought from Italy as a resource for the younger generation. And in due time, their influence began to show.

213
Paul Cézanne,
*View of
Gardanne*,
c.1886.
Oil on canvas;
80 × 64·1 cm,
31$\frac{1}{2}$ × 25$\frac{1}{4}$ in.
Metropolitan
Museum of Art,
New York

214
**Georges
Seurat**,
*Bathers at
Asnières*,
1883–4.
Oil on canvas;
201 × 300 cm,
79$\frac{1}{8}$ × 118$\frac{1}{4}$ in.
National
Gallery,
London

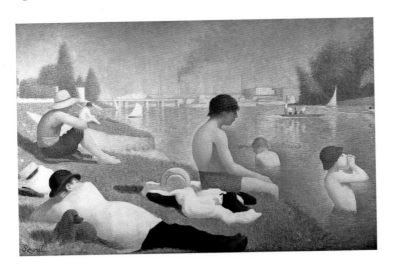

Although Paul Cézanne (1839–1906) never went to Italy, he did study in Paris as well as Aix-en-Provence. In 1874, he showed in the first Impressionist exhibition and was travelling to and from the city for the next two years. It is therefore quite possible he saw the Piero replicas soon after they arrived and found certain qualities that related to his own interests. In one landscape in particular, the *View of Gardanne* (213), he focused on the same mounting arrangement of geometric solids as can be seen in Piero's cityscape in the background of the *Finding of the Cross* (see 102). This particular link from Piero to modern art has long been recognized, since Cézanne's composition is known to have influenced what

are called the first true Cubist landscapes of Georges Braque and Pablo Picasso, painted in 1908–9, and related works by André Derain (1880–1954).

Students at the École des Beaux-Arts continued to have access to the Piero copies and photographs. This was the case with Georges Seurat (1859–91), who entered the school in 1878. Again a

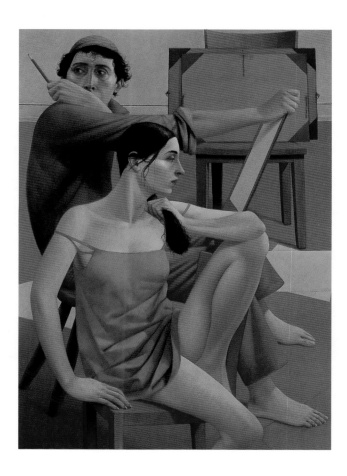

215
Alan Feltus,
The Painter and his Muse,
2000.
Oil on linen;
109·2 × 80 cm,
43 1⁄$_8$ × 31 1⁄$_2$ in.
Private collection

similarity of interests, such as stabilized poses embedded in rational space, would have drawn him to Piero. It has often been remarked how closely Seurat observed Piero's figure-studies, since identical motifs appear in some of his most familiar paintings. For example, the boy seated on the left of *Bathers at Asnières* (214) repeats the position of a guard in Piero's *Resurrection* (see 152), and other

works by Seurat recall figures to be found in the Arezzo frescos. Thus, quite ironically, it was examples offered by the academy itself that stimulated some of the most progressive advances towards abstract 'modern' art.

While his work had been described as 'naïve' by Jacob Burckhardt in the nineteenth century, and he had been initially evaluated as a 'mediocre artist' among the great figures of the Renaissance, by the early twentieth century Piero's status among critics began to rise. The English writer Aldous Huxley called his paintings 'strange and startlingly successful … experiments in composition'. Roberto Longhi extolled his poetic organization of tones, lack of emotion and the archaic quality of his classicism. And in 1929 the French painter and critic André Lhote (1885–1962) named him the 'first cubist' and sealed his fate. Piero became a historical paradigm for contemporary artists wishing to justify art for art's sake, and he offered secular viewers a way of looking at church art without having to deal with religious belief. This attitude persisted until the 1950s when it became evident that to ignore Piero's subject matter was to do him an injustice. Moreover, it was not necessary to do so. To see his paintings within their own historical context does not remove their value as independent works of art but rather enriches our understanding of their intellectual content. He may have lived at a time when spiritual values had a different set of names, but his visual language communicates in a universal tongue. His paintings are uncanny because he used his prodigious gifts in the service of a supernatural cause; but they are also charismatic, affective, familiar and accessible. It is as a totality, with all these aspects fully recognized, that Piero has entered into the consciousness not only of Modernism but also other, more emotional forms of contemporary expression. Artists on both sides of the Atlantic have followed his call, from Balthus (1908–2001) and Philip Guston (1913–80) to the Surrealist Salvador Dalí (1904–89), who reproduced quite closely the composition of the *Montefeltro Altarpiece* (see 176) in his *Madonna of Port Lligat* (see 207). There Dalí presents an impossible dream-like image of his wife Gala as the Madonna, with the same portentous, hard-edged clarity Piero used. Other younger artists

**216
Robert
Mangold,**
*Curved Plane/
Figure III,*
1994.
Acrylic and
pencil on
canvas;
249×315cm,
98×124 in.
Private
collection

continue on these paths: the American Alan Feltus (b.1943) has
focused on reflecting Piero's deep intelligence in painting human
relationships (215); and Robert Mangold (b.1937) has found the
power of unadorned line (216) to express the profundity of space
and calm in Piero's *Madonna del Parto.* Piero's influence has been
felt, as well, outside the realm of visual art, inspiring the Czech
composer Bohuslav Martinů (1890–1959) to create his manly yet
elegiac symphonic tone poem *The Frescos of Piero della Francesca*
in 1955 after visiting Arezzo. While there are still debates over the
chronology of his life and the iconography of individual works, all
agree that Piero's unique contribution was to use the crystalline
world of mathematical purity to describe the numinous quality in
human life and make it visible for all to see.

Glossary

Altarpiece Representations of figures from the Christian hierarchy in stone, wood or paint, placed on the altar of a church as the focus of prayer and meditation. Altarpieces can show devotional figures or narrative subjects, but these are usually related to the dedication of the altar or the church. The painted altarpiece came into use only in the thirteenth century and developed different forms as time went on: the polyptych (a structure made of many individual panels), the triptych (a central panel with wings) and the *pala* (one large unified rectangle), almost all of which are set on a base called a predella which is usually decorated with small paintings in a simplified style.

Apse A semicircular, polygonal or rectangular vaulted space, usually at the eastern end of the main body of a church (the nave), where the altar and often the choir are placed and where Holy Mass is performed. The entrance to the apse, called the triumphal arch, is usually behind the crossing (the intersection of the nave and the transept).

Braccio pl. **braccia** The Italian word for 'arm'. A late medieval and Renaissance unit of measurement, varying in length in different communities. The Florentine *braccio* is 58·36 cm (23 in) long.

Cartoon From the Italian word *cartone*, meaning 'heavy paper', a cartoon is an enlarged version of the main lines of a final composition, done on paper or cloth, and sometimes (but not always) equal in size to the area to be painted. The cartoon was used to transfer the design to a wall, and it could be divided into several sections so that one large image could be created piece by piece. In mural painting it was laid on the wall over the final layer of fine wet plaster, so that outlines of the forms could be either incised with a stylus or transferred by 'pouncing' (forcing charcoal dust through holes pricked along the outline of forms). In either case, the outlines were used as painting guides for the artist or his assistants. The procedure was in common use by the second half of the fifteenth century, although it had been developed earlier for decorations and borders.

Catechumen A newly converted member of the Christian Church (especially the early Church); one who is undergoing instruction and awaiting full baptism into the faith.

Cioppa An elegant Italian Renaissance garment worn by men, it was a knee- or full-length gown with full, semicircular sleeves. It could be made of velvet brocade or heavy but fine wool and was often fur-lined. It was worn by members of the aristocracy and the upper-middle class.

Condottieri Late medieval and Renaissance mercenary military leaders, regularly hired by cities, communes and courts to assemble armies and conduct offensive or defensive campaigns.

Confraternity A society or association of lay men or women united for a common cause, professional, educational or charitable. In the Renaissance such organizations were often connected to a particular church or religious order.

Devotional Image An image, fixed or portable, to which religious obeisance is paid in private devotion; usually the representation of one or more saints or other members of the religious hierarchy without implications of narrative or anecdotal context.

Ecclesia From the Greek, meaning 'assembly'. Originally the word signified congregations of early Christians, then the church building in which they met, and finally came to mean the corporate body of the Church in general. From the tenth to the twelfth centuries, Ecclesia (the Church) was personified as a stalwart woman usually wearing a massive crown and larger in scale than other figures in the same representation. By the thirteenth century the Virgin Mary was identified with this personification, and became known as Maria Ecclesia, representing both the Mother of Christ and the corporate body of the Church.

Fresco The Italian word for 'fresh', it denotes a method of wall painting. The wall was first prepared with a layer of plaster spread on the masonry and purposely left rough (*arriccio*); compositional drawings (or *sinopie*) were executed on this level. A top layer of fine plaster (*intonaco*, essentially whitewash) was applied in patches large enough for a day's work (*giornate*) and painted with pigment mixed with water. Work was done quickly, in time for the coloured paint and plaster to dry together and become chemically bonded. It has recently become apparent that 'true' fresco (known as *buon fresco*), which has no additives, is rare. More often, after the

surface was dry, details and other effects were carried out in tempera (pigment and glue) or *tempera grassa* (tempera mixed with oil) and sometimes true oil glazes. These colours are said to have been added *a secco*.

Fresco Cycle A sequence of scenes used to tell the plot of an extended narrative. Until the invention of printing, large scale fresco (and other media) cycles in public places were a major tool for broadcasting various kinds of information.

Gonfaloniere An official flag-bearer; originally he who carried the banner or flag that symbolized the authority of a religious or civic institution.

Humanism One of the most significant markers separating the Renaissance from the Middle Ages, the intellectual movement called humanism involved the rigorous study of all forms of classical culture, including Latin and Greek language, literature, rhetoric, moral philosophy and science. Said to have begun in the mind of Petrarch, it was carried on by Boccaccio, Coluccio Salutati, **Bruni** and **Filelfo**, among many others. Humanists believed that secular learning (*literae humaniores*, from which the movement derives its name) and Christian spirituality (*literae sacrae*) were not only compatible but also mutually fulfilling; indeed, some of the humanists were priests (Petrarch and **Alberti**) or members of religious orders (Ambrogio Traversari, **Bessarion**). Returning to the Socratic directive to 'know thyself' as a primary goal of philosophy, they sought deep knowledge of human values, based not on traditional doctrine but rather on perceived reality. They were responsible for finding and publishing original texts of ancient writers and for helping to found the major libraries of Italy. The republican rulers of Florence and Venice themselves had humanistic training, and aristocrats at courts like Ferrara, Urbino, Mantua and Milan engaged professional humanists to tutor their children in the classics. By the mid-fifteenth century, a practising humanist, Enea Silvio Piccolomini, had ascended the papal throne as Pius II.

Liturgy A collection of forms of worship (or rituals) prescribed by the Church. In the Catholic Church, the liturgy of Holy Mass is performed publicly at an altar; the Divine Office is read by monastics during private meditations. Both forms have variations for specific feast days dedicated to individual members of the Christian hierarchy.

Misericordia Italian word meaning 'mercy', 'pity' or 'compassion'. It is also one of the attributes of the Virgin Mary, and in her role of *Madonna della Misericordia* she is shown sheltering a group of suppliants under her cloak. The name was also adopted by many **confraternities** dedicated to assisting the poor and sick.

Oil Technique A method of painting that makes use of oil mixed with pigments in varying proportions. When the oil is mixed with very small amounts of colour, the result is a tinted transparent glaze that absorbs and reflects light on the painting's surface. The early fifteenth-century Netherlandish School (eg Robert Campin and Jan van Eyck) is regarded as having perfected the technique. Later in the century the Italians, and the Venetians in particular, made it their own.

Pala See **Altarpiece**

Perspective From the Latin *perspicere*, meaning 'to see through'. The problem of suggesting spatial recession on a flat surface has intrigued artists for centuries. The Greeks and Romans employed an intuitive and inconsistent form of perspective for architectural representations. Late in the thirteenth century (beginning with Cimabue) and throughout the fourteenth century many artists used orthogonal lines that slant at angles to suggest recession. In the first decade of the fifteenth century Brunelleschi made public his unprecedented geometric system for representing the illusion of three dimensions on a two-dimensional surface. This technique is called linear perspective. Another approach to the problem was to suggest intervening atmospheric conditions (moisture and humidity) by blurring the painted forms as they receded in space, similar to the way in which objects blur the further they get from the human eye. This approach is called aerial perspective.

Polyptych See **Altarpiece**

Relic The physical remains of a sanctified person or event with mystic value. The bones or body parts of saints are often the focus of veneration in a church or a chapel. They are preserved in sarcophagi under altars or in reliquaries (containers) which can be highly decorated, often with a transparent side for viewing. Relics vary from as small as a single joint from a finger or a splinter of the True Cross to a whole arm, a head or an entire structure, like the Virgin Mary's house.

Support The surface on which a painting is executed. In Italy until around 1500 the usual support was wood (normally poplar), either in the form of a single square or larger panels made up of several planks joined vertically. In northern Europe the usual wood was walnut and larger panels (not produced until the later 1450s) were made up of planks joined horizontally. Canvas was used for paintings that would be carried through the streets in processions on religious feast days; these processional standards were often painted on both sides. After about 1500 canvas came into general use for oil painting.

Triptych See **Altarpiece**

Leon Battista Alberti (1404–72) Architect, sculptor, theoretician, social philosopher, classical scholar and ordained priest, he was one of the most influential intellectuals of the Renaissance. Born in Genoa, the illegitimate son of a prominent family banished from Florence, Alberti was educated in Padua and Bologna before going to Rome in 1432. There his intellectual brilliance was immediately recognized and he was appointed as a papal secretary, a position that gained him financial security and enabled him to pursue a lifetime of scholarship and artistic creation. Moving to Florence in 1434, he found that **Masaccio**, **Donatello**, Lorenzo Ghiberti and Luca della Robbia were in the process of revamping the city with works of art that coincided with his own interests in both innovations and the classical past. In response to what he saw, he wrote his first treatise *On Painting* ('*Della pittura*', Latin 1435, Italian 1436) which was meant to elevate the craft of painting to a theoretical level. He laid out rules defining how painters should comport themselves, how they should structure their compositions and what they should represent. Fifteen years later he wrote his *Ten Books on Architecture* ('*De re aedificatoria*', 1452), a longer work which revived and expanded the classical architectural treatise by Vitruvius. This treatise, too, had an immediate and powerful impact on his contemporaries and is still read and discussed today. Not only a theoretician, Alberti became a consulting architect on many major projects in Florence and at the courts of Rimini, Urbino, Ferrara and Mantua. Although they may not have actually crossed paths, Piero and Alberti shared a profound interest in the visual forms of classical art, while Alberti's theoretical works undoubtedly stimulated parts of Piero's own treatises. Together their writings formed the foundation of the theoretical works of Leonardo da Vinci, Albercht Dürer and the other mathematician–artists of the sixteenth and seventeenth centuries.

Bacci Family Patrons of Piero della Francesca's fresco cycle of the True Cross in San Francesco, Arezzo. Baccio di Maso (or Magio) Bacci (d.1417) was the leading member of this well-to-do Aretine family of importers of spices and herbs from the Orient. He had three sons: Francesco, Tommaso and Girolamo. Baccio stipulated in his will (1408) a wish to be buried in San Francesco, and promised to pay for appropriate decorations in the main apse;

in 1411 he made a new will that required his beneficiaries to complete the decorations if the work was not done by the time he died. In fact no plans for the paintings had developed by the time of his death in 1417. After three decades, an earthquake and complaints from the Franciscan friars, in 1447 Baccio's son Francesco and two grandchildren, Andrea (son of Tommaso) and Agnolo (son of Girolamo), sold a vineyard for 16 florins to pay for the painting, after which work on the frescos began. When **Bicci di Lorenzo**, the painter who at first won the commission, died in 1452, another contract must have been drawn up, this time with Piero. However, no documents of either part of the commission have been found. Moreover, the Bacci family never fully paid Piero, and we have documents from 1473 and again from 1486 showing that he and his brother Marco empowered their other brother Antonio (who owned property in Arezzo) to sue the Bacci family for payment still owing.

John Bessarion (c.1403–72) Greek Orthodox priest who transferred to the Roman Catholic Rite, was appointed cardinal, and remained in the West for the rest of his life. Born in Trebizond, he was schooled in Constantinople and in 1423 entered the Order of St Basil. His learning and eloquence soon brought him appointments: he became Bishop of Nicaea and he received an invitation from the Byzantine emperor, **John VIII Palaeologus**, to accompany him to Italy to attend the Council of Union between the Orthodox and Roman Catholic Churches (Ferrara, 1438; Florence, 1439). Bessarion impressed all the delegates with his dignity, eloquence and vast theological erudition. After the council Bessarion joined the Catholic Church and was appointed to many church offices and ambassadorial missions. After Constantinople's fall to the Turks in 1453, he promulgated a crusade for its reconquest, but his efforts had no practical results and he returned to Rome disillusioned and discouraged. In recompense, the pope gave him the Abbey of Grotta-Ferrata a few miles south of Rome, where he created a centre of learning. Withdrawing from all active affairs he devoted himself entirely to study. At tremendous cost he gathered together a library of 800 Greek codices, which after 1464 he gave to the Republic of Venice (where they formed the nucleus of the famous Marciana Library, still in operation). He died in Ravenna in 1472.

Bicci di Lorenzo (1373–1452) One of a family of Florentine painters, all of whom were masters of large, commercial workshops that for several generations supplied paintings and murals to unpretentious patrons throughout Tuscany. Bicci's early style continued that of his father, Lorenzo di Bicci, who in turn had followed the principles of painting of Agnolo Gaddi. Competent but unadventurous, he was commissioned some time after 1447 to carry out the frescos in the apse (Cappella Maggiore) of San Francesco, Arezzo. While his health held out, he and his assistants completed the *Last Judgement* on the triumphal arch, the paintings on the vault including the four Evangelists, two of the four fathers of the church and some of the figures surrounding what was originally a one-light window. Because of illness Bicci returned to Florence in 1452 and died soon after.

Filippo Brunelleschi (1377–1446) Architect, sculptor and theorist. Although known today as the foremost architect of the Early Renaissance and the builder of the dome of Florence Cathedral, Brunelleschi in fact trained as a goldsmith. He had high hopes for this profession until he entered the competition for the bronze doors of the Florentine Baptistery with Lorenzo Ghiberti and lost. His disappointment was architecture's gain, and Giannozzo Manetti, his biographer, described his contribution as having 'restored the ancient manner of building'. Brunelleschi's interest in classical art was enriched when, in the early part of the century, he made a trip to Rome with the sculptor **Donatello** to study the ancient ruins. Back in Florence, he must also have had training in engineering and construction, for he convinced the city fathers that he could build a covering for what was then the largest unsupported space in the Western world, the huge area of the crossing of the nave and transept of the cathedral. And this without divulging how he would do it. He began his work in around 1418 and finished in 1436, having devised a technique of continuously self-supporting masonry without centring. From this achievement he became the most celebrated architect of the Renaissance. He was the author or several other major buildings in Florence, including San Lorenzo and Santo Spirito, in which his style and architectural ideas became ever more refined and purified. He reintroduced the classical orders of columns and moulding and built spaces of admirable clarity and beauty of detail. Architects in other Italian centres like Urbino and Milan were quick to follow his lead, thereby spreading his fame and the characteristics of his style throughout Italy and beyond. Brunelleschi's second great achievement was in the realm of linear perspective, an innovation that was taken up immediately by painters and relief sculptors as well as architects. His demonstration of perspective was in the form of an experimental painting showing the relative positions of the Florentine Baptistery and the Palazzo Vecchio as viewed from the steps of the cathedral. Using the principles of geometry, and probably some mechanical viewing device, he formulated a system whereby the relative size of figures and objects could be exactly determined according to their distance from the eye, with their size becoming smaller the further they receded into the distance. Unfortunately Brunelleschi left neither the painting nor a clear explanation of his method. We have only the evidence that **Donatello** made use of it in his *St George* relief, as did **Masaccio** in the Brancacci Chapel, and what can be learnt from **Alberti**'s complicated description and Piero's clearly illustrated demonstrations.

Lionardo Bruni (1369–1444) Scholar and writer. Bruni was born in Arezzo, a city known for its high level of education and culture. In this environment Bruni, although from a relatively modest family, was able to become one of the leading intellectuals of the century. He settled in Florence and, except for some time in Rome as a papal secretary, he lived out his life there. He was a champion of the city's republicanism, which he promulgated in his *Panegyric of the City of Florence* ('*Laudatio Florentinae urbis*', 1401). He went on to write the *History of the Florentine People*, the first historical tract since Roman times written in elegant Latin and based on original source material, and was also a leading scholar in Greek. In 1427 Bruni was elected chancellor of the city, governing according to his own principles that linked Roman republicanism, classical learning and social well-being. He openly favoured the establishment of a citizen army rather than dependence on foreign and often capricious hired *condottieri*. When Bruni died, he was buried with great pomp and tribute in a grand marble tomb in Santa Croce, Florence. Bernardo Rossellino designed this monument to reflect Bruni's commitment to classical values, and within it included Corinthian pilasters, an entablature with palmette frieze and lion-footed supports for the sarcophagus.

Cyriacus of Ancona (*c*.1390–1455) Ciriaco Pizzicolli was an Italian antiquarian who travelled extensively in the Near East. His descriptions (known as the *Commentaria*, now lost) and rather amateurish drawings not only served as introductions to classical works of art for many Early Renaissance artists but also are unique records of objects that have since been destroyed. His first trip was to Constantinople in 1418, to be followed by many returns to that city and other centres in Greece as well as Egypt. An avid collector, he brought together numerous gems, medallions, manuscripts and inscriptions which he drew and copied for a planned publication. All that remains today are a few of his sketches. During his lifetime he moved from court to court

in Italy putting his collection on view and offering pieces for sale. In such circumstances, he was in contact with many artists who profited greatly from seeing the classical motifs and compositions he made available.

Domenico Veneziano (c.1410–61)
Domenico came to Florence, presumably from Venice, at a relatively early age. Having trained in the workshop of Gentile da Fabriano, he travelled to Rome with Pisanello to work on frescos in San Giovanni Laterano (destroyed in the seventeenth century), where he learned about active figures, exotic costumes and the emotional treatment of landscape. When he returned to Florence as an independent master he obtained the patronage of the Medici. He soon had a commission in Perugia (1437), where it has been suggested he met Piero for the first time. Two years later he undertook a fresco cycle on the Life of the Virgin in the hospital church of Sant'Egidio back in Florence, destroyed during later renovations. Domenico painted his masterpiece, the *St Lucy Altarpiece*, for the high altar of Santa Lucia de' Magnoli in the same city. Generally dated to 1445–7, it has several progressive characteristics; it is the style, however, that gives the altarpiece its place in history. The pale colours are penetrated by light, and surfaces are buoyant with edges formed by countless overlays of brushstrokes that follow the underlying form. The depicted space, although not adhering to the notion of single-point perspective, is nevertheless mathematically structured, and the result is one of great dignity and solemnity – a visual language very close to Piero's own. In fact, the two worked together again soon after the *St Lucy Altarpiece* was finished, going to Loreto about 1447 to paint in the shrine of the Virgin. Their work was left unfinished, however, when they fled from an outbreak of the plague. Domenico returned to Florence and completed a number of individual panel paintings, mainly for private devotion. But he never finished his part of the Sant'Egidio frescos and in late 1461 turned the job over to Alesso Baldovinetti. It seems he was destitute when he died later that year.

Donatello (1386–1466) Donato di Niccolò di Betto Bardi (his full name) was the greatest sculptor of the Early Renaissance. At first an assistant to Ghiberti, he rapidly gained independent commissions for public buildings. By 1418 he had completed a stalwart marble figure of St George for the exterior of the church of Orsanmichele in Florence, with a relief of the saint killing the dragon set in a landscape structured with **Brunelleschi**'s newly invented rules of linear perspective. In 1443, Donatello went to Padua where he carried out two major commissions: the huge bronze equestrian monument of the *condottiere* Gattamelata, a masterpiece of characterization and

classical detail; and the complex structure of eight almost life-size figures and eight reliefs for the high altar of the Basilica del Santo. He was in fact one of the pioneers in bronze casting, as evinced by his *David* (1450s) – the first fully life-size nude statue of the Renaissance. The rest of his career was divided between Florence and Siena, where he produced statues of wood, stone and bronze in a style that became ever more expressionistic and anguished. Figures of the Magdalene and John the Baptist, and two pulpits with the wrenching story of Christ's Passion, evince a psychological and emotional burden that spectators of the fifteenth century as much as those of the modern age may have found difficult. It is said that Cosimo de' Medici made sure his favourite master had work to the very end of his life.

Eugenius IV (1383?–1447) Born Gabriele Condulmer in Venice, this pope was the nephew of the Latin Patriarch of Constantinople (later Pope Gregory XII) who made him a cardinal in 1408. He was elected pope in March of 1431 and had a turbulent but quite long reign. There was an immediate sign of trouble when in July 1431 he attended the Council of Basel and came into conflict with the cardinals of the fierce Roman Colonna family over the question of papal authority itself. Nevertheless he continued in his duties, crowning King Sigismund of Hungary Holy Roman Emperor in 1433 and commissioning a number of important works of art. But soon he was threatened with physical danger and in 1434 fled with his entire court to Florence, where they were welcomed with enthusiasm. He presided over the Council of Union with the Byzantines, held first in Ferrara (1438) and then Florence (1439), and the resulting accord was broadcast as a triumph, even though it was never ratified by the Eastern Church. Meanwhile in Rome Eugenius was declared deposed and an another pope called Felix V elected in his place. By a series of favourable alliances, Eugenius regained his dignity, and soon his enemies in Rome lost popularity and were routed. Eugenius was able to return, making a triumphal entry on 28 September 1443. Until his death in 1447, he spent his time improving conditions in Rome and renovated the Basilica of St Peter's, commissioning new bronze doors by Filarete on which Eugenius is represented several times and his success at the Council of Florence is graphically recalled.

Francesco Filelfo (1398–1481) A peripatetic humanist, born in Tolentino (in the Marche), he studied in Padua and was offered a professorship at eighteen. He worked as teacher and court humanist in Venice, Constantinople, Florence, Siena and Milan but, owing to a somewhat capricious personality, never stayed long in any position he held. Filelfo was an indefatigable letter-writer, and left a

number of satires and other compositions. His great claim to fame was his proficiency in Latin and Greek, which he had learned in Constantinople; he brought many Greek manuscripts back to Italy and made them available to other scholars.

Franciscan Order Made up of mendicant preachers (called Friars Minor or Minorites), the order was founded by St Francis of Assisi (1181/2–1226) with eleven disciples, and in less than a hundred years had spread throughout Europe. Although official acceptance of the order's rigorous rule did not come until 1223, Francis and his brothers (friars) had established themselves earlier in a valley below Assisi and began to preach their theology of poverty (eschewing any kind of property or possessions and surviving only on what they received by begging), chastity (eliminating every sexual thought except that enjoyed by a marriage to 'Lady Poverty') and obedience (adhering to the rule and to the will of God). Their self-proclaimed function was to preach and proselytize these virtues. In keeping with Francis's concept of Minorite (lower-class) values, the friars were not ordained nor did they, at first, hold any office in the church. They were allowed to wear only rough garments and open sandals; and they were taught to preach not in churches but in the streets and open places. This direct approach to the public without formal ritual was revolutionary and it brought them unprecedented success. The number of Franciscan followers increased rapidly and three divisions soon formed: one was the Friars Minor, the second was the Poor Clares, made up of women who followed the same or a similar rule, and the third order consisted of lay men and women, often married, who used the rule as a moral guide in their secular lives. The visual arts that developed in relation to this movement from the thirteenth century on were profoundly effected by its emotional appeal and earthy quality, resulting in increased realism and the expression of passionate feelings. As long as Francis was alive, the friars formed a tightly-knit, loving community. But immediately following his death, various points of contention emerged. There was a question as to whether he had actually received the *stigmata* (marks of Christ's wounds on the body) while alive, and plans to build a great shrine in Assisi were debated, with some brothers lashing out against the ostentation. Although a papal bull decreed that such a monument, which was to include the tomb of Francis, would belong to the Church and not to any individual(s) and therefore would not break the rule of poverty, the order split apart, the Conventuals siding with the papacy and the Spirituals and later the Capuchins refusing any taint of property. This rift continued with ever-increasing force. The Conventuals worked closely with a series of popes, receiving substantial financial aid in building the great basilica in Assisi, still the mother church of the order. Money for the final decorations came directly from Nicholas IV, the first Franciscan to be elected as pope. More and more friaries were founded in the fourteenth century throughout Italy, and by the early fifteenth century there was a strong reform movement led by St Bernardino of Siena, who preached a return to the primitive values of St Francis.

Ludovico II Gonzaga (1412–78) Raised to Marquis of Mantua in 1444, he was said to be just, pious and learned, a model ruler for his time. As a child he studied with the great teacher Vittorino da Feltre at the court school, La Giocosa, where he was trained in letters with many of the boys who would later be his counterparts in rulership, including **Federico da Montefeltro**. He also studied the art of war with them later at the court of the Visconti in Milan, and for a short time became a *condottiere*, fighting for both the Venetians and the Milanese. After retiring to full-time administration of his state, Ludovico became a great patron of the arts. Pisanello decorated the huge meeting hall in his palace, and Mantegna worked for him for years, completing his famous fresco cycle of the Gonzaga family in the private rooms. An interest in fine architecture led Ludovico to invite **Alberti** to Mantua to carry out two major buildings as part of his plan for urban renewal, and he also financed the great tribune of the church of the Annunziata in Florence, where he was in touch with the **Medici**. He was in diplomatic contact with governments and individuals all over Italy and the rest of Europe, and the archive of the family (which continued in power for many generations) is one of the world's great resources for historical study.

Jacobus de Voragine (c.1230–96) Author of one of the most popular books of all times, the *Golden Legend* or *Lives of the Saints*. Born in Varazze near Genoa, he entered the Dominican order in 1244 and compiled his book between 1261 and 1266. He arranged the *Lives* in the chronological order of Christian feast days, beginning with Advent at the end of November and continuing around the year. He drew his material from a wide variety of sources, all of which he identifies in the text. He wrote the text in Latin, perhaps to provide material for his brothers to use in composing their sermons. By the end of the century, this work was becoming independently famous and was soon translated into Italian, French, German, English and ultimately many other languages. One of the first times the text was used as a source for painting was for Cimabue's murals of the Life of the Virgin in the Upper Church, Assisi. Thereafter it became a major source for the iconography of Italian painting. There is evidence from the fifteenth century that the Italian text was used in schools to teach reading, and in

this way the stories would have become familiar to people even with minimal education. Besides the *Golden Legend*, Jacobus left several volumes of sermons, a chronicle of the city of Genoa and a historical study of the Lombard people. In 1292 he was elected Archbishop of Genoa.

Fra Filippo Lippi (c.1405–64) A Florentine painter who rose to great prominence. He was an orphan who in 1421 his aunt placed him in the Carmelite monastery of Florence. His later activities indicate that he had no inner vocation for the religious life: once he was sued for fraud and he kidnapped and later married a nun, Lucrezia Buti, with whom he fathered a child (Filippino Lippi, who also became a great painter). However, he did have an artistic vocation, developing an original style that made him one of the favourite painters to the **Medici**. Living at the very monastery (Santa Maria del Carmine) where **Masaccio** painted his ground-breaking cycle of frescos in the Brancacci Chapel, Filippo could watch first hand the grave figures placed in landscapes structured with linear perspective – a strong influence on his early works. As Lippi matured, however, richness of surface and rationality of scale in turn gave way to a contemplative, almost mystical spirituality. His last work was a papal commission of great solemnity in the cathedral of Spoleto, the city in which he died.

Sigismondo Pandolfo Malatesta (1417–68) Renaissance prince, soldier and art patron, whose salty reputation has cast him, unfairly, in the role of the model tyrant. He was the illegitimate son of Pandolfo Malatesta (ruler of Fano) and nephew of Carlo I, Lord of Rimini, whom he replaced in 1432 at the age of fifteen. As a skilled soldier and strategist Sigismondo made his fortune in the employ of the rulers of other states, such as Francesco Sforza of Milan and the displaced pope **Eugenius IV**. Alfonso of Aragon, King of Naples, was also one of his clients, but at the Battle of Piombino (1447) against Florence, Sigismondo suddenly switched sides and brought victory to the enemy. As a result, he was greatly honoured by Florence and roundly hated by his former allies. **Federico da Montefeltro**, in the neighbouring province, was an adversary for life, as were Federico's in-laws, the Sforza of Pesaro. Most implacable of all was Pope Pius II, who recorded his hatred in his famous diaries, where he tells of condemning Sigismondo to hell and burning him in effigy not once but twice in Rome. Despite all these negative reports, Sigismondo seems to have been well liked by his subjects. And despite rumours of sexual excess, he was a dear and faithful lover to his adored Isotta degli Atti, whom he married in 1456 after several years of happy cohabitation. He was very learned in both literary and the visual arts, and his court included erudite humanists of

the highest skills. When engaged by Sigismondo as consulting architect, Leon Battista Alberti devised for him one of the great monuments of Renaissance style, the Tempio Malatestiano. This building not only has the first classical façade of the Renaissance, but an interior filled with such a complex blend of classical and astrological conceits that its many levels of meaning are still today being unravelled. (The so-called pagan content of these decorations was another source of Sigismondo's later romantic unpopularity.) Towards the end of his life, when Sigismondo was in rather dire financial straights and fighting for a lost cause in southern Greece, he still had enough energy to bring back with him to Rimini the body of the hermetic philosopher Gemistus Plethon for burial in his church.

Masaccio (1402–28) Born Tommaso di Ser Giovanni di Mone, he became one of the founders and most admired painters of the Early Renaissance, despite his early death. Originally from San Giovanni Valdarno, south of Florence, he moved to the larger city in 1422. For the next few years he worked here and in Pisa, and in 1428 travelled to Rome where he died within months of his arrival, probably of malaria. A previously unknown triptych of the Madonna and Child, dated 1422 but discovered as recently as 1961, shows that he already had a notion of linear perspective, and the figures already show a sense of volume and plasticity. For a couple of years Masaccio and his partner Masolino worked together and separately, until they started the frescos in the Brancacci Chapel of the church of Santa Maria del Carmine. It is there that Masaccio changed the course of painting: he put the new technique of linear perspective into a framework of naturalistic vistas; he created figures of consummate anatomical grandeur and emotional depth; and he organized a complex narrative into one unified spatial concept. For generations artists, including Michelangelo, came to the chapel to study Masaccio's work, drawing on its form and its profundity to seek out ways in which 'art could surpass nature'.

Medici Family Bankers, rulers and patrons from the Tuscan region of the Mugello. They began to exert financial and political power in Florence in the mid-fourteenth century. Cosimo (known as *il Vecchio*; 1389–1464) became the dominant personality in the republic from 1434, increasing his family's wealth through industry and banking and creating a network of commercial branches throughout Europe. The city became dependent on his leadership, and he saw the benefits for himself of encouraging others to cultivate their talents in political organization. Cosimo himself was astutely sensitive to the learning and artistic acumen of his subalterns, encouraging humanists, poets, artists and musicians to fulfil their

own destinies for his own magnification. Above all, he consolidated the position of his own family and was known as the founding father of what ultimately became a great dynasty. Cosimo was succeeded by his son Piero, who outlived him by only five years, and then by his grandson Lorenzo ('the Magnificent'; 1449–92). This boy, only twenty years old at the time he took the reins, had survived the so-called Pazzi Conspiracy (1478) in which he was attacked and his brother Giuliano was assassinated. It was under Lorenzo's aegis of fourteen years that Florence came to the great last flowering of the Early Renaissance, just before the cultural centre of Italy shifted its locus from Florence to Rome. Through a series of marriages the family later entered the aristocracy and finally Florence itself became a duchy, with Cosimo I ruling as Duke from 1537–69 and as Grand Duke from 1569 until his death in 1574.

Federico da Montefeltro (1422–82)
Renaissance prince, soldier, bibliophile and art patron, whose idealized reputation has cast him in role of the model ruler. He was the illegitimate son of the Lord of Urbino, and just happened to be waiting at the gates with a squadron of horsemen on the night his half-brother Duke Oddantonio was assassinated in 1444. Federico was accepted by the populace immediately and given the rank of count. Trained at the court of Milan, Federico was a fighting man who made his living and enlarged his territories by working as a professional general (*ie* he fought for money). The one enemy who remained constant was **Sigismondo Malatesta** and the borders between their lands were in a steady state of flux. Federico regularly participated in jousts, losing his right eye and the bridge of his nose in a contest in 1451. (Owing to this injury, his hawk-nose profile is easy to spot.) Federico's first wife had died without bearing a child, and in about 1460 Federico carefully chose the young Battista Sforza of Pesaro for his second try. After eight daughters in eleven years of marriage, she finally produced a male heir. Six months later (July 1472) she died, and Federico, who had fallen deeply in love with Battista, was struck with grief. He retired from fighting to concentrate on building his palace and various fortresses, he expanded his extraordinary library of manuscripts (which became one of the biggest in Europe, and is now part of the Vatican Library) and he commissioned a number of artists, including Piero, to paint major altarpieces and other decorations. In 1472 he was called back to service by Pope Sixtus IV to break an embarrassing stalemate with the vicious tyrant of Città di Castello, who had refused to submit to the papal army. In Rome, Federico was first heaped with honours, raised to the rank of Duke and given permission for one of his daughters to marry the pope's nephew. He then massed his forces and marched to the gates of Città di Castello where, it is said, his imposing presence was enough to force the city to capitulate without bloodshed. Following these triumphs he spent the rest of his life with his young son in peaceful tranquility. As opposed to **Sigismondo Malatesta**, held up in the nineteenth century as the perfect profligate despot, Federico was considered the ideal prince, strong, generous and cultured. Both generalizations lack dimension, but together characterize the complex mix of erudition, cunning and force of will that made up the Early Renaissance.

John VIII Palaeologus (1390–1448) A Byzantine emperor who, like his forebears, spent his reign appealing to the West for help against assaults by the Ottoman Turks. Son of Manuel II Palaeologus, John was crowned co-emperor with his father in 1421 and succeeded him in July 1425. He ruled the area immediately surrounding Constantinople, while his brothers governed remnants of the fragmented empire in the Peloponnese and in districts on the Black Sea. During the 1420s Constantinople and northern Greece were under attack by the Turkish sultan Murad II, whose incremental success made John turn to the West for help. The Western response had always sought an underlying *quid pro quo*: in exchange for military assistance it longed for ecclesiastical reunion with the Orthodox church under the dominance of the Roman papacy. John now claimed to hold the key to this possibility. In 1437 he came to Europe with delegations of Orthodox churchmen to hold council on the matter, first in Basel, then in Ferrara (1438) and finally in Florence (1439). Discussions at the council were serious, heated and prolonged, and sections of the meeting dragged on until 1445. In the end, a document of union was drawn up and victory proclaimed. However, when John returned to Constantinople, the accord caused nothing but dissension and distrust among the local church officials and was soon defeated. This failure broke John's spirit, and having suffered intrigues over the succession to his throne and new Turkish victories, he died in a state of deep depression. In spite of the urging of a series of popes and the forceful preaching of the Franciscans, no crusade army was formed. Even after the fall of Constantinople in 1453, and another papal council in Mantua in 1459 under Pope Pius II, the princes of Europe did not recognize the impressive power of the Turks enough to put aside their own differences and defend themselves as a unified block.

Ottaviano Ubaldini della Carda (*c.*1423–98) Administrator, humanist, poet, art collector and astrologer, he was **Federico da Montefeltro**'s treasurer and counsellor throughout his career. Although they were nearly the same age, Federico was Ottaviano's uncle. They were brought up together, and both studied at Mantua and

later at military school with the Visconti of Milan. As they matured, it was Federico who became the military man while Ottaviano, ever the intellectual, stayed in Urbino carrying out the administrative duties of government. They also grew rich together, and even before Federico started his renowned collections Ottaviano was buying paintings and sculpture. He is extolled in Giovanni Santi's rhymed chronicle as: 'Fast and ready in theology, he also took time to enjoy music, and was so skilled in astrology he seemed truly born to the practice.' Ottaviano was appointed Count of Mercatello sul Metauro, a property outside Urbino, in 1474, and after Federico's death in 1482 he became guardian of Federico's son Guidobaldo, acting as regent of Urbino. Until the boy's majority Ottaviano ruled effectively; it was not until after Guidobaldo died childless in 1508 that Ottaviano was blamed for the lack of heirs and subsequent loss of Urbino to the Della Rovere papal family.

Paolo Uccello (1396/7–1475) A Florentine painter with such a fanatical interest in linear perspective that his wife claimed he spoke about it in his sleep. He began his career as an apprentice to Ghiberti, and in 1425 went to Venice and worked on mosaics in St Mark's. After about five years he returned to Florence. In 1436, the city of Florence gave him the commission to create a monument to the *condottiere* Sir John Hawkwood – the great equestrian figure in monochrome now in the cathedral. He later carried out the fresco cycle of the *Creation* (c.1445–7) in the so-called Green Cloister of Santa Maria Novella, in which he employed perspective not according to dry theory but in an exaggerated form in order to increase the emotional impact of the disaster. Uccello also worked for the **Medici,** painting three large, colourful scenes of the Battle of San Romano (an incident from Florentine history) for the walls of a private room in their palace. Although they show the army in the thick of battle, the figures of the men and the horses, and the many details of costume, armour and hilly landscapes, are made to comply with his chosen measurements and strict gridlines marking diminution. His obsession with perspective seems to have caused him problems later in his career and he began to lose commissions. In 1465 he took the job of painting a new altarpiece for the Confraternity of Corpus Domini in the distant town of Urbino. He travelled there and in a short time painted his famous *Profanation of the Host by a Jewish Family* for the predella – again with exaggerated perspective diminution. It would seem that Uccello displeased the Confraternity in some way because soon afterwards Piero was called in to consult about the unfinished main panel of the altarpiece. Uccello returned to Florence where, it is said, he received no more commissions and died quite insolvent and alone.

Numbers in square brackets refer to illustrations

The Life and Art of Piero della Francesca	A Context of Events
c.1413 Piero born	
	1414–18 Council of Constance held (heals the schism between pope and cardinals)
	1416 Donatello's marble *David*
	1423 Gentile da Fabriano's *Adoration of the Magi*
	1427 Lionardo Bruni appointed Chancellor of Florence
	1430s Donatello's bronze *David*
1431 Paints candles or candlesticks	**1431** Joan of Arc burnt at the stake in Rouen, accused of heresy and witchcraft
1432 Receives salary from Antonio d'Anghiari	**1432** Van Eyck's *Ghent Altarpiece* finished
	1433 Sigismund of Hungary crowned Holy Rome Emperor in Rome
	1435 Alberti circulates his *Treatise on Painting*
	1436 Bruni writes his *Life of Petrarch*; Uccello paints *Sir John Hawkwood* [15]
1437 Witnesses a will in Sansepolcro	
1438 Receives payment from Antonio d'Anghiari	**1438** Fra Angelico begins to paint his frescos in San Marco, Florence. St Catherine of Bologna writes her *Seven Arms Needed for Spiritual Battle*. Sassetta's altarpiece for San Francesco, Sansepolcro, begun [5]. Habsburgs begin their rule of the Holy Roman Empire
1439 Works with Domenico Veneziano in Florence	**1439** Francesco di Giorgio Martini born. Council of Florence held (between Byzantium and the papacy)
1440 In Florence	**1440** Master E S starts making engravings in Germany. Battle of Anghiari (Florence and Venice defeat Filippo Maria Visconti)
1442 Included in a list of eligible citizens for the town council in Sansepolcro	**1442** Palazzo Medici, Florence, started by Michelozzo. Flavio Biondo writes about Roman history
1445 Contract for the *Misericordia Altarpiece* [23]	**1445** Domenico Veneziano begins his *St Lucy Altarpiece* [17, 18]. Nicholas V elected pope
1449 Perhaps in Ferrara at d'Este court	**1449** Rebuilding of Tempio Malatestiano, Rimini [36–8], begun. Federico da Montefeltro [170] recognized as Count of Urbino

The Life and Art of Piero della Francesca	A Context of Events
1450 Panel of *St Jerome* (dated) [31]; writes *Trattato d'Abaco*	**1450** Rogier van der Weyden in Italy; paints for the Medici. Francesco Sforza created Duke of Milan
	c.1450 Alberti's *De re aedificatoria* circulated
1451 Signs Malatesta fresco, Tempio Malatestiano, Rimini [39]	**1451** Mehmed II ascends throne for the second time at Edirne
1452 Earliest possible start date for the *Legend of the True Cross* fresco cycle, San Francesco, Arezzo [76]	**1452** Ghiberti's Gates of Paradise set in place, Florentine Baptistery. Frederic II crowned Holy Roman Emperor
1453 Given a crossbow by the city of Sansepolcro	**1453** Donatello completes his statue of Gattamelata, Padua. Constantinople falls to Turks
1454 Contract for the *Sant'Agostino Altarpiece* [136–9]	**1454** Mantegna's Ovetari Chapel, Padua, begun. Peace of Lodi (end of Venice–Milan war). In Mainz Johann Gutenberg begins printing his Bible using the new invention of movable type
1455 Plot of land to be used as payment surveyed	**1455** Castagno paints fresco of *St Jerome*, SS Annunziata, Florence. Pope Nicholas V dies
1456 Working on True Cross cycle in San Francesco, Arezzo	**1456** Alberti begins the façade of Santa Maria Novella, Florence. Turks take Athens; Battle at Danube, Fra Giovanni da Capistrano leads Italian army
1458 Goes to Rome to paint in pope's apartment	**1458** Mantegna's *San Zeno Altarpiece*, Verona [179]. Enea Silvio Piccolomini elected as Pope Pius II
c.1459 Paints frescos of the four Evangelists [117]	
1459 Piero's mother dies; he leaves Rome and returns to Sansepolcro	**1459** Fra Filippo Lippi's *Adoration of the Child with Two Angels*. Congress of Mantua convened by Pius II to discuss crusade
1460 Latest possible date for the *Flagellation of Christ* [62]	**1460** Portuguese Prince Henry the Navigator dies
	c.1460 Antonio Pollaiuolo paints his *Labours of Hercules* cycle for the Medici
1461 Receives payments from Confraternity of the Misericordia	**1461** Nicolas Forment, a French artist, paints the *Raising of Lazarus*. Edward IV of England fights the Lancastrians in the War of the Roses
1463 Possibly begins to paint the *Resurrection of Christ* fresco [152]	**1463** Mino da Fiesole in Rome working for Cardinal Pietro Riario. War between Venice and the Turks
1464 Death of Piero's father, 20 February	**1464** Pope Pius II dies in Ancona
1465 Possibly at work on the *Sant'Agostino Altarpiece* [136–9]	**1465** Uccello's *Profanation of the Host* [164] begun. First printing press in Italy established at Subiaco
1466 Commissioned to paint *Annunciation* banner; mentions Arezzo cycle	**1466** Donatello dies, 14 December. In Venice Francesco Colonna completes his philosophical romance *Hypnerotomachia Polifili*. Presumed birth date of the humanist scholar Erasmus of Rotterdam

The Life and Art of Piero della Francesca	**A Context of Events**
1468 Receives payment for the *Sant'Agostino Altarpiece*. *St Anthony Altarpiece* [130] completed by this date	**1468** Luciano Laurana appointed court architect at Urbino [167]. Death of Sigismondo Pandolfo Malatesta
1469 In Urbino to look at panel for the Confraternity of Corpus Domini [164]	**1469** Niccolò dell'Arca works on the Tomb of San Domenico, Bologna. Lorenzo de' Medici becomes ruler of Florence. Ferdinand and Isabella of Spain marry, uniting Spain
1470 Receives final payment for the *Sant'Agostino Altarpiece*	**1470** Sant'Andrea in Mantua designed by Alberti. Thomas Malory writing *Morte d'Arthur*
1471 Receives payment for a fresco in the Badia, Sansepolcro	**1471** Francesco di Giorgio Martini starts painting his *Coronation of the Virgin*, Siena. Francesco della Rovere, a Franciscan, is appointed Pope Sixtus IV
1472 Pays off taxes owed to city of Sansepolcro	**1472** Leonardo's name entered in Red Book of Painters, Florence, confirming his status as an artist. Guidobaldo Montefeltro born. Battista Sforza [169] dies
1473 Sues for money owing on Arezzo cycle	**1473** Nicolaus Copernicus is born
	***c*.1473** Giovanni Bellini paints *Coronation of the Virgin* altarpiece, Pesaro
1474 Latest possible date for the *Montefeltro Altarpiece* [176]	**1474** Mantegna completes his Camera degli Sposi, Palazzo Ducale, Mantua. Federico da Montefeltro raised to Duke of Urbino, elected to Order of the Garter, receives Order of the Ermine
1475 Prior of Confraternity of San Bartolomeo	**1475** Michelangelo Buonarroti born. First dated piece of Faenza majolica
1477 Elected communal councillor in Sansepolcro	**1477** Veit Stoss carves the high altar for the Church of the Virgin, Kraków. Five hundred copies of Ptolemy's *Geography* printed in Bologna
1478 Receives payment for an outdoor fresco for the Confraternity of the Misericordia	**1478** Botticelli paints the *Primavera*. Pazzi conspiracy takes place in Florence; Giuliano de' Medici killed in the cathedral
1479 Possible date of the *Senigallia Madonna* [186]	**1479** Gentile Bellini paints *Portrait of a Turkish Boy*. Demetrius Chalcondyles, philosopher, is summoned to Florence by Lorenzo de' Medici
1480 Prior of the Confraternity of San Bartolomeo	**1480** Ghirlandaio's *Last Supper* completed in the Ognissanti, Florence. Grand Prince of Moscow defeats the Tartars after their invasion
1482 Rents house and garden in Rimini	**1482** Botticelli at work in the Sistine Chapel. Federico da Montefeltro dies
1483 Buys land with his brothers	**1483** Leonardo's first *Madonna of the Rocks* begun. Raphael born in Urbino. Edward V of England deposed and possibly murdered by Richard III
1485 Buys house in Sansepolcro with his brother	**1485** Savonarola puts forth his propositions in San Gimignano

The Life and Art of Piero della Francesca	A Context of Events
1486 Possibly working on the *Five Regular Bodies* [150]	**1486** Bramante starts building Santa Maria presso San Satiro, Milan. Andrea del Sarto born. Pico della Mirandola defends the study of magic. In Mexico the Aztecs found the city of Oaxaca
1487 Piero writes his will	**1487** Filippino Lippi starts work on frescos in the Strozzi Chapel, Santa Maria Novella, Florence. Pandolfo Petrucci takes over Siena as tyrant
1488 Pays dowry for his niece Contessa	**1488** Bellini completes *Madonna and Child with Saints*, Frari, Venice. Possible birthdate of Titian. Bartolomeu Dias rounds the Cape of Good Hope while returning to Portugal
1489 Possibly going blind	**1489** Michelangelo at work on the *Madonna of the Stairs*. Ferdinand and Isabella capture Granada (Andalusia)
	1490 First Latin edition of Galen's medical works published in Venice
1492 Piero dies on 12 October. He is buried in the Cappella di San Leonardo in the Badia, Sansepolcro	**1492** Pietro Lombardo starts Santa Maria dei Miracoli, Venice. Death of Lorenzo de' Medici. Columbus arrives in the New World

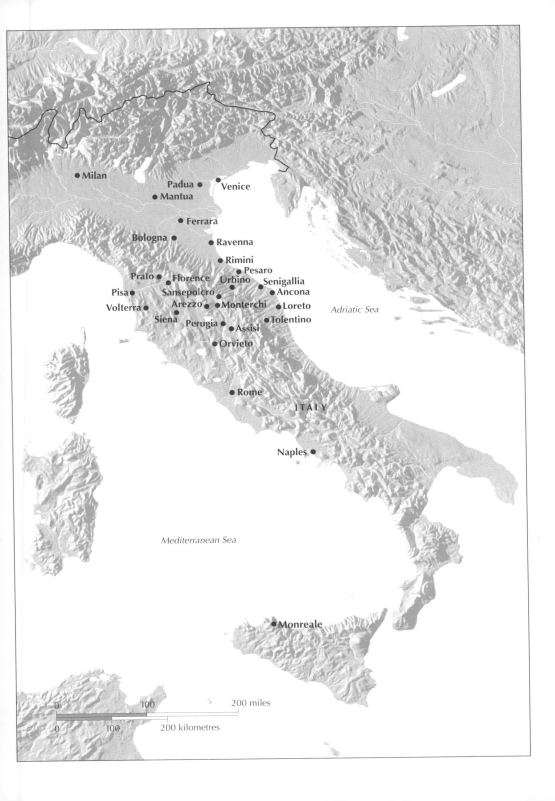

Milan

Padua Venice
Mantua

Ferrara

Bologna Ravenna

Rimini
Pesaro
Prato Florence Urbino Senigallia
Pisa Sansepolcro Ancona
Volterra Arezzo Monterchi Loreto
Siena Perugia Tolentino
Assisi
Orvieto

Rome ITALY

Adriatic Sea

Naples

Mediterranean Sea

Monreale

0 100 200 miles

0 100 200 kilometres

Further Reading

Chapter 1

James R Banker, 'The Altarpiece of the Confraternity of Santa Maria della Misericordia in Borgo Sansepolcro', in Marilyn Aronberg Lavin (ed.), *Piero della Francesca and His Legacy* (Washington, DC, 1995), pp.21–35

—, *Death in the Community: Memorialization and Confraternities in an Italian Commune in the late Middle Ages* (Athens, GA, 1988)

Eugenio Battisti, *Piero della Francesca* (Milan, 1971)

Christa Belting-Ihm, *'Sub matris tutela': Unters. zur Vorgeschichte d. Schutzmantelmadonna* (Heidelberg, 1976)

Bernard Berenson, *Piero della Francesca or the Ineloquent in Art* (New York and London, 1954)

Carlo Bertelli, *Piero della Francesca* (New Haven and London, 1992)

Marshall Clagett, *Archimedes in the Middle Ages* (The Medieval Archimedes in the Renaissance 1450–1565) 3:3 (Philadelphia, 1978)

Kenneth Clark, *Piero della Francesca* (London, 1951, 2nd edn, 1969)

Frank Dabell, 'Antonio d'Anghiari e gli inizi di Piero della Francesca', *Paragone*, 417 (1984), pp.73–94

Amintore Fanfani, 'Le arti di Sansepolcro dal XIV al XVI secolo', *Saggi di storia economica italiana* (Milan, 1936), pp.85–107

Christa Gardner von Teuffel, 'The Buttressed Altarpiece: A Forgotten Aspect of Tuscan Fourteenth-Century Altarpiece Design', *Jahrbuch der Berliner Museen* (1979), pp.22–65

Creighton Gilbert, *Change in Piero della Francesca* (Locust Valley, NY, 1968)

Ronald Lightbown, *Piero della Francesca* (New York, 1992)

Roberto Longhi, *Piero della Francesca* (Florence, 1963)

Chapter 2

P J Jones, *The Malatesta of Rimini and the Papal State* (London and New York, 1974)

Marilyn Aronberg Lavin, 'Piero della Francesca's Fresco of Sigismondo Pandolfo Malatesta before St Sigismund', *Art Bulletin* 56 (1974), pp.345–74; ibid., 57 (1975), p.307 and p.607; and 'The Antique Source for the Tempio Malatestiano's Greek Inscriptions', ibid., 59 (1977), pp.421–2

Charles Mitchell, 'The Imagery of the Tempio Malatestiano', *Studi Romagnoli*, 2 (1951), pp.77–90

C Ricci, *Il Tempio Malatestiano* (Milan and Rome, 1924)

Charles de Tolnay, 'Conceptions religieuses dans la peinture de Piero della Francesca', *Arte antica e moderna*, 23 (1963), pp.205–41

Angelo Turchini, 'Un'ipotesi per la "Flagellazione" di Piero della Francesca', *Quaderni Medievali*, 14 (1982), pp.61–93

Chapter 3

J Bridgeman, '"Belle considerazioni": Dress in the Work of Piero della Francesca', *Apollo*, 136 (1992), pp.218–25

Maurizio Calvesi, *Piero della Francesca* (New York, 1998)

L Coleschi and Franco Polcri, *La Storia di Sansepolcro dalle origini al 1860* (2nd edn, Sansepolcro, 1966)

Francesco Filelfo, *Oratio consolatoria ad Iacobum Antonium Marcellum de obitu Valerii filii* (1461)

Carlo Ginzburg, *The Enigma of Piero* (London, 1985)

Thalia Gouma-Peterson, 'Piero della Francesca's *Flagellation*: An Historical Interpretation', *Storia dell'arte*, 28 (1976), pp.117–33

J Hoffmann, 'Piero della Francesca's "Flagellation". A Reading from Jewish History.' *Zeitschrift für Kunstgeschichte*, 44 (1981), pp.340–57

Josef Andreas Jungmann, *The Early Liturgy: To the Time of Gregory the Great* (Notre Dame, IN, 1959)

Marilyn Aronberg Lavin (appendix by B A R Carter), *Piero della Francesca's 'Baptism of Christ'* (New Haven, 1981)

—, 'Piero della Francesca's "Flagellation": The Triumph of Christian Glory', *Art Bulletin*, 50 (1968), p.321–42

—, *Piero della Francesca: 'The Flagellation'* (London, 1972 and Chicago, 1990)

Fabrizio Lollini, 'Una possibile connotazione antiebraica della "Flagellazione" di Piero della Francesca', *Bollettino d'arte*, 65 (1991), pp.1–28

George W McClure, *Sorrow and Consolation in Italian Humanism* (Princeton, 1991)

Giannozzo Manetti, *Dialogus Consolatorius*. ed. Alfonso De Petris, *Temi e Testi*, 32 (1983) [Original in Latin 1438, translated into Italian 1439]

I Ricci, *Storia di (Borgo) Sansepolcro* (Sansepolcro, 1956)

M Tanner, 'Concordia in Piero della Francesca's 'Baptism of Christ', *Art Quarterly*, 35 (1972), pp.1–21

R Wittkower and B A R Carter, 'The Perspective of Piero della Francesca's "Flagellation"', *Journal of the Warburg and Courtauld Institutes*, 16 (1953), pp.292–302

Chapter 4

Michel Alpatov, 'Les Fresques de Piero della Francesca a Arezzo: Semantique et Stilistique', *Commentari*, 1 (1963), pp.17–38

John Ashton, *The Legendary History of the Cross* (London, 1887)

Jean Babelon, 'Jean Paleologus et Ponce Pilate', *Gazette des Beaux-Arts*, 4, series 6 (1930), pp.365–75

St Bonaventura (trans. Eric Doyle), *The Disciple and the Master: St Bonaventure's Sermons on St Francis of Assisi* (Chicago, 1983)

Jacopo Burali, *Vite de' Vescovi Aretini 336–1638* (Arezzo, 1638)

Frank Büttner, 'Das Thema der Kostantinschlacht Piero della Francesca', *Mitteilungen des Kunsthistorischen Institutes in Florenz*, 1–2 (1992), pp.23–40

Maurizio Calvesi, 'Sistema degli equivalenti ed equivalenze del sistema in Piero della Francesca', *Storia dell'arte*, 24/25 (1975), pp.83–110

—, 'La Flagellazione nel quadro storico del Convegno di Mantova e dei progetti di Mattia Corvino', in Marilyn Aronberg Lavin (ed.), *Piero della Francesca and His Legacy* (Washington, DC, 1995), pp.115–26

Enzo Carli, *Piero della Francesca, The Frescoes in the Church of San Francesco at Arezzo* (Milan, 1965)

G A Centauro (ed.), *Un Progetto per Piero della Francesca: Indagini diagnostico-conoscitive per la conservazione della 'Leggenda della Vera Croce' e della 'Madonna del Parto'* (Florence, 1989)

Jonathan Goldberg, 'Quattrocento Dematerialization: Some Paradoxes in a Conceptual Art', *Journal of Aesthetics and Art Criticism*, 35 (1976), pp.162ff

Philip Guston, 'Piero della Francesca: The Impossibility of Painting', *Art News*, 64 (1965), pp.38–9

Horace (ed. Charles D N Costa), *Ars Poetica* (London and Boston, 1973)

Theodor Graesse (ed.), *Jacobus de Voragine, Legenda aurea, vulgo historia lombardica dicta* (Leipzig, 1850); translated and adapted as *The Golden Legend of Jacobus de Voragine* by William Granger Ryan and Helmut Ripperger (New York, 1969): see entries for 3 May and 14 September

Marilyn Aronberg Lavin, *The Place of Narrative: Mural Decoration in Italian Churches, AD 431–1600* (Chicago, 1990)

—, *Piero della Francesca, San Francesco, Arezzo* (New York, 1994)

Marilyn Aronberg Lavin and Irving Lavin, *The Liturgy of Love: Images of the Song of Songs in the Art of Cimabue, Michelangelo, and Rembrandt* (Modena, 1999)

Rene Lindekens, 'Analyse semiotique d'une fresque de Piero della Francesca: la legende de la vraie Croix', *Canadian Journal of Research in Semiotics*, 4:3 (1979), pp.3–19

Michael Podro, *Piero della Francesca's Legend of the True Cross* (55th Charleton Lecture, University of Newcastle upon Tyne) (Edinburgh, 1974)

Laurie Schneider, 'The Iconography of Piero della Francesca's Frescoes Illustrating the Legend of the True Cross in the Church of San Francesco in Arezzo', *Art Quarterly*, 32 (1969), pp.22–48

Michael Vickers, 'Theodosius, Justinian, or Heraclius', *Art Bulletin*, 58 (1976), pp.281–2

Chapter 5

James R Banker, 'Piero della Francesca's S Agostino Altarpiece: Some New Documents', *Burlington Magazine*, 129 (1987), pp.645–51

Convegno internazionale sulla 'Madonna del parto' di Piero della Francesca (Monterchi, 1980)

Vittoria Garibaldi (ed.), *Il polittico di Sant'Antonio* (Perugia, 1993)

B Giorni, *La Madonna del Parto di Piero della Francesca* (Sansepolcro, 1977)

Andrea di Lorenzo (ed.), *Il polittico Agostiniano di Piero della Francesca* (Turin, 1996)

Millard Meiss, 'A Documented Altarpiece by Piero della Francesca', *Art Bulletin*, 23 (1941), pp.53–68

—, *The Great Age of Fresco: Discoveries, Recoveries and Survivals* (New York, 1970)

Franco Polcri, 'Ritrovamenti pierfrancescani nell'archivio giudiziario di Sansepolcro', *Atti e memorie della Accademia Petrarca di lettere, arti e scienze*, n.s.I, 1988 (Arezzo, 1990), pp.203–17

Chapter 6

Marisa Dalai Emiliani and Valter Curzi (eds), *Piero della Francesca tra arte e scienza* (Venice, 1996), with reference to major works on Piero's science by Martin Kemp, Cecil Grayson, J V Field *et al.*

Margaret Daly Davis, *Piero della Francesca's Mathematical Treatises* (Ravenna, 1977)

Luca Pacioli, *De divina proportione* in *Fontes Ambrosiani in lucem editi cura et studio Bibliothecae Ambrosianae*, 31 (Verona, 1956)

Piero della Francesca, *De prospectiva pingendi*, ed. Giusta Nicco Fasola, 2 vols (Florence, 1942, revised edn, 1984)

Piero della Francesca, *Libellus de quinque corporibus regularibus*, from the Italian version by Luca Pacioli, 3 vols (Florence, 1995)

Piero della Francesca, *Trattato d'abaco*, ed. Gino Arrighi (Pisa, 1970)

Francesco P di Teodoro, 'Per una filologia del disegno geometrico', in Marisa Dalai Emiliani and Valter Curzi (eds), *Piero della Francesca tra arte e scienza* (Venice, 1996)

Chapter 7

Ingrid C Alexander and Antonietta Gallone Galassi, 'A Study of Piero della Francesca's Sacra Conversazione and its Relationship to Flemish Painting Techniques', *Preprints*, ICOM Committee for Conservation (Getty Conservation Institute, Los Angeles, 1987)

Mariano Apa, *La 'Resurrezione di Cristo': Itinerario sull'affresco di Piero della Francesca a Sansepolcro* (Sansepolcro, 1980)

Marilyn Aronberg Lavin, 'The Corpus Domini Altar of Urbino: Paolo Uccello, Joos van Ghent, Piero della Francesca', *Art Bulletin*, 49 (1967), pp.1–24

—, 'Piero della Francesca's Montefeltro Altarpiece: A Pledge of Fidelity', *Art Bulletin*, 51 (1969), pp.367–71

Millard Meiss with T G Jones, 'Once Again Piero della Francesca's Montefeltro Altarpiece', *Art Bulletin*, 48 (1966), pp.203–6

—, 'Ovum Struthionis: Symbol and Allusion in Piero della Francesca's Montefeltro Altarpiece', in Dorothy Miner (ed.), *Studies in Art and and Literature for Belle da Costa Green* (Princeton, 1954), pp.92–101

John Pope-Hennessy, *The Portrait in the Renaissance* (New York, 1966); review by Creighton Gilbert, *Burlington Magazine*, 110 (1968), pp.278–85

Guido Ugolino, *La Pala dei Montefeltro: Una Porta per il Mausoleo Dinastico di Federico* (Pesaro, 1985)

Chapter 8

Bibliotheca Sanctorum, 14 vols (Vatican City, 1963) vol.3, pp.439–533

Eve Borsook and Johannes Offerhaus, *Francesco Sassetti and Ghirlandaio at Santa Trinita, Florence: History and Legend in a Renaissance Chapel* (Doornspijk, 1981)

Henrik Cornell, *The Iconography of the Nativity of Christ*, Uppsala Universitets Årsskrift, 1924, 1 (Uppsala, 1924)

Ruth Wedgwood Kennedy, *Alesso Baldovinetti* (New Haven, 1938)

Francis Klingender, *Animals in Art and Thought to the End of the Middle Ages* (London, 1971)

Marilyn Aronberg Lavin, 'Piero's Meditation on the Nativity', in Marilyn Aronberg Lavin (ed.), *Piero della Francesca and His Legacy* (Washington, DC, 1995), pp.127–42

W B McNamee, 'The Origin of the Vested Angel as a Eucharistic Symbol in Flemish Painting', *Art Bulletin*, 54 (1972), pp.263–78

Nel Raggio di Piero: La pittura nell'Italia centrale nell'età di Piero della Francesca (exh. cat., Museo Civico, Sansepolcro, 1992)

Rosalind Schaff, 'The Iconography of the Nativity in Florentine Painting of the Third Quarter of the Quattrocento with Particular Reference to the Madonna and Child', MA Thesis, Institute of Fine Arts, New York University, 1942 (unpublished)

Gertrud Schiller, *Ikonographie der christlichen Kunst*, 6 vols (Kassel, 1966), vol.1, pp.88–90

Bianca Hatfield Strens, 'L'arrivo del trittico Portinari a Firenze', *Commentari*, 19 (1968), pp.315–19

Index

Numbers in **bold** refer to illustrations

Piero della Francesca

Acknowledgements

This book is dedicated to
Jasper Lavin Lynn (b. 22 June 2001)

Pietra dura, tanto caro

Following the quincentenary of Piero's death in 1992, there was an unprecedented efflorescence of new work on the artist. The heroic publications of Longhi and Clark in the first part of the century were followed by a steady stream of smaller books and articles that kept the momentum going, but as the anniversary approached the tempo markedly increased. Most of the paintings were cleaned and restored and a number of colloquia with concomitant volumes of fresh research honoured the event in Europe and America. Previously unknown documentary material was discovered and published, mainly by James R Banker, Frank Dabell and Franco Polcri. Most impressive were the massive monographs with brilliant reproductions produced by a generation of scholars who shared the same enthusiasm and admiration for the artist: Carlo Bertelli, Maurizio Calvesi, Ronald Lightbown, Anna Maria Maetzke, Antonio Paolucci, myself and the late Eugenio Battisti, whose two volume work of 1971 was given a new incarnation by the learned acumen and editorial skill of Marisa Dalai Emiliani. I have made ample use of these publications to the great benefit of my current text and to my understanding of Piero and his contribution to the art of the fifteenth and the twentieth centuries. However, most of the interpretations I present here are the result of my own study of themes and topics I have been considering over a period of forty years. Some of my readings differ radically from other interpretations, and the reader is encouraged to take advantage of the bibliographies I have assembled for each chapter and come to his/her own conclusions.

Special thanks go to Alessandro Benci, official photographer of the Soprintendenza of Arezzo. He is the author of the splendid photographs of the True Cross fresco cycle, and was more than helpful in making them available for this publication. My thanks also to my colleague Jack Freiberg for his clear-headed reading of the manuscript, and to the editorial staff of Phaidon Press, always understanding, meticulous and patient. I am particularly grateful to Pat Barylski and Sam Wythe, who set the pace and tone and who made sure that reason guided this labour of love to its logical completion.

M A L

Photographic Credits

Archivio Alinari, Florence: 7, 56, 104; Fratelli Alinari, Florence: 107; Ministero per i Beni Culturali e Ambientali/Soprintendenza per i Beni A A A S di Arezzo: photo Alessandro Benci 1, 28, 83–4, 86–93, 95, 98, 101–3, 105, 108–11, 118, 145; © Artephot/Bapier: 3, 23, 29, 43, 120, 147; Arthothek/Städelsches Kunstinstitut, Frankfurt: 135; © Nicolò Orsi Battaglini: 65, 78–9, 156, 158, 208; Berenson Collection, Florence, reproduced by permission of the President and Fellows of Harvard College: 5; Biblioteca Ambrosiana, Milan: 143; Biblioteca Apostolica Vaticana: 42, 73, 117, 150; Biblioteca Egidiana, Tolentino: photo Ecoart–Varese 140; Biblioteca Palatina, Parma: 142, 144, 148; Bibliothèque Nationale de France, Paris: 49; Osvaldo Böhm, Venice: 212; Bridgeman Art Library, London/Isabella Stewart Gardner Museum, Boston, MA: 163; © British Museum, London: 35, 47, 203; © Bibliothèque Royale Albert 1er, Brussels: 127; © 1990 Sterling and Francine Clark Art Institute, Williamstown, MA: 211; Conway Library, Courtauld Institute of Art, London: 121; Electa, Milan: 182; © 2000 Alan Feltus/courtesy Forum Gallery, New York: 215; © Fitzwilliam Museum, Cambridge: 132; Ministero per i Beni e le Attività Culturali, Florence: photo Microfoto, Florence 6; © Frick Collection, New York: 138; Hessische Landesbibliothek, Fulda: 57; Index, Florence: 13, 197; Index, Ravenna: 168, 187; © Könemann Verlagsgesellschaft mbH: photo Achim Bednorz, Cologne 94; Kunstmuseum Düsseldorf im Ehrenhof: 96; Kunsthistorisches Museum, Vienna: 44; Fabio Lensini: 201; Library of the Hungarian Academy of Sciences, Budapest University: 106; courtesy Lisson Gallery, London: photo Stephen White 216; © Marquette University: 207; The Metropolitan Museum of Art, New York: gift of Dr and Mrs Franz H Hirschland, 1957 (57.181), photograph © 1991 The Metropolitan Museum of Art 213; Microfoto, Florence: 149, 175; Mountain High Maps © 1995 Digital Wisdom Inc: p.340; Musées des Beaux-Arts de Belgique, Brussels: 171, 183; Musée des Beaux-Arts, Tours: photo Patrick Boyer 154; Musei Civici di Torino: photo Studio Fotografico Chomon 190, 194; Museo Civico, Sansepolcro: 160; Museo Poldi Pezzoli, Milan: 139; Museo Poldi Pezzoli, Milan/Opificio delle Pietre Dure, Florence: 134; © National Gallery, London: 53–4, 58, 83, 137, 185, 193, 200, 206, 214; National Gallery of Art, Washington/Samuel H Kress Collection: 18; Foto Paritani, Rimini: 34, 36–7, 45, 50; © Vivi Papi, Varese: 141; Luciano Pedicini: 26; José Pessoa/Divisão Documentação Fotográfica, Insituto Português des Museus: 136; © Publifoto, Palermo: 131; Antonio Quattrone, Florence: 15, 85, 125, 179, 184, 204; RMN, Paris: Daniel Arnaudet 5, 11, Gérard Blot 10, R G Ojeda 52; Ministero per i Beni e le Attività Culturali, Rome/Istituto Centrale per il Catalogo e la Documentazione: 71; Ministero per i Beni e le Attività Culturali, Rome/Soprintendenza Archeologica: 188; Scala, Florence: frontispiece, 4, 8–9, 12, 14, 16–17, 19, 20–2, 24–5, 27, 32–3, 39, 41, 46, 55, 62–4, 70, 74, 76–7, 80, 82, 97, 112, 119, 122–4, 128, 130, 146, 151–3, 157, 159, 161–2, 164–7, 169, 170, 172–4, 176, 180, 186, 189, 191, 196, 198–9, 202, 205, 209–10; Staatliche Museen zu Berlin, Preussischer Kulturbesitz: Gemäldegalerie 72, photo Jörg P Anders 31, 155, 177, 195; Stiftsbibliotek Engelberg: 133; © Foto Vasari, Rome: 100, 126, 129; Vatican Museums: 117; Walters Art Gallery, Baltimore, MA: 30

Phaidon Press Limited
Regent's Wharf
All Saints Street
London N1 9PA

Phaidon Press Inc.
180 Varick Street
New York, NY 10014

www.phaidon.com

First published 2002
© 2002 Phaidon Press Limited

ISBN 0 7148 3852 7

A CIP catalogue record for this book is
available from the British Library

Typeset in Optima

Printed in Singapore

Cover illustration *St Michael*, 1454–69
(see p.212)